In the Shadow of the Eagles

In the Shadow of the Eagles

Sonora and the Transformation of the Border during the Porfiriato

Miguel Tinker Salas

UNIVERSITY OF CALIFORNIA PRESS

Berkeley • *Los Angeles* • *London*

University of California Press
Berkeley and Los Angeles, California

University of California Press, Ltd.
London, England

© 1997 by the Regents of the University of
California

Parts of this book were published in earlier ver-
sions.
Introduction: "Sonora: The Making of a Border
Society," *Journal of the Southwest* (Winter 1992):
429–56.
Chapter 5: "Del crédito al contado: cambios en el
comercio de Sonora después de 1850," *Revista del
Colegio de Sonora* (1994): 65–77.

Library of Congress Cataloging-in-Publication Data

Tinker Salas, Miguel.
 In the shadow of the eagles : Sonora and the
transformation of the border during the porfiriato /
Miguel Tinker Salas.
 p. cm.
 Includes bibliographic references and index.
 ISBN 0-520-20129-9 (alk. paper)
 1. Sonora (Mexico : State)—History. 2.
Mexican-American Border Region—History. 3.
Mexico—History—1867–1910. 4. Frontier and
pioneer life—Mexico—Sonora. I. Title.
 F1346.T56 1997
 972'.17—dc20 95-39423
 CIP

Printed in the United States of America
9 8 7 6 5 4 3 2 1

Para mi madre Luisa Amelia,
mi esposa María Eva
y nuestras hijas Rosa Elena y Ana Luisa

Contents

Contents

Acknowledgments

Intellectual activities are seldom individual ventures. In the process of researching and developing this work I incurred many debts. Above all, I am beholden to Ramón Eduardo Ruiz and Natalia for their constant support and encouragement. Don Ramón's knowledge of Mexico and his own research served to guide and direct my efforts.

John Hart and Allen Wells took time to read the entire manuscript and provided meaningful insights. The work benefited tremendously from their input and the comments of the anonymous reviewers. William Beezley examined several chapters and suggested avenues of research. Arturo Rosales challenged my assumptions, leading me to reconsider many issues. I would also like to thank Michael Monteon and Eric Van Young at the University of California, San Diego, for their earlier counsel.

At different points in this work, I received financial support from the Organization of American States, the President's Fellowship at the University of California, and a Faculty Research grant from Arizona State University and Pomona College. Their assistance proved invaluable.

In Hermosillo, the staff of the Archivo Histórico del Gobierno del Estado de Sonora and its former director, Sr. Gilberto Escobosa Gamez, allowed me unlimited access to this valuable collection. Their prompt and courteous assistance greatly facilitated my work. Don Gilberto also facilitated access to municipal archives at La Colorada and elsewhere.

At the University of Sonora, I am grateful to the staff of the Museo Regional de la Universidad de Sonora and its former director, Maestro Ismael Valencia Ortega, who also graciously shared his own research on land tenure and commerce.

The socios of the Sociedad Sonorenses de Historia in Hermosillo and former presidents Lic. José Rómulo Félix Gastelum and Dr. Arturo Arellano welcomed me to their meetings and eagerly recounted their experiences. Arq. Jesús Félix Uribe García provided important insights into the urban growth of Hermosillo and the development of transportation in Sonora. Researchers at the Instituto Nacional de Antropología e Historia and the Colegio de Sonora in Hermosillo allowed me use of their resources. At the Hotel Kino, Sr. Armando Benard kindly permitted me to examine his personal collection. Dr. Manuel Santillana and Graciela, as well as Humberto Pérez Valle, opened their homes and always welcomed me to Hermosillo. I am extremely thankful to these and all the Sonorans who shared with me their history and their friendship.

In Mexico City, the staff of the Archivo General de la Nación (Gobernación) and the Porfirio Díaz Archives at the Universidad Iberoamericana provided gracious assistance during my research in the capital.

In Nogales, Arizona, I am thankful to the Pimeria Alta Historical Society and its former director Susan Clarke Spater who provided access to their excellent collection on border history. In Ambos Nogales I also benefited from the advice and counsel of ingeniero Eduardo Robinson and the opportunity to consult his valuable collection of Sonoran documents. The comments and knowledge of Alberto Suarez Barnett also proved invaluable. The staff at the Special Collections of the University of Arizona and the Arizona Historical Society in Tucson were always helpful. Chris Marin, archivist at the Chicano Collection at Arizona State University helped with the Pradeau papers and other materials housed in Hayden Library.

At the University of California Press, I would like to thank Eileen McWilliam, Barbara Howell, and Tony Hicks for their efforts. Colleagues at Arizona State University, including Robert Alvarez, Peter Iverson, Lynn Stonner, Phil Soergel, Albert Hurtado, and at Pomona College—Sid Lemelle, Deena González, Sam Yamashita, and Ken Wolf—provided encouragement and support.

To Frank, Pam, Kimberly, Arturo, and Graciela—thanks for your

years of friendship. Above all, I owe a debt of gratitude to my wife, María Eva, and our two daughters, Rosa Elena and Ana Luisa. Without their unwavering support, patience, and love, none of this would have been possible.

Miguel Tinker Salas

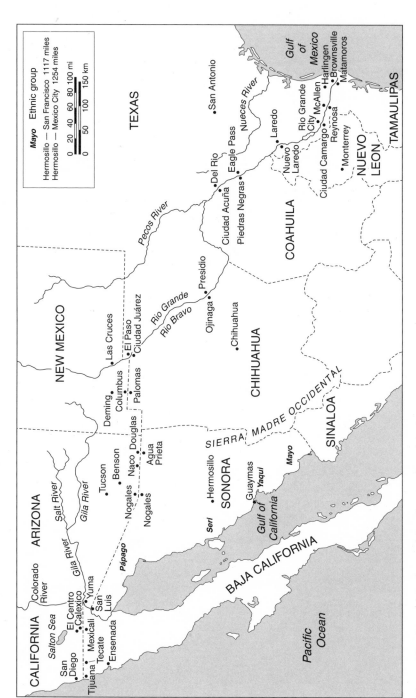

Map 1. Northwest Mexico and Southwest United States

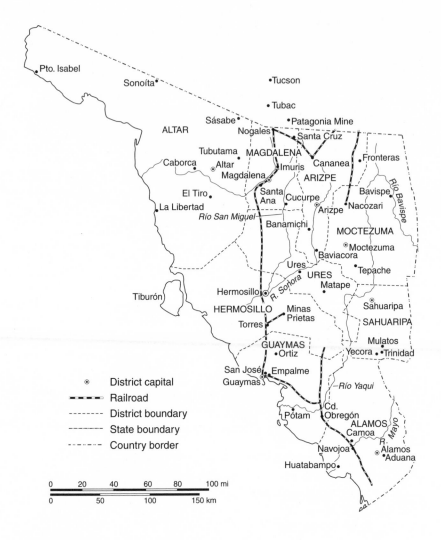

Map 2. Sonora, 1910

Introduction

For decades, the Mexican northwest has captured the imagination of scholars and the general public. It has been portrayed as a region of untold mineral wealth, insurgent Apaches and Yaquis, independent cowboys, border bandits, rugged miners, self-reliant women, wily smugglers, revolutionary caudillos; and recently as the home of conservative business and political interests. At different moments, these seemingly contrary forces have influenced the region's history and stamped its culture.

A lucrative mining economy during the late nineteenth century and Sonoran exploits during the revolution thrust the image of the *norteños* onto the national stage. Military charges by Yaqui soldiers and the exploits of Sonoran generals during the revolution framed how many Mexicans and Americans viewed norteños. Sonorans such as Alvaro Obregón and Plutarco Elías Calles dominated the postrevolutionary period, guiding the destiny of Mexico until Lázaro Cárdenas wrested power from the northerners. Images of Sonoran norteños portrayed in the popular culture earned them a special place in both the politics and the folklore of Mexico and the United States.

This book began as an attempt to uncover the roots of northwest Mexican society and how it influenced the nature of Sonoran participation in the revolution. As the work developed, it turned into an analysis of the transformation Sonora experienced from a neglected *provincia interna,* an internal frontier, to a bustling and influential border state during the last decades of the nineteenth century. In exploring this process, this study breaks the artificial boundary that views the people of

northern Mexico and the southwest United States only within their national borders. Situated between Mexico proper to the south and the United States to the north, the norteño reflects a dual cultural experience: that of the northern Mexican and, to a lesser extent, that of the American. Northwest Mexican society owes as much to face-to-face border interaction as it does to exchanges with the indigenous population, the development of mining towns, haciendas, and urban centers, and to the growing presence of Sonorans and Yaquis in the United States southwest. These factors imply that studies of this region should not be limited exclusively by national boundaries or limited to interaction among border towns, but instead should look at the comprehensive process of change occurring throughout society. Reflecting this integrative approach, the first chapters of the book examine the character of society, commercial structures, conflict with the indigenous populations and early contact with foreigners. Subsequent chapters address increased border exchanges, the arrival of the railroad, the founding of twin border towns, life in mining camps, the new social order, conflict with immigrants, and the multiple fissures evident in Sonoran society by 1900.

The establishment of cross-border relations brought to the forefront a host of new issues, including contending views on modernization, the survival of traditional cultural practices, and conflictive perspectives on identity. It also redefined old issues such as commerce, politics, mining, land use, labor, and relations with the indigenous population. Rather than being simply passive recipients of American-inspired change, Sonoran merchants and hacendados actively participated in the reorganization of their state. No single event determined the restructuring of Sonoran society. The border provides the context for change driven by political interests, construction of the Sonoran railroad, commercial interaction, immigration, and foreign investments in mining and agriculture.

After years of isolation, northwestern Mexican elites, like their counterparts today, ardently supported free trade with the United States. Trade with California and Arizona reinforced their expectations despite repeated forays by American filibusters. Within four decades, from 1860 to 1900, the Mexican northwest underwent a pronounced social and economic reorientation as a border economy took root. The establishment of a border did not restrain foreign capital, nor did it restrict cultural interaction. As Mexicans and Americans came into contact, a

far-reaching exchange of customs took place on both sides of the international line, producing a complex web of social and cultural interrelations.

Border interaction added another dimension to the rich history of the Mexican northwest. The stalwart image of the independent and rebellious norteños had its foundations in the state's early frontier experiences. At a general level, the fundamental codes of culture—"those governing its language, its schemas of perception, its exchanges, its techniques, its values, the hierarchy of its practices"—evolved during this formative period.[1] Still, to speak of a distinctive or unique Sonoran norteño identity proves difficult. Most settlements in this period constituted isolated entities, between which little personal contact occurred. Thus, not just one Sonoran identity existed, but rather multiple identities coexisted. Parallel to the Mexican society, the indigenous people, mainly Yaqui and Mayos, maintained their own identity.

Still, within these isolated communities, Sonora's small close-knit European and mestizo populations demonstrated a strong sense of regional loyalty and accentuated their distinctiveness.[2] The symbols of this Sonoran identity, or what Benedict Anderson characterized as the artifacts of an "imagined community," found expression in popular folklore, music, political lore, and myths.[3] Struggles against enemies, real or mythical, reinforced this frame of mind. The indigenous population, in particular the Apaches and the Yaquis, provided the "other" against which Sonorans initially defined their identity.

By the 1850s, conflict with foreigners, especially recurring attacks by filibusters, and neglect by the federal government reinforced the issue of resistance and identity. Those in power skillfully manipulated historic events and figures. The proselytizing of the Jesuit Eusebio Kino, the exploits of the defenders of Guaymas and Caborca against foreign intruders, and the deeds of the Yaqui leader José María Leyva Cajeme acquired symbolic importance, becoming identified with the Sonorense image. Linked to the accomplishment of Sonorans during the revolution, these events and the broader issues they represented evolved into the popular norteño folklore that flourished in the twentieth century.

Stereotypes concerning the Sonoran norteño abound throughout Mexico. One popular image of the norteño which pervades popular folklore is that of a tall *güero* (light-skinned), wearing an *estetson* (stetson) cowboy hat, blue jeans, denim shirts, metal belt buckle, and leather boots.[4] On festive occasions, they consume large amounts of

carne asada (grilled beef), flour tortillas (not corn), *frijoles con queso* (beans with cheese), and beer. Unlike their Mexican counterparts, the norteño is perceived, according to Mexican intellectuals, "as less complicated . . . clearer and more direct, with simpler manners and less affability, but much more practical, enterprising and efficient."[5] Resistance to "the absolute authority" of the federal government has earned them the reputation of political dissenters. These depictions, however, are typically penned by urban writers hoping to recapture an imagined bygone past. A marked difference existed between popular portrayals of norteños and the daily life of most Sonorans. Romanticized depictions of light-skinned, free-spirited norteños as "self made persons" do not conform to the reality confronted by most northerners.[6] Life in the north remained precarious, and although land was available, countless Sonorans and indigenous people survived as indebted laborers on haciendas and cattle ranches.

Still, Sonora's hacendados, unlike their Chihuahuan counterparts, did not monopolize all productive land. A small class of rancheros managed to eke out a precarious existence cultivating wheat and raising cattle. Merchants from Guaymas and Hermosillo, who exported flour to Sinaloa and Baja California, eagerly purchased crops from both hacendados and rancheros.[7] A close-knit group of notable families dominated politics and monopolized trade with Europe,[8] and although independence from Spain displaced the role of the old colonial metropolis, it did little to alter the nascent export economy.[9] Distance from central Mexico, aggravated by the lack of reliable overland routes, accentuated reliance on foreign commerce. With a relatively small population base, internal markets remained fragile. Confronted by fluctuating world prices for minerals and by civil unrest, Sonora faced repeated economic crisis. Decades of frontier isolation, government neglect, and economic stagnation heightened local elites' determination to forge closer commercial ties with foreigners, particularly North Americans.

THE BORDER

The Mexican-American War and the Gadsden Purchase redrew international boundaries but did not produce immediate contact between Mexicans and Americans. Unlike areas along the Río Grande between Texas and Chihuahua, no population centers existed along the future border between Arizona and Sonora.[10] Not until the mid-1850s did

small numbers of Anglo-Americans trickle into the Arizona-Sonora border region in search of mining opportunities. Border interaction reflected politics and power relations. The initial contact between Mexicans and Americans produced a clash of cultures which deteriorated into open racial conflict and scarred future relations. During this period, Sonora maintained certain key advantages over the new American territory. Arizona remained isolated from American commercial centers and relied on Mexican merchants and hacendados for basic goods. The components of a border economy evolved at a time when no settlements existed along the boundary between both countries.

During the 1870s, a flood of published accounts, written by both Mexicans and foreigners, promoted Sonora's mineral wealth and attracted large numbers of North Americans and Europeans to the "new border empire." As the railroad reached the American territory from California in 1877 and the Anglo population of Arizona increased, the early commercial advantages enjoyed by Sonoran business faded.[11] Arizona's absorption by West Coast commercial centers forced the Sonoran economy to undergo the first of many adaptations. A new cash economy controlled by the Americans displaced the credit system that the Europeans had employed for decades. Sonoran merchants gradually deserted traditional suppliers in France, Germany, and England and forged alliances with business interests in San Francisco.

Mining and the potential for trade with the Pacific inspired projects for building a railroad in Sonora. Facing recurring wars with Indians, political strife, the lack of financing, and the absence of American rail lines, these early railroad schemes never materialized. By the late 1870s, as these tensions lessened, the federal government approved several plans to link Sonora to Arizona. The railroad symbolized the impending changes the state confronted and it generated heated debates over the future of Sonora's culture and identity. Divergent economic interests invariably masked the rhetoric concerning railroad projects. Sonorans who feared that their state would be absorbed by the "colossus of the north" vigorously protested against the concessions offered to foreigners. Other Sonorans viewed the railroad as an agent of modernization and labeled opponents of the project as retrograde.

Promoters of free trade with the United States dominated politics and carried the day. With the railroad in place, Americans invested in mining enterprises throughout the state, and many Sonoran elites, functioning largely as middlemen, profited from the expanding relationship

with those investors. Integration of the Sonoran economy by Arizona quickened the pace of social change. Besides fueling an export economy, the railroad consolidated the local economy and brought Sonorans from throughout the state face to face with each other. This encounter initiated fundamental changes and adaptations in nearly all spheres of social and political life.

The most profound modifications in the northwest occurred in the new border towns, such as Ambos Nogales, which developed in response to commerce between Sonora and Arizona. Ambos Nogales grew simultaneously, giving rise to a economic interdependence between the United States and the Mexican community. The absence of existing border settlements with established urban traditions and cultural practices facilitated greater exchange between both communities. Since Americans relied on Mexican commerce, relations between Ambos Nogales in this early period did not reflect the marked asymmetry found elsewhere in the Mexican north. To prosper in the new border environment, some enlightened Americans adapted Mexican cultural norms, learned Spanish, and interacted socially with their southern neighbors. In contrast to developments along the Texas-Chihuahua border, Sonoran and Arizonan business groups forged a working consensus and attempted to minimize open conflict and economic competition.[12] The Mexican revolution strained, but did not derail, the economic and social rapport operating between business groups in Nogales.

Despite this consensus, elites from both countries had only limited success in imposing their vision of peaceful coexistence on the population. The influx of immigrants, both Americans and Mexicans, repeatedly threatened the tenuous peace which elites established between Ambos Nogales. Border relations are not unilinear but, rather, embody many different and distinct layers, shared by diverse groups of individuals, in which conflict and convergence actually coexist. Viewed from this perspective, border culture does not represent a uniform concept shared by all border residents, but instead, has definite meaning only to specific groups. There is a culture shared by business interests, both Mexican and American, one by long-term residents, one by Mexicans immigrants, and one by indigenous groups such as Yaquis and Tohono O'odhams (formerly called Papagos) who may have roots in both Arizona and Sonora. Fueled by ongoing immigration, social interaction, and economic growth, border society continuously evolved. Border interaction produced a complex cultural layering in which Americans and

Mexicans acquired the knowledge and ability to function effectively in each others' world. Crass mimicking of American culture did occur, particularly among Mexican upper classes, but in general both groups preserved their past traditions. Ambos Nogales experienced a process of internationalization but did not produce a bifurcated culture which operated independently of either Mexico or the United States.[13]

Border interaction, exposure to the "other," did bring the issue of identity into sharper relief. Mexican identity, however, was not forged only in relation to the American. Conflict alone does not capture the complex web of social, economic, interpersonal, and familial relations which arose between border communities. Neither does it capture the dynamics of a Mexican population that lived on both sides of the border nor that of individuals–Mexicans and Americans–who maintained social ties and economic interests in both nations and thus sought to mitigate conflict when it erupted.

In the developing mining enclaves of rural Sonora, such as La Colorada and Minas Prietas, little parity existed between North Americans and Mexicans. In these areas, the absence of previous Mexican settlements proved advantageous to American economic interests. Offering comparatively high wages, mining centers became magnets for a diverse population and gave rise to a new working class composed of Yaquis and Sonorans. Accommodating Mexican officials allowed foreign mining companies a free hand in regulating the settlements, in controlling labor, and in exploiting natural resources. Sonoran land owners, merchants, and government officials profited from their relationship with foreign interests. A racial and social hierarchy permeated life in both the mines and the settlements. Confronting a host of dilemmas, including labor strife, ethnic discrimination, violence, and conflicting cultural values, mining towns embodied the full range of problems facing Sonora's Porfirian leaders.

During the nineteenth century, the northwest also served as a meeting ground for Mexicans from different parts of the country. Jalisences, Michoacanos, Guanajuatenses, and others migrated to the mines, haciendas and border towns of the north searching for work. These movements of people exposed northerners to the broad ethnic, cultural, and regional diversity of Mexico and began to redefine concepts of regional and national identity. Such diverse cultural exchanges were not easily replicated until the onset of the revolution. At one level the border divided two countries, yet at another level, it brought together mem-

bers of the same nation. The appearance of Mexicans from other states added yet another layer of complexity to border society.

Buoyed by their new-found status, Mexican elites transformed their urban environment, accentuating social differences with the rest of the population. Domingo Sarmiento's classic struggle between barbarism and civilization played itself out in Sonora between the rising urban classes of Hermosillo and Guaymas, which directly benefited from increased economic relations with the United States, and the common folk, the rancheros, the miners, and the Yaquis.[14] The enthusiasm expressed by elites and middle sectors masked the serious problems that Sonora confronted. Precipitated by fluctuations in the price of silver and copper, recurring economic crisis throughout the nineteenth century exposed the fragility of the Sonoran economy. After the 1907 crisis, the promise of development became increasingly illusory—as the mines closed, as merchants' sales plummeted, and as agriculture declined, old social cleavages acquired new importance. The foreign presence, which included Americans, Europeans, and significant numbers of Asians, became a source of conflict.[15] Spurred by the preferential treatment that the Porfiriato afforded foreigners, old concerns regarding culture and identity resurfaced. Nationalism assumed multiple characteristics and was not defined only by physical attacks on foreigners or their property.[16] Demands by workers over wage inequity, protests by local municipios over the loss of autonomy, and even middle-class alarm over morality, embodied these nationalist concerns.

Regional inequality and intercity strife compounded rising class antagonisms, moralistic proclivities, racial prejudices, and nationalistic fervor. Local Porfirian officials proved incapable of responding to the growing discontent among disgruntled hacendados, middle classes, and labor. Facing mounting economic problems and the potential for social rebellion, pragmatic northern business interests and middle classes gradually withdrew their support for the Porfirian state. The foundations of a binational economic order were firmly in place. Norteño elites no longer needed the old regime to maintain the prosperous border economy, and the political turmoil that followed did not alter the basic economic and social tenets of this society.

MUCHOS MEXICOS: EL NORTE

The notion of "many Mexicos" encompasses not only Mexico's complex geography, but also embodies a multitude of human experiences

including complex interactions between race, ethnicity, and gender and structural relations such as the nature of economic exchange, land-tenure systems, and methods of labor exploitation.[17] Under certain circumstances, these conditions coalesce and find expression in unique regional experiences. Yet these differences are not always absolute, and distinct regions, such as the north, share similarities with other states in Mexico. At one level, Sonoran economic development parallels the general transformation of the Mexican north during the Porfiriato.[18] American investments in mining and railroads also produced change in Chihuahua, Coahuila, Tamaulipas, and Nuevo León.[19] The various regions of the Mexican north shared similar forms of economic development, and American customs also penetrated these regions,[20] but how the Mexican north adapted to external pressures, whether American or Mexican, varied from region to region. Specific historic conditions and the context in which they arose produced important variances. The north by no means experienced uniform patterns of development. As the late Mexican anthropologist Guillermo Bonfil Batalla pointed out, "the rural culture of Sonora was not the same as that of Nuevo León."[21] Common patterns of economic development did not mitigate disparities in communication, in population size, in conflict with the indigenous, in control of land, in political alliances, and in the strength of regional elites. In many cases, the interplay between these factors determined how areas responded to economic and cultural pressures from the United States.[22]

Physical separation from other Mexican states and immediate contiguity with the United States distinguished Sonoran development from the general pattern in the north.[23] The early world of the Sonoran remained constrained by the foreboding Sierra Madre Occidental and by recurring attacks from the dreaded Apaches on its eastern flank and from the formidable Yaquis to the south. The mountains, which encircled the state, and the frequent Indian wars acquired symbolic dimensions, placing tangible spatial limits on Sonoran society.[24] Isolation influenced the nature of politics in the region. During the colonial era, Sonora was relegated, along with Sinaloa, Durango, and Baja California, to the status of a provincia interna. Following independence, the Mexican congress united Sonora and Sinaloa into El Estado de Occidente.[25] This isolation, according to Stuart Voss, repeatedly undermined the economic and political plans of the Sonora's notables.[26] Unable to overcome these obstacles, the union collapsed in 1831. Torn by civil war, Mexico City paid scant attention to the north.

Before the Porfiriato, Sonora seldom intruded into Mexican national life.[27] Ignacio Zúñiga, an influential Sonoran statesman, believed that Mexican political leaders had a greater degree of familiarity with the problems of Central America and Cuba than with his state. In 1842 Zúñiga wrote that "Sonorans have not found any sympathy among the sensible and humane inhabitants of the capital [Mexico City]."[28] Forty years later, when Sonoran congressman José Patricio Nicoli arrived in Mexico City, he discovered that fellow representatives still knew little about his native state.[29] In the first decade of the Porfiriato, political leaders lamented that Europeans and North Americans knew Sonora better than most Mexicans did.[30]

While Sonora remained physically isolated, other northern Mexican states established, according to Mexican geographer Jesús Galindo y Villa, "good communications with Chihuahua and with the rest of the nation."[31] This process allowed the north and northeast to develop varying degrees of economic, political, and even social ties with the central region.[32] The Sánchez Navarros of Coahuila maintained a lucrative business selling sheep in Mexico City. Family members regularly visited the capital and participated in the politics and social life of the city.[33] Long before the border with the United States acquired importance, economic interests in the Mexican north and northeast had established relations with the south.[34]

No one family dominated land or economic activity in Sonora as they did in Chihuahua, where the Terrazas clan's monopolization of land and mining allowed them to extract concessions from the central government and foreign interests.[35] Similar patterns existed in Coahuila, where the Sánchez Navarro family had controlled extensive tracts of land.[36] In both cases, access to markets in central Mexico stimulated early acquisition of land and the development of cattle- and sheep-ranching. Removed from markets, property in pre-border Sonora did not attain the value it did elsewhere in the Mexican north: pronounced isolation in the northwest exacerbated Sonora's long-term political and economic problems.[37]

While the Sonoran economy languished through much of the nineteenth century, Monterrey, the capital of Nuevo León, slowly emerged as an important commercial center in the northeast. The absence of geographic barriers in northeastern Mexico permitted Monterrey greater economic and social interaction with the surrounding area. Unlike their Sonoran counterparts, who remained fragmented, Monterrey

elites took advantage of the emerging opportunities, adeptly forging familial and political alliances. With caudillo Santiago Vidaurri at the helm, Monterrey became the hub of a extensive regional economy.[38] Increased trade during the American Civil War brought in much-needed capital. With access to ports in Tamaulipas and to American markets in the north, Monterrey developed extensive commercial relations with the surrounding states of Chihuahua and Coahuila and with areas as far south as Durango, Zacatecas, and San Luis Potosí.[39]

Economic groups in Sinaloa, in particular those in the port of Mazatlán, also became an important obstacle to the southern expansion of Sonoran commercial interests. Despite its rocky and inhospitable harbor, Mazatlán had access to diverse markets in the interior such as Durango, Colima, Chihuahua, and Jalisco. Aside from precious metals, foreign ships loaded a wide variety of agricultural products from these areas. With the arrival of Chinese, British, German, and American vessels, Mazatlán became the principal commercial entrepôt of the Mexican Pacific northwest. By 1842 Mazatlán also served as headquarters for several powerful German merchant houses.[40]

Guaymas, Sonora's principal port, lived in the shadow of the Mazatlán. Its location in the Gulf of California proved disadvantageous in the new order that emerged in the Mexican northwest. The principal attraction Sonora offered continued to be access to silver and other minerals. Silver, however, remained an unpredictable commodity. Its price constantly fluctuated on international markets, thereby leaving Sonora vulnerable to repeated economic crisis throughout the nineteenth century. As silver prices once again plummeted in the 1850s, José Velasco, a noted political figure, lamented that "trade in exports remained precarious, we lack products for returning ships, the only thing Sonora has to offer now is flour."[41] To develop its own economy, Sonora had to increase the export of minerals and develop trade relations with the north, but outside of the orbit of Mazatlán merchants.

By the mid-1880s most of the Mexican north and northeast, including the states of Chihuahua, Coahuila, and Nuevo León, had rail or other access to markets in central Mexico. Increased economic and social interaction between these states and central Mexico provided them a measure of autonomy from the United States, and while elites in these regions welcomed relations with the United States, they did not forsake trade with other Mexican states. In cases when the United States adopted restrictive trade measures, rail access to the south allowed mer-

chants and hacendados in Chihuahua and Monterrey to reach alterna-
tive markets; for example, to circumvent the United States' restrictions
on Mexican beef in 1892, Luis Terrazas and other cattle producers
found outlets for their livestock in Mexico City.[42]

With no rail links to the south and with limited access to other
Mexican markets, Sonoran agricultural and mineral production grew
increasingly dependent on the United States. Writing in the 1890s,
Alfonso Luis Velasco explained that geographic isolation had forced
Sonora to limit its "commerce with the western United States of which
it is a real dependency and the states of Sinaloa, Chihuahua and the
territory of Baja California."[43] Expanded economic activity, as Ramón
Ruiz demonstrated, increased Sonora's reliance on the United States.[44]

Reliance on exports further magnified foreign influences in Sonora.
Most elites relied on precarious mining operations and the export of
wheat to neighboring Sinaloa to generate capital,[45] and the advent of
economic relations with the United States intensified this orientation.
As foreign capital penetrated the state, Sonoran elites increasingly func-
tioned as intermediaries. American and British interests dominated the
largest mining enterprises and the railroads, and Sonoran notables
found themselves relegated to agriculture, cattle, and limited trade. Pro-
nounced reliance on American investments and markets eventually pro-
duced unexpected and dramatic cultural changes in Sonoran society.

In contrast, elites in Nuevo León achieved significant independent
expansion without becoming wholly dependent on the infusion of
United States capital.[46] In Chihuahua, as Mark Wasserman observed,
Luis Terrazas avoided outright subordination to foreigners and exer-
cised a near total monopoly on the politics and the economy of the
state.[47] This was not the case in Sonora. Constrained geographically
and fragmented politically, Sonoran elites remained divided. Regional
antagonisms between Alamos, Guaymas, and Hermosillo masked eco-
nomic and political differences among local elites.[48] In many respects,
Sonoran upper classes resembled the weaker Californio elites during the
Mexican era rather than their more powerful northern counterparts.[49]

Beside economic competition from neighboring states, Sonora also
faced serious internal contradictions. While most of Mexico lived at
peace with its indigenous population, a persistent state of war with
the Yaquis and Apaches continued to foment turmoil in Sonora.[50] So-
noran elites viewed the Indians as a retrograde force and the principal
cause of the states' inability to develop. By the mid-1880s other north-

ern Mexican regions had come to terms with the indigenous populations, whereas in Sonora, wars with Yaquis provided opportunities for ambitious military officers and corrupt politicians to advance their careers but continually squandered state resources.

Intense political factionalism further divided Sonorans, adding to the uncertainty of life in the northwest. The insecurity of life prompted many Sonorenses to look for opportunities in California and Arizona. This constant out-migration of laborers severely depleted the local population. As the second largest state in Mexico, Sonora remained seriously underpopulated—a condition that prevented the creation of a stable labor force and limited the formation of internal markets. With the exception of the territory of Baja California, it had the smallest population of all the northern states. In 1888, its population lagged at 150,391, whereas neighboring Chihuahua had 298,073 and Nuevo León 244,052.[51]

A recurrent pattern of social and political strife prevented local elites from effectively consolidating power. After the French intervention, officials in Mexico City moved to integrate the north in order to stabilize relations with the United States. The presidency of Lerdo de Tejada marked the beginning of the region's slow and arduous integration into the Mexican political mainstream.[52] Lerdo established federal control over economic policy and international relations, vetoing several foreign plans to build railroads in the northwest. A rebellion against long-time caudillo Ignacio Pesqueira, led by a coalition of mine owners, merchants, and urban middle class, gave Lerdo the opportunity to intervene in state politics. He supported the ouster of Ignacio Pesqueira and in 1876 appointed General Vicente Mariscal as military governor of Sonora. A small contingent of federal troops helped ensure the new order in the state.

Pesqueira's ouster facilitated efforts by the central government to manipulate events in the state. Historically, the federal government's ability to influence events in most northern states had been limited by the presence of strong local elites. President Benito Juárez struggled to break the power of Governor Santiago Vidaurri in the northeast.[53] In Chihuahua, General Porfirio Díaz negotiated with Governor Luis Terrazas in order to reach a workable compromise between federal and state interest. Instead, among those who had rebelled against Pesqueira, Díaz found a sympathetic group who shared his agenda. The relationship proved beneficial to both groups: Díaz needed strong allies in the

region to ensure his control of politics, and the "young turks" who assumed power needed the support of the federal government to deflect local opposition. The relationship between this group and the Díaz administration embodied multiple levels of patronage and clientelism, which were replicated at the national, regional, and local levels.

Shortly after arriving in Sonora, Díaz's emissary, General José Guillermo Carbó, received a letter from General Manuel González instructing him to make sure that the new leaders of Sonora belong in "body and soul to our party."[54] A triumvirate composed of Luis E. Torres, Ramón Corral, and Rafael Izábal accommodated the demands of the Porfirian regime. Torres often referred to Carbó as the benefactor of the Sonoran triumvirate.[55] Supported by Carbó, they orchestrated a rebellion against Mariscal, the popular interim governor appointed by Lerdo.[56] Unlike former political factions, which governed with varying degrees of autonomy, the triumvirates' control of the state increasingly rested on the military and political support of the federal government.

As commander of the federal troops for northwest Mexico, Carbó often played a decisive role in local affairs. Politically astute, he warned Díaz never to appoint Mexicans from other states to fill important offices in Sonora.[57] To appease the general, Corral found himself forced to shuffle nominees from district to district prior to an election in 1883. Following Carbó's example, Corral insisted that the new legislature would include "our most trusted friends, those we judge to be loyal and energetic."[58] Until his death in October 1885, Carbó oversaw a political machine which included Sinaloa, Sonora, and Baja California. Afterward, Díaz dealt directly with Torres, and later with Corral.

Each member of the Sonoran triumvirate played a specific role in the new government. Torres, a native of Chihuahua and a military figure, exhibited a strongly pragmatic orientation.[59] He had been an early supporter of Díaz, endorsing the Plan de Noria and, later, Tuxtepec. In a very candid letter to a trusted ally, José Negrete of Guaymas, Torres summarized the relationship between the three men.[60] Torres portrayed himself as the senior member of the group, removed from the daily operations of the state, which he entrusted to Corral and Izábal. In practice, he became the triumvirate's point man with the administration in Mexico City and a troubleshooter in the state. Díaz later used him in the same capacity, assigning him as political boss to Baja California and later as military emissary in Yucatán. Corral, a native of Alamos, became the intellectual architect of the group. As secretary of state and

later governor, he authored numerous laws, restructured the educational system, and worked to attract foreign investments. In the process he acquired an immense personal fortune. Born in Sinaloa, Izábal, the least member of the group, functioned as a political operative in the state legislature, served as governor, and led bloody campaigns against the Yaquis and Seris. Beside politics, the three men became intimate personal friends, and Torres served as godfather in both Corral and Izábal's weddings. Beyond this inner circle, the triumvirate established a network of patronage which included merchants, hacendados, and government functionaries throughout the state. Marriage into notable families and extended family relations cemented ties within this broader alliance.

The Sonoran triumvirate relied on Carbó and the federal government to neutralize political opponents. In 1882, when governor Carlos Ortiz, an ally of the triumvirate in the ouster of Mariscal, pursued an independent course, they plotted his removal. From Mazatlán, Carbó coordinated the plan against Ortiz. While Corral and Izábal stayed behind to build political support, Carbó dispatched Torres to Mexico City to win over Díaz. Ortiz tried unsuccessfully to woo Díaz by lobbying the influential Minister of the Public Works Carlos Pacheco.[61] Under Ortiz's direction, the official government press repeatedly denounced Carbó's interference in the internal affairs of Sonora.[62] Ortiz's mistakes in dealings with the Apaches and Yaquis, his educational reforms, and his attempts to reorganize the state militia played into the hands of the opposition. Bernardo Reyes, commander of federal troops in Sonora, openly clashed with Ortiz over a purported Yaqui rebellion.[63] Political pressure and a well-staged "mutiny" by federal troops in Sonora eventually forced Ortiz to leave the state. Summarizing his efforts to Izábal, Carbó indicated that "the work of Luis in Mexico combined with the help that I lent from here tilted the balance in our favor. We were fortunate that our interest happened to coincide with the interest of the center. . . . otherwise it is difficult to get them to notice Sonora since it is such a distant state."[64]

Despite repeated electoral challenges, the triumvirate composed of Torres, Corral, and Izábal managed to control the destiny of Sonora until 1911. Support for the Sonoran triumvirate did not, however, embody broader ideological unity, but rather immediate self interest. A coalition of elites and political interest agreed on the need to eliminate the Apache and Yaqui threat, create a stable political climate and at-

tract United States investors. Except for the issue of the Yaquis, these goals had been largely accomplished by 1900. The absence of broader ideological cohesion fueled an active multiclass opposition.

The rise of Díaz coincided with expanded economic ties between Sonora and the United States. Sonora found itself pulled in two directions; political absorption by Mexico City and economic integration by the United States. Beside economic control by the United States, Sonora gradually relinquished political autonomy to Mexico City. For local elites, economic expansion and prosperity produced by increased relations with the north made stronger ties with Mexico palatable. Even before the 1850s, the presence of Yankees in these areas excited many Sonoran notables who hoped that commercial ties with the north would allow the state to emerge as a powerhouse in the northwest. Ultimately, the border embodied both the promise and peril of closer relations with the United States.

"Dust and Foam"

Life in the Mexican Northwest

The austere Sonoran desert, with its summer heat, arid lands, and scarcity of water, indelibly stamped local society, affecting architecture, diet, attire, leisure, socialization, and travel.[1] Desert environments did not encourage much social experimentation, and the course of daily life seldom changed. Nearly every human activity required adaptation to the rigors of the climate. Severe conditions of life tended to impose a basic uniformity on "both landscape and ways of life."[2] Shared environmental and social conditions exerted a powerful influence on the evolution of a local society. Far from being a destitute frontier, early-nineteenth-century Sonora possessed a close-knit population which lived in well established urban areas.[3] An economy based on the export of silver and wheat gave rise to an influential body of notables, including a significant number of foreigners. Ongoing wars with Yaquis diminished miscegenation and increased the region's reliance on traditional Spanish cultural norms.[4]

A continuously low population ensured the uniformity of cultural values and the maintenance of a traditional way of life—the smaller the population, "the more homogeneous its patterns of belief and behavior will be."[5] The low population density permitted the rise of a pervasive cultural aesthetic, ranging from simple matters such as music, dress, and food to more complex issues, such as social attitudes toward the indigenous people and views of modernization. Despite differences in social class, diverse groups shared similar norms and customs, forging

a close-knit community. Sonoran society epitomized the continuity and discontinuity present throughout Mexico. Some social practices were regional in origin, while others mirrored general patterns of behavior found elsewhere in Mexico.

NORTHERN SETTLEMENT PATTERNS

The settlement of northern Sonora represented a break with the experiences of the southern half of the state. The colonial mining center of Alamos, near the Sinaloan border, could not influence the development of northern Sonora. The bay at Guaymas became the new focal point for future northern settlements, serving as the axis for a succession of communities that extended north toward the direction of the future border. The development of this area reoriented economic activity away from the south and toward the northern districts. In this new emerging economic and political order, the Guaymas-Hermosillo corridor became the most important force in the development of northern Sonora.

Despite one of the best natural harbors in the Pacific, Guaymas remained uninhabited for some time. The rocky hills that protected the harbor from violent trade winds also encircled the town, reflecting the midday heat, making Guaymas a veritable furnace in the summer:[6] one foreign traveler remarked that the port reminded him of a Dutch oven.[7] Due to its inhospitable environment, Sonorans resisted settling near the bay, which was surrounded on all sides by "rocks, cactus, and brush."[8] Instead settlers erected a village, San José de Guaymas, in one of the interior estuaries, where a stream of water flowed nearby. The inlet, however, proved shallow and impractical for larger ships, which continued to dock in the deeper outer bay. To compensate, early residents maintained an observation post atop a nearby hill from where they could notice the arrival of foreign trading ships and converge on the bay. In the 1820s, several intrepid businessmen, among them the future American consul Juan A. Robinson, moved their operations to a location on the actual bay, and merchants became the driving force in the port's development.

The new Guaymas suffered from a chronic lack of water and sparse vegetation. Water had to be drawn from distant wells and brought into town in "carts or in canvas bags slung across the backs of burros and delivered from door to door,"[9] and young Mexican boys atop burros transporting water became a common sight throughout the town.

Mexicans and foreigners alike complained about the unpalatable and brackish water of Guaymas. Hoping to capitalize on the situation, two Germans opened a small brewery in the 1850s.[10]

Gradually, single-storied buildings, built around the bay's edge, marked the urban landscape of Guaymas. Merchants monopolized most of the bay-front property, building stores and warehouses to stockpile goods. In appearance, Guaymas reminded a writer for the *New York Times* of "a small country village in Spain"; however, "its chief characteristic was the abundance of dust, and dirt, hot pavement, drunken Indians, and mongrel curs, that snap and snarl at every passer-by."[11] When Cyprien Combier, a French merchant arrived in Guaymas in 1830, he found little evidence of commercial activity. Rather what struck him most about the port was the presence of "one hundred Indians all naked except for a loin cloth," sitting around the central plaza of Guaymas.[12] These stereotypes aside, the presence of these Indians, mainly Yaquis, proved critical to Guaymas' survival.

More than any other area in the state, Guaymas depended on Yaquis for commerce and labor. Lacking water and fertile lands, Guaymas relied on the people of other districts, and especially on the Yaquis, to provide the town with most agricultural goods.[13] A constant stream of caravans kept the town stocked with basic agricultural products. Since most food had to be brought into the port, the cost of living in Guaymas exceeded that in other areas. One observer noted that "everything is brought from great distances, even oysters generally come from the Yaqui river."[14] During the spring, Tohono O'odhams, sold *pitayas* (saguaro fruit) by the basket and honey in the streets.[15] The Yaquis traded finished goods, such as sarapes, pottery, and straw hats.[16] Likewise, most of the ranchos and haciendas in the district relied on Yaqui laborers. Local elites had a vested interest in maintaining good relations with the indigenous population.

In the proximity of the San Miguel and the Sonora Rivers, the Spaniards in 1700 selected Pitic (Hermosillo) as the site for a presidio. Because of its central position as gateway to the northern districts, Hermosillo became the de facto commercial and economic entrepôt of the state. Supplied by a constant stream of mule trains from Guaymas, the stores of Hermosillo offered a wide assortment of foreign and regional goods,[17] and its mills, powered by water and steam, processed much of the wheat produced in northern haciendas.[18] Hermosillo came to dominate the surrounding regions—even the state capital of Ures could not

escape from its shadow. Captain Guillet, a French officer who reconnoitered the state prior to France's invasion, observed that Ures existed as an "artificial city which would quickly become a simple rancheria if government offices moved."[19]

Originally, northern urban areas, such as Hermosillo, had been established as self-sufficient, defensible enclaves against Indian attacks. Farming inside the urban perimeter provided a safe and reliable supply of agricultural products in times of wars, when most residents did not dare venture beyond the confines of the city. The fertile land surrounding Hermosillo supported extensive orange groves, wheat and sugarcane fields, and vineyards. Over time, Hermosillo became known for its fine brandies. The urban farms (*fincas urbanas*) which surrounded Hermosillo permitted wealthier families to construct ornate dwellings with "gardens and vineyards of several acres attached to them."[20] A system of underground *acequias* drained water from the neighboring rivers to supply the city's human and agricultural needs.

Hermosillo's rustic beauty impressed most early visitors. The surrounding desert and its many whitewashed walls, according to John Hardy, gave Hermosillo a Moorish appearance,[21] although he complained, as did most travelers, that a fine layer of gritty desert dust covered everything in the city. As in other Mexican towns, a large plaza surrounded by ash trees—where people assembled for public ceremonies, festivals, and political events—dominated the center of the community. In typical Spanish fashion, one side of the plaza was "taken up by a church, with a clock in a tower, public offices and town jail."[22] To the south of the city, separated from Hermosillo proper by the Sonora river, lay the pueblo of Seris, a community of Seri Indians who supplied most of Hermosillo's basic labor needs. Most lived in frail adobe structures surrounded by fences made of dried ocotillo branches.

Beside the customary municipal offices, jail, and public schools, Hermosillo had few public amenities. By the late 1860s the city had its own hotel—*los Tres Amigos*—several bars, and a number of billiard establishments.[23] In earlier times, travelers had depended on the largesse of residents for shelter or they simply had slept under a tree in the local plaza. The city also supported three bakeries, pharmacy, three dairies, one slaughterhouse, a small *parian* (market), and several sugar and flour mills. Like Guaymas, Hermosillo had carpenters, carriage makers, tailors, blacksmiths, jewelers, tanners, and shoemakers. Despite limitations imposed by the surrounding environment, the two cities con-

tinued to be the most important population centers of northern and central Sonora. An interrelationship existed between the two—Guaymas retained control over arriving products, while Hermosillo became the depot for goods distributed throughout the north.

Sonora's important merchants and hacendados maintained businesses and residences in Hermosillo. Notables lived in "large and costly houses, built of stone, brick, or adobe and finished and furnished in the interior in the best European style."[24] Despite their social standing, at first little if any great physical separation existed between the dwellings of the affluent and those of the lower socioeconomic classes. Not far from the residences of wealthy merchants and hacendados, the laboring classes lived in *jacales*—simple whitewashed adobe dwellings with straw roofs and doors made of hides. The need to defend against Indian attacks compelled elites and common folk to share the same urban space. Not until the threat of Apache and Yaqui attacks diminished in the latter part of the nineteenth century, did notables begin to live in separate urban areas.

Notables built their houses in order to minimize the effects of the heat and maximize ventilation.[25] Construction of these residences took place "with a view to coolness, with thick walls, large rooms, high ceilings, and many doors, giving plenty of ventilation, but admirably excluding the heat in the summer when they are closed except at night."[26] In the words of Thomas Robinson Warren, nephew of a United States consul in Guaymas, these usually included "large grated windows, which ran from the floor to the ceiling, well ventilated bedrooms, long corridors or piazzas, so deep as always to be shaded from the sun," detached kitchens, and shaded patios to ameliorate the intense summer heat.[27] To escape the sweltering heat on summer nights, the affluent slept outdoors in their interior shaded patios "without thought of fire."[28] By contrast, most Sonorenses, having limited resources, simply suffered with the scorching temperatures, and the majority of the population slept on the sidewalk in front of their homes or in the public plazas during summer months.[29] On most warm evenings, foreigners complained that it became impossible to stroll down city streets. Combier noted that after eight o'clock men and women "laid in the street with a sheet and a petate and would begin talking and finally fall asleep. The houses were left deserted and the doors open."[30] This practice could be found in most northern settlements.[31] Though surprising to outsiders, this type of open and public association among residents reinforced a

sense of community and social cohesion among norteños of various social backgrounds.

Further north, isolated settlements such as Caborca, Altar, Magdalena, and Arizpe struggled to survive amidst a population of Tohono O'odhams, Seris, Opatas, and Apaches. The welfare of these communities depended in great measure on their ability to exploit the limited resources of the adjacent countryside. As the surrounding region remained under constant siege from Apaches and bandits, most northern towns stagnated and lost population. On the edge of Altar, homes built with thick walls and fortified towers bore testament to the ongoing wars with the native populations.[32] Fearful of raids, residents cultivated most of their basic crops in extensive urban gardens. The date palms which dotted the outer perimeter of the city stood as reminders of the city's past, when it had been an important colonial mining center.

Magdalena became an exception to the ills that afflicted northern towns. Situated on the principal trade routed between Hermosillo and Tucson, it became an important distribution center for the American territory, retaining a relatively stable population. With access to water, agriculture and cattle ranches flourished. Like most other northern towns, Magdalena maintained a "municipal building, a church [in various stages of construction] a jail, three or four stores [kept by an American and a German]," and when funds permitted, a school.[33] Some Americans who passed through the town, however, did not appear impressed. In 1860 John Ross Browne described it as a "parched-up confusion of adobe huts, scattered over the slope of a barren hill like so many mud boxes."[34] What Magdalena lacked in glamour, it made up in economic importance.

EARLY PATTERNS OF CONSUMPTION

During the first half of the nineteenth century, the French and British supplied the majority of finished goods to the state and influenced Sonorense patterns of consumption. Notable families grew accustomed to imported fabrics such as muslin, cotton, denim, cashmere, linens, and wools. Sonoran seamstresses exhibited great skill in producing the latest European fashions since the elites favored Parisian fashions.[35] In 1830 one Spanish traveler observed that the "women of Pitic (Hermosillo) [created] their own dresses and [did] so with such perfection that it would surprise the tailors of Europe."[36] Besides designing dresses,

these industrious women gained distinction for their embroidery, weav-
ing, and needlepoint and won many prizes in international competi-
tions.[37] Local designers also became adept at handicrafts. The prefect of
Hermosillo expressed pride in the ability of local artisans to weave "ar-
tificial flowers that looked so much like the real thing that the unsus-
pecting observer could not tell them apart from natural flowers."[38]

For most people, however, the blistering weather determined the
type of clothing that could be worn comfortably. Although elite Sono-
ran women "scrupulously followed the latest European fashions, they
refused to cover their heads with the classic mantillas of Spain."[39] Men-
folk customarily donned clothing made from *manta* (an inexpensive,
lightweight, white cloth) or "white cotton drawers and shirts" and
hats, especially during the scorching summer months. Field hands com-
monly wore straw hats whose material they obtained after the wheat
harvest or from the abundant palm trees.[40] Shoes consisted of *teguas,* a
sandal crafted from coarse leather.[41] Since notables preferred imported
felt hats and apparel made of linen, clothing denoted social status.[42]

For the affluent families, the possession of foreign goods confirmed
their social standing. An eclectic assortment of foreign artifacts deco-
rated the interiors of their homes, reflecting the wide range of trading
partners. The residence of the American Juan Robinson, for example,
included a table setting of Chinese dishes and European glasses and sil-
verware. The interior of the house followed the "European style . . . the
walls hung with paintings, (sic) . . . rich lace curtains and Chinese art,
a piano by Collard and Callaro and a mammoth harp by a French ce-
lebrity."[43] The living room contained "Japanese divans and furniture of
rich French pattern."[44] The Urrea residence in Alamos had an Austrian
cane furniture set, Venetian glass vases, French beveled mirrors, and an
old Bechstein grand piano.[45] Trade relations with Europe and Asia
established the patterns of consumption among the wealthy.

Education during the early nineteenth century reinforced the
strength of foreign culture. Except for institutions in Ures and Her-
mosillo, for the most part formal schools did not function. With a de-
pleted state treasury and only a handful of teachers, no real incentive
existed for schooling. Confronting these conditions, many notable
families sent their children to schools in Spain, France, or Mexico City.
As a result, the generation of leaders which dominated the state during
the first half of the nineteenth century, including Ignacio Pesqueira and
Carlos Ortiz, had been educated abroad.[46]

EARLY FOREIGN PRESENCE

Despite its isolation, the export economy exposed Sonorans to diverse cultures. Besides carrying cargo, ships acted as a source of cultural exchange, bringing with them information about Europe, the latest fashions, and trends on the continent. During his visit to the state, one Spanish visitor noted that Sonorans eagerly read the foreign newspapers received from the ships that docked at Guaymas.[47] The state's official newspaper regularly reprinted articles from the European press. Trade relations with the rest of the world also conditioned Sonorans to the presence of foreigners. On several occasions during the 1850s, the *New York Times* reported on the favorable reception accorded foreigners in Guaymas in spite of repeated forays by United States filibusters.[48] The insecurity and isolation of the frontier compelled the inhabitants of the region to adopt foreign customs and to welcome outsiders.[49]

Hoping to capitalize on trade or mining, a significant number of French, British, Germans, and Americans settled in Sonora. To gain acceptance, they usually married into local notable families. Due to the beauty and demeanor of Sonoran women, "whenever foreigners would settle in Pitic, even for a short time, many of them would marry."[50] It was not unusual to find a substantial number of influential Sonorans with such last names as Camou, Hugues, Hoffer, Barnett, Müller, Spence, Ronstadt, Johnson, or Robinson.[51] Customarily, Mexicans translated the newcomer's first name into Spanish. The cases of American John "don Juan" A. Robinson and Frenchman Jean Pierre "Juan" P. Camou represent examples of foreigners who, originally drawn by the state's mineral wealth, sank permanent roots in Sonora. Besides the relatively minor name change, the small size of the Mexican elite in Sonora allowed foreigners to retain their culture and preserve their customs for several generations. With little interaction outside of the state, no impetus existed for a greater assimilation of Mexican values or customs. Foreign ancestry proved to be an asset rather than a detriment in trade with Europe and, later, the United States.

"Juan" A. Robinson, a native of New York, arrived in Sonora during the late 1820s. At first, Robinson attempted to make his fortune as a merchant and silver miner in Alamos. While there, he married Francisca Ibarra, with whom he had eleven children, all Mexican citizens. Robinson became one of the first foreigners to establish a residence in the new port of Guaymas, becoming a successful merchant and real-estate speculator.[52] From the early 1840s through the mid-1850s,

he served as United States consul in Guaymas. Afterward, he became a mining promoter and functioned as an intermediary for Americans investing in the state. State authorities treated him with deference and consulted with him in matters pertaining to the United States. By the 1860s the Robinson family became so integrated into the fabric of Sonoran society that United States officials repeatedly called into question the elder Robinson's citizenship.[53] Although the senior Robinson controlled large tracts of land throughout the state, he never managed to acquire substantial wealth. But despite the failure of his many speculative enterprises, his children acquired important political posts in Sonora, serving as a district prefect, judges, city councilmen, and congressmen. The elder Robinson retired to San Francisco, where he continued to promote Sonoran interests through the American press.

Juan Pierre Camou Sarralierre migrated to Sonora in the 1820s from France, where his family had been poor, itinerant farmers.[54] Other members of the Camou clan settled in Sonora during the 1840s and 1850s, becoming a conduit for other French immigrants to the state. They used ties in their former homeland to attract merchants such as C. Combier and Leon Horvilleur to Sonora. Using wealth acquired as brokers and owners of several mines, they opened commercial houses in Guaymas and Hermosillo. They intermarried with local families, and their clan prospered as new members of the family joined the business. The Camous slowly began acquiring tracts of land in the northern section of the state and emerged as powerful landowners. One French observer in the 1860s contemptuously described them as uneducated peasants from the Pyrenees who appeared as "vain as all the new rich."[55]

Despite the birth of offspring in Sonora, many in the Camou clan continued to identify as French subjects, some older members still harboring a desire to return to France.[56] The elders spoke French at home and required that the children learn the language. Their loyalties suffered during the French intervention, when most of the family sided with the invading imperial forces. Still, their social status allowed them to escape relatively unscathed from the acrimony that followed.[57] The issue of identity continued to trouble senior members of the family. When the patriarch of the Camous expressed interest in attending the 1889 Paris exposition, his son José objected, fearing that his father would decide to stay in France.[58] By the late nineteenth century, the Camous had emerged as one of the wealthiest and most politically influential families in Sonora.

Exchanges between foreigners, Sonorans, and the indigenous popu-

lation occurred in urban as well as rural areas and between elites and popular classes, further adding to the region's diversity. Ross Browne took note of Sonora's racial and ethnic heterogeneity. While in Magdalena, he observed that nearly all the inhabitants appeared to have some Indian ancestry, but he added, one "often [saw] in one family a remarkable variety of races. A mother with white-headed and blue-eyed children, and black-headed and black-eyed children, and children with straight hair, and curly hair."[59] In 1858, the *New York Times,* which underscored the diverse character of the population, described Guaymas as a city with a "sprinkling of almost every nation under the sun, in all about 5,000 souls."[60] The *San Francisco Chronicle* reaffirmed that observation in 1861; it claimed that half of the "white" population of the port, "not counting Indians and peons," were foreigners from all over the world.[61]

RACIAL ATTITUDES

Late colonization, economic relations with foreigners and wars with the Yaquis nurtured the false perception among northern elites that they were somehow ethnically different from other Mexicans. Views of race reflected an attempt by this group to protect the parameters of their class and to preserve the previous colonial social and cultural order. Consequently, according to C. Combier, marriage to anyone but a "white man" would bring censure for the daughter of a notable. Marriage records in the Hermosillo cathedral indicate that a significant number of upper-class Sonoran women married foreigners.[62] This attitude permitted the "white caste to preserve itself without mixture." While attending a ball in Hermosillo, Combier expressed astonishment at the value that local elites attached to having "light skin."[63] He noted that few individuals in upper-class society circles appeared to have mixed blood. For elites, however, race itself did not appear to be a central issue—many had mixed ancestry. Rather, their primary concern continued to be economic and political power. Beyond simply reflecting racial attitudes, these views conformed to the economic interest of Sonoran notables who sought to protect their status in a changing social order.

Indian wars invariably hardened racial attitudes and broadly affected the society, including lower socioeconomic groups. Many individuals of mixed heritage made it a point to deny their indigenous roots. Tiburcio Toledo of Baroyeca, the son of a Spanish father and an indige-

nous mother, expressed great pride in his European ancestry, proclaiming himself "white," even though he lived a rather destitute existence. For the Sonoran, being European did not simply imply physical appearance, but rather, it stressed the preservation of a particular lifestyle and customs. To prove his heritage, Toledo made it a point to receive travelers with the "the greatest hospitality and etiquette ... he was proud that his children were well disciplined and none ... dare sit in his presence." Don Tiburcio's friends also reflected these views, expressing pride in being "Spaniards from Europe" despite being born in Sonora and "disdaining anyone who was not white."[64]

Ethnic and racial attitudes slowly found their way into popular culture as well. Women from Sonora, according to local tradition, were not just the "tallest" in Mexico, but also "light of skin and the most beautiful."[65] Visiting foreigners also propagated this view. Marie Robinson Wright, author of *Picturesque Mexico*, wrote that Sonoran women had "light hair ... blue eyes predominate and there is many a fair head covered with Cleopatra-auburn hair."[66] Calvo, a long-time resident, wrote that "Europeans think that the women are dark and have rough complexion; on the contrary, the majority of them are very white and have fine skin."[67] When Sonora participated in the Chicago Exposition of 1892, besides sending the usual samples of minerals and agricultural products, the committee in charge of its exhibits also included several photographic portraits of light-skinned Sonoran women.[68] To preserve their social standing and distinguish themselves from the larger mixed population, Sonoran notables nurtured the perception of an ethnically distinct northerner.

GENDER

The appearance, mannerism, and directness of Sonoran women impressed most visitors. Invariably American, European, and Mexican travelers felt compelled to write about the charm of Sonoran women. Thomas Robinson Warren, for example, expressed astonishment at finding "at the very far end of creation ... young girls so exceedingly lady-like, displaying such good taste in dress."[69] Combier, a French merchant, appeared surprised to find "agréables femmes blanches" in several ranchos he visited in Sonora.[70] Alfonso Luis Velasco, a Mexican geographer, described the women of Hermosillo as "beautiful and intelligent."[71] Aside from depicting physical attributes, these accounts reveal prevalent cultural preferences and racial attitudes. Foreign trav-

elers also took note of the "independent" nature of Sonoran women. Vicente Calvo believed Sonoran women to be "talented, joyful . . . with superior intellect than most men...and surprisingly straightforward in expressing their sentiments."[72] He pitied any man who consorted with a Sonoran woman without "honorable" intentions.[73] Women, wrote Calvo, "live the same as the men, their habits and tastes are identical and they appear as independent as they are. They mount horses, ride burros, smoke, they gamble, play boisterous games and they are not afraid to look at you with flirtatious intrigue."[74] He insisted that the "climate and the lack of formal instruction" were responsible for the apparent autonomy of the women.[75]

Undoubtedly, the absence of schools and a strong church may have contributed to the "autonomy" of women; however, other practical considerations appeared equally important.[76] The "independence" of Sonoran women can also be attributed to the rigors of frontier life which required greater participation of both sexes in the organization and production of society and hence produced somewhat less restrictive gender roles. Other factors also appear to have influenced the condition of women. The persistent patterns of wars with Indians and political acrimony significantly reduced the male population. Moreover, out-migration, especially to California, remained by and large a male enterprise. In town after town, the number of single and widowed women remained high.[77] As a result, in 1856, early immigrants to Tubac included large numbers of single Sonoran women.[78] The absence of males permitted Sonoran women greater access to traditionally male-dominated occupations. Women owned land, engaged in trade, and in the larger towns, controlled merchant houses inherited from their family or spouses. American travelers expressed surprise to see Sonoran women come "freely into the visitors' camp to trade for soap and sugar."[79]

The growing number of female landowners and entrepreneurs compelled the state congress to debate the status of women in 1861. In February of that year, Manuel Monteverde, scion of a wealthy Hermosillo family, introduced a bill to legalize the economic status of single and widowed women.[80] Monteverde passionately argued that married women in Sonora did not enjoy the same legal rights afforded their counterparts in Europe. He insisted that it remained essential for the legislature to guarantee women's right to own private property. A fellow legislator, Jesús Quijada, rose to oppose Monteverdes' resolution, insisting that such a decree would destroy the basis of family unity and trust. Despite his opposition, a majority of the delegates approved the

edict. For delegates such as Monteverde, economic motivation seemed to have inspired his support for women's rights: notables feared that their daughters would lose land acquired in matrimony if their spouse died. With the legal affirmation of property ownership, women who owned land regularly appeared in the state census. In addition they helped sponsor public works projects, paid property taxes, and continued to operate small businesses, such as stores, schools, cantinas, and even bordellos.

The economic standing of a woman and her family invariably influenced their social position. The world of elite women contrasted sharply with that of the poor. Among the wealthy, Indian servants did most of the household chores. The list of families receiving Yaqui children as servants included the most renowned names in the state. With a host of servants, the women of the Camou clan in Hermosillo, for example, seldom performed any household tasks. Women of lower socioeconomic groups enjoyed no such privileges since they cared for animals, helped with farming, and in isolated rural areas, contributed to the defense of their communities. In this context, life on the frontier tended to place greater physical, rather than social, constraints on women.

LANGUAGE AND CUSTOM

Language employed in the state reflected its late colonization and continued isolation. The Spanish used in the north, as León Portilla noted, preserved obsolete expression and "phonetically, what is known as the norteño accent can be clearly perceived."[81] The northwestern dialect retained Spanish phrases long ago abandoned in other areas of Mexico. Words such as *ancheta* for "merchandise," *anchetero* for "traveling salesman," and *pacotilla* for "products" were still widely used by the middle of the nineteenth century.[82] This vernacular dates to Spain's domination of Mexico and underscores the isolation of the northwest from the rest of Mexico, where changes in vocabulary had already taken place.[83] The vocabulary utilized by early Sonoran writers reflected their economic sphere, and Velasco and others typically compared conditions in Sonora to those found in Ecuador and Peru, which were early, coastal trading partners.

Beyond language, social relations in Sonora also reflected the strengths of existing traditions. Speech, as George Foster points out, "reflect[s] the ways in which members of a community perceive the

social relations . . . and social distances on which the life group is based."[84] Interpersonal relations in Sonora did not appear to be overly encumbered by excessive expressions of social deference. For instance, a letter by merchant José Camou to his "servant" signed "tu amo" nonetheless began with the salutation "Sr. Don Juan Ochoa."[85] The status of Indians was the most distinguishing feature of census, civil records, and court proceedings. As in the rest of Mexico, civil society did not acknowledge Indians as full-fledged citizens or *ciudadanos*. When referring to Yaquis, newspapers and government records identified them as *indígenas*.[86]

Except for notables, Sonorans of different social groups frequently used nicknames. Common *apodos,* such as *el coyote, el Yaqui, el indio, el mayo, el chito,* and *el cocha,* not only reflected physical appearance, but also tended to express characteristics of the Sonoran landscape. Apodos appeared frequently in official documents and even newspaper articles. Court records typically employed the accused's given name as well as his or her nickname. One proceeding for robbery, for example, listed the defendants as Jesús Corral (*el Papigochi*), Manuel Escobosa (*el Güero*), José María Rivera (*el Pochote*), Jesús Rodríguez (*el cola de palo*), Salvador Serna (*el chino*), and Ramón González (*el mayo*).[87] The use of apodos in formal proceedings such as judicial matters reflected the existing social familiarity of this close-knit population.[88] Many families also preserved the use of first names traditionally perceived as provincial in origin. Appellations such as Severo, Dadislao, Secundino, Gumersindo, Ruperto, Apolinar, Neupomuseno, Javiela, and Artemisa persisted throughout the nineteenth century.[89]

CELEBRATIONS AND FESTIVITIES

Despite the difficulties of life on the northern frontier, norteños celebrated a wide range of public cultural events. Residents of larger cities regularly attended theatrical presentations as well as musical works. Aficionados commonly organized amateur drama companies and staged performances at homes. Funds raised from these events went to schools and local charities.[90] Circuses, puppeteers, and acrobats from the United States and Europe performed in Guaymas, Hermosillo, and Alamos.[91] These events attracted people from throughout the state. When a traveling Italian opera company appeared in Hermosillo in 1870, residents from Ures traveled to the city to attend the performance.[92] More important, however, is the fact that a wide spectrum of social urban groups

attended these events. Musical and theatrical performances, especially those staged in city parks, were not the exclusive domain of notables. As the prefect of Guaymas reported in 1873, "all social classes attended the drama performances twice a week."[93]

Many cultural events popular throughout Mexico found expression in Sonora. Residents of the state commemorated traditional Mexican political and religious celebrations as well as many specific regional holidays. Sonorans had a passion for music. Formal musical groups originated with the local civilian militias, which most towns had, so even the smallest settlement could usually count on a rudimentary band.[94] According to one American consul, "the people are great lovers of music and no matter how poor the home one will always find therein some musical instrument."[95] *Conjuntos* usually with an assortment of instruments—including accordions, horns, and guitar—appeared regularly at political and social events.[96] In the larger cities of the state—Hermosillo, Ures, Magdalena, and Guaymas—bands played in city parks on weekends.[97] The wealthier residents held private musical recitals in their homes. European melodies, such as mazurkas, waltzes, and polkas, could be heard in most private and public affairs.[98] Adapted by local bands who played them with accordion, guitar, and drum, these compositions became the foundation of future norteño musical compositions.[99] While visiting Ures, naturalist James Audubon reported listening to music with the "same peculiar nasal twang [which] pervades the singing of the whole of northern Mexico."[100]

By the 1870s traditional forms of Mexican music had also begun to penetrate the north. According to the prefect of Hermosillo, by 1871, every eight days in the central plaza "there would be public dances, vulgarly known as mariachis for the common people."[101] The prefect's distinction underscored an important cleavage in society. Since all residents confronted the same hardships of life on the frontier, differentiation between social groups tended to be subtle, involving mostly cultural preferences. In most Sonoran towns musical concerts and social gatherings inevitably became public affairs, involving, in one degree or another, most members of the community. Days before any social affair took place, everyone in town knew about the upcoming event. A rather limited urban space simply did not permit notables to hold completely separate or private social gatherings. While in Hermosillo, Calvo noticed that whenever parties took place, the host made provisions for onlookers and hangers-on that showed up.[102] Customarily, a servant would be made responsible for all the bystanders. At another social re-

union, John Hall, a British traveler, observed the same phenomenon. He noticed that "all classes of society are represented, from the wealthy landed proprietor to the poorest peon, all mix together, drink and gamble at the same table. When any distinction is made, it is that the poor class dance to the sound of the fiddle and drum in a ramada . . . while the aristocracy do the same to the sound of a full brass band a la casino."[103] Hall preferred the dances of the "poor" over those of the "rich" since they performed all the national "dances, chotes, pascolas, fandangos, jarabes, etc., with a zest that showed that they at least enjoyed their holidays."[104]

Besides music, many Sonorans engaged in poetry writing. Compositions about the desert, ocean, sunset, and many other subjects which captured the images of life in Sonora appeared regularly in the state press. One poem, entitled "Sonora," submitted by C. Gordoa of Ures and published in 1877 by the *Boletín Oficial,* reflected a romantic nostalgia for the state:

> There is a land of passions,
> Which the rays of the sun tan,
> A mansion of lights and colors,
> Of birds, women and flowers,
> And this land is Sonora.
>
> Approaching from the clear east,
> With the sun I find the dawn,
> If God is merciful,
> I will die in the west,
> In the land of Sonora.[105]

Newspapers devoted ample space to these compositions. Poetry and other forms of literature served to cloak political opposition against the government and appeared as an acceptable form of dissent.[106]

Public celebrations such as carnival, Christmas, and New Year's invariably brought together diverse strata of the community. Notables played important roles in sponsoring most public celebrations. Usually, they formed a committee to raise funds to finance the activities. During carnival, parades including *carros alegoricos* (floats) made their way down city streets, with people of various social strata dressed in festive costumes. Activities during carnival underscored the fusion of Mexican customs and regional practices. As in other parts of Mexico, Sonorans threw confetti-filled eggshells on unsuspecting passers-by; however,

they also doused them with flour during the week in which they celebrated carnival.

Carnival, a celebration usually not associated with the Mexican north, had a strong following in early-nineteenth-century Sonora. People prepared for it and the *fiesta de cascarones* (fiesta of eggshells) weeks in advance, gathering empty shells, filling them with confetti, and sealing them with wax.[107] Writing to his brother in Guaymas in 1889, José Camou recounted that during the three days of carnival, work came to a standstill and Hermosillo "burned like Troy."[108] Strolling along city streets became risky business—anybody caught outside became fair game for a dousing of flour. Those who ventured into the streets dashed from one place to another in order to avoid being blanketed with flour. Camou indicated he had two choices, either join the masked throngs in the streets or stay locked up in his house all day. During evening dances, couples could still be seen covered with flour, a testament to earlier carnival battles.[109]

Christmas celebrations revolved around the traditional *pastorelas,* a semi-religious ceremony of song and poetry, and *posadas,* which started on the fifteenth of the month and were held at different homes until the twenty-fifth of December.[110] The posadas reenacted the biblical pilgrimage of Mary and Joseph. On the fifteenth of December, a public play took place in the plaza, and on subsequent nights the party made the rounds of people's homes.[111] In contrast, New Year's festivities usually culminated in fireworks displays and public dances.

DÍA DEL SANTO

The celebration of a town's patron saints became by far the town's most important holiday. In *cabeceras* (county seats) such as Magdalena, the festivities during a good year usually lasted several days and included a procession and solemn mass every night. After the religious ceremony, sporting events, parades, and a certain amount of gambling under the guise of *juegos permitidos* usually took place. In the evenings, mescal flowed freely and the merriment culminated with fireworks in the central plaza as well as with several public and private dances.[112] Magdalena's annual fair of Saint Francis, its patron saint, acquired fame throughout the north, attracting followers from as far away as Hermosillo and Tucson.[113] The junta in charge of the activities gave notice to the surrounding towns of the planned activities. In a letter to

Tucson's *Las Dos Republicas,* organizers boasted that in preparation
for the celebration, "merchants have already stocked their stores from
Guaymas, Hermosillo, and Tucson. Ranchers prepare their horses for
the race, and their cows and steer for the bets."[114] Caravans of people
from outlying towns streamed into Magdalena. For months in ad-
vance, Sonorenses made plans to attend the Magdalena festivity. Several
women from Cucurpe, for example, even made special vows (*mandas*)
to Saint Francis in return for the safe return of their husbands from
California, where they had gone to mine. On the feast day of Saint
Francis, they walked barefooted the entire distance to Magdalena.[115]
Despite this reputation, the lack of safe transportation limited the num-
ber of people who could actually attend the festivities.

Isolation from the rest of Mexico did not dampen patriotism in So-
nora. Observance of national holidays took place throughout the state
and also among Mexicans who lived in Arizona. Celebrations of Mexi-
can independence and the Battle of Puebla included the usual politi-
cal speeches and an official parade through the main street of the city.
A month before the festivities, city leaders formed a *Junta Patriotica.*
In Guaymas, to commemorate the Battle of Puebla, a junta led by
Guillermo Robinson, Alejandro Elías, and Manuel Ondovilla organized
a rally and other public events.[116] Hermosillo's independence junta,
composed of dignitaries such as Vicente Escalante, Pedro Monteverde,
Carlos Noriega, and others, organized speeches, a parade, fireworks,
and a dance in the central plaza.[117] In Tucson in 1877, Ignacio Bonillas,
Antonio Urrea, and Santiago Ainza headed the organizing committee
for the sixty-seventh celebration of Mexican independence. *Las Dos
Republicas,* a local newspaper, reported that on September 16, both the
Mexicans and United States flags flew over most buildings in Tucson.
For two days, Mexican and Americans attended festivities at Levin
Park.[118]

Typically, religious and civic holidays became excuses for staging
sporting events. Sonorans flocked to horse races and *corridas* (bull-
fights) which drew upon the region's *vaquero* (cowboy) culture. Beside
testing the speed of horse in races, cowboys also competed against each
other—at full gallop vaqueros endeavored to pick up a rooster from the
ground or to thread a metal ring perched atop a fixture.[119] Nonprofes-
sional bullfighting also excited passions in Sonora, and every town had
some form of rudimentary bull ring, where aficionados witnessed cor-
ridas on Sunday afternoons.[120] Newspapers in Hermosillo, Guaymas,
and Alamos announced upcoming corridas.[121] Bullfighters tended to be

cowboys or urban aficionados rather than professional *matadores*. The popularity of bullfighting persisted until the beginning of the twentieth century, when it succumbed under a wave of moralizing condemnation and the rise of baseball. Other sports such as cockfighting, billiards, and lawn bowling also remained popular throughout Sonora, attracting all segments of the population, including women.[122] Not only did women regularly attend sporting events, but according to Calvo, they also were skilled riders and at times partook in various games.[123]

Beside those sporting events which drew from the region's cattle and cowboy culture, others borrowed from indigenous customs. The Seris, Tohono O'odhams, and Opatas, according to tradition, were renowned for their speed and agility, which were enough to outrun a horse in short distances.[124] The annual celebration by the townspeople of Caborca featured "stunning races by the Papagos who raced among themselves and against mestizos.[125] Most early communication between towns had depended on swift indigenous runners.

In both urban and rural areas the conditions of life continued to be very austere. Although upper classes actively sought to replicate Spanish lifestyles, the conditions of life in the semi-desert environment placed constraints upon all groups. Life in the northern frontier exhibited a certain continuity influencing language, urban patterns, sports, diet, music, and dress. The cultural, political, and economic elements that characterized this frontier lifestyle directly shaped the lives of most Sonorans. Yet, for most of the nineteenth century it is difficult to speak of a distinctive or singular Sonoran identity. Since most settlements constituted isolated entities and communication proved difficult, little personal contact occurred between most common Sonorans. For the region's Mexican population there did not exist just one Sonoran identity, but rather multiple identities forged by the experience of living along the Sierra Madre, in the desolate northern district, in the coastal communities, or in the plains and river valleys of southern Sonora. Beyond the Mexican experience, the indigenous population, including Yaquis, Mayos, O'odhams, and Seris, also maintained elements of their own identity. The establishment of a broader regional identity awaited the construction of the railroad and developments of large-scale mining in the last two decades of the nineteenth century. These two events produced a greater degree of interaction among Sonorans and gave rise to a new sense of solidarity.

Merchants, Miners, and Labor in the Northwest

Long before the rise of border relations with the United States, Sonora's economy relied on foreign trade. The persistent drain of its mineral wealth, the low wages, and a small population base undercut the basis for a stable internal market, forcing the state to rely on an export economy in order to generate capital. A small group of merchants and hacendados dominated key economic activity and exerted tremendous influence on society. The widespread availability of land also permitted a small proprietor class, the owners of ranchos, to coexist in the shadow of the larger haciendas. On the frontier, traditional institutions, such as the state and the church, remained weak, allowing a small body of notables to assume greater authority in northern society.[1] This vacuum increased the role that hacendados, mine owners, and merchants played in the day-to-day organization of Sonoran society. The state government and the local population depended on their philanthropy for most basic social services such as roads and hospitals. In this capacity notables acquired a special status in norteño society and successfully weathered political storms.

CHURCH AND POLITICS

Religious institutions had frail roots in northwest Mexico.[2] Except for the initial success of Jesuits among the Indian population, Catholicism did not generate the same devotion it garnered in other areas of central Mexico.[3] Outside of Hermosillo, Guaymas, and Alamos, few churches

actually operated in Sonora during most of the nineteenth century. In the outlying areas most of the old colonial churches had been attacked by Apaches and robbed by Mexican and American bandits. Lázaro de la Garza y Ballesteros, the bishop of Sonora, lamented that only a handful of clerics served the state.[4] Priests visited rural areas once a year to legitimate common-law marriages and perform overdue baptisms.

Political institutions fared no better than religious ones. The lack of revenues, the political infighting, and the inability to halt incursions by Apaches exposed the inherent weakness of the state and increased public distrust in government. As the principal authority, the governor oversaw the administration of the state and shared power with a twelve-member state assembly and a judicial branch. During the first decades of the nineteenth century, disputes between the assembly and the governor occurred frequently, and rival political groups in the assembly repeatedly sought to place limits on the governor's authority. The judiciary included three supreme judges and magistrates of the first instance assigned to each district. The state encompassed nine separate districts, each overseen by a prefect appointed by the governor,[5] and possessing a cabecera. An *ayuntamiento* (town council) headed by an *alcalde* (mayor) ran the affairs of the larger towns, and in smaller settlements, a *comisario* (police constable) maintained a tenuous order.

Despite the apparent high level of organization, the political system remained flawed. Except for the highest positions, such as governor, little incentive existed in this early period for public service. From 1857 to 1875, Ignacio Pesqueira dominated the governorship. At the local level, individuals had to be coerced to serve in politics. The state's constitution prohibited the compensation of public servants at the local level, stating that "service to the municipalities had no other remuneration but *la gratitud pública* [public gratitude]."[6] Assuming the responsibility of prefect or *presidente municipal* (town mayor) often meant incurring a loss of personal income because business interests suffered from inattention. Most Sonorans tried to avoid public service at all cost, and according to one observer, they actually campaigned "against themselves in order not to be elected," while others left "the state to California or Arizona to avoid nomination."[7]

In large towns such Guaymas and Hermosillo, convincing anyone to serve a full term became a difficult task. In the district of Guaymas, Prefect Pedro Tato resigned his post in 1861 citing personal hardships and the lack of resources as the principal reason.[8] In Hermosillo, frustrated by the fact that the majority of the city council had requested *li-*

cencias (leaves of absence) in order to tend to their own affairs, Francisco Serna, the mayor, also quit. In January 1861, Hermosillo's judges of the first instance resigned, citing near bankruptcy.[9] A handful of public servants often wore many hats. At times, as in the case of Hermosillo in 1867, the district prefect also doubled as military commander.[10] Since the state did not remunerate officials, only the affluent could afford to hold positions and not suffer undue hardships. As a result, small groups of notables regularly rotated positions of authority. In Hermosillo, members of the Escalante, Monteverde, Loustaunau, and Robles families dominated local government.[11] In Guaymas, members of the Spence, Robinson, Elías, Bustamante, Maytorena, and Corella clans controlled politics in the port.[12] This reluctance to assume public posts changed dramatically after closer relations with the United States developed.

NOTABLES AND THE GOVERNMENT

The absence of a strong state government gave notable families many advantages. It allowed them access to a greater leadership position and equipped them to assume the role of social benefactor. With meager resources, the state reinforced the role of notables by fostering economic expansion for them and relying on their generosity. Whenever it needed funds, the government invariably turned to contributions from wealthy merchants or hacendados. Authorities levied taxes on businesses and "requested" special loans from their owners.[13] During the 1850s, Juan A. Robinson, the American consul in Guaymas and owner of a large import-export house, complained that he had "lent" the government over $18,000. Robinson and others never actually anticipated repayment, although they did expect special treatment when requesting trade concessions or the acquisition of land from local officials. When Robinson sought unused land near Guaymas Bay, he called on the governor and local authorities for support. A long list of other notables, including Francisco Noriega, Celedonio Ortíz, Juan P. Camou, Pablo Rubio, and Francisco Espriú also regularly lent funds to the government. Under the heading of *deuda flotante* (floating debt), government budgets kept a running account of the unpaid balance owed to hacendados and merchants.

Seldom did state and municipal governments take the lead on important matters without prior consultation with prominent families. Sonoran society found itself increasingly dependent on the benevolence of merchants and hacendados for the construction of public projects. As

commerce increased, in 1836 the leading merchants of Guaymas organized a committee and raised funds to build a dock in the port city.[14] In 1867 the Hermosillo ayuntamiento relied on funds raised from the merchants and ranchers to divert the Río Sonora, which flooded the surrounding areas and disrupted commerce during the rainy season. To establish Hermosillo's first formal hospital, the wealthiest residents of the city formed a *junta de beneficencia* (beneficence committee) in 1872 and raised funds.[15] Without exception, local notables and the aspiring middle class contributed to these projects.[16] Most members of the upper classes assumed the responsibility of social benefactors willingly. The infrastructural improvements to which they contributed facilitated commerce and increased profits. Reliance on the altruism of the private sector magnified their status in the local community, earning them the unfailing respect of most groups.

TAXATION

To initiate public works, the state entered into "use-contracts" for the construction of projects such as aqueducts, irrigation, dams, market places, and other utilities.[17] In 1874, for example, the ayuntamiento of Hermosillo contracted with Eduardo Rodríguez for the construction of a new *parian* (municipal market). The local authorities agreed to provide city land for the undertaking and not charge municipal taxes on building material. Rodríguez and his brothers supplied the materials and labor and absorbed the construction costs. To recoup their investment, the Rodríguez family received an exclusive monopoly to operate the municipal market in Hermosillo for twenty years. They profited by renting market stalls to local sellers at a price established by the city government.[18] After twenty years, the parian would revert to the ayuntamiento, which then would either renegotiate the contract or agree to manage the market. State and local governments used such contracts well into the twentieth century to provide most basic services. For their part, merchants and hacendados who invested in these projects monopolized public services and turned a sizable profit. During the Porfiriato, foreign capital employed use contracts to invest in public utilities and transportation.

To assure taxes from large enterprises, such as mines and flour mills, the state government entered into *contratos de iguala*.[19] Under these arrangements the owners prepaid an estimated tax on their revenue. In June 1888, to cite one case, Vicente Almada, owner of the San Ignacio

mill in Magdalena, entered into a contrato de iguala, in which he agreed to pay a monthly tax of one hundred pesos for the flour his mill processed. The tax would be paid whether the mill operated or not. Almada profited by processing flour in excess of the projected tax, and the state government dispensed with establishing time-consuming records and collection mechanisms. His competitors in Magdalena, including the mills at Santa Marta, San Joaquín, and Rancho Viejo, agreed to similar contracts.[20]

Municipal governments also established an elaborate taxation structure. They raised funds by levying assessments on nearly every form of economic activity. Merchants paid an *impuesto de piso* (entrance tax) on the products they brought into the district, even if these involved goods in transit through the district. The sale of liquor licenses created another source for securing revenue. Retailers bid for the right to sell liquor in an entire district. Once acquiring the rights, they could then resell them from town to town, doubling their profit. In many cases, schools and local prisons depended on the taxes collected from the sale of liquor permits. With these resources, the *municipio* attempted to maintain public services such as lighting, policemen, and teachers. For their operations, most ayuntamientos rented buildings from notables, who charged a small fee and in return expected political favors. In Hermosillo the city government rented buildings from the Camou family for the city jail and the local school.[21] Without the assistance provided by notables, state and municipal authorities would have been unable to operate, and the government's dependence on business groups, in turn, increased their power throughout the north.

COMMERCE AND TRADITION

A small elite with access to both scarce capital and foreign connections monopolized commerce and land. Initially trade in the northwest depended on the merchant guilds of Guadalajara. After independence, these relations loosened, and a small group of businessmen with extensive commercial and credit ties to Europe dominated trade in the northwest. Over time, intricate relationships developed between Sonoran entrepreneurs such Camou, Möller, Robinson, Bulle, Hoffer, Ruiz, Aguilar, and Iberri and French, German, and English commercial interests and banks. Merchants such as the Camous, themselves recent French émigrés, used contacts in France to establish their nascent busi-

ness operations. The Camous, for example, entered into agreements with several French businessmen, such as Cyprien Combier and later Leon Horvilleur. From these suppliers they acquired, on credit, European goods to sell in the state. Initially the Camous and others remained commercial brokers who facilitated trade for foreigners, but in the process they accumulated capital, invested in mining operations, and became merchants in their own right, acquiring land and mines.

Prior to the completion of the Sonoran railroad in 1882, the port city of Guaymas remained Sonora's principal contact with the outside. Guaymas became so important to the state's commercial dealings that most people commonly referred to it as Sonora's "door to the world."[22] English, German, Dutch, and even Danish vessels docked at the port,[23] but not until the mid-1850s did American merchants establish a significant presence. Cargoes usually consisted of a wide array of products such as clothing, linens, wood, nails, paint, paper, as well as silverware, glassware, dishes, furniture, cheeses, fine liquors, wines, and even champagne.[24] Guaymas also served as the center of an active coastal trade with Baja California, Sinaloa, and Chihuahua, where Mexican schooners from Mazatlán, San Blas, La Páz, and San José del Cabo docked regularly. A large quantity of goods in transit to the state of Chihuahua were also disembarked at Guaymas.[25] Merchants expecting cargo stationed "a boat outside the harbor to communicate with his ship" and inspect the products before docking. Foreign ships even arrived unannounced and bargained at sea with local merchants for the distribution of goods.[26] When an arrangement could not be reached, the ship's captain repeated the practice at another Pacific port.[27]

Commerce in Sonora followed certain time-honored practices. To circumvent the local bureaucracy, Europeans formed alliances with local retailers. Thomas Robinson Warren pointed out that dealings with customs officials remained "extremely laborious, and involve[d] an immense expenditure of time and patience."[28] In 1829, the French ship *La Felice,* belonging to Combier, arrived at Guaymas with an assortment of textiles, wines, brandies, construction material, and other manufactured goods loaded at La Havre. Through agents in Mexico, Combier established a partnership with "Jean" Juan P. Camou to act as his representative in Sonora. Camou arranged meetings with customs, military, and political officials in order to secure the best terms possible for Combier's cargo. As Combier noted, visits to officials were of the utmost importance since in "isolated regions the power of the central gov-

ernment is weak, and each official, whether a military commander, the director of the customs house, or the political boss, are little despots who do as they see fit."[29]

With Camou at his side, Combier first paid his respects to the military commander Ignacio Ibarra, then to the head of the customs house, and lastly to the mayor of Guaymas, Andre Desse, who also happened to be French.[30] Duties, based on a less-than-truthful manifest, were divided into equal parts between the three officials. Establishing the price of goods at Guaymas became essential in order to circumvent the gauntlet of interior district *aduanas* (customshouses). This process usually involved the reclassification of certain goods to circumvent exorbitant taxes. For example, Madeira wine, which was assessed a much higher duty, appeared on the customs records as a cheaper Muscatel, thereby avoiding the higher tax.[31] If officials charged full taxes on foreign goods, profits would diminish significantly.

Contraband and trafficking in smuggled goods became socially acceptable practices in the isolated northwest. Nearly everyone knew that officials made arrangements with Europeans and merchants to circumvent high tariffs. Rather than frown on this behavior, most accepted the custom as necessary in order to acquire lower-priced goods. By facilitating these agreements, state authorities hoped to undermine smuggling and ensure revenues. Since federal officials sent to supervise customs also partook in the illicit trade, Mexico City could not prevent the constant hemorrhaging of funds on the frontier.

Once officials had agreed to the price, foreign merchants unloaded their goods at rustic warehouses along the bay at Guaymas. Notice of the ship's arrival quickly spread from town to town and retailers made their way to Guaymas to procure goods. The appearance of foreign merchant vessels provided cause for celebration for Guaymas's inhabitants.[32] According to Alfredo Iberri, a member of an established Guaymas merchant family, "nothing caused more rejoicement and awakened more interest than the arrival of the large four masted German ships, under full sail, as they entered [the port] from the Gulf of Cortez after a lengthy voyage from Hamburg."[33] Invariably, Guaymenses congregated around the wharf to watch the ships dock. Following the unloading, the longshoremen customarily received the last crate of the shipment.[34]

After dockworkers unloaded the ship, public and private festivities took place. Combier described one occasion on which several foreign ships arrived at Guaymas within a week of each other. Guaymas mer-

chants, officials, and other notables formed a committee to raise funds in order to stage an impressive celebration.[35] Locals expected the ship's captain to make a generous contribution to the committee's treasury and, on occasion, to sponsor an evening ball on the ship. These events involved more than just the residents of the port. Invitations went out to families in outlying areas as far away as Hermosillo. After a few days, people began arriving in the port. The week of activities, according to Combier, incorporated the entire town and included visits on the ships, sailing cruises along the bay, banquets of fish and oysters, hunting parties, and at night, a dance.[36] These affairs helped announce the arrival of foreign ships to the state and promote the sale of merchandise. To make a profit, foreign shipowners had to be patient while local merchants resold goods throughout Sonora and raised sufficient money to pay their debts. Sonorans expected foreigners to adapt to local practices and take part in the festivities and other social events.

At first, the handful of American traders who visited the area did not comprehend these time-honored practices and expected to conduct business on their terms. As late as 1870, United States consul Alexander Willard complained that Americans appeared unwilling to adapt to the rules of business in Sonora. Few spoke Spanish, and more importantly, American suppliers demanded cash for their products, whereas German and English captains extended liberal terms of credit.[37] American merchants did not have intermediaries in the state and out of ignorance or arrogance refused to enter into agreements with local officials. Consequently, United States vessels continued paying full duties and could not "compete with this fraudulent system of introducing goods into the country."[38] As a result, according to Willard, "wholesale trade along the coast is a German and British monopoly."[39]

Unlike their American counterparts, European merchants waited patiently to turn a profit. At times shipowners spent over a year and a half in the Mexican northwest while their goods sold and they received full compensation. In the meantime, they mingled with notables and visited settlements throughout the state to check on the progress of sales. Their ships, however, did not sit idly by during this time. The vessels traveled the Gulf of California distributing products in Mazatlán, La Páz, Mulege, and San José. When cargoes diminished, the ships journeyed to Valparaíso, Chile, an important resupply center for trade on the Pacific coast of Latin America before the opening of the Panama Canal.[40]

HERMOSILLO

While Guaymas remained the point of entry of goods into Sonora, Hermosillo functioned as the principal distribution center of stocks destined for northern and central Sonora.[41] With partners in Guaymas, Hermosillo merchants controlled northern trade. Wagons and mule trains defied Indians and bandits and made the relatively short trip between Guaymas and Hermosillo on a regular basis, filling the cities' warehouses and retail shops.[42] Wagon and mule convoys formed every fifteen days in Guaymas to make the trip to Hermosillo. In periods of Yaqui revolts, authorities prohibited travel to Hermosillo unless as part of a caravan. The government established military outposts along the way to ensure that the road between Hermosillo and Guaymas stayed opened,[43] and merchants collected funds to pay the soldiers who patrolled the route.[44] Merchants recognized the importance of paying for the protection since they annually received "from abroad, through the port of Guaymas, about two million dollars worth of foreign goods, which were sold to the merchants of interior towns."[45]

From Hermosillo, mule trains and caravans departed to trade with the major towns of central and northern Sonora: Altar, Magdalena, Arizpe, Moctezuma, Ures, and Sahuaripa. From the cabeceras, products made their way to the smaller settlements and outlying ranches. As a result of this network, the state became linked by an intricate system of commerce with Guaymas as the epicenter, Hermosillo as the warehouse and distribution point, and the district cabeceras as regional outlets. In this manner, wheat and minerals found their way to Guaymas for export to other parts of Mexico, as well as to Europe and the United States. In addition, basic foreign and Mexican manufactured goods reached even the most isolated outposts.

Foreign merchants did not make the long trip to the Mexican northwest simply to supply the state with consumer goods. The acquisition of silver and other valuable mineral provided additional impetus for these long voyages. Even before Mexican independence, Sonora's mineral wealth had been legendary in Europe and the United States. By the 1860s, mints owned by British interests operated at Hermosillo and at Alamos.[46] Very little of the silver processed at the mints remained in the state. The silver not officially exported "was smuggled out of the country in small coasting vessels and placed on board vessels at sea, to be sent to the United States and Europe."[47] Many Sonorenses hoarded silver coins and used them in trade with foreigners.[48] The outward drain

of silver coinage had a detrimental effect on the Sonoran economy, creating a permanent shortage of hard currency, hindering commercial transactions, and ironically, increasing reliance on foreign imports. Attempts by the government to introduce copper coins to stimulate commerce failed miserably, being compared by most Sonoran businessmen to the "plague."

District prefects repeatedly cited the lack of silver coinage as the principal reason for the depressed conditions of native commerce.[49] Early dependence on foreign trade and the small size of the population intensified reliance on the importation of consumer items to fulfill local market needs. Thomas Robinson Warren described Sonorans notables as "a people long accustomed to European articles of luxury, who could never be induced to forego their use."[50] As European ship owners dealt with local merchants, little currency actually exchanged hands. Commerce in Sonora as one American noted in the 1850s operated on "the credit system."[51] Even the customs house extended liberal credit terms to local and foreign retailers—Mexican merchants had a year to pay the full tax on their goods, although foreigners only had eight months.[52] The government allowed G. Möller, a Guaymas merchant who had imported ninety-one bolts of cloth from New York, to pay the 5 percent duty on textiles in installments. As he sold the cloth, he paid the tax.[53]

Sonoran merchants received foreign and Mexican goods on consignments, never having, as Juan Robinson, Jr., pointed out, sufficient capital to actually purchase products outright.[54] The European traders extended liberal terms of credit to local traders. For collateral, Sonorans offered foreigners silver and other products. For example, Pedro Ynsunza, a small trader from southern Sonora, agreed to purchase a large amount of cloth from Combier's ship docked at Guaymas. As payment, he advanced the Frenchman a small quantity of silver, agreeing to pay the remaining debt in Brazil and ebony woods, to be loaded clandestinely of the coast of northern Sinaloa.[55]

As they established reputations, Sonoran merchants received other consignments and credits from banks and European commercial houses. In one case, the Manchester Liverpool District bank advanced the Escobosa family a line of credit in exchange for a large quantity of antimony.[56] The bank deposited the money into an account which Escobosa and his representatives could draw upon. Escobosa contacted business associates in Bilbao, who used the capital to purchase goods and forwarded them to Sonora. Merchants in Guaymas and Hermosillo later distributed the merchandise, again on credit, to local outlets in the

state. Before the 1850s, all goods arrived at Guaymas by sea since no
other stable source, except contraband, existed to acquire products.
Few individuals without ties to the large houses of Guaymas and Her-
mosillo could survive in this market.

SYSTEM OF CREDIT

By controlling access to goods, the large merchant houses of Guaymas
and Hermosillo monopolized trade in the state. To receive merchandise
for resale involved entering into arrangements with these wholesalers.
A handful of merchants dominated commercial exchange, function-
ing as intermediaries to Europeans and distributing goods on credit
throughout Sonora and neighboring Baja California, Arizona, and
western Chihuahua. To assure adequate market penetration, they either
sent traveling agents into the field, or they entered into secondary agree-
ment with other small-scale merchants. They assumed the risk for lend-
ing to outlying areas and compensated for their investment by dramati-
cally inflating prices on products. Liberal credit terms, or *el crédito de
mi firma* as the powerful Manuel Mascareñas often stated, compen-
sated for the lack of specie and allowed the system to function. For in-
stance, when Mascareñas sought to equip his recently acquired Haci-
enda Santa Barbara, he relied on lines of credit from other merchants.[57]
In a society as tight-knit as Sonora's, a merchant's word represented his
social worth.

Credit implied a degree of social trust and an adequate system of for-
mal and informal controls to ensure that debtors made payments. When
Mascareñas closed his store in Hermosillo in order to move to Nogales,
he sent letters to all debtors asking that they pay their accounts. Several
individuals in Nacori and Granada ignored his request. Mascareñas
then contacted local merchants and his friends to exert pressure on the
individuals who remained in arrears. This informal system compelled
people to pay off their debts. If persons did not make payments, their
reputations would be ruined, and they received no further credit from
other merchants. These mechanisms of control implied the existence of
strong ties between merchants of the area, cementing relations within
this socioeconomic class.

The system of credit allowed merchants to acquire land, to become
large hacendados in their own right, and to develop vertical production
ties. Typically, agricultural producers received a line of credit from mer-
chants based on the value of their projected harvests. Cattle, flour mills,

and land also served as collateral. When Jesús Moreno of Magdalena borrowed money in 1886 from merchant Pascual Camou, he offered his land as collateral.[58] With a line of credit, hacendados and rancheros acquired items such as cloth and other consumer products with which they paid their labor force. This system produced tremendous advantages for merchants. First, since most rancheros and even hacendados desperately needed products, they sold their future crops at very low prices.[59] Merchants like Camou, Escobosa, Mascareñas, and others thus acquired wheat crops at a decided advantage. They exported the flour to Sinaloa or Arizona where they made a hefty profit. When crops failed to materialize, which they often did, merchants foreclosed on vast number of properties, thus becoming significant hacendados themselves. The Camous, for example, acquired a large number of cattle ranches in this way, becoming large-scale producers and retailers of beef. As this credit system took root, debtor notes became a commodity that could be sold repeatedly by business interests. In one case, J. P. Camou reported acquiring a note that had been ceded first to the inheritors of the F. Aguilar estate and then to Rafael Ruiz.[60]

LIMITS OF POWER

On the surface, the merchants of Guaymas and Hermosillo appeared to be a wealthy class. Their condition, however, remained extremely tenuous. Commercial transactions, after all, depended on the success or failure of Sonora's two most important enterprises, agriculture and mining. Protesting yet another tax assessment imposed by Governor Pesqueira, Juan Robinson, Jr., the municipal president of Guaymas, pointed out the insecure position of most merchants in the state. He argued that merchants did not have "huge amounts of capital, or banks, . . . their wealth, rested in the land they owned and the stocks stored in their warehouses."[61] If mining and agriculture did poorly, sales plummeted. The retailers' worth depended greatly on their credit ratings. The state census rated each merchant's credit status, distinguishing between actual wealth and the stocks in warehouses.[62] Merchants recognized their tenuous position and made conscious efforts to diversify and invest in mining and agriculture.

Reliance on credit made merchants especially susceptible to recurring economic crises. Despite diversifying, they still relied on foreign suppliers, never amassing sufficient wealth to make the transition to local industry. Thus, they remained largely intermediaries for foreign and,

later, Mexican manufacturers. The limited size of internal markets further undermined the development of local industry, and as a result, the manufacturing sector continued to be neglected. The most notable exception was the San Miguel clothing factory, established in Horcasitas, which produced mainly mantas. However, most apparel continued to be made from imported fabric, especially linen.

The lack of any significant native industries impressed most foreign travelers to Sonora. The peripatetic Calvo insisted that, except for the small industries of wine and brandy in Hermosillo and textiles in San Miguel de Horcasitas, "the manufacturing class does not exist in Sonora. The division of labor, machinery, and the use of worker is unknown in the state."[63] In 1873 the Guaymas prefect reported that there was no manufacturing in the district since most residents purchased their goods from the ships that arrived from San Francisco and Europe.[64] With no currency in circulation and no guarantees from the government, elites refused to invest capital in manufacturing enterprises when greater profits could be derived from mining or commercial agriculture.

The Sonoran government refused to protect local industry with tariffs, forcing it to compete with foreign products. In 1874 local entrepreneurs from Guaymas proposed developing Sonora's timber resources if Governor Pesqueira would impose a duty on imported lumber. In spite of a relatively ample supply of timber in northern and southern Sonora, the state commonly imported lumber for construction, and even for furniture, from as far away as Ecuador and the United States Northwest. The merchants insisted that the high cost of transportation made it impossible to compete with the price of lumber from abroad. Foreign ships in need of ballast for long voyages could easily afford to bring lumber and sell it at reduced prices. The governor refused to grant this demand, arguing that such an arrangement would give the merchants a captive market and allow them to charge exorbitant prices.[65] Sonora continued to import basic items such as lumber, tile, and brick during the nineteenth century.[66]

AGRICULTURAL PRODUCTION

Sonoran agriculture had two pillars, corn and wheat. Where water sources proved scarce, agriculture took place *al tempora,* relying on rainfall to irrigate the crops. The planting of corn, which required large

amounts of water to grow, occurred at the beginning of the rainy season, usually in June and July. Since wheat survived on less water and resisted temperatures changes, it was cultivated in the winter, beginning in December.[67] Ranchos customarily cultivated much the same sort of products found on haciendas. Larger haciendas harvested upward of 500,000 kilos of wheat a year while the largest ranchos yielded no more than 150,000 kilos a year.[68] Dominating agricultural production, wheat eventually became the state's principal cash crop. Moreover, by the 1850s the export of wheat helped Sonora break out of its previous isolation. It gradually began to supply the needs of Sinaloa, Tepic, Nayarit, Baja California, and even San Francisco, becoming known as the breadbasket of northwest Mexico. Sales to Sinaloa and other Pacific ports became an important source of capital.[69] To facilitate the export of wheat, the state government at times exempted export crops from local taxation.[70] Likewise, Sonora's congressional delegation in Mexico City vehemently opposed all legislation that would affect the state's ability to export the crop[71] and repeatedly defeated attempts by Sinaloa to import California wheat free of tariffs.[72]

RANCHOS AND HACIENDAS

With an expansive territory and a small population, land in Sonora remained accessible to a relatively large number of people, but where they owned land, the indigenous population repeatedly lost ground to greedy hacendados and rancheros. According to one government report, population density in 1890 was still one person per square kilometer.[73] By contrast, in the neighboring states of Chihuahua and Coahuila, large hacendados monopolized most productive lands. Marginal, yet arable land existed throughout Sonora, especially in the sparsely populated central and northern districts. The many river valleys of the region provided excellent soil for cultivation and pasture for cattle. Access to land allowed smaller ranchos to coexist in the shadow of larger haciendas. An agricultural economy, based primarily on the export of wheat to Sinaloa and other Pacific ports, did not discriminate against the smaller ranchos. Those who successfully produced wheat, mescal, hides, or other products found outlets for their goods. Middle and small producers could either sell their grains to the numerous flour mills or directly to the merchants in Hermosillo and Guaymas who eagerly bought the wheat for export.

The Sonoran ranchos were generally medium-scale agricultural or cattle operations employing permanent and seasonal labor, and throughout Mexico, the rancheros constituted a "rural middle sector."[74] Usually several ranchos shared a fertile valley or plain; the lone farmer remained a rare entity on the northern frontier. The rancho resembled a hacienda in every way except that it was smaller in size. One French traveler to Sonora in 1830 described the northern *hacienda* as a large territorial property and the rancho as smaller farms grouped in a hamlet.[75] The presence of ranchos and haciendas meant, according to nineteenth-century geographer Alfonso Luis Velasco, that property "was exceedingly well distributed in Sonora. In just about every settlement where great quantities of cereals are cultivated, the land belongs to numerous small proprietors."[76]

Prime land with access to precious water was monopolized everywhere. Haciendas such as La Labor, Topahui, Carmen, Buena Vista, La Arizona, Alamito, Molino, and Las Delicias dominated their respective valleys. These large estates monopolized land next to rivers, where canals drained the water to irrigate crops and power flour mills. Large haciendas operated as self-sufficient enterprises producing a wide variety of products and employing a regular work force. Most, according to John Hall, had their "own flour mill to grind wheat for the Mazatlán market."[77] The owners of these enterprises represented the important economic and political figures of the state, including such notable families as the Pesqueiras, Gandaras, Almadas, Escalantes, and Maytorenas.

Commercial reports and districts census revealed the fact that ranchos usually outnumbered large haciendas. A comparison between an 1872 and an 1895 report provides the following information on the numbers of ranchos and haciendas:[78]

	1872		1895	
	Haciendas	Ranchos	Haciendas	Ranchos
Alamos	14	144	26	172
Altar	12	37	5	86
Arizpe	20	28	26	77
Guaymas	4	31	12	44
Hermosillo	26	57	22	83
Magdalena	8	6	17	50
Moctezuma	5	2	7	58

| | 1872 | | 1895 | |
	Haciendas (*continued*)	Ranchos	Haciendas	Ranchos
Sahuaripa	4	40	10	49
Ures	19	51	26	90
Total	112	396	151	709

Between 1872 and 1895, haciendas increased by 135 percent, while ranchos increased by 179 percent. Hermosillo and Altar actually had a drop in the number of haciendas, which reflected a shift from agriculture to mining. In the more stable district of Alamos, the number of ranchos proliferated. Except for Moctezuma and Magdalena, ranchos outnumbered haciendas in 1872. The presence of Apaches and a sparse population limited the number of smaller, economically unstable ranchos in these districts. Once the north achieved stability, these two areas experienced prodigious growth in ranchos reflecting the general pattern found elsewhere in the state. Between 1872 and 1895 the proportion of individuals owning land expanded as greater amounts of property became available.

Before the advent of the railroad, acquisition of unused land in the desolate north involved little capital outlay. After publishing an announcement in the state press and payment of an amount established by the government, a person could officially claim empty tracts of land. To *denunciar* (lay claim to an empty parcel) simply required a *vista de ojo* (visual inspection) by an official, after which a person erected "*mohoneras* [markers] to demarcate the land."[79] Many smaller landowners did not bother with the legalities and simply settled on the land, eventually acquiring informal squatters rights. Despite periodic speculative booms, such as those which followed the Gadsden Purchase, northern real estate actually had little monetary worth before the 1870s. Markets for agricultural products remained distant, and transportation continued to be inadequate. Access to land and fear of Apache attacks depressed the price of property throughout most of the early nineteenth century. In the north, Hall observed that "ranches, mines and farms are all abandoned, and the owners have emigrated to the lower country, and at present their property is worthless."[80] With unsettled land in the north, the state used empty tracts of land as an incentive to attract Sonorans who had migrated to California.

Early attempts by the state and federal governments to formally survey the territory met with opposition from local landed interests.[81] After the Gadsden Purchase, many Sonorans feared that any mapping of the state was an indication that Mexico planned to sell more land to the Americans.[82] Hacendados also had other reasons for concern—most had quietly extended the legal limits of their properties. According to one source, "several ranches and haciendas which have been allocated 48 square leagues have extended property to incorporate 60 leagues."[83] Hacendados opposed formal surveys contracted by the federal government during the 1850s because they would establish the true property boundaries and increase the tax assessments. The landowners preferred nebulous limits to conceal their illegal acquisitions of land. Moreover, the maintenance of ambiguous limitations permitted them to continue expanding operations and negotiate informally with state leaders for additional lands.

MAHUECHI

Statistics on haciendas and ranchos reflected only those individuals currently paying taxes or appearing on commercial census. The census failed to record the hundreds of others who simply began cultivating empty land without seeking formal title. In drawing up a report of the ranchos and haciendas in his districts, the prefect of Guaymas warned that his report could not account for the numerous land holdings that were never reported to his office.[84] Beyond haciendas and ranchos, marginal surplus land existed for Sonorans and the indigenous population which engaged in subsistence agriculture. Most made no pretense of ownership, opting instead to simply work the unused land. These individuals followed the traditional slash-and-burn method of agriculture. Though rudimentary, it nonetheless proved effective. According to anthropologist Ernesto Camou, this typical form of subsistence farming, known in Sonora as the *mahuechi,* could be found throughout the state, but especially near the sierras and the southern river valleys where the Yaquis and Mayos lived.[85] These small fields produced most basic food stuffs. Once harvested, the plot remained fallow for several seasons in order for it to recover nutrients. Despite the formal absence of ownership, the mahuechi continued as a form of agriculture. With the introduction of cattle in the late colonial period, wild herds proliferated, providing a source of meat and hides. The availability of wild cattle and

a diverse plant life allowed many northerners an additional degree of autonomy over their lives.

Except for the indigenous population, Sonorans never developed traditional strong bonds to the land. Many of the people were geographically mobile, willing to move elsewhere to improve their condition. In the northern districts, raids by Apaches compelled settlers to relocate frequently. On other occasions, the nature of the mining operation required recurrent moves. Another partial explanation of this phenomenon, however, can be found in the availability of land. Most Sonorans tended to regard land as a commodity rather than as communal property. The concept of private property, with all its attenuating social values, appeared firmly in place among Sonoran notables and the ambitious middle groups composed of rancheros; however, among the common people of Sonora, access to land did not imply wealth or any great measure of independence. Most of them could not rely on their subsistence crops for survival. At times, factors outside of their control, such as climate, droughts, or raids by Apaches, consistently undermined their efforts. The harsh life of the frontier forced the majority to hire themselves out as peones on ranchos and haciendas or to prospect as *gambucinos* in abandoned mines.

LABOR AND SERVITUDE

The popular notion that northern Mexican labor escaped peonage did not reflect the reality in Sonora. Likewise, the traditional view of the independent northern vaquero does not conform to the historical experience of most Sonorans. That free labor existed in the some parts of the north is indisputable, but in Sonora it coexisted side by side with indentured labor. The Mexican north consists of many distinct regions with different forms of production and varying labor systems.[86] Between the extremes of free labor and slavery, as Moisés González Navarro pointed out, other institutions, such as peonage, survived throughout Mexico in the nineteenth century.[87]

On Sonoran haciendas and ranchos the predominant form of labor remained debt peonage. Employers vied for control of a limited labor force. With a relatively small population and the inability to come to terms with the Yaquis, they regularly complained about the lack of a stable work force. On the surface, these conditions would seem to augur well for hired hands, allowing them greater opportunities to sell

their labor. The reality proved to be quite different. In the weak Sonoran economy, most notables remained constantly strapped for capital, surviving largely on credit. They leveraged their ability to acquire goods on credit and passed this indebtedness on to their laborers. Under these conditions, "market pressures," if they can genuinely be so labeled, drove most elites to become dependent on credit and most laborers to place themselves in peonage to survive. Confronting this predicament, peonage relations cannot be viewed as fully consensual nor should they always be equated with ill treatment.[88]

On the isolated frontier, many Sonorans, especially Yaquis, had no other alternative but to become indebted. In addition, the state of war with the Apaches and Yaquis drove many northerners from the land, forcing them to become indebted to larger hacendados or groups of ranchers who could absorb the cost of defense. As the circumspect Hall noted, "a man who has no more to depend upon than his manual labor, hires himself or his sons to some person who will advance some money on account of his or their wages. . . . But, as soon as the peon becomes indebted he is a slave."[89] To ensure employment and a suitable dwelling and to acquire goods, many Sonorans, with no physical coercion, willingly offered themselves as peones and became indebted. Most laborers, Mexican or Yaqui, received payment in kind. Remuneration for the laborers which C. Combier observed at various sites throughout the state, consisted of "goods and food like sugar, beef, liquor, cloth, or whatever else the foreman wishes."[90] For mine owners and hacendados, agricultural products and cheap cloth could be easily obtained on credit. Foreign and Mexican merchants offered other notables goods on credit in return for mineral products or a wide array of agricultural goods. This practice allowed land owners and miners to bind large numbers of laborers with little capital outlay. To ensure the indebtedness of the peones, the mine owner charged as much as three times the original value of most goods,[91] so the people seldom managed to pay off their original debts, and the operators could be assured of a relatively stable labor force.

Sonoran mining and agriculture became synonymous with the exploitation of Yaqui labor. Except for a few permanent employees, most labor in agricultural enterprises invariably included Yaquis. After visiting the Minas Prietas mines in 1829, the gallivanting Calvo noted that the labor force consisted of Yaquis, "for whom labor was hard and pay low."[92] This exploitation also set the tone for acrimonious relations between Sonorans and the indigenous population. Manuel Mascareñas,

one of the state's largest hacendados, summarized the view which landed elites held of the Yaqui. He portrayed Yaquis as excellent laborers either for mining or agriculture, believing them to be "intelligent in their work and humble and docile as servants."[93] These traits, Mascareñas worried, would also make Yaquis the preferred labor in the Arizona Territory. The issue of flight, especially over the border to the United States, an early problem for landowners in Coahuila and elsewhere in the north, did not become an option for runaway peons in Sonora until the mid-1870s.[94] Even after the American acquisition of the Mesilla in 1853, peonage continued to be practiced by early miners throughout southern Arizona. In addition, the Apache domination of northern Sonoran and southern Arizona made this area inhospitable.

Under the Sonoran state constitution, individuals classified as "servants" did not enjoy full citizenship rights.[95] The Ley de Sirvientes (law of servants) permitted persons to "voluntarily" enter into a contractual agreement with the *amo* (employer) to supply labor in return for a cash advance, shelter, or other agreed-upon remuneration.[96] State authorities strictly enforced all laws regarding servitude. Magistrates commonly issued judgments and officials tracked down individuals who fled from their "masters" employ. Captured servants were required to pay whatever expenses had been incurred in their apprehension. As one British commentator observed, "nothing is pardoned."[97] Despite attempts by local officials to keep exact civil registries in order to dissuade servants from fleeing, escapes occurred regularly. Those who managed to flee changed their names to avoid apprehension. As competition for workers increased, many hacendados, short on labor, gladly took in the runaways. Not all, however, were so fortunate. Despite the existence of these laws, the treatment of peones varied widely.

In larger cattle- or wheat-producing enterprises, where hacendados regularly needed labor, the relations proved advantageous to both groups. The land owners acquired a dependable work force, and the laborers, shelter and basic goods. After several generations, some hacendado-laborer relations acquired a degree of familiarity and mutual trust, decreasing the use of coercion. Paternalism appeared to be a factor in some Sonoran master and servant relations. Wealthy hacendados and merchants, such as the Camou family, maintained a permanent number of indebted peons. Letters from José Camou to some "servants" on his hacienda reflected a knowledge of their families and a concern for their well being.[98] During the California bonanza, businessmen such as Antonio Uruchurtu and Juan P. Camou dispatched trusted

servants to the gold fields, paying for equipment and supplies to search for gold. As an incentive, servants who went to the California diggings could keep whatever gold they found on designated free days.[99] When the servants returned from California, these merchants made a handsome profit. In these cases the relationship necessarily implied a degree of loyalty which extended beyond a simple contractual obligation.

On outlying smaller ranches, where labor remained scarce, coercion became the rule, especially where indigenous labor was involved. Though laws existed which delineated the treatment of servants, seldom did officials in rural areas have the capacity or will to enforce these regulations. In the northern countryside of Altar and Arizpe, ranchers resorted to brutality to maintain a stable labor force and hunted down escaping workers like runaway slaves. When confronted by flight, other northern Mexican states also adopted coercive tactics to intimidate peons. During the early 1850s, for example, the Coahuilan legislature ignored the governor's objections and temporarily approved public whippings for runaways peons.[100] Sonoran land owners also enforced their own brand of justice. In 1873 in the district of Altar, a Yaqui laborer employed at La Boquilla an hacienda owned by Juan R. Orcí, an influential landowner, escaped. Orcí and a group of men gave chase and, after a few days, captured the runaway. Upon returning with the man, Orcí beat the prisoner in front of other servants in order to dissuade them from escaping. The Yaqui man later died from his wounds. The local Yaqui governor complained to the district prefect regarding the abuses by Orcí.[101] The Yaquis testified against Orcí and informed the judge where the victim had been buried. Given such overwhelming evidence and fearful of Yaqui reaction, the prefect of Altar ordered Orcí arrested; however, he disregarded the order and continued to operate his ranch with impunity. Similar cases of abuse occurred elsewhere in the region.

Beside using indigenous labor for agricultural work, notables "contracted" servants, mostly women, to perform household tasks.[102] In the larger urban areas the upper and even the middle classes relied on Indian servants. For Indian women, this service implied the double burden posed by servitude and separation from their families. During 1861 the prefect of Hermosillo reported having received 160 Yaqui women en route to the district of Altar to be resettled. Before he had the opportunity to dispatch them, however, residents of Hermosillo claimed many of the women as their "runaway servants . . . who had escaped with Yaquis from nearby Villa de Seris."[103] Though he questioned the

legitimacy of their petitions, the prefect complained that he had been forced "to turn over the women to their amos because of their claims."[104] The warlike atmosphere that persisted against the Yaquis justified the taking of females and children as servants. Female servitude, driven by access to captured Indian women, persisted well into the twentieth century.[105]

Where escape did not appear as an option, servants, especially those employed in urban areas, made use of the judiciary system to extricate themselves from oppressive conditions of employment. In 1860 Manuela Celedonia filed a formal complaint against Jesús Fimbres for "maintaining her as a slave." Celedonia complained that she had agreed to work for Fimbres as a free woman, not as an indentured servant, and that now he refused to allow her to leave. The judge, Francisco Salido, sided with Fimbres, and Celedonia was forced to continue in his employ.[106]

For many Sonorans, indebtedness continued to be the principal means to participate in the labor market. Despite their willingness to practice peonage, many elites did not appear satisfied. In 1861, as cases of flight to the new Arizona Territory became noticeable, some notables introduced a bill to the legislature which would have further constrained servants. Cognizant that Arizona had become an alternative to indebtedness, some landowners did not wish to antagonize relations with their peones. Manuel Escalante, prefect of Hermosillo, wrote a scathing report to the governor, insisting that the "petitioners simply sought to reclaim their domination, near slavery, over the laboring class."[107] Attempts to enact a new law reflected the values of those who still called themselves "amos, (masters) a despicable inheritance that was left us by our ancient oppressors [Spaniards]."[108] Facing strong opposition, the new servant law died in the assembly.

In 1883 the state legislature once again took up the issue of indebtedness. In that year the Sonoran chamber limited debt to the equivalent of six months labor. Other states in the Mexican north pursued similar policies with varying degrees of success.[109] These changes reflected the wider range of options that laborers now had to pursue employment on the American side or in large foreign-owned mining enterprises within Sonora. Mascareñas earlier fears concerning the migration of Yaqui labor to Arizona slowly came to pass and formal peonage gradually lost ground. Despite options in the United States, servitude continued to be a key method of labor acquisition in Sonora into the early decades of the twentieth century.[110]

"The Repose of the Dead"

Conflict and Power on the Frontier

Traditionally, frontiers have been depicted as the antithesis to order, yet on the surface Sonora appeared to be a very structured society.[1] Laws governing public behavior, the ownership of weapons, drinking, and even profanity, existed in most municipalities. In addition, strong moral codes regulated most interpersonal relationships. Despite these formal regulations, the world of the early Sonoran remained precarious, plagued by internal strife and wars with the indigenous people. Studies of the Mexican north have equated this pattern of conflict with a legacy of northern individualism and generalized resistance to authority. Little conclusive evidence exists for such broad assumptions—the presence of civil disorder on the frontier can be deceiving. Lacking strong political or social institutions, strife provided an important mechanism of social control. A certain dialectic existed between discord, economic opportunity, and the maintenance of political power. For the federal government, conflict on the frontier temporarily prevented any one group from completely dominating politics. Groups which emerged from the fracas could be slowly co-opted in exchange for recognition and legitimacy.[2] Moreover, the appearance of chaos also made the region unattractive to all but the most determined foreign interlopers. Local political factions and notables also benefited from conflict. On countless occasions, competing interest groups, whether liberal or conservative, used the threat of Apache and Yaqui attacks, invasions from filibusters,

or disagreements with neighboring states to institute dictatorial powers or to extract higher taxes from the populace.[3] Notables and foreigners took advantage of recurring conflicts to amass personal fortunes without the undue competition which they might confront during peacetime.

The tendency of norteños to take matters into their own hands obscured the role that violence played in the maintenance of political order. For elites, the existence of strife became an important means of control, deflecting political opposition in times of crisis. When such conditions did not exist, contending political groups, such as those led by Manuel María Gándara, José Urrea, and Ignacio Pesqueira, fomented unrest by entering into agreements with Seris, Yaquis, or foreigners in order to gain political advantages. Within Sonora this ruse came to be known as the *petate del muerto* (the repose of the dead).

As accounts of wars spread, Sonora gained a reputation for being a dangerous state that was inhospitable to outsiders. For many years, this notoriety afforded the state a degree of protection. In his journal, William Perkins summarized the ambivalence with which most outsiders viewed Sonora: "[S]uch is the terror inspired by the numerous tribes of warlike Indians in that district [Sonora] that no one as yet has ventured into the dangerous but at the same time tempting mountains."[4] This dubious appraisal of Sonora found resonance even in Europe. In 1860, on the eve of the French intervention, a member of that country's chamber indicated that "the only thing we know is that the climate of Sonora is dangerous, deadly mortiferous for Europeans, and that ferocious savages Apache Indians have rendered that province uninhabitable."[5]

Confronted by the insecurity of life on the frontier, Silvio Zavala noted that the norteño took "on a spirit in which the prevailing dangers and hardships could be confronted."[6] The inability of the authorities to oversee a massive territory forced Sonorans to take up arms against Apaches, bandits, and foreign border interlopers. A strong tradition of self-defense rooted in the necessities of life and the struggle for survival became a significant feature of Sonora's regional identity.[7] Miguel León Portilla argued that as a result of conflict, the norteño adopted an attitude of "permanent defense," a siege mentality.[8] As historian Héctor Aguilar Camín points out, "inhabitants of isolated townships always had some episode of armed combat among their anecdotes and a rifle or revolver among their belongings."[9] Attempts by the state to exert its authority over the population proved ineffective.

GUERRA DE CASTAS

The state of relations between Sonora's Mexican and its indigenous population continued to be a principal source of conflict. After independence, Sonorans engaged in a relentless *guerra de castas* (caste war) with large segments of the indigenous population.[10] In the north, raids by Apaches occurred with such regularity that one French traveler compared them to the ebb and flow of the ocean tide.[11] Repeated unrest caused by wars with the indigenous destabilized the organization of Mexican and native society. Sonoran *blancos,* as many notables referred to themselves, viewed the indigenous as the "plague of the state" and blamed them for the lack of prosperity. State leaders characterized campaigns against the Apache and the Yaqui as an epic struggle between the forces of "barbarism and civilization." Antipathy against the Apache reached extreme levels of hatred. Lorenzo García, an influential military and political figure, typified this spirit when he wrote that "nothing is more noble than the campaign that we have launched, . . . that we are fighting against the sworn enemy of the civilization, against an avid vampire which draws the blood of humanity on the march of progress."[12] The indigenous, however, viewed things differently. The acquisition of land and the procurement of a labor force came, as they saw it, at their expense. Military campaigns meant to subjugate the Yaqui and Mayo in the south, the Seri in the coastal region, and Apaches in the north engendered a legacy of conflict in the state. Access to land and the need to secure a labor force fueled most of the wars with the indigenous groups. The Seri, Yaqui, and Mayo tenaciously struggled to maintain their traditional lifestyle and resisted encroachment by the Mexicans.[13] Wars with these groups and the Apache from the north reached levels of violence unparalleled elsewhere in Mexico.[14]

YAQUIS

Sonora's indigenous population inhabited every area of the state, forcing a relatively small number of Mexican forces to fight on many fronts. In the south, the Yaqui occupied the fertile lands adjoining the river valley which bears their name and resisted encroachment upon their lands by the Spanish, Mexicans, and foreign speculators. They maintained a strong sense of ethnic identity rooted in traditional lands, an established village structure, and a history of self government. The Yaquis

"survived by asserting their distinct identity and insisting on a separate existence."[15] Sonoran measures to deal with the Yaquis borrowed from Spanish practices. During the 1850s and 1860s, when military efforts to "pacify" the Yaqui failed, the state implemented campaigns to exterminate them by separating the male and female populations. Officials deported captured Yaqui women and children to the northern border districts, far from their families and traditional surroundings. In 1861 Manuel Escalante, the prefect of Hermosillo, received a party of over one hundred and fifty captured Yaqui women and children; he sent them to the prefect of Altar so that they might be dispersed in his district as servants.[16] In urban areas, abducted Yaqui children made up a great percentage of the household servants.[17]

SERIS

The Seris, numbering approximately 5,000, lived in the western coastal region of Hermosillo and the adjoining island of Tiburón.[18] Owing to their largely nomadic existence, they never submitted to Spanish efforts to "reduce" them to mission life.[19] According to Ramón Corral, who wrote a brief history of them, the Seris resolutely opposed "intermixing with other communities" and repeatedly challenged civil authority.[20] Perplexed by his inability to "pacify" rebellious Seri's, Cayetano Navarro, the prefect of Salvación (later made a part of Guaymas), proposed a plan in 1852 to Governor Fernando Cubillas to capture Seri women. Navarro intended to hold them in presidios and to use them as inducement in order to force Seri men to surrender.[21] Since 1850 Navarro had already "successfully" implemented this plan on a smaller scale, keeping a running count of the number of captured Seri women and children.[22] In his letter to the governor, Navarro insisted that, although the state desperately needed immigrants, the Seri "because of their character and customs could never be transformed into useful citizens and workers."[23] Navarro's plan to "resolve" the Seri threat received the approval of the military commander of the state General Miguel Blanco, who, in addition, proposed to deport the Seris to the interior of Mexico, where they would become "useful agricultural workers."[24] Access to land continued to fuel conflict with the indigenous. In the midst of Navarro's plan to quash the Seri, the government sold their homeland, Tiburón Island, to several local Mexican ranchers.[25]

APACHES

In the northern border districts, Sonorans faced their most dreaded enemy, the Apache.[26] From safe havens across the United States or in neighboring Chihuahua, the Apache, in particular the Chiricahua, waged guerrilla warfare in Sonora.[27] The northern districts of Altar, Magdalena, Arizpe, and Moctezuma bore the brunt of Apache attacks. Although northern Sonora accounted for over half of the state's territory, the area retained less than a quarter of Sonora's population.[28] Incursions by the Apaches made the region practically uninhabitable.[29] During colonial times, the presence of military presidios had limited Apache raids. After independence, with the demise of the presidios, the Apache had virtually a free reign over the north. Apache forays pushed population either south, to the vicinity of larger settlements, or after 1856, north into the Arizona territory. José Velasco estimated that each year upwards of one thousand residents lost their lives fighting Apaches.[30] In 1871, American consul Alexander Willard offered his own estimate of the number of people who perished and migrated. He reported that from 1861 to 1869, 8,500 Sonoran had migrated to California, 7,500 to Arizona, and 4,000 had perished at the hands of the Apache.[31] According to Willard, the situation in Sonora had become so tragic that "the number of deaths registered exceeded those of birth by 1,184."[32] The sparse northern settlements resembled remote Mexican islands surrounded by hostile Apaches who kept them separated from the rest of the state.[33] To reside in the north, one newspaper insisted, required the patience of Job.[34]

For those with patience and resources, disorder could prove profitable. Encouraged by the American acquisition of Arizona and early plans to build a railroad, a long list of wealthy families, including the Camou, Elías, Ainza, and others, acquired lands previously owned by the indigenous, the Catholic Church, and retreating Sonorans.[35] Able to finance defense of their property, they acquired large tracts of northern land. Some foreigners also anticipated that profits could be made in periods of crisis. A small number of Americans began to organize companies in order to finance the exploitation of Sonora's mineral wealth. Several speculators formed the Cincinnati and Sonora Mining Company and proposed to be the "pioneers of the great American wave of miners that will flow in by the ocean from San Francisco or roll down from the segregated mines of Arizona to the great fissure mines of northern Sonora."[36] While most Americans feared turmoil, a cunning few saw an

opportunity "to select the best property, without the competition or op-
position that our agents must have encountered had they reached there
when citizens and foreigners were alike devoted to mining."[37] Disorder
and conflict, in short, could also be profitable.

Most common people could not prosper from these conditions and
conflict continued to take its toll. Unable to wage effective campaigns
to deter the Apaches, the state government resorted instead to offering
rewards for their capture. A decree in February of 1850 informed "mili-
tary officers and entrepreneurs that they would receive a reward of one
hundred and fifty pesos for every male Indian, dead or alive, and one
hundred pesos for every live woman." In addition they would be al-
lowed to keep children of either sex under fourteen years of age, "to
educate in social principles."[38] To pay for these rewards, the govern-
ment planned to use the tax imposed on the sale of tobacco and luxury
products. Besides trafficking in Apaches, money could also be made by
recovering lost or stolen cattle and horses. Ranchers were required to
pay a fee to persons who returned their lost or stolen animals. By im-
plementing this policy, the government hoped to induce the formation
of raiding parties to hunt Apaches.[39] For the forcibly drafted state mili-
tary forces, these rewards became the only incentive for serving. The
militia force at Cumpas, for example, was financed from payment for
scalps and captured Apaches.[40]

Within a few months, the government increased the reward for
Apaches to two hundred pesos and offered to pay for all ammunition
expended.[41] Ten years later, Governor Ignacio Pesqueira increased the
reward to three hundred pesos.[42] Notice of the reward appeared in lo-
cal newspapers as well as in the Chihuahuan and Arizona presses. The
compensation attracted raiding parties from neighboring states and the
Arizona Territory. The rewards for Apaches had dire consequences for
indigenous and Mexicans alike. Americans who responded to the ad-
vertisement, according to John Hall, a long-time resident from Britain,
hunted down "Tarahumaras, Mexicans and Yaquis . . . turning them in
for Indian scalps."[43]

To combat the Apache, Sonora made use of traditional tensions be-
tween indigenous groups. Conflict with the Apache allowed Sonoran
authorities to enter into alliances with groups who under normal cir-
cumstances might have rejected joint action. Having suffered the wrath
of the Apache, other groups—the Pima, Tohono O'odham, and Opata—
willingly joined forces with the Sonoran authorities.[44] With govern-
ment forces, they repelled Apaches and hunted them down in order to

claim the reward offered for their scalps.[45] The Opatas and Tohono O'odhams became in the words of one venerable observer, the "main brake on Apache incursions."[46]

Americans exploited the tensions that existed between Apaches and Mexicans. After their acquisition of Arizona, most Sonorans, including top leaders like Corral, contended that Americans openly colluded with Apaches in their attacks on Mexico. Colonel García, a veteran of many campaigns, maintained that Apaches received American weapons, clothing, and provisions in return for peace in the U. S. territory.[47] García described one episode in which his troops overran an Apache position and found American weapons, blankets, uniforms, and even a new United States Army reloading machine.[48] Sylvester Mowry, an American mining speculator, validated this view when he argued that the "Apache Indian [is] preparing Sonora for the rule of a higher civilization than the Mexican." Mowry believed that the Apache would eventually drive the Mexicans "farther south, leaving to us (when the time is ripe for our possession) the territory without its population."[49] Mowry's comments reflected a widely held view among Americans in the region during the 1850s and 1860s. North Americans such as Mowry and General John B. Frisbee hoped to acquire an empty Sonora, one without the racial issue that would result with the annexation of a "mongrelized race."[50] Captain Charles P. Stone, the United States consul in Guaymas, described Sonora as "the great Apache rancho, where they went when they needed cattle or horses."[51] This situation continued until the signing of a reciprocal agreement in 1882 by which military forces could cross the border while in pursuit of Apaches.[52]

BESIEGED

Friction with the Native Americans forced Sonoran settlements to be constantly on the alert for raids and reinforced the need for owning weapons. Attacks by Apaches did not occur only on lonely trails and outlying northern towns—raiding parties conducted forays as far south as Hermosillo and Guaymas.[53] Even in larger urban areas, residents kept on the alert for possible attacks. The urban schema of most towns, with large tracts of land under cultivation within the urban area, reflected how conflict had influenced settlement patterns. One barrio in Hermosillo, known as *la Cohetera,* earned its name because in earlier years, one older woman launched rockets into the night sky to frighten attackers.[54]

Thomas Robinson Warren mocked what he perceived as a Sonoran "besieged mentality." To prove his point, during a hot summer night in Guaymas with some friends, he provoked a "herd of jackasses quietly snoozing and giving a series of diabolic yells" turned the animals loose on a street. People sleeping on the sidewalks, a custom during hot summer nights, awoke and assumed they were under attack by Apaches. According to Warren, his actions caused such "hubbub [as] never was seen or heard, every cot overturned, women half dressed rushing about crying Indians, Indians . . . while men, seizing their arms, let fly into the unfortunate donkeys."[55] A similar instance occurred at Campo Viejo in the vicinity of Hermosillo. When residents heard noises on the outskirts of town, they presumed it to be an attack by Apache. Several men opened fire in the direction of the noise, convinced that they had repelled an attack. The next morning, fearing further attacks, residents had yet to venture out of the town. Upon hearing of the incident at Campo Viejo, the district prefect ordered an investigation. A party scouted the area where the noise had originated. Rather than an Apache raiding party, it found a "Yaqui, who always ran around naked with a bow and arrow, dead under some trees."[56] The prefect jailed those responsible for the shooting on the grounds of raising false alarms and creating a disturbance.

EL PETATE DEL MUERTO

Liberal and conservative factions exploited hostile relations with the indigenous population to gain political advantages. They forged temporary alliances to out-maneuver rivals and used the threat of attack to repress opponents. When they needed armies to fight their enemies, Sonoran rebels typically augmented their numbers by recruiting forces from among the native population. For the indigenous these occasions became an opportunity to extract concessions, if only temporary, from feuding forces. In 1833, for example, the captain of the Hermosillo guard, Juan José Tovar, seconded Santa Anna's call to topple Bustamante and rebelled against the governor. To mount his campaign, Tovar recruited a military force from among the Seris and, later, the Yaquis, promising them access to new lands.[57]

Some of the bloodiest episodes in Sonoran history occurred when the contending forces of José Urrea, Manuel Gándara, and Ignacio Pesqueira drew the Seri and Yaqui populations into their conflict. During their tenure, these governors alternately utilized the danger of Yaqui

rebellions to impose taxes, suspend civil liberties, declare martial law, raise armies, and cancel elections. Using the threat that Urrea had sold their valley to foreigners, Gándara raised an army from among Yaquis, forging long-term alliances with many local governors.[58] To counter Gándara's actions, Urrea moved against the Seris and indiscriminately destroyed several rancherias. Before long, his bloody plan worked and the Seris rebelled, thus forcing Gándara's forces to fight a war on several fronts.[59]

Governors selectively distributed resources to fight the threat of the Apache or Yaqui. On more than one occasion residents of the northern districts claimed that in reprisal for not supporting Gándara's policies, state military forces had been withdrawn from their area. To wage war on Pesqueira, the Gándara government withdrew troops from the north, concentrating forces around Guaymas, where he had established his base of operations.[60] With no assistance, most ranchos in the area were overrun. The government insisted that it simply lacked the funds to wage a war on all fronts.[61]

The practice of recruiting Yaqui combatants reached new levels under the governorship of Ignacio Pesqueira from the late 1850s through 1870s. Historian Manuel González contends that Gándara and others fomented "persistent rebellion among the Yaquis and Mayos in order to achieve political objectives."[62] Pesqueira eventually managed to break Gándara's hold on the Yaquis, forging his own separate peace with several native leaders. The Gándara-Yaqui alliance resurfaced once again during the French intervention as both sides made appeals to the Yaqui population. The French, with Gándara and the Yaqui leader Tanóri at their side, succeeded in wining over a significant number of Yaquis. The French commander General Castagny recognized the importance of the Yaqui allies and authorized local officers to spare no expense to win them over. On the other side, Pesqueira and General Angel Martínez actively recruited from among the Opatas and other groups, eventually gaining the upper hand in the conflict.[63]

With the French defeated, Pesqueira once again resumed the governorship and actively used the Yaqui threat to squash a growing opposition. At times he even relied on the Yaqui vote to stay in office. When it suited them, ranchers customarily cast votes for all their laborers, whether they were Yaqui or not.[64] In a close election, a large block of votes, usually from the Yaqui or Mayo Valley and in most cases obtained either through coercion or in exchange for favors, would invariably swing elections in favor of the incumbent governor. Frustrated by

Pesqueira's use of the Yaqui threat to quash opposition, in 1873 a faction in the state assembly attempted to weaken the governor by reforming the state constitution. The dissidents sought to prohibit the reelection of governors, establish direct elections for prefects, and more importantly, strip all Yaquis and Mayos of the right to vote. This last move was an effort to prevent the governor's manipulation of Yaqui votes and undercut his reelection. After a heated debate, the assembly adopted the amendments by a narrow margin.[65] Rather than simply reflecting deep-seated anti-Yaqui sentiments, the issue of voting rights became part of an effort to weaken the power of Pesqueira.

Faced with the prospect of losing an important voting bloc, Pesqueira and his supporters became ardent supporters of the Yaquis' and Mayos' political rights. The congress received a flood of petitions from El Mineral de la Trinidad, Bacanora, Tepoca, and Arivechi, all in the district of Sahuaripa and all traditional strongholds of Governor Pesqueira. Moreover, to arouse local indignation against the electoral reforms, Pesqueira wrapped himself in the mantle of nationalism and insisted that the constitutional modifications were an attempt to "implant the American political system in México."[66] The governor and his allies eventually out-maneuvered the opposition and forced a new vote with alternative delegates present. Though undermined by Pesqueira, the reformers nonetheless managed to exclude "rebellious Yaquis" from voting—under the new regulation, only Yaquis who lived in formal towns, under civil authority, where competing political interests could campaign for their support, could vote.[67] This compromise weakened Pesqueira's long hold on power.

CRIME AND BANDITRY

Political disputes, whether regional or national, also provided a cover for banditry. In 1870 one case in particular exposed the powerlessness of state authorities. In May of that year, Fortino Vizcaíno, a supporter of Plácido Vega's call against Benito Juárez, raided Guaymas. Under the cover of darkness, Vizcaíno slipped into Guaymas Bay, and his forces commandeered the local jail and freed the prisoners.[68] By daybreak Vizcaíno had taken over the town. A small force of Guaymenses escaped and assembled at San José de Guaymas several kilometers away to plan a counterattack. Since most of Guaymas councilmen had previously requested leaves and could not be reached, resistance floundered. Eleazar Muñoz, the prefect of Hermosillo, and General Jesús Morales attempted

to organize a small defense force. By the time they reentered the town, the invaders had departed. In assessing the damage they found that Vizcaíno had removed 5,000 rifles from the armory, robbed the local aduana of over 100,000 pesos, looted most of the leading merchants and had taken several ships under tow.[69] In an action which newspapers in Mazatlán labeled disloyal, local authorities, unable to pursue Vizcaíno, requested the assistance of an American naval vessel, which docked several days later.[70]

Most Sonoran settlements had more to worry about than Apache and Yaqui attacks. Confronting extremely harsh conditions of life and taking advantage of the weak state authority, many Sonorans turned to banditry to improve their lot. The contradictions between the lucrative extraction of precious metals and the relative deplorable living conditions spawned most banditry. At this level, the Sonoran bandit seems to corroborate the traditional image of people who take up arms to avenge social injustices.[71] Yet there are important differences from the notion of unorganized peasants turning to banditry to compensate for social inequities. Except for the Yaqui leader José María Leyva Cajeme, few became heroes or fought for anything resembling a social cause. In such instances, the image that emerges of these characters "emanated from the pens of urban middle class writers, not from folk sources per se."[72] In the case of the Yaqui leader, Governor Corral published a tribute to the legendary figure presumably based on interviews he conducted on the eve of Cajeme's death by firing squad.[73] Serialized in a state newspaper, Corral's work reached a broad audience. For most Sonorans, the lore surrounding banditry never materialized. Rather the bandits emerged as faceless criminals who lashed out indiscriminately at class enemies and also at members of their own social group. In the final analysis, however, broader sectors of the population benefited indirectly from banditry; however, for bandits this service simply represented a profitable venture and not a planned social strategy to remedy class injustices.

As crops failed and mining declined, many Sonorans turned to banditry. Travelers, especially foreigners, became favorite targets of the *bandoleros* (brigands). C. Combier, a French merchant, advised outsiders to follow Mexican tradition and travel light.[74] In keeping with this practice, he "went on horseback, well armed and followed by one servant, without carrying any baggage."[75] Newcomers who failed to heed the advice usually fell prey to bandits. One typical case involved three Americans en route to Hermosillo in 1873. Unable to reach their desti-

nation before nightfall, they sought shelter at the Tavique ranch. The next morning as they resumed their journey, two armed men robbed them not far from the ranch. The brigands took their horses, personal belongings, clothing, and "175 greenbacks."[76] The district prefect who investigated the incident determined that the owners of the ranch had perpetrated the theft. Frustrated by the repeated assaults, in 1873 the state enacted the death penalty for highwaymen. Ruperto Lopez, for example, was condemned to death for having robbed and killed a Chinese traveler returning from a buying excursion to Tucson.[77]

Isolated mining camps which proliferated throughout the state also became frequent targets of bandits. In addition to precious metals, mines usually stored large stocks of goods to sell on credit to their laborers. In July 1860, a gang of bandits descended on the San Pedro mine, in the district of Hermosillo, taking everything they could carry off. The list of stolen articles illustrates how common Sonorans might have benefited from banditry. It includes the usual assortment of rifles and pistols, as well as dozens of boots, shoes, shirts, ties, undergarments, and several dozen pairs of pants.[78] Seldom frequented by merchants, remote villages in the interior of the state depended on the traffic of stolen property, and this illicit trade became an important source of merchandise. Bandits frequently used towns along the border and near the coast as their bases of operation and as outlets for stolen goods. Residents in these areas benefited from the banditry and at times protected them from state authorities. Up the coast from Guaymas at the small port of Comuripa, Prefect G. Corella reported that many in the town made their living from robbery and openly sold their loot in the town square.[79] Military authorities who visited San Marcial in the district of Hermosillo complained that bandits "leave and enter the town as if they were legitimate merchants."[80] The military officer responsible for the area complained to the prefect of Hermosillo that the municipal president of San Marcial openly colluded with the bandits. When one outlaw, known as "el Cojo Vidal," offered to implicate the municipal president, he mysteriously died while in custody. Incidents similar to those at Comuripa and San Marcial could be found elsewhere in the state. Further north near the border, the prefect of Altar complained that Saric and Caborca had become dens of thieves who openly trafficked in stolen merchandise.[81]

The presence of bandoleros, some in organized bands, others acting independently, further destabilized life in the north. For campesinos

with a few head of cattle, large ranchers, or urban merchants, little distinction existed between raids by Apaches, brigands, or abusive officials. The outcome was usually the same, including the loss of property, or worse, life. The dual threats—bandits and Apaches—took their toll on the people of the area. In the district of Guaymas, the owner of a small rancho, the Santa Ana, appeared at his wits end. In the morning of August 14, 1871, bandits raided his ranch. In the afternoon of the same day, Apaches showed up and took what little remained on his land.[82]

Lower-level government officials, both civilians and the military, actively participated in banditry, and ethnic tension and political acrimony permitted authorities to cloak their actions. Under the guise of waging war on the Apaches, robbery became quite profitable for some in the military. Officers abused the state laws which permitted them to expropriate food and animals while in pursuit of Apaches or Yaquis. Sonorans lodged numerous complaints against officers who confiscated their crops and animals for their own use. In Fronteras, for example, the commander of the town came under increasing criticism for taking supplies from the local population.[83] Even foreign mine operators fell victim to this scheme. John Anderson, the American superintendent of the Trinidad mine, protested that, while claiming to be chasing Yaquis, Mexican troops had twice seized his horses and mules.[84] In another case, rancher Ventura Angulo protested to the prefect of Guaymas that government troops had taken his entire corn crop to feed their animals. Angulo insisted that he supported the war against the Yaquis but could not survive unless the government compensated him for the loss of his crops.[85] For Angulo and countless others, no reimbursement was forthcoming.

Northern residents found it difficult to distinguish between the atrocities committed by Apaches and those of the military authorities charged with their protection. In Ures during 1880, for example, the platoon of soldiers which guarded the old capital released all the prisoners, and together they looted the town before heading north to Arizona. According to the district prefect, after robbing most of the town's important stores, the gang of ten soldiers and eleven prisoners "kicked down the doors of the most respected and well off and began to verbally insult them without reason."[86] The incident demonstrated the deep-seated social cleavages which existed in this society. Soldiers, who repeatedly risked their lives in Apache wars and political disputes, re-

ceived little compensation for their efforts and frequently deserted or rebelled.[87]

CATTLE RUSTLING

Cattle became a persistent target of bandits. Most early Sonoran rustlers and Apaches stole cattle for meat and not as part of an organized contraband trade. Strict laws governing the sale of cattle deterred an extensive market in stolen animals within the state. All brands had to be recorded with state officials, and from time to time, they appeared in the state newspaper. These conditions changed dramatically with the presence of population in Arizona. As settlements increased north of the border, rustlers found ready markets for stolen cattle.[88] During one three-month period in 1879 in the district of Altar, more than 500 cattle and 300 horses were stolen and sold across the border in Arizona.[89] Although state authorities periodically sent the national guard to patrol the area, they proved ineffective in deterring the cattle rustlers.[90]

The illegal sale of cattle proved so lucrative that even wealthy landowners and local authorities became involved. Ranchers in Magdalena accused the powerful hacendado Manuel Mascareñas of appropriating unbranded calves on his property and selling them in the United States. Mascareñas became indignant at the accusation, scolding local authorities. Rather than face charges, he telegraphed his good friend Governor Luis Torres, who ordered the prefect to drop the investigation.[91] Elsewhere in Magdalena, ranchers complained to the state government that they confronted "two maladies, Apaches and bandits."[92] They knew how to defend themselves against Apaches, but the rustlers had bribed the municipal president, thus allowing the thieves a free hand. Local authorities disregarded rancher's complaints, and although several bandits had been arrested, the municipal president refused to prosecute.

Because it employed traditional practices, cattle-ranching lent itself to abuse. Without fences, cattle from various ranches usually grazed side by side. Once a year, the district prefect appointed a *juez de campo* (field judge) to oversee an area-wide roundup, during which, the cattle would be counted and the calves branded. Eventually taxes would be assessed on the size of the herd. Invariably, as cattle sales to the United States became lucrative, the once traditional roundup became mired

in controversy. Several levels of abuse existed. A few days prior to the roundup, ranchers who sought to avoid full disclosure, butchered young calves and sold them clandestinely. In one case, in district of Magdalena, a field judge reported finding the remains of over twenty calves which had been killed just days before the inspection.[93] Another common practice that judges found involved the rebranding of cattle that had strayed onto another rancher's property. Disputes of this sort pitted neighbor against neighbor. Even field judges did not escape criticism—ranchers accused them of seeking to profit from the roundups by confiscating any cattle whose owner could not be ascertained.[94]

GUARDIA NACIONAL

The state government responded to Apache and bandit attacks by requiring all males to serve in the *Guardia Nacional* (civil militia).[95] Laws enacted in 1835 created a state militia and ordered every municipality to establish a food deposit from which to provide for soldiers families. Having declared the Apache an "enemy of society," the state ordered "all individuals to sustain the war until its just end." Persons not willing to serve or who assisted the Apache in any way were considered foes of the state.[96] National legislation enacted in 1846 reinforced the local effort. The militia functioned at the local, district, and state levels and, theoretically, included all adult males between the ages of eighteen and fifty in the state.[97] Conscripts received training in the use of weapons and general principles of warfare from officers of the regular army. District prefects and municipal presidents assumed responsibility for the recruitment and maintenance of the civil militia. Whenever raids occurred, residents would be mobilized into units, shoulder their weapons, and pursue the lawbreakers.

The guardia augmented a smaller, regular military force which, in its early days, operated under the jurisdiction of the governor and after 1867 under a military commander appointed by the president.[98] Before 1880, the federal force remained small, and the primary responsibility for preserving order in the state fell on the civil militia.[99] Privilege, status, and occupation determined who served in the militia: merchants, politicians, hacendados, and rancheros avoided the draft by paying an exemption tax. In Hermosillo, for example, between March and July of 1861 Jesús Pesqueira, Juan Camou, Ignacio Buelna, and General Francisco Serna paid between 3 and 4 pesos a month to avoid service. Hermosillo authorities collected a total of $190.75 pesos in tax for ex-

emption from service.[100] In some cases, the draft also excused miners. Francisco Espino, the prefect of the Hermosillo district, reported that the mining town of Los Bronces could not comply with the draft because all the "men were *barreteros* [drillers] and as such did not have to serve."[101] Individuals who could not acquire a reprieve hid in the countryside to avoid service. Those under compulsory service in the guardia were usually from the lower classes, who could not afford to pay the exemption tax.

The money raised from guardia exemptions played an important role in the maintenance of the militia, helping to purchase horses, supplies, weapons, and munitions. Moreover, due to the government's chronic lack of funds, it is doubtful that the guardia could operate without the exemption tax. In the northern districts, where few notables lived, funds remained scarce. Facing constant deficits, northern prefects lacked weapons for their troops.[102] In Fronteras, for example, 100 trainees shared fewer than twenty weapons and in Hermosillo, 268 conscripts shared seventy rifles.[103] At times the local population appeared better armed than the authorities.

Facing raids by Apaches and bandits, frontier communities developed a keen interest in weaponry of all sorts.[104] A reconnaissance report prepared by a French captain noted that "in every ranch there is not an Indian or mestizo who does not own a rifle and sufficient munition for its use; to deny them of this right would be to condemn them to a sure death." The officer asserted that the widespread ownership of arms would be an impediment to the conquest of Sonora by the French. To assure subjugation of the state, the French must disarm the Sonorans "as soon as possible."[105] As the imperial forces later found out, Sonorans did not willingly relinquish possessions of their weapons.

To compensate for shortages in arms, local authorities maintained an inventory of the guns owned by citizens. For example, Santiago García, the prefect of Arizpe in 1858, reminded all municipal authorities to update records of the number of weapons owned by each individual. His communiqué also urged residents to carry their rifles at the ready in the event of Apache raids, telling municipal authorities to verify compliance with his order every fifteen days and during social gatherings and festivities.[106] When officials needed weapons they turned to the local population. In 1871, after a band of Apaches attacked the rancho Corral de Piedra in the district of Guaymas, the prefect confiscated the rifles and pistols of local residents in order to give chase to the attackers.[107] When political turmoil broke out in 1877, the military com-

mander of the district of Hermosillo, Francisco Espino, tried unsuccessfully to confiscate the weapons held by the citizenry.[108]

The scarce population in northern rural areas and the rotating nature of the draft increased the likelihood of men being forced to serve in the militia. Arizpe, for instance, had in 1872 a total population of 8,530 inhabitants, roughly half of whom were males. The district's militia included 462 active members and 102 exempted—a total of 562. Over 20 percent of the able male adult population served in the guardia at any one time.[109] In the district of Magdalena, a similar situation existed. In 1870 Magdalena had a population of 5,388 inhabitants, approximately half of them males.[110] The guardia force there included 662 active-duty personnel and 62 exempted individuals, a total of 724, or well over 20 percent of the males. Because of Magdalena's smaller population, the actual percentage of persons on active duty remained higher than in Arizpe. This pattern of conscription held true for the remaining border districts of Altar and Moctezuma.[111]

THE PRICE OF CONFLICT

Mandatory service in the guardia depleted the state's labor force. Landowners protested that the draft took their best laborers and on several occasions requested that their men be exempted from military service.[112] In 1873 in the border district of Moctezuma, for example, Jesús Provencio complained to local authorities that every time his men were mobilized into the guardia, the work on his ranch suffered. Provencio insisted that "his employees neither completely finished their work nor completely eliminated the threat from the bárbaros [Apaches]." He requested permission to form his own private militia from among his employees and patrol the areas which Apaches most frequented. Governor Ignacio Pesqueira approved his plan.[113] Other ranchers also maintained an armed force to defend their property.

Political turmoil and the price of waging a constant war against the Apaches and Yaquis drained local resources and stymied the state's long-term development.[114] In order to finance the wars, state authorities normally levied a special tax on towns and commercial enterprises.[115] To determine the amount of tax which each municipality must pay, prefects periodically conducted a census of the net worth of each community, including its principal commercial enterprises. Based on the result of the survey, the governor then assessed a tax on each town. To increase revenue, state authorities usually inflated the value of commer-

cial enterprises and land, so after the tax assessment, a ritual process of negotiation ensued between the state government, municipal authorities, and local business over the inflated figures.

In 1860, for example, the Pesqueira government levied a special tax of 56,000 pesos to deal with the "guerra de castas and repeated incidents of banditry."[116] The town of Baviacora received an assessment of 555 pesos. While affirming their support of the government's effort, the townspeople insisted that they lacked the money to pay taxes. The area surrounding Baviacora, in the foothills of the Sierra Madre, made it a frequent target of Apache raids. Strife, they argued did not allow them to "plant, and mining remained at a standstill."[117] Despite weeks of negotiations, Baviacora was forced to pay the assessed tax. Towns throughout the state repeated this complex process.[118]

After 1856, settlements in Arizona provided an alternative from taxes and compulsory military service. Prefects reported increases in the number of deserters from the guardia and the regular army,[119] and due to the flight of men in the northern districts, they could not adequately form guardia units. By the 1870s, the problem of out-migration had become a source of embarrassment for state authorities. To illustrate the point, the municipal president of Santa Cruz, district of Magdalena, reported to the prefect on March 9, 1874, that he could not fulfill his quota of twenty-five draftees because of "the considerable migration that his town had experienced."[120] Even the fifteen draftees he had managed to cajole petitioned to be exempted from service in order to tend their crops. The governor, however, refused to release the fifteen men, citing continued attacks by "bárbaros in the border districts."[121] Not surprisingly, life in Arizona, where no draft existed, became an attractive alternative to many residents serving in the guardia.[122]

The state government acknowledged that it faced a dilemma in the northern districts. With the guardia in crisis, the official newspaper, *La Estrella de Occidente,* assured prospective conscripts that they would be called upon only in times of extreme emergency. To allay anxieties, the paper wrote that "citizens of Sonora, who out of fear of the draft are emigrating to the American territory, should note that . . . the people of the frontier are only obligated to sacrifice their lives when the independence of the republic or its democratic institutions are in jeopardy."[123] Despite the assurances, young men continued fleeing to Arizona, and municipal authorities began jailing individuals selected for the draft until they were turned over to the military. With the guardia understaffed, in 1869 the prefect of Magdalena ordered all

"tramps, drifters, drunks, and vagrants drafted . . . to make up for the deserters."[124] In addition, prisoners in the state jails could have their sentence commuted if they agreed to serve time in the military. Frustrated by the incidents of flight, local authorities in Altar attempted to force foreigners to serve in the militia. Frank J. Boisville, a native of Louisiana, married to a Mexican woman and employed in Altar as a school teacher, was ordered to serve in the guardia or pay the appropriate tax. Only after the United States' consul in Guaymas intervened did the governor exempt Boisville from service.[125]

The financial and even personal sacrifices represented only one aspect of the conflict with the Yaquis. There were also potential cultural and social ramifications from this ongoing strife. In a letter to José Guillermo Carbó, military commander of the northwest, Pedro Hinojosa, the secretary of war, summarized these concerns. He vehemently objected to the requests for campaigns of extermination against the Yaquis. With whom, he asked "would the Indian laborers be replaced?" Citing the war with Texas, he reminded Carbó that it would be absurd to expect to replace them with "Yankees," "Mormon colonies," or "Chinese servants," since Mexico would lose one of its richest states.[126] He urged an end to wars against the Yaquis and instead advocated negotiations. With the exception of a few hacendados in the south who depended on Yaqui labor, his concerns fell on deaf ears.

ARMED POPULATION

The general climate of lawlessness invariably affected women, especially indigenous women, more than men. Judicial records indicated that attacks against women occurred often and for the most part went unpunished. In Altar, two Sonoran men attempted to rape a Tohono O'odham woman who worked in a field. Although she managed to repel her attackers she was not so fortunate later that night—under the cover of darkness the men dragged her out of her home and raped her. Word quickly spread among the O'odham community, and the local authorities became concerned about Indian reprisals. The men managed to escape since, according to the prefect, the local judge "stayed in his ranch and refused to fulfill his responsibilities."[127] Other similar cases occurred elsewhere in Altar. In Caborca, the prefect Lucas Llain ordered the arrest of nine men, including three members of the local town council, for raping a young woman visiting from California. One man,

Francisco Ortega, received a six-month jail term for the rape and abduction. His accomplices, however, remained free.[128]

In the long run, violence and the proliferation of weapons among the population proved to be a problem for state authorities, who eventually had to regulate the use of firearms. Fearing the worst, municipal police commonly disarmed participants before sporting events. To cite one case, during a horse race in Hermosillo in 1870, even though all of the riders had been disarmed, the winner still perished in an altercation with the disgruntled loser.[129] Sporting contests were not the only events subject to regulation. Brawls in cantinas invariably led to armed confrontations, and saloons in larger towns prohibited admission to armed customers. Despite the regulation, violent barroom fights continued to plague local authorities. Even when police managed to ban weapons, disgruntled individuals always found ways of exacting their own form of personal justice. Cananea police reported that even after they had "diligently confiscated revolvers and knives, miners regularly killed each other with *candeleros* (metal candlesticks) which they used to hold their candles while they worked."[130]

In an effort to prevent disorders, the state and local municipalities passed strict laws regulating public behavior and the ownership of weapons.[131] Military authorities in Guaymas enforced rigid compliance with the new edicts. A decree published by José María Rangel, commander of the port, reminded Guaymenses that owners of weapons must have permits, that foul language was prohibited in public places, and that public drunkenness would not be tolerated. Any infraction of these laws, Rangel warned, would lead to immediate arrest.[132] Adherence to these new laws remained limited. Long accustomed to possessing firearms, Sonorans resisted attempts to restrict their right to bear arms. Officials had only limited success in enforcing these laws and problems associated with the widespread ownership of weapons continued to be a source of trouble. After the 1870s, authorities confronted the formidable task of establishing civil authority over a population long accustomed to resolving matters on their own. Frustrated by their inability to control these recurring problems, authorities at times resorted to their own form of justice. Incidents of prisoners shot by soldiers, supposedly while "trying to escape," occurred frequently.[133]

On the Sonoran frontier, ethnic conflict and civil strife became important weapons in the maintenance of political power. They served to place demands on the central government, to increase taxes, and to re-

press opposition. On the personal level, the experience produced "individuals aware of their rights and capable of fighting for them."[134] This was true of both the Mexicans who struggled to retain a foothold in the north and the Yaquis who tenaciously fought for their lands. Sonora's Porfirian officials also made use of these contradictions to gain a hold on power.[135] As foreign-inspired economic growth gave rise to a host of new contradictions, government officials gradually lost the ability to use the threat of attacks—el petate del muerto—to deflect criticism and contain dissidents.

Sonora and Arizona

A Legacy of Distrust

Frontiers are not static phenomena: they adjust to changing social and economic conditions.[1] Separated from southern Mexico by distance and geography, Sonora interacted with areas later annexed by the United States. Long before the border with the United States materialized, exchanges with the north proved critical to the economic survival of the state. Relations with New Mexico, California, and Arizona compelled Sonora to undergo repeated cultural and political adjustments. A qualitative difference existed, however, between contact with distant territories and that with contiguous areas. Economic and social exchanges with California occurred without any of the host of difficulties encountered in a relationship with an adjoining region. With Arizona, interaction involved direct contact over a broad expanse of territory penetrating deep into both states. This face-to-face exchange set the tone for future border relations, leaving in its wake a legacy of distrust.

NEW MEXICO AND CALIFORNIA

During most of the eighteenth century, Sonora and New Mexico delineated the outer boundaries of the far-flung Spanish colonial empire in Mexico. Contact between these two outposts occurred frequently, and when Spanish military authorities in Sonora needed troops, they turned to New Mexico for relief. Relations between the two states increased in

the wake of the Pueblo Revolt of 1680, as many fleeing Spaniards reset-
tled in Sonora.[2] Even before the arrival of the Spaniards, contact be-
tween these two areas already existed. The indigenous population of
northern Sonora—the Tohono O'odhams, the Pimas, and the Opatas—
had a long tradition of trade with the Pueblo Indians of New Mexico.
Hoping to exploit commerce with northern Mexico, Mexican and
American merchants in Santa Fe also promoted interaction between
Sonora and New Mexico. Hermosillo became the center of a lucrative
trade with New Mexico.[3] As late as 1830, caravans from New Mexico
still made the trip to Sonora, going as far as Alamos, its most southern
city. According to one French merchant, teamsters from New Mexico
brought to Sonora buffalo hides, serapes, and woolen goods, returning
north with "iron, steel and fabrics imported from Europe."[4] Relations
between the two states declined, however, as Apaches moved into the
area and gained "undisputed control of the territory separating south-
ern Arizona from those in New Mexico."[5]

Alta California represented Sonora's second distant frontier. Social
and economic exchange between Sonora and California provided a
glimpse of the future border relations between northwestern Mexico
and the United States. Despite the great distance, no real physical im-
pediment obstructed communications with California.[6] Moreover, to-
ward the west, Apache raids occurred less frequently. During the 1760s
Sonora had been the genesis for numerous expeditions to settle and sup-
ply California. Caravans frequently traveled between Hermosillo, Tuc-
son, and northern California. Eventually, Sonorans and Californians
became linked by commerce and a complex web of family and social
relationships,[7] and Sonorans soon viewed California as a natural exten-
sion of their state.

The United States' acquisition of California did little to alter rela-
tions between the two areas. The discovery of gold in 1848 drew thou-
sands of Sonorans to California. By the mid-1850s one observer noted
that "everyone had a son, brother, uncle, father, cousin, husband, or
relative working in the bonanza."[8] J. R. Southworth, a businessman fa-
miliar with both states, credits these Sonorans with teaching the early
American neophytes how to extract gold from California mines.[9] At
first, Americans unfamiliar with mining practices valued Sonorans min-
ing skills. With new markets in the region, Sonoran ranchers drove steer
and sheep to sell in California. On one occasion, a Mexican party drove
as many as twenty thousand head of sheep to California.[10] At the same

time, schooners—such as the *Newbern,* owned by Juan A. Robinson—
began to ply the waters between Guaymas and San Francisco, taking
Sonoran wheat and dried beef to hungry California miners.

Entire Sonoran families migrated north and established permanent
settlements. Intrepid Sonorans also formed circuses and traveled to
California during the gold rush to stage events in the Mexican commu-
nities.[11] The northern migration of Sonorans permitted an early cul-
tural exchange with Americans. Those who returned from the Califor-
nia mines incorporated some American norms and values into their
cultural repertoire. Commissioned to survey the border after the war of
1846–1848, John Russell Bartlett documented this interaction. While
on a visit to Fronteras, he reported hearing the Mexican inhabitants of
the town sing American songs such as "Old Susannah, Dan Tucker, and
other popular airs which had probably been introduced by the Sonori-
ans, [sic] who had returned from California."[12] Interaction with Anglo-
Californians not only exposed Sonorans to the English language, but
also to new values and customs.

Despite the pattern of racial antagonism which eventually marred re-
lations between Anglos and Mexicans, contact with the American Cali-
fornia proved largely beneficial to Sonoran business interests. With
new outlets for their products, Sonoran merchants and cattlemen made
handsome profits. Chronicler José Velasco points out that the Camou
family obtained over fifty thousand pesos from commerce and mining
in California, and other Sonoran merchants fared just as well.[13] These
earnings allowed a number of elites to expand their commercial opera-
tions and to acquire new tracts of land.[14]

The economic boom with California demonstrated to business inter-
ests the profitability of relations with the United States. In subsequent
decades, state leaders referred to this early experience in promoting
commercial ties with the Americans. In an 1870 address, Governor
Ignacio Pesqueira drew on this period, asserting that Sonora's earliest
prosperity had been the result of "commercial relations with Califor-
nia."[15] These activities, he argued, led to foreign investments, which
stimulated commerce and the formation of new mining operations.
American racial attitudes aside, the absence of contiguity and the sym-
metry in these early associations had, to a degree, insulated the state
from dramatic internal changes, emphasizing the positive aspect of the
exchange. A contiguous, face-to-face relationship with Arizona altered
this delicate balance of power.

ARIZONA

Historically, Arizona represented a dichotomy for Sonora. At the time, the Gila River defined the farthest reaches of the state, beyond which few Sonorans had traveled and beyond which no permanent Mexican settlements existed. Historically, this region symbolized the hostile border with the Apache, an environment over which Mexicans had little control. At one time, seven presidios at Altar, Santa Cruz, Babispe, Bacoachi, Fronteras, Tubac, and Tucson outlined Sonora's northern frontier.[16] The lack of funds after independence resulted in the deterioration of these fortifications. Tucson, the northern most Mexican settlement, clung to life despite repeated attacks by Apaches. From Hermosillo several rugged overland roads led to the northern district and on to Tucson. Most routes paralleled old presidial trails originally used to reach the distant military outpost and settlements. The principal trail followed the San Miguel River valley toward Magdalena then veered west to Altar, Tubutama, Saric, and Sasabe before crossing the border.[17] After funding for the presidios ceased, few incentives, however, existed for going north.

Since the founding of missions and presidios, Sonoran prospectors had periodically worked the mines of southern Arizona. Seldom did these early mining ventures become permanent; most remained precarious operations, and as difficulties with the Apaches arose or funds became depleted, miners abandoned the diggings. The use of land for agricultural production also involved substantial risks. Although some notables, like Manuel Gándara, purchased property in Calabazas and began cultivation, the absence of markets and frequent raids by Apaches impeded full-scale development of agriculture in the area.

NORTE AMERICANOS

After the United States' acquisition of the Mesilla in 1853, a handful of American settlers slowly moved into the new territory, opening businesses in Tucson. By 1856, others, such as Charles Poston and several associates of the Sonora Mining and Exploring Company, settled at the old presidio at Tubac, north of the actual border, hoping to undertake mining operations in the nearby Santa Rita mountains.[18] Heavy equipment to operate the mines arrived from San Francisco via Guaymas and then through Sonora to southern Arizona. Other machinery came over-

land from the Texas coast.[19] Americans hoped to recruit laborers from the Mexican and indigenous population in the area.

News of American mining operations at Tubac, Cerro Colorado, and Patagonia promptly reached the embattled communities of northern Sonora. As word spread, small numbers of Mexicans began migrating north including, according to Charles Poston, entire families.[20] In addition, significant numbers of Tohono O'odhams also arrived at the mines. Because the Sonorans had previous mining experience, American mine owners preferred hiring them to Americans. To promote his venture among East Coast investors, Poston claimed that Tubac had grown to one thousand residents. Yet, according to Raphael Pumpelly, who visited the site, the small settlement consisted of a handful of Mexicans and Americans and just over one hundred Tohono O'odhams on the outer edges of the town.[21] Pumpelly's distinction is important because it underscores the persistent scarcity of labor which American operators confronted. Still, by 1859, the population in Southern Arizona had grown sufficiently to merit its own newspaper, the *Weekly Arizonian*, which began publishing in 1859.[22] Beside serving the small, local, English-speaking population, the paper promoted southern Arizona among Eastern capitalists.

Trade with the new American settlements began to redefine commercial relations and trading routes throughout northern Sonora. Intrepid Mexican merchants promptly set out to fill the needs of southern Arizona. Sonoran teamsters and their pack trains arrived carrying "all kinds of provisions" including "flour, beef, beans, sugar, barley, corn, and vegetables at moderate prices."[23] Trade caravans now proceeded directly to the Santa Cruz Valley and Tucson, bypassing Altar to the west and Fronteras to the east. A British doctor traveling north from Cucurpe in the late 1850s reported that "a brisk trade with Sonora was being carried on; mules and wagon trains were continuously on the road, which is an excellent one."[24] In addition to receiving goods from Sonora, American mine owners shipped their silver through Guaymas, loading it on vessels destined for San Francisco. During this early period, trade was unrestricted, since in the words of Poston, there existed no "frontier custom houses . . . to vex and hinder commerce."[25] Focused exclusively on mining, the relatively small American population in Arizona grew dependent on Sonorans for labor, foodstuffs, and commerce.

Recollecting the bitter experiences of Texas and California, some So-

noran officials expressed concern regarding the arrival of Americans to
their former territory. The absence of Mexican aduanas along the bor-
der heightened these fears. The only established aduanas were inland—
at Altar in the west, Magdalena in the central region, and Fronteras in
the east. During 1857, unable to determine American intentions, the
militia commander of Santa Cruz, in the district of Magdalena, peri-
odically sent guardsmen disguised in civilian clothing north to Cala-
bazas and even as far as Tucson "to mingle with the populace and re-
port on the arrival and movements of Americans in the area."[26] On
occasion the commander instructed the guardsmen to pretend to be
farmers in the vicinity of rancho Nogales and Calabazas in order to
report on American activity in the area. The news gathered by infor-
mants augmented Sonorans fears of possible American military en-
croachment.

The United States military moved into the area after 1856, estab-
lishing operations at Fort Buchanan later the next year. The rigors of
life encountered by the American troops reminded Sonorans of the
plight of their own northern presidios after independence. Forced to
construct their own living quarters, plant their own food, patrol, and
engage the Apaches, many soldiers deserted. Confronted with Arizona's
isolation, the United States Army found it difficult to supply troops in
the newly acquired territory. From San Francisco, the United States'
principal depot on the West Coast, overland routes were long and ardu-
ous. From Texas, distances proved equally prohibitive for regular com-
munication. Fort Buchanan increasingly relied on Sonorans to supply
stock, grain, and foodstuffs.[27] The United States government began
shipping military supplies and even the troops' pay through Guaymas;
on occasion American soldiers crossed into Mexico and escorted the
quartermaster on trips from the Mexican port.

Guaymas merchants sought to take advantage of the increasing trade
with the north. In 1859 Alphonso Coindreau, a prominent Guaymas
merchant, requested that the Sonoran government grant American and
European ships the right to dock at Guaymas and unload products in
transit without paying duties. Coindreau explained that although the
state would not collect duties, the move would provide employment for
wagoners, teamsters, and local merchants who would handle the or-
ders.[28] With plans of his own, the governor rejected the proposal. Up
the coast from Guaymas, the state government in 1859 opened a new
port, Puerto Libertad, to accept American products in transit to Ari-
zona.[29] Puerto Libertad evolved as the brainchild of Juan A. Robinson,

a former American consul with extensive political ties in Sonora.[30] After the ships docked at Puerto Libertad, wagon caravans transported the goods north via Altar, Tubutama, and Saric before crossing the border into Arizona. The Sonoran government and Robinson expected to profit from this venture. By authorizing the port, Pesqueira hoped to regularize commerce and undercut contraband. By routing all traffic with Arizona through one port, the government expected to maintain tight control on this growing trade. Robinson, a long-time commercial broker, wanted to monopolize business with the north. Hoping to acquire a secure port for Arizona, the United States military commissioned a study of Puerto Libertad. The founding of Libertad received much publicity in the San Francisco press, and initially the United States government used it to supply the cavalry in Arizona. As occurred with most early schemes to exploit increasing border trade, the port never reached its expected potential, and the Mexican government eventually withdrew its support.

ADUANAS

For Americans and Sonorans, the freedom to operate without government regulations soon came to an end. Eventually, the Mexicans established an aduana at Magdalena, and the Americans a customshouse at Calabazas. Magdalena appeared as a logical choice for the Mexicans to place an aduana, for it and the neighboring community of Ymuris stood as the last formal Mexican settlements before reaching the actual border. Beyond Ymuris, the trail traversed Agua Zarca before meandering up the valley to Puertecitos, where the Santa Cruz River turned toward the United States territory. Several factors influenced the placing of the American customshouse at Calabazas. Americans already knew the site well. In 1856, the United States military had established a base of operation there, naming it Camp Moore.[31] More importantly, at Calabazas, the trails which originated at Magdalena and Santa Cruz converged, allowing a customs officers to observe approaching wagons and muleteers.

The establishment of American and Mexican customs houses represented attempts by both governments to control the burgeoning commerce and mining along the border, although the movement of people continued unregulated. Products registered at the Calabazas station represented the basic needs of the new mining communities in Arizona. Mules trains and wagons arrived at Calabazas from throughout So-

nora. From Ures, Nicolas Soto led a pack of mules loaded with seven
cargoes of raw sugar (*panocha*), soap, ten and a half cargoes of oranges,
and fourteen cheeses. The mules of Santiago Campillo from Magdalena
brought sacks of beans, seventy-five pounds of sugar, five cargoes of
flour, and sixty *fanegas* of barley. From the state capital at Ures, José
Vásquez arrived with one hundred pounds of tobacco and a load of or-
anges. In addition to basic staples, Joseph Rothenhausler drove wagons
from Ures loaded with barrels of mescal and brandy.[32]

Most Anglo-Americans and Mexicans deplored the establishment of
the customshouse at Calabazas. Samuel Heintzelman, operator of the
Cerro Colorado mine, noted with concern the arrival of John Donalson,
the customs officer. Alarmed, he wrote that the presence of a customs
officer "will occasion us some trouble. He made a Mexican (Fernández)
pay duties. I fear he will interfere with us also."[33] Poston reflected the
general sentiment of most settlers when in an 1857 letter to Sylvester
Mowry, the territorial delegate to Washington, he wrote, "[T]he govern-
ment has blessed us with a customs house at Calabazas to collect duties
upon the necessaries of life which by chance and running the gauntlet
we may get from Sonora. God send that we had been left alone with the
Apaches. We should have been a thousand times better off in every re-
spect."[34] The customs office, however, proved to be only a minor incon-
venience. Donalson had other personal interests that seemed to take up
much of his time. Next to the customshouse he maintained a small
ranch with a herd of cattle, and on more than one occasion he aban-
doned his post and prospected for silver and gold in the surrounding
mountains.[35] Astute Mexican teamsters learned to simply circumvent
the customshouse.

The small number of entries during January 1859 reflected the abil-
ity of Sonorans and Americans to bypass a stationary customs house.
In Sonora, smuggling traditionally had involved clandestine trade in
minerals—for some time British and other European ships had traf-
ficked in smuggled gold and silver.[36] The establishment of mining op-
erations in Arizona promptly gave rise to new illicit trade in consumer
goods and foodstuffs. The American collector at Calabazas complained
about the inability to control contraband from his inland customs sta-
tion. Smuggling, he wrote to his superiors in Las Cruces, New Mexico,
"is carried on by all parties."[37] A Seri leader reported to the district
prefect regularly sighting several ships "on the islands and coast of
Altar." According to the Seri, one ship had been permanently docked
off a coastal island for over six months. From time to time two other

ships would appear, transfer their cargo, and depart.[38] Smuggling and the economic activity it generated enlivened many decaying northern towns, stimulating the sale of stock and providing employment for muleteers from Altar to Arizpe. Though the national treasury lost revenue, local economies gained.

Overwhelmed by the growing contraband between Arizona and Sonora, Donalson sought permission to leave his post and inspect the area's mines.[39] He also appealed for the hiring of more customs agents to patrol the southern Arizona border. His request, however, fell on deaf ears. Mexican officials also expressed concern over the unfolding contraband trade. They complained that the presence of Americans in Arizona had given rise to smuggling into Mexico. On their return trips from Tubac, Mexican teamsters loaded American goods, mainly textiles. In 1856, José Elías, the prefect of San Ignacio [later Magdalena], reported that since the arrival of United States troops in the Mesilla (Arizona), contraband, principally manufactured clothing and cloth, had appeared in the northern parts of his district. According to Elías, merchants had "opened stores in Tucson and Calabazas from which they shipped clothing to the towns of the state."[40] The prefect insisted that since several of these outlets opened near Calabazas, their main clients became Sonorans teamsters returning to the state. He urged state and federal officials to establish aduanas on the actual border to control the contraband which could undermine local commerce. Ironically, much of these goods, especially textiles, had first entered Arizona through Sonora as goods in transit.

CLASH OF CULTURES

The United States presence in Arizona brought Sonorans face-to-face with the Americans. From 1853 through the 1870s, American mine owners and ranchers desperately needed Mexican labor to sustain operations. To attract and retain Mexican labor, Americans managers and political leaders grudgingly promoted good relations with their new neighbors and, at times, fended off racist attacks against Mexicans. Moreover, with the help of Tucson's small Mexican elite, they attempted to establish a working rapport with notables in Sonora. Northern Mexican notables likewise sought to prosper from new commercial ties with the Americans. Since American mine operators needed their labor, Mexicans had some latitude to negotiate their social position. Not all Americans approved of this policy, and racially

inspired clashes occurred frequently. Confronted with severe hardships and overt racism, Mexicans fought back against injustices and committed atrocities of their own. Racist attitudes slowly hardened on both sides.

Antagonism between Mexicans and Americans contained several layers of contradictions, including the exploitation of labor, racial prejudice, and cultural differences. Except for gold digging along the Gila in southern Arizona, little real competition existed between Mexican and American mine owners. With the backing of Eastern capital, Americans such as Poston, Heintzelman, Ewell, and Mowry controlled most large operations in the area. Few Mexicans actually had the resources necessary to finance large-scale underground mining and most opted instead to sell their claims to the Americans.[41]

LABOR EXPLOITATION

Mining became fertile ground for ethnic and racial strife since Mexicans and Indians constituted the majority of laborers and Anglo-Americans composed the bulk of the supervisors and mine owners. Even in cases where Americans worked side by side with Mexicans, a dual wage-labor system prevailed. Anglos uniformly received higher wages than did Mexicans for performing the same tasks. An adversarial relationship, originating from the exploitation of labor, permeated race relations between both groups. Beyond discrepancies in pay, the method used to acquire Mexican labor further exacerbated racial and ethnic relations. Despite some early migration by Sonorans, labor continued to be extremely scarce, and newspapers in southern Arizona regularly featured advertisements for miners, carpenters, and general laborers.[42] Unable to sustain operations at Cerro Colorado, Heintzelman, at his wits' end, wrote in his journal: "All we want is more workers."[43] Lacking hired hands, American mine owners turned to Mexican hacendados in northern Sonora for help. To initiate operation in the Santa Cruz Valley, Poston and other mine operators purchased indebted laborers from their Sonoran owners in Tubutama and Magdalena.[44] The use of indentured peones, a practice with established roots in Sonora, became an important feature of the labor system in southern Arizona between 1856 and 1861. With little specie available, even those Sonorans who voluntarily migrated to southern Arizona, eventually became *enganchados* (indebted peons). Hacendados in northern Sonora willingly sold their laborers to the American mine operators. As the circumspect John

Hall pointed out, Mexican hacendados sold to the Americans "their peons—debts—and do not even take the trouble to notify the peons of the change which has taken place in their condition, much less take into consideration their will and consent."[45] In Sonora, the long history of exploitation of indigenous labor and land had worsened racial antagonisms between Mexicans and the native population. The exploitation of indentured Mexican and Indian labor by Anglo-Americans further heightened the racial friction that held sway in southern Arizona.

Many Anglo-Americans resented the fact that large-mine owners, such as Poston and Mowry, preferred to employ Mexicans. They complained that "the managers of Tubac employed foreigners and greasers, and would not give a white man a chance."[46] The preference for hiring Mexicans as laborers did not reflect a benevolent disposition on the part of mine operators. As Joseph Parks points out most Anglo-American miners on the frontier "tended to work only long enough to grubstake themselves, then struck off to prospect on their own."[47] They migrated to the border in order to improve their social and economic status, not to become laborers.

Mining remained a dangerous, labor-intensive operation, and most Mexicans and Tohono O'odhams worked under deplorable conditions. To acquire a substantial quantity of silver required refining larger amounts of bulk ores. As shafts penetrated deeper into the unstable earth, accidents became more frequent. While working above ground, laborers confronted spoiled food, inadequate shelter, toxic chemicals used to leach minerals, and their worst fear, attacks by the dreaded Apaches. Mexicans and Tohono O'odhams bore the brunt of these occupational hazards. Distrust between Anglo-Americans and Mexicans in mining gave rise to peculiar arrangements. As smelting produced large quantities of pure silver, many American mine operators feared that the Mexican workers might rebel and steal their precious metals. Several incidents of theft had already taken place, and some Americans had been killed. Anglo mine operators found themselves in an awkward predicament. To defend against the feared Apache, the Anglos had to arm the Mexican workers. A strange dynamic developed wherein Mexicans kept watch and defended against Apaches, while a small number of armed Americans kept watch over the Mexicans laborers. In 1861, as most mines prepared to shut down, Mexicans, "under penalty of death," could not enter camp areas where the Americans resided and stored the processed silver.

Mexican resistance to the abusive conditions of employment oc-

curred frequently and included strikes and repeated cases of flight. Heintzelman narrates one incident in 1858 in which Mexican workers struck over the inadequate amount of food they received. Despite recognizing the legitimacy of their claim, he resented submitting to their demands under pressure. Insurgency also took other forms. One sympathetic mining speculator described that after a Mexican asked "for his money in a respectful manner he has been ill-treated as a greaser and unpaid driven out of the country." By refusing to pay the workers, mine owners tried to coerce Mexicans to stay on in hopes of eventually recouping their pay. Disgruntled and seeking revenge, the abused Mexican on occasion paid "himself by carrying off a horse or two" from his previous employer.[48] Many indentured servants, forcibly brought north from Tubutama and elsewhere, regularly escaped, leaving their angry bosses holding their debts. Announcements of runaway servants appeared in the local English-language press. In one case, the firm of Hoppin and Appel of Tubac, sought the return of Juan José Arenas, who fled while still owing $82.63. Hoppin and Appel offered "a suitable reward" for the return of Arenas.[49]

Beside announcements in the local press, some Anglo-American bosses took direct action in seeking the return of their indebted laborers, provoking a cycle of violence which proved difficult to break. In one incident, in protest over the lack of pay, several Sonoran peones fled from the Reventon ranch in southern Arizona. Americans ranchers, as their hacendado counterparts would have done in Sonora, hunted them down as "runaway peons." A posse of Anglo-American men headed by George Mercer, a local miner, and including customs officer Donalson, set out in pursuit of the Mexican laborers. They captured the fleeing men at Agua Fria and bound them "hand and foot," whipping them "to within an inch of their lives." Not content with this punishment, Mercer, "half drunk, acted as a barber and dressed their hair in a barbarous fashion, and not being over particular, or his razor, bowie knife slipping, I don't know which, in cutting the hair he brought away a portion of their scalp and a fraction of the ear. . . . Still their wages had not been paid."[50] Despite the brutality, the Mexicans survived the attack and sought revenge on an Anglo squatter who had witnessed their beating. They robbed him of his stock and then "chopped [him] to pieces with an axe." In retribution, a group of Anglo-Americans attacked a band of Mexicans producing mescal at a vinateria at Sonoita, on the eastern edge of the Santa Cruz mountains. They descended on the camp, yelling "Death to the Greasers" and killing several Mexicans

and Yaquis.[51] As tempers continued to flare, the Anglo "regulators," as they called themselves, raided ranches throughout the Sonoita Valley and promoted a campaign to expel all Mexicans from southern Arizona. Confronting an escalation of violence, many Mexicans returned to Sonora. The massacre, according to the *Arizonian,* proved disastrous for those who depended on Mexican labor since "every ranch on the Sonoita is deserted by its laborers."[52] Mexicans returning to Sonora spread news of the atrocities in southern Arizona, and authorities throughout the state, according to Hall, had to "restrain the people from retaliating against Americans living there."[53]

In the long run, the independent actions of these self-professed regulators ran counter to the economic interest of American mine owners who depended on Sonoran labor. Without laborers, mines such as those at Cerro Colorada and the Patagonia closed, and others curtailed their operations.[54] To allay Mexican fears, leading Anglo-American politicians from Tucson and mine owners from the Santa Cruz Valley—including Aldrich, Poston, Donalson, Caruthers, Ehrenberg, and Ewell—signed a public declaration denouncing the incident at Sonoita as "cowardly, cruel and unwarranted." Moreover, the proclamation asserted that no "steps should be taken to effect the Mexican population of this Territory or our relations with Sonora . . . without the intervention of respectable men of the territory."[55] The resolutions adopted by the gathering called for the arrest of the regulators, a promise of protection for Mexicans and assurances to "those Sonorians (sic) who have been furnishing us with supplies."[56] Finally, the assembly resolved to send a delegation to northern Sonora to meet with leading Mexican citizens in order to resume normal relations. In a move aimed at appeasing Sonoran elites, more so than laborers, the declaration published by the *Arizonian* newspaper appeared in Spanish and English. In the final analysis, the signers decried physical violence against the Mexicans, not because of any great concern for the Sonorans, but rather because they continued to desperately need their labor.

Not all Mexicans confronted the same circumstances. Obvious distinctions existed between the treatment afforded Mexican laborers and notables. Many mine operators, such as Poston and others, maintained cordial relations with hacendados in Santa Cruz, Magdalena, and Tubutama with whom they traded for laborers, stock, and supplies. Likewise, since a dependence existed on Mexican goods, Sonoran elites and merchants continued to be welcomed in the area and received fair treatment from the Anglo-Americans. Heintzelman, to cite one case,

made specific mention of the cordial treatment afforded to the children of the Sonoran caudillo Manuel Gándara, who visited their property in the area regularly.[57]

Northern Sonoran elites and American mine owners developed a common set of interests, and along with it, a growing interrelationship between both groups. In 1857, when American bandits raided several Mexican mules trains and killed their owners, American mine operators at Tubac "formed a company and took the property away from them and returned it to their owners in Magdalena."[58] Efforts of this sort underscored the growing relationship that evolved between American mine operators and the hacendados and merchants of Magdalena upon whom they relied for the bulk of their products and for the export of silver. This dependence compelled some farsighted Anglos to defend the interests of Mexicans. Lamentably, these individuals remained in a decided minority throughout southern Arizona.

LEGACY OF DISTRUST

The benevolent actions of a handful of mine owners, however self-serving, did not reflect the views of increasing numbers of Anglo-Americans in the area. Hoping to duplicate the heyday of the California gold rush, Southern Arizona attracted many unscrupulous Anglo-American settlers. Besides hardworking miners, Sonora also supplied the region with an ample assortment of bandoleros. Following the Gadsden Purchase, Tucson and southern Arizona became, in the words of one observer, a "resort for traders, speculators, gamblers, horse thieves, murderers and vagrant politicians."[59] Settlement of the region according to Ross Browne, a companion of Poston, owed much to the California vigilante committees, who expelled large numbers of nefarious individuals from northern mining regions. Groups of Texans also settled mines in southern Arizona.[60] Most Anglo-Americans who arrived in southern Arizona from California and Texas held well-established prejudices against Mexicans.

The often-cited examples of intermarriage between Sonoran women and Anglo-American men does not constitute proof of benign racial relations. Rather it indicates the near total absence of Anglo-American women in the area. Heintzelman repeatedly mentioned the lack of "white" women in southern Arizona. In describing the fiesta of Saint Augustine, Tucson's patron saint, he noted that "all sorts of people are found there except white women. There is not one."[61] As they did else-

where in the southwest, Anglo-American men drew distinctions in their attitudes toward Mexican women and their male counterparts.[62]

Cordial relations between Charles Poston and the Mexican population did not reflect the outlook of most new settlers. Contemporary portrayals of Poston as a "great white god of the Mexicans" are at best patronizing.[63] Dependence on Mexican labor did not translate into better relations between both groups. One British observer expressed surprise at the treatment of Mexicans in southern Arizona, reporting that they have been regarded "in every way as a race to be despised."[64] Mowry's and Heintzelman's views of Mexicans contrast sharply with those of Poston. Mowry openly despised Mexicans and seldom missed an opportunity to ridicule or assail this population. He often expressed the view that Arizona's principal advantage over New Mexico continued to be its small Mexican population. Mowry harbored ambitions that, with the help of the Apache, Anglo-Americans would eventually acquire an unpopulated Sonora.[65]

Southern Arizona could be characterized as an ethnic frontier "marked by mistrust and exploitation and violence."[66] A legacy of distrust existed between the three main population groups—indigenous, Anglo-Americans, and Mexicans. Raphael Pumpelly, a long-time resident, wrote that in southern Arizona there was "hardly a pretense at civil organization; . . . Murder was the order of the day among a total white and peon population of a few thousand souls; it was daily committed by Americans upon Americans, Mexicans and Indians, by Mexicans upon Americans and the hand of the Apaches was not without reason against both of the intruding races."[67] Even the mutual fear that both groups held of Apaches did not prove strong enough to unite Mexicans and Anglo-Americans. Parks notes that Anglo-American settlers "looked upon the arrival of Sonoran riders with the same apprehension they felt toward an Apache war party."[68]

Border society remained lawless: "[E]veryone goes around armed to the teeth, and a difficulty is sure to prevail."[69] Intolerant attitudes toward Mexicans became especially apparent in the administration of justice. No pretense of formal law enforcement existed in the early years of the territory—"[T]hroughout the whole country there is no redress for crimes or civil injuries, no courts, no law, no magistrate."[70] Construction of the territorial prison at Yuma did not begin until 1879.[71] Most mining operations administered their own brand of justice. Public floggings, lynchings, and other abuses of Mexicans were not uncommon, even in Tucson.[72] To establish order, Tucson mayor Mark

Aldrich, with the support of local Mexican notables, resorted to public whippings in the city's main plaza.[73] To enforce justice, Poston and others also formed "vigilance committees." Violent altercations between Anglo-Americans, Mexicans, and the indigenous population occurred frequently. In cases where an Anglo-American perished and residents suspected a Mexican, retribution against all Spanish-speaking people occurred swiftly.[74] Vigilantes seldom distinguished between Mexicans who were guilty and those who were innocent. In their zeal for revenge, most believed that "any Mexican will do, sometime they kill the first Mexican they see."[75]

Conditions for Mexicans in Arizona worsened in the wake of an unsuccessful American filibuster attempt into Sonora. In 1856 filibuster forces led by Henry Crabbs invaded Sonora, but the Mexicans defeated Crabbs and his troops at Caborca. Newspapers throughout the United States Southwest published sensational accounts about Crabbs' beheading and the execution of his men The reports, according to Mowry, generated "a desire for revenge" among the Anglo Americans in Arizona and California. He indicated that "[C]ompanies have been formed, and large parties are settling in Arizona near the Mexican line with the ulterior objective of overrunning Sonora and revenging the tragedy in which was shed some of the best blood of the state."[76] In light of further border threats, Governor Pesqueira formally embargoed all trade into Arizona from Sonora. Contraband nonetheless continued flowing north. After 1860, U. S. authorities attempted to reestablish commerce with Mexico by entering into a formal agreement with Governor Pesqueira. The governor acquiesced, but in order to maintain strict controls over the trade, he set limits on which routes merchants could follow.

Relations between Americans and Sonorenses deteriorated with both sides suffering heavy casualties. The *Weekly Arizonian* presented its own views for dealing with Mexicans. After recounting the theft of a horse at the Sopori ranch by an unknown Mexican, it proposed that "if citizens would adopt the plan of shooting on sight all strangers and suspicious Mexicans found lurking about their premises it would doubtless have a salutary effect."[77] Other newspapers, such as the *Arizona Citizen* and the *Arizona Miner,* also antagonized relations with Mexicans by mocking immigrants and their culture. Politicians continued to express concern over the growing number of Mexicans in Arizona and worried that the large Mexican population might hinder the territory's ability to acquire statehood. On their part, Mexicans feared a repeat of

the earlier California lynchings, and some Sonoran newspapers even urged their compatriots to abandon the territory. Alexander Willard, the influential United States consul in Guaymas, publicly condemned the treatment that Mexicans received in southern Arizona.[78]

Mexicans in Tucson also expressed concern over the treatment of their fellow citizens. Carlos I. Velasco, a recent immigrant who became a prominent Tucson Sonoran, reminded Anglo-Americans in Arizona that without Mexican labor, the state would not prosper. The future of two states, he argued, remained intricately linked. In a defiant letter to the *Arizona Miner* (Prescott), he wrote, "tied to us, you shall march with us."[79] Acrimonious racial attitudes of this sort eventually took their toll on mining and commerce. Despite Poston's efforts to make amends, conditions deteriorated to the point that "Americans [were] afraid to venture into Sonora for supplies and Mexicans [were] afraid to venture over the line. Americans who had nothing to do with the filibustering invasion have been treated badly in Sonora and driven out of the country, and Mexicans coming into the purchase with supplies and animals have been robbed and plundered by the returned filibusters."[80] No force appeared capable of uniformly and equitably administering justice. A vicious cycle of violence continued to grip the area. Still, facing little opportunity and raids by Apaches, Sonorans continued to trickle north to work in the new Arizona mines.

Various indigenous groups that lived in southern Arizona also felt the brunt of the rapid changes occurring in the area. Clashes between Apaches, Mexicans, and Anglo-Americans took place regularly, and retribution occurred swiftly whenever disputes erupted with the native population. In one case, authorities mistakenly presumed that Apaches had taken the child of a Mexican and American and decided to raid their village.[81] In retribution for the raid, the Apaches killed several American prisoners, and in retaliation the United States forces hung five indigenous leaders. This cycle of violence and mistrust seemed, at times, impossible to break.

Besides oppressive labor conditions, dissimilar cultural norms further exacerbated differences between Anglo-Americans, the indigenous population, and Mexicans. As hostility increased, even the mission of San Xavier del Bac became the butt of "anti-Catholic frontiersmen." Some Anglo-Americans used the statues which adorned the entrance of the mission for target practice.[82] In southern Arizona, several different worldviews clashed as traditional Mexican and indigenous customs confronted a new Anglo-American system of conduct. These differences

became especially evident in attitudes toward work.[83] Mexicans regularly suspended mining operations to attend religious or cultural festivals. Even though they toiled in the Santa Cruz Valley, most still had roots in northern Sonora. They made it a practice, for example, to attend religious and social festivities for Saint Francis, the patron saint of Magdalena. Others attended the festival of Saint Augustine in Tucson. Heintzelman and other Anglo-Americans did not comprehend the importance that these festivities held for the culture of the region.

Eventually, two approaches for dealing with the Mexicans emerged among Anglo-American elites. One, exemplified by Poston, sought coexistence with the established culture and practices of the area. The other, expressed by Heintzelman and Mowry, rejected Mexican culture as inferior and sought to impose new Anglo-American values and their own work ethic. In fact Heintzelman even took to criticizing Poston for attending Mexican celebrations. As the festivities of Saint Francis drew near he complained, "Mr. Poston, Huselman, and Henry our driver and José our servant all leave on the 1st of October for Magdalena to attend the fiesta like a pack of children . . . They will go and all our operations are suspended."[84] Heintzelman's disappointment must have increased when workers at his Cerro Colorado mine also left to attend the festivities. Racial hostilities heightened as some Anglo mining operators labeled Mexicans as indolent, shiftless, and untrustworthy. Conflicting cultural values served to heighten antagonism.

Mexicans did not have a uniform view of Americans. Still reeling from the bitter experiences of Sonorans in California, from the loss of the Mesilla, and from recent American invasions of Sonora, government officials appeared cool toward the Anglo-Americans.[85] The state press and government communications described the bands of Americans along the border and in Sonora as uneducated and uncultured "cowboys" or *tejanos* [Texans]. These labels gained widespread acceptance among the population, yet they never led to racial or cultural discrimination against Anglo-Americans. In practice, the Sonoran government promoted trade with Arizona, welcomed American investors, and facilitated the acquisition of mines in the state. Moreover, the growing body of Sonoran merchants and landed interests who benefited from increased trade with the Americans also lobbied on their behalf.

The outbreak of the American Civil War and Apache raids finally ended the first Anglo-American efforts to settle southern Arizona and the border region.[86] In 1861 the United States military troops, who had imposed a fragile peace in the area, pulled out. Americans learned the

bitter lesson that residents of northern Sonora had known all along. Without a strong military presence, the Sonoran frontier could not be safely settled. Apache raids on mining settlements increased, and many people perished. Even Donalson, the American customs officer at Cala-bazas, fell victim to an Apache arrow.[87] Poston and his associates aban-doned their operations at Tubac, moving temporarily to California. Other Americans sought refuge by resettling in the old presidio of Tuc-son, thus aggravating relations between Mexicans and Americans. Dur-ing a visit to the place, Ross Browne observed that "if the world were searched over I suppose there could not be found so degraded a set of villains as then formed the principal society of Tucson. Every man went armed to the teeth; and street fighting and bloody affrays were a daily occurrence."[88] While Mexican and Anglo-American notables there reached a certain level of accommodation, this attitude seldom trickled down to the remainder of the population.

In the wake of their departure, Americans left behind a wide assort-ment of mining equipment which had been brought at great ex-pense from Guaymas and overland from Texas. Mexican bandoleros joined in and raided the forsaken mining camps, taking south with them heavy machines and other equipment. The American mining camps and ranches near the border ended in dismal failure. Lawlessness increasingly became the norm in the region, and the Apaches temporar-ily regained de facto control over much of southern Arizona.[89]

As mining in southern Arizona declined, most Anglo-Americans turned their attention to the Gila River basin, where gold deposits had been discovered, or to "safer" northern mining settlements, such as Prescott and Wickenburg. As news of gold along the Gila spread, Mexi-cans joined in the movement toward the river, becoming miners in their own right. Violence between Mexicans, Apaches, Tohono O'odhams, and Anglo-Americans continued to be a feature of life long the Gila. Sonoran newspapers kept a running account of the difficulties that Mexicans confronted in the area. The death in 1872 of Francisco Gán-dara especially outraged many Sonorans. The Sonoran press claimed that Gándara had been executed in reprisal for the disappearance of William McFarland,[90] who had been romantically linked with a young Mexican woman who lived in Gándara's household. No evidence ex-isted to implicate Gándara in the McFarland affair. Nonetheless, an armed group of Anglo vigilantes descended on his house and shot him in front of his wife and children, not leaving until they had stolen Gán-dara's valuables.[91] After his death, several fatal clashes erupted between

Mexicans and Americans in towns in the area. The pattern of racial violence which had held sway in the Santa Cruz Valley, shifted north and reoccurred along the Gila.

A NEW BORDER REALITY

By the 1860s, relations between Sonora and Arizona had improved sufficiently to merit a stagecoach line between Hermosillo and Tucson.[92] Coindreau, an early promoter of free trade, acquired the concession for the Tucson route in November 1860. The three stagecoaches and all the necessary equipment to initiate service between Hermosillo and Tucson arrived at Guaymas from San Francisco.[93] Within a few years, additional lines provided service from Hermosillo to Tucson by way of Sasabe and Altar.[94] Speculators openly competed to win the government contract and establish a line north to the United States. Sonoran authorities, however, had less success in developing stage service south from Guaymas to the important mining district of Alamos. Despite offering liberal subsidies, operators remained uninterested in southern routes, claiming that hostile Yaquis and Mayos would not permit travel through their valleys. To the north, economic advantages outweighed the possible risks presented by Apache or bandoleros.

Sonorans had to adapt to the growing presence of foreigners living in their midst, especially those who came to stake out mines. As Ross Browne noted, with "every steamer from San Francisco that lands at Mazatlán and Guaymas from 100 to 200 passengers, many of them disappointed in more northern regions, desire to establish themselves in the rich mineral fields of the south."[95] Although these early miners remained few in number, they made their presence felt in Sonora. Reports from the United States consul in Sonora reflected their growing importance. Farrelly Alden, the United States consul in Guaymas in 1860, indicated that the "foreign element is steadily increasing and I am confident of soon seeing here a sufficient number of foreigners to be able to command peace and consequently prosperity."[96] Consul Alden indicated that in the first few months of 1860, 874 passengers had arrived by steamer from San Francisco, and of these, 512 departed while 362 remained. Alden appeared encouraged by the number of foreigners he daily met in Guaymas, pointing out that "throughout the whole state they [foreigners] are to be found in considerable numbers."[97] Invariably, the number of Americans fluctuated considerably—in times of crisis or

wars with the Yaquis it dwindled. Although constituting a small percentage of the overall population, foreigner investors enjoyed a considerable amount of influence in proportion to their actual numbers.

The American presence, however small, changed the relationship between Sonora and central Mexico. In 1856, residents of Ures, requested that federal authorities earmark the money received from the United States government for the sale of the Mesilla for "the military defense of the border." According to them, Mexico should use the money to fortify the border not only against Apaches but also against American incursions "that appeared from the North."[98] The growing importance of the international border allowed Sonorans to request special treatment from the Mexican government. On more than one occasion, local officials reminded the federal government of Sonora's strategic position for Mexico. In an 1855 communiqué to the federal government, the governor of Sonora, Manuel Gándara, urged that in "elaborating national policy, Mexico City must view Sonora differently than it does central states. The policies for the populous states of Puebla and Mexico could not be applied to Sonora."[99] He warned the national government not to view Sonora as simply another state, "but rather as the gateway to the republic and the bulwark of Mexican nationalism." Gándara's declaration bore testament to Sonora's gradual transformation from an internal frontier to an international border.

The loss of the Mesilla after 1853 altered the character of Sonora's northern border. It changed from a desolate frontier dominated by Apaches to a border between distinct cultures, reflecting a different "psychological, social and cultural order."[100] Despite environmental similarities, differences between Arizona and Sonora became palpable for both Mexicans and Anglos. After crossing a border marker erected near Los Nogales, John Hall, reflected that "for the first time in many years I found myself again on soil belonging to the Anglo-Saxon race, I even imagined that I felt a difference in the atmosphere—it must have been imagination; it could not have been anything else."[101] Crossing the border had acquired a symbolic meaning for Mexicans and Anglos. Beyond a political delineation, the actual border now demarcated different ways of life.

The first sustained contact with Americans left many Sonorans with a sense of ambivalence. A small number of ranchers and merchants benefited from increased trade with Americans and were unaffected by limited smuggling occurring in the north. The ethnic violence and con-

flict along the border did not pervade the entire state since most Sono-
rans remained disassociated from events occurring in the desolate
north. The initial contact between both cultures had involved only a
relatively limited number of people. Insulated from these incidents,
elites continued to promote the need for interaction with their new
northern neighbors.

Sonora and Arizona

"A New Border Empire"

After 1870, the socioeconomic integration of Arizona and Sonora intensified and became asymmetrical. Rather than passively await developments in the north, Sonoran merchants became active participants in the process of change. They recognized the important developments occurring in Arizona, especially the arrival of a railroad to the American territory. To compensate, Mexican business interests lessened their reliance on their traditional European trading partners and began cementing linkages with their new American suppliers. Despite this increased economic interaction, most Sonorans and Anglo-Americans still viewed each other with apprehension. Repeated incidents of racially motivated violence against Mexicans continued to mar relations; yet, increased contact also produced other unexpected outcomes. For Sonorans living near the border or those forced to emigrate north, expanded relations invariably influenced their culture and identity.

At the conclusion of the U.S. Civil War, Sonorans confronted a different type of American. Although Arizona still continued to attract its share of "ruffians and cutthroats from all parts of the union,"[1] outlaws had not been the only group to take notice of developments along the Arizona-Sonora border. Since the late 1850s, numerous publications and newspapers promoting Sonora's mineral riches circulated throughout the United States and Europe.[2] As opportunities in California diminished, a growing number of Americans chose to relocate to Arizona and Sonora as news of a "new border empire, of untold mineral treasure,

vast grazing ranges bathed in sunshine and a new frontier to develop"
spread throughout the United States. A miner by trade, Robert Ekey, for
example, decided to settle in the area when news of the "opening of a
border empire along the Mexican-Arizona border reached California."[3]
For Americans such as John Matthews, a railroad employee, Sonora be-
came the land of opportunity, "such as exist[s] nowhere in the United
States nowadays."[4]

The appearance of foreign capital and miners had an unexpected re-
sult for the Mexican north. Investments by foreigners in Sonora served
to deter further attempts at outright annexation by filibusters from the
United States. Americans and Europeans acquired a vested interest in
maintaining an independent Mexico which allowed them liberal land
concessions and tax exemptions to exploit minerals. The movement of
foreign capital into the region deterred the plans of Americans who
hoped to annex the Mexican northwest. Writing in the 1870s, Leonidas
Hamilton echoed these sentiments when he warned annexationists that
beside Mexican patriotism, they would confront "capitalists who reside
in the United States and Europe [and] who have invested in mines and
lands in Mexico . . . since their property under the laws of Mexico es-
capes free of taxation."[5] The material benefits foreign investors derived
from an independent yet compliant Mexico helped dissuade future an-
nexationists.

Responding to the growing importance of ties between Sonora and
Arizona, residents of the state petitioned the federal government in
1873 to open a Mexican consular office in Tucson. In addition to
the increased commerce between the states, they argued that Tucson
needed a consular office to protect the "large number of Sonorans who
are daily emigrating to Arizona in search of work. The mistreatment
they confront in Arizona makes it necessary for Mexico to have a con-
sul in that territory."[6] Mexicans had gradually spread throughout most
of southern Arizona, especially to the new boom towns such as Tomb-
stone where they composed the backbone of the labor force. Reports in
the New York Times expressed alarm at the growing numbers of Mexi-
cans in the region.[7] Pressured by Mexican immigrants in the north and
by Sonoran merchants eager to protect their expanding commerce with
the region, the federal government established a consular office in Tuc-
son. The new consul, D. Velasco, tried to regulate contact between the
two states, requiring all those engaged in trade with Sonora to register
with his office.[8]

IMMIGRATION AND RACE

The flow of Sonorans to Arizona continued unabated during the 1870s. Political instability and continued wars with the Apaches remained the principal reasons people migrated.[9] Despite their growing numbers, conditions for Mexicans did not dramatically improve. Racist attitudes toward Mexicans persisted, and American bandits continued to harass Mexicans in both Arizona and Sonora. During 1872 and 1873, several Mexicans had been lynched by Anglo-Americans in Tucson.[10] Mexicans in Tombstone complained that they had been persecuted by a group of American "cowboys."[11] Tejanos had also robbed a groups of Mexicans from Babispe of 2,500 pesos as they traveled north toward Tucson.[12] Random violence by "cowboys" against Mexicans occurred frequently. When Francisco Jiménez, a mescal distiller from Magdalena, informed authorities that his son had not returned from a delivery to the American side, a search party found the youngster hung from a tree. A subsequent investigation determined that the boy had delivered the mescal to a party of Americans, who after getting drunk, decided to lynch him.[13]

Mexican bandoleros who robbed stagecoaches and travelers also heightened tensions. Important differences existed between how the Anglo population reacted to the behavior of the American cowboys and the actions of Mexican bandits. Attacks by Anglo-American cowboys against Mexicans seldom generated much public outcry. Violence connected with Sonoran bandits, however, typically ignited racist sentiments against all Mexican people. Two such cases involved the death of several well-known Californians and the holdup of the Maricopa stagecoach by several Mexicans. In response to the events, Anglo-Americans in Tucson formed a secret vigilante committee, calling themselves the "minute men." A local Tucson paper, the *Arizona Star,* inflamed matters, urging the group to take immediate action and lynch the guilty party from the nearest tree. The Mexican consul at Tucson, Manuel Escalante, feared that the vigilantes would take reprisal against all Sonorans. He wrote to the Mexican foreign office that the "minute men," which in years prior had lynched several Mexicans in Tucson, again threatened the community with similar action. He urged the foreign office to contact Washington, since according to Escalante, the local police did nothing.[14] As the number of attacks on Mexicans increased, Sonoran authorities requested the intervention of the Arizona govern-

ment. John J. Gosper, the acting territorial governor of Arizona, promised to increase American supervision in the area, yet very little actually changed.

As the Sonoran population in Arizona experienced reproach by the Anglo community, for some people, Mexican culture assumed a greater importance. Tucson newspapers such as *Las Dos Republicas* and the *Fronterizo* exhorted Mexicans not to abandon their past traditions. Writing in *Las Dos Republicas* in July 1877, one author addressed the issue of cultural preservation as a matter of extreme urgency and advised Sonorans to abandon any dreams of physically recapturing their "lost land." Mexico, the writer insisted, could not militarily defeat the United States. Mexicans, he argued, confronted a cultural, not a military struggle with the United States. In this contest, Mexican culture would eventually overwhelm the "Anglo-Saxon." Mexicans in Arizona, according to the author, confronted a two-fold challenge: "[O]ne is moral and the other physical. One is for our customs, the other is for our existence. . . . Our customs, our faith, our language, . . . these are the weapons which the Latino has at his disposal to defeat the Saxon."[15]

Exclusion from Anglo society, the influx of immigrants, and continued social and economic relations with Mexico reinforced the value of previous traditions. Despite such fervent exhortations, most Mexicans did not see their situation in Arizona as a battle of cultures. Over time, Sonorans adjusted to the growing American presence in Tucson, incorporating the English language while retaining many of the customs of their previous country. Most continued to function in two environments, influencing events in southern Arizona as well as in their native Sonora.

SONORENSES AMERICANIZADOS

In contrast to earlier years, when seasonal immigration patterns dominated, Mexicans now settled permanently in Arizona, and some became American citizens. The *Arizona Daily Star* urged that Mexican immigrants be forced to undergo a five-year probationary period before being allowed citizenship.[16] Sonoran government officials expressed outrage over what they perceived as an act of desertion by their fellow countrymen. This increasing out-migration became a source of embarrassment to state officials. To retaliate against the so-called *sonorenses americanizados* (Americanized Sonorans), in 1874 the state's official

newspaper, *La Estrella de Occidente,* published a list of those individuals who had changed their nationality.[17]

Mexican and American objections did not influence Sonorans confronting hardships in the desolate north. Neither government regulations nor cultural constraints prevented them from migrating or even becoming United States citizens since naturalization required little effort. More importantly, for a Mexican to become an American citizen in Tucson or southern Arizona did not imply a dramatic change in their lifestyle or culture. Sonorans constituted the majority of the population throughout the region, and their culture pervaded the social organization of life in most areas. Dependence on Sonorans for trade allowed Mexicans to play important roles in the commerce of the area.[18] Cities like Tucson retained a strong Sonoran character, and their culture continued to be validated through existing institutions and by a host of public celebrations. In fact, outsiders often described Tucson as a Mexican city on American soil. In 1891 the *San Francisco Chronicle* insisted that Tucson was a "decidedly foreign town, foreign in its looks, in its habits, its population, . . . it is no more American than the northwest provinces of British India is European."[19] By becoming citizens, Sonorans in southern Arizona did not relinquish their culture, but rather sought to enhance the advantages of living near the border.[20]

It did not take long for astute American politicians in Tucson to capitalize on the growing numbers of sonorenses americanizados in order to get elected. Unfamiliar with the political process and swayed by a host of promises, some Mexicans changed their nationality in order to vote in local elections. *El Fronterizo,* Tucson's leading Spanish-language newspaper, blasted Mexicans who allowed their vote to be used by Anglo politicians.[21] Their critique of recent immigrants recognized the growing stream of Mexicans opting to settle in Arizona. The newspaper's editors understood the factors that compelled hundreds of Sonorans to migrate. But Carlos Velasco and other leaders of the Mexican community objected to the manner in which electoral agents had taken Mexicans "like a flock of sheep to the local court to become citizens on the eve of an elections . . . disgracing all Mexicans living in the United States."[22] Active in local politics, Velasco preferred to see Mexicans vote as a block in order to obtain concessions from the local Anglo power structure. *El Fronterizo's* public endorsement of American candidates underscored this point. In order to punish the sonorense americanizados, Velasco, the editor of *El Fronterizo,* reported their names to Sonoran officials. Government offices in Sonora received instructions to

treat as foreigners any Mexicans who had acquired United States citizenship.

The measures taken by the Sonoran government to curtail the activity of Americanized Sonorans indicated that most of the latter continued to retain strong ties in Mexico. For example, Ramón Araiza, a rancher, maintained a residence in Sasabe, Sonora, and one in Sasabe, Arizona. What's more, according to officials, Araiza had taken the liberty of moving the United States-Mexico border marker to ensure that one part of his ranch would be in Mexico and the other in the United States. Sonoran authorities repeatedly accused him of smuggling. Francisco Prieto, the Mexican consul at Tucson, claimed that many Sonorans, such as Araiza, became Americans in order acquire rights in the United States and, if necessary, avoid persecution in Mexico. He wrote to Porfirio Díaz in 1879 that nationality along the border had become "ambiguous since individuals opted for which ever one proved convenient at a given moment."[23]

Economic opportunity redefined traditional concepts of identity. In the vicinity of the border town of Saric, Antonio Burruel, a Mexican who now claimed to be American citizen, operated a mine in Sonoran territory. Trinidad Padilla, the legal owner of the Tres Bellotas ranch, demanded that the government take action to protect his property against the new Americanized Sonorans. Padilla alleged that Burruel had fenced in his (Padilla's) property, claiming that the land belonged to the United States.[24] Confronting a host of similar border problems, Luis Torres, governor of Sonora, pleaded with the federal government to demarcate clearly the limits between both countries. He warned that unless the federal government took immediate action to resolve this issue, difficulties along the border would be interminable, and "small altercations could escalate into international conflicts."[25] Clear demarcations of the border would not, however, resolve the murky issue of persons who now claimed dual citizenship.

Most Sonorans eventually accepted the sonorenses americanizados as assets and not as traitors.[26] With limited resources, prefects of northern Sonora often requested economic assistance from their countrymen in Arizona. For example, when in 1879 the prefect of Altar needed funds to pay his district's share of the federal debt, he sought contributions from among the Mexican residents of Tucson.[27] State leaders, like Governor Francisco Serna, also viewed the sonorenses americanizados as important allies. Like a host of Sonoran politicians before him, Serna

sought refuge in Tucson during periods of political turmoil, becoming familiar with the old town and its inhabitants.[28] When the federal government in 1879 warned Serna about possible attacks by American filibusters, he dismissed the idea, indicating that the state had nothing to fear from Arizona because "Sonorans comprised the majority of Arizona's population. They are true patriots, who appreciate the honor and dignity of Mexico, more so than many Mexicans who live in their own nation."[29] He assured the federal government that if Americans invaded the state, Sonorans living in Arizona would sound the alarm and take up arms against any intruders.

Mexicans living in Tucson actively participated in the social and political life of Sonora. *Las Dos Republicas, La Sonora,* and the *Fronterizo* kept them abreast of politics in Sonora, and many Mexicans supported political candidates in their native state by writing letters or donating money. In 1878 Tucson's Mexicans, for example, fomented opposition against the interim governor Vicente Mariscal, blaming him for the ills of the border area.[30] Leading Sonorans in Tucson became de facto ambassadors of the state, acting as intermediaries in government, commerce, mining, and agriculture. They also helped Americans establish good relations with the Sonoran government. After the ouster of Ignacio Pesqueira, General Mariscal, the interim governor, invited Leopoldo Carrillo, a leading Mexican businessman in Tucson, to Sonora. Upon his return, Carrillo arranged an invitation from the Tucson city council for Mariscal to visit the American town.[31] In Tucson, influential Sonorans, such as Carlos Velasco, F. T. Davila, and others, formed the nucleus of future Mexican political organizations in Arizona, for example, La Alianza Hispano-Americana.[32] These individuals also used their extensive connections in Sonora to advance their economic interests in Arizona.

PSEUDO-MEXICANS

Sonorans were not the only people altering their nationality to take advantage of opportunities along the border. Since Mexico prohibited foreigners from owning land in the proximity of the border, Mexican citizenship acquired new value. Foreigners developed several ways to circumvent the issue of citizenship. They entered into covert agreements with Mexican partners who functioned as *presta nombres* ("name lenders") for the foreigners investing in Mexico. When in 1830 Cyprien

Combier considered investing in Minas Prietas, a mining area east of
Hermosillo, his partner, Jean (Juan) Camou offered to become a Mexi-
can citizen in order to acquire title to the property.[33] Those unwillingly
to enter into such an arrangement opted to simply become Mexican citi-
zens. Foreigners acquired Mexican citizenship in order to assume ad-
ministrative posts and to participate in commercial ventures. In 1860
C. J. Smith, an American ship captain from San Francisco, requested
Mexican citizenship in order to operate freely out of the port of Guay-
mas.[34] Enrique Spence and Thomas Farell also sought citizenship in
order to acquire title to several mines. German and British citizens
frequently changed their nationality to benefit from commerce in
Mexico.[35]

Despite the opposition of some local officials, these "foreign Mexi-
cans" secured land and even acquired government positions. Once ob-
taining title to mines, foreigners usually sought local government posi-
tions in order to protect their investments. The prefect of Guaymas,
Wenceslao Martínez, complained that a German had become *comisario*
at the Chiponeña mine. Despite the German's claim of Mexican citizen-
ship, Martínez believed that the state should reserve government posi-
tions for only native-born Sonorans.[36] Eager to attract foreign capital,
state officials continued granting requests by foreigners.

By the late 1870s, the Mexican federal government expressed alarm
at the number of foreigners changing their citizenship in the northwest.
They viewed the Americans acquiring citizenship along the border, or
"pseudomexicans," as one political figure labeled them, with growing
concern. Their presence according to C. Treviño, a customs officer,
made a mockery of Mexican citizenship and prevented legitimate resi-
dents from acquiring valuable lands.[37] To remedy the growing prob-
lems, state officials were instructed to forward all citizenship requests
to Mexico City for formal review. Although the process now required
federal approval, the practice did not cease. To improve their economic
standing, Americans continued to become Mexican citizens. Sonoran
officials wrote glowing letters of recommendation to Mexico City to
expedite these applications. Others simply requested and received spe-
cial exemptions from the Mexican government in order to own acquire
property in the "prohibited zone." Several influential businessmen, such
as Luis Proto, Leon Horvilleur, and Arthur Roas, obtained special dis-
pensation to own land along the border in what became Nogales and
Agua Prieta.[38]

INDIGENOUS POPULATIONS

Beside affecting Mexicans and Anglos, border relations also had an impact upon the region's indigenous populations. For these people, the presence of a border exacerbated old problems and gave rise to a host of new challenges. Traditionally, the Yuma, Gila, Maricopa, and Tohono O'odham peoples migrated regularly between Sonora, Arizona, and even Baja California to celebrate festivities or during specific seasons of the year. Other groups, such as the O'odhams, had settlements in both Sonora and Arizona. The location of the border divided indigenous peoples, formally establishing some as Mexicans and others as Americans.[39]

Neither Mexico or the United States appeared concerned by the plight of the indigenous, forcing each group to fend for itself. Still, the border provided some with the opportunity to mitigate their situation and seek better treatment.[40] Dissatisfied with their experiences under the United States government, a leader of the Maricopa, Juan Moreno, sought permission from the governor of Sonora for his group to resettle in Mexico. Moreno recounted the condition the Maricopa faced in the United States, complaining that the "Americans had taken their animals and lands . . . depriving them of a livelihood."[41] Citing the usual lack of resources, the Sonoran state authorities, who simply did not consider resettling Maricopas a priority, rejected Moreno's request.

Indigenous groups in Sonora also used the border to improve opportunities or to escape ruthless prosecution. Displaced by Sonoran cattle interests bent on monopolizing land in the north and by aggressive government campaigns, large numbers of Tohono O'odhams and Yaquis resettled in southern Arizona during the 1870s.[42] O'odham communities in southern Arizona absorbed most of the new immigrants. Mexican campaigns against the Yaquis continued unabated during the Porfiriato, forcing countless numbers to migrate to avoid persecution. As the numbers of Yaquis swelled, they eventually formed their own separate and distinctive communities in Arizona.

UNDEFINED BORDER

Indigenous peoples were not the only group to be displaced by the border. The uncertainty regarding the exact location of the border placed several ranches which straddled the United States and Mexico in a pe-

culiar predicament. William S. Sturges owned the old rancho Ortiz, whose confines encompassed both countries. As a result, he paid taxes on one part of his ranch in Tucson and assessments on the Mexican part in Altar. Mexicans officials wanted him also to pay duties on goods he brought onto the property from the American side. Likewise, American officials informed him that he would be expected to pay tariffs on any goods brought in on the Mexican side. Sturges wrote to the administrator of the aduana, insisting that he found himself surrounded by "two fires."[43] Two years earlier, Fernando Ortiz, the previous owner of the ranch, had been arrested by American officials for paying taxes in Mexico and not in Arizona.[44] To appease Mexican officials, who had contemplated building a customshouse on the border, Sturges offered to donate part of his property. State officials deferred judgment and forwarded the matter to Mexico City. In the meantime, the administrator of the Sasabe aduana, Ramón Gaxiola, agreed to simply record the goods that Sturges used on his ranch and delay payment until Mexico City and the United States government decided the issue. Confronted by long delays from the federal government, Sonoran officials usually sought local solutions to complicated international matters.

A NEW REGIONAL ECONOMY

Population growth in the Arizona Territory had a commensurate effect on agricultural production and trade in northern Sonora. For years, agriculture in the area had been limited by Apache raids and a scant and dispersed population.[45] Merchants in the area protested that their trade caravans could not travel without the protection of an armed escort. Payment of guards increased the price of their goods, cutting into their limited profits.[46] The resident of the villa de Altar proposed that they be allowed to ship their goods by sea to Guaymas in order to avoid Apache raids. After four years of deliberations, the Mexican government allowed commercial shipping from Ensenada de los Lobos in the district of Altar.

After the Civil War, the return of the United States cavalry to Arizona made travel through the American territory somewhat safer. During this period, the population growth throughout southern Arizona produced a discernible effect on Sonora. In his quarterly report, the district prefect of Altar described this change: "[F]or many years the towns of the district have been reduced to cultivating only small portions of land in order to meet the needs of its inhabitants. Arizona changed

these conditions for the farmer, . . . providing reasonable prices for their agricultural products."[47] With new markets in Arizona, agricultural production, especially that of wheat, increased throughout northern Sonora. Both large and small ranches placed greater amounts of acreage under cultivation. Flour mills in the proximity of the border, especially those in the district of Magdalena, also expanded production. Not all land owners fared equally. By controlling the refining process, mill operators, such as José Pierson, at Terrenate, could set prices and monopolize output. Terrenate regularly dispatched caravans loaded with flour north to Tucson.[48] In turn, Pierson established lucrative partnerships with American agents, such as L. M. Jacobs and Company, who sold his products throughout Arizona. The Sonoran Pierson became well known within Tucson social circle, and the American press reported on his activity.[49]

Caravans with as many as seventy or eighty mules made the trek from the flour mills of the northern districts to Tucson. In addition to wheat, according to *La Reconstrucción,* an Hermosillo newspaper, teamsters traveled to Arizona with a wide array of products such as "beans, chile, *panocha,* straw hats, *petates,* soap, dried and fresh fruits, oil as well as mescal. Adolphe Bandelier, a French traveler, reported seeing caravans with dozens of horses, mules, and wagons loaded with products destined for Arizona.[50] In his 1873 report, U.S. consul A. Willard indicated that Mexicans dominated the agricultural trade between Sonora and Arizona.[51]

Northern Sonoran agriculture became increasingly dependent on markets in southern Arizona. This relationship also implied that the region's production became vulnerable to shifts in the Arizona economy over which Mexicans had little control. Although district prefects in the region expressed optimism over new opportunities in Arizona, they also warned of the danger of relying exclusively on exports. Earlier experiences with the sale of wheat to Sinaloa alerted them to the risks of relying on one market. Whenever the price of grain and flour dropped in Arizona, farmers in northern Sonora suffered the consequences.[52] Authorities at Magdalena and Altar argued that market fluctuations prevented farmers from effectively planning yields. Eager to increase profits, many had invested heavily and expanded production only to see prices drop as supply increased. The prefect of Altar also blamed the large number of Sonorans in Arizona who farmed in the Santa Cruz Valley for undercutting the production of wheat in the northern districts of Sonora.[53]

Despite these obstacles, new markets in the north elated large land-owners. Since mill operators and agricultural brokers stood to make a greater profit from exporting wheat, many sought to monopolize local production. As a consequence, many areas in the state actually experienced occasional grain shortages. In May of 1864, at the height of the harvest season, the district prefect of Magdalena complained about the scarcity of wheat. According to him, although other grains remained in abundant supply, "wheat was scarce in the district because of its export to other Mexican states and abroad."[54] Most of the grain in Magdalena had been shipped north to Tucson, where producers obtained a higher price than by selling it to the local inhabitants.

Conditions such as those present in Magdalena could be found throughout the state. The powerful merchants of Guaymas and Hermosillo openly speculated on the price of wheat, buying all the flour ground by local mills in an attempt to monopolize this export product and increase prices. In Sonora, the breadbasket of the northwest, urban dwellers often had difficulty finding wheat—one newspaper reported that whereas bakeries and local stores lacked flour, merchants maintained large supplies of grain stored in warehouses and earmarked for export.[55] These speculators either refused to sell the wheat locally or sold it at such prohibitive prices that the population could not afford to purchase the product. In April 1878 a crowd of angry Guaymenses stormed the city council chambers and demanded an immediate end to all exports of wheat and flour until local demand was met. Council members (regidores) agreed that shortages resulted from "the considerable export of wheat that occurs through the port of Guaymas to other Mexican states."[56] The regidores convened a meeting of the city's most prominent merchants, including Juan P. Camou, Juan Möller, and Adolfo Bülle. Each merchant agreed to contribute a certain percentage of his wheat supplies to a store run by the municipio in an effort to appease the populace and forestall the demands for full-scale restriction on exports. Many residents, however, complained that the "establishment of a bakery and butcher shop run by the city would not remedy the situation of the overwhelming majority of the populace which suffers from the lack of wheat and, above all, the prices being charged for basic products."[57] Despite the protest, the city-operated store, which resembled the colonial alhóndigas (grain storage facilities), calmed most dissent.

These measures, however, proved only a temporary solution. Occasional droughts and continued speculation by merchants worsened the

grain crisis in Sonora. As exports increased in the late nineteenth century, most of the region still suffered from lack of wheat. In 1880 General José G. Carbó, military commander of the northwest, complained to Porfirio Díaz that flour continued to be scarce in the region.[58] To compensate for the lack of grain, the federal government, still weary about unstable political conditions in the northwest, permitted wheat from the United States to enter Mexico without paying taxes.[59]

Despite the bitter experience with wheat shortages, merchants continued to speculate with the product. In a letter to his uncle, Juan P. M. Camou indicated that no flour existed in Hermosillo since a broker, "Carmelo Echeverria had just purchased the entire stock."[60] As a result, the price of common wheat had jumped dramatically. The Camous, however, employed the same tactics as their competitors to inflate the price of flour. As the cost of wheat increased it became more difficult to monopolize production and still make a profit. Hoping to dissuade his uncle from trying to corner the local wheat market, Juan P. M. Camou insisted that the "millers will not sell you all their stock when they know that you are trying to raise the price."[61] The argument appeared to discourage the older Camou. As Sonoran merchants fought among themselves to control wheat production, San Francisco interests, such as the Stockton Milling Company, took advantage of the shortage caused by speculation and penetrated the local market selling at lower prices.[62]

THE POROUS BORDER

Besides stimulating agriculture in northern Sonora, the increased population in Arizona also attracted the attention of California business interests. San Francisco merchants dispatched ships up the Gulf of California to the mouth of the Colorado River and from there by flat-bottom steamers up to Yuma.[63] From there, mule trains followed the Gila River into central Arizona, distributing products to old and new population centers. For trade caravans destined for southern Arizona, however, this route remained time-consuming and costly. As the military had learned earlier, the Guaymas route provided quicker access to southern Arizona. As late as 1875, United States troops destined for forts in southern Arizona still landed at Guaymas. In August of that year, the *Montana* docked at the port with thirty American soldiers en route to Arizona.[64]

Since the establishment of the first Anglo settlement in southern Ari-

zona, United States and Sonoran merchants had supported the use of Mexican ports to supply the territory.[65] On sporadic occasions between the late 1850s and the 1870s, the Sonoran government allowed goods from the United States to travel in transit through the state. During such times, the American and Mexican merchants of Tucson, according to consul A. F. Garrison quickly availed "themselves of this privilege," and mule trains made the trek successfully.[66] This commerce proved significant for Arizona's early development. Mexican freighters, as Henry Pickering Walker points out, could haul "four thousand pound loads with an eight-mule team."[67] Products carried in transit included basic items such as rope, wire, and tools, as well as luxury goods. One shipment received in 1872 by the Jacobs brothers of Tucson consisted of a bed and mattress, "one sofa, eleven chairs, one 'Bereaux' with marble top, one washstand with marble top and a towel rack."[68] Consul Willard estimated that in 1870 between one-half and three-quarters of a million dollars worth of goods passed through Sonora in transit to Arizona and southwestern New Mexico.[69]

Treaties governing the transit of goods proved problematic. Disagreements over storage charges, duties, and suspicious manifests occurred frequently. Irate local officials insisted that merchants simply padded orders and reclassified their products as goods in transit to evade municipal taxes.[70] The house of Bülle and Sandoval in 1873 ordered 20,000 pounds of sugar from Tepic for C. F. Hayden of Arizona. The prefect of Guaymas sought to make an example of Bülle and Sandoval and insisted that they pay an assessment whether their goods came from Tepic or "from the Great China."[71]

Goods in transit represented only a fraction of the trade between Sonora and Arizona. Excessively high duties and taxes charged by Mexico encouraged smuggling along the border. To dock at Guaymas, for example, foreign ships had to pay a lighthouse tax although no lighthouse existed and a pilotage fee although no piloting was provided. Other charges included "a certificate of health" for the ship's crew, duties on the goods they unloaded, and taxes on the products they loaded.[72] Ships seeking to avoid this array of charges traditionally used unguarded natural inlets on the coast to land supplies and send them by mule trains into Sonora and Arizona. By the late 1860s, Americans established a town known as Puerto Isabel (or Santa Isabel) at the mouth of the Colorado River in Mexican territory.[73] Although the Mexican government under Benito Juárez established a customshouse on the site, Americans exercised de facto control. In 1870 a group of

Americans expelled Quirino García, the Mexican customs officer from the port, killing three of his assistants who resisted.[74] Puerto Isabel remained without any Mexican supervision and American influence over the small port continued unchallenged. American troops from Fort Yuma patrolled the area from the border to Puerto Isabel and, according to Mexican officials, enforced two sets of laws, one for Americans and the other for Mexicans. Alberto Sandoval, a resident of Altar, protested that American authorities act "as if they own the territory and the destiny of the Mexicans that reside there."[75] The administrator of the aduana at Guaymas complained to the federal government that local officials had no way of controlling this booming American settlement in Mexico.[76]

By 1871 Puerto Isabel had a Wells Fargo Office, a North Pacific Steamship office, a bank, and warehouse facilities.[77] One steamship line in San Francisco established regular service to Puerto Isabel every twenty days.[78] Ships en route to the port docked at Guaymas and loaded goods, thus profiting Mexican merchants. The complicity of these merchants appeared to have ensured the smooth operation of the illicit port. American smugglers used Puerto Isabel not only as depot for goods destined for Arizona, but also for contraband into Baja California and the coastal areas of Sonora.[79] Even though some Guaymas merchants, such as Wenceslao Iberri and C. Sandoval, complained about the lost revenue produced by the contraband, the government appeared powerless to control the situation at Puerto Isabel.[80] After the expulsion of García, pleas to establish an aduana there went unheeded. The Mexican government bore partial responsibility for the conditions at Puerto Isabel and throughout the northern Pacific coast. To alleviate the region's isolation, the Mexican government initially subsidized the operation of San Francisco shipping companies delivering goods to the area, including to Sonora.[81] Under the guise of legitimate commerce, American smugglers began to penetrate the region.[82]

Goods received at Puerto Isabel usually found their way back into northern Sonora. With no regular military force in the north and little to demarcate the border except an occasional stone monument, smugglers had a free hand. At times both Mexicans and Americans simply moved the landmarks to suit their own needs. Most disregarded the existence of a border and operated freely on either side of the line. In the Santa Cruz Valley, several Americans established a small mining and trading post within Mexican territory at an old rancho known as *La Noria*. From this site, the Americans traded for minerals and sold prod-

ucts to the local inhabitants in Santa Cruz and elsewhere in the valley. In a report to Mexico City, Governor Torres described the installations at La Noria as a group of *casas aviadoras* (mobile structures) that could be moved at a moment's notice.[83] Benefiting from access to cheap consumer goods, local residents seldom complained about the presence of these wandering tradesmen. When confronted by several local officials over the location of their enterprise, the Americans became indignant and claimed that a territorial engineer had certified that the site belonged to the United States. Unable to resolve the conflict peacefully, Sonoran officials forwarded the matter to Mexico City, where it joined hundreds of other complaints arising from new border interaction.

RAILROAD TO ARIZONA

Nothing changed relations between Sonora and Arizona as dramatically as the arrival of the railroad in Yuma in 1877. With the coming of the iron horse, Puerto Isabel became obsolete.[84] Within two years, rail lines reached deep into the Arizona Territory, advancing east along the outskirts of Tucson. The road from San Francisco to Arizona ended the American territory's near-total isolation, connecting it to West Coast supply centers. With a railroad, American producers could now afford to provide the area with inexpensive consumer goods as well as with luxury items.[85] Access to American products in Arizona and Sonora further vitiated the development of manufacturing in the Mexican state. Little incentives existed for elites to invest in industry when foreign goods could be easily purchased throughout the state. With limited funds at their disposal, Mexican authorities remained powerless to enjoin the illicit traffic. In 1879 less than fifty soldiers patrolled a two-hundred-and-fifty-mile border.[86] Confronted by the growing tide of contraband, one newspaper in Guaymas mockingly reported that rather than detain smugglers, most of the poor *celadores* (border guardsmen) looked forward to the opportunity to buy the "cheap wool shirts" sold by the traffickers.[87] Eugenio Duran, the official responsible for activity in the Gulf of California, complained to President Díaz that little could be done to stop the growing flood of contraband. Duran suggested that Díaz either dramatically increase the numbers of agents and station several ships in the gulf or declare the northwest a *zona libre* (free zone), thus diminishing the material basis for smuggling.[88] Eager to reconcile relations with the United States, officials in Mexico City eventually opted for the zona libre.

A handful of Sonoran merchants, teamsters, and other intermediaries made hefty profits transporting and reselling contraband items throughout the state.[89] Towns in the proximity of the northern border provided excellent cover for smugglers. One visitor to Imuris noticed that many homes had high rear walls and "skilfully contrived hiding-places designed for the concealment of smuggled goods."[90] Legal commerce also continued to provide an excellent cover for the sale of contraband items. Smuggling of this magnitude could not have occurred without the participation of established economic interests who facilitated the transportation and the resale of goods. Reporting to Díaz on conditions in the northwest, Patricio Avalos believed that many merchants made sizable profits by trafficking in contraband.[91] Several levels of cooperation existed between American suppliers and Sonoran businesses. Some Guaymas merchants who functioned as brokers for Arizona merchants evaded customs by padding orders received for their American clients. Once in the port, the merchandise became part of their existing inventories and thus avoided taxation. In other cases, merchants arranged with American suppliers to unload goods along the unprotected coast, after which the merchandise would be sold through existing legitimate enterprises.[92] Customs agents complained that under the guise of legal trade, Americans ships actively engaged in smuggling.[93] After auditing the merchants' ledgers, one customs agent in the gulf reported that although no foreign hats or shoes had been officially imported for two years, they could be found in most local stores.[94] The United States consul to Guaymas estimated that over $187,000 in contraband had been introduced into Guaymas in this manner during 1879.[95] Closer to the border, hacendados and merchants also actively participated in the illicit trade. On several occasions, for example, General Serna had been accused of using his hacienda, *Arituaba,* as a storehouse for illegal merchandise. Others accused him of allowing traffickers to use his property to avoid apprehension. Several merchants in Hermosillo also came under attack for collaborating with smugglers and merchants.[96]

Besides enriching a select few, smuggling operations eventually increased violence along the northern border. In several cases, emboldened bandits overran customs stations and stole all the receipts. In April 1878, for example, a party of thieves attacked the inland aduana at Altar, killing three officials. Authorities suspected two Mexican brothers, Jesús and Antonio Bustamante, of the assault. Both lived in Tucson, and although Mexican officials requested their extradition, they eluded cap-

ture.[97] Three months later, the Altar station once again fell to bandits. This time, the guards were held hostage while the smuggled goods made their way to Hermosillo.

Individual travel became a risky proposition along northern roads. Robbers now took the place of the Apache raiding parties. Highwaymen presumed that individuals traveling between northern Sonora and Arizona carried silver or currency for trade in Tucson. Journeying north of Magdalena on the road to Arizona, Alphonse Pinart warned that in "los Llano there is a den of thieves that robs people on their way to Tucson."[98] Most arrests for contraband involved the poor teamsters who hauled the illegal traffic. Americans suppliers and their wealthy Mexican allies usually remained out of reach of the law. Losing substantial amounts of tax revenue, the state government in 1879 passed a new law mandating long jail terms for smugglers.[99]

Recognizing that inland aduanas at Altar, Magdalena, and Fronteras proved incapable of regulating commerce, in 1880 the federal government established four customs stations on the actual boundary line with the United States at Quitovaquita, Sasabe, Palominas, and Nogales.[100] These stations became the first government facilities placed on the actual border between Sonora and Arizona. Economic activity, whether legal or illicit, served to demarcate the actual international boundary between Mexico and the United States. Despite the establishment of these aduanas, smuggling continued unabated. They proved ineffective in deterring contraband and eventually the federal government established a constabulary force on horseback to patrol the area and deter illegal trafficking.

CULTURAL CONSEQUENCES

The preponderance of American goods slowly altered traditional patterns of consumption in the Mexican northwest. American fashions and consumer goods, including a wide range of food items, became an alternative for European and local products. Transportation costs had always limited European products to more expensive items. The influx of low-cost American products refashioned clothing styles, modified traditional dietary patterns, and decreased the dominance of European interests. In the view of one official, the central government had to exert greater authority over the northwest since constant exposure to Americans products had made the people of the region, *ayankada* or "Yankee-fied."[101]

The quantity and character of the smuggled goods provided insights into these changing patterns of consumption. Cloth and manufactured garments composed the backbone of the illicit trade. The sheer quantity of the material introduced stands as a testament to the skill of Sonoran teamsters. For instance, on one occasion, authorities in Magdalena reported seizing 6,813 yards of printed cotton cloth and 1,627 yards of plain cloth, in addition to several dozen denim pants, shoes, socks, and underwear.[102] Magdalena did not prove to be an exception. Authorities at Fronteras and other ports of entry reported confiscating similar shipments of fabric and clothing.[103] With limited resources, authorities could do little to seal the porous border. At best, officials managed to intercept only a small portion of the contraband. Alexander Willard, U.S. consul at Guaymas, estimated that four-fifths of the "cotton and woolen goods" sold in Sonora had been smuggled into the state.[104] Willard faulted Mexican tariffs and customs policies, which charged extremely high duties on fabrics, for encouraging smuggling.[105]

Besides the usual assortment of clothing, authorities began to expropriate a bevy of dry food items and canned goods destined for the tables of Sonoran families. Authorities at Magdalena confiscated 25 pounds of California chocolates, 12 pounds of refined white sugar, 15 pounds of assorted nuts, and 9 pounds of *orejones* (dried apples).[106] At Sasabe, government officials seized "25 pounds of white refined sugar, 20 boxes of canned fruits, 24 cases of canned English hams, 6 boxes of coffee, 11 pounds of English meats, [sic] 3 boxes of canned English sardines and 25 pounds of rice."[107] Smuggled consumer goods reached many in the general population, altering dietary practices. For Sonora's upper and middle classes, products such as "refined white sugar" replaced the traditional *panocha* (brown sugar). According to U.S. consul A. F. Garrison, after the introduction of imported white sugar, the production of panocha continued mainly for the benefit of the "poorer classes."[108] As this trade grew, the consumption of local products, such as panocha, corn tortillas, dried beef, and *pinole* (dry, ground corn meal) became increasingly identified with the diet of the laboring classes.

By the end of the 1870s, the balance of power between northern Sonora and Arizona had shifted. From being a recipient of goods, albeit in transit, Arizona eventually became the supplier of Sonora's commercial needs. Sonoran pack trains which previously supplied Arizona arrived empty at Tucson, where according to one observer, they "loaded all kinds of wares suitable for the Sonoran markets."[109] Smuggling eventually drove many smaller merchants in the north to the brink of

bankruptcy and undermined legitimate commerce in places as far south as Mazatlán and San Blas.[110] According to the United States consul in Guaymas, by the mid-1870s the complaints from the merchants of Guaymas became more vocal as trade increased "between the people of northern Sonora and the territory of Arizona."[111] He reported that "in the north of the state, American manufactured goods, of cotton and woolen, [have] taken the place of European goods heretofore furnished from this port."[112] Americans also established themselves as the principal suppliers of heavy goods such as steam engines, mining and agricultural implements, and lumber—products which remained too costly to bring from Europe.

Groups who had not benefited from the new economic conditions deplored the situation in their state. Echoing these sentiments, the Hermosillo newspaper *La Reconstrucción* lamented that increasingly

> Tucson is where the residents of our border districts of Altar, Arizpe and Magdalena purchase the products that they need. The impact of this trade is felt in Hermosillo and in the port of Guaymas, because it has been a long time since the residents of the North have come here to shop. Even the campesinos of those districts save their earnings and go to the American border to buy what they need for their families without having to pay duties.[113]

The newspaper's comments dramatically illustrated the shift occurring in patterns of consumption and trade. The fact that even laborers pooled their resources in order to make purchases in Arizona underscored the extent to which conditions between both states had changed. By 1878, access to American products forced many smaller commercial houses in Guaymas to curtail operations.[114] Other cities also experienced economic contractions. Relations with the United States had not produced the positive results which many had earlier envisioned. Unable to compete with Tucson, Hermosillo, once considered the commercial emporium of the state, now only supplied settlements in its immediate vicinity.[115]

The United States consul confirmed this new trend in his 1878 report to Washington, stating that throughout the state the "consumption of American manufactured goods is now in excess of European goods, whilst ten years ago cotton and woolen goods consumed in this district were almost entirely imported from Europe."[116] Frederick Schwatka, who traveled extensively in Sonora, echoed Consul Willard's observations. He noted that during an earlier visit, commerce "although small indeed was three-fourths in the hands of the Europeans, while today

[1880s] three-fourths of it is American."[117] Contraband had under-
mined traditional commerce, influenced cultural patterns, and spilled
over into adjoining regions in the Mexican northwest. The new promi-
nence of American products compelled merchants who relied on more
expensive European suppliers to either adapt or be displaced.

A NEW MERCHANT ELITE

Since the late 1850s, a select group of merchants had profited from in-
creased trade with the United States. Economic relations with the north
provided the impetus for the formation of a new merchant and landed
elite. Individuals who adapted to the growing trade with the United
States represented both older established retailers, such as the Aguilar,
Camou, and Ortiz families, who had been operating since the 1830s
and younger upstarts such as Manuel Mascareñas and Luis Martínez,
recent arrivals from the state of Durango. Markets in Arizona, whether
civilian or military, provided them with new opportunities and in-
creased revenues.

The old credit system employed by the Europeans had allowed a
large number of individuals to establish operations and take part in
commerce. This arrangement had benefited European commerce, and
as a result, American suppliers who demanded cash for their goods re-
mained uncompetitive.[118] The American ambassador in Mexico City
complained that his countrymen did not have access to long-term credit
in the United States, where money remained tight. German merchants
operating in Mexico, he insisted, had the backing of large European
banks who extended liberal credit terms.[119] Americans required imme-
diate payment for their goods, and when they did accept credit, it was
usually short-term—in most cases less than thirty days. To compensate
for granting credit and to cover the cost of transportation, Germans
and others inflated the price of their goods. The arrival of the railroad
in Arizona increased the availability of inexpensive consumer goods
from the United States, providing American businesses with new advan-
tages. Cheaper U.S. products displaced the Europeans and their credit
system. Smaller, less capitalized merchants who depended almost exclu-
sively on credit to supply their stores now found themselves excluded
from a new important source of supplies. Only a small elite possessed
the means to make the transition to the new cash system required by
American suppliers.

The 1869 commercial census of Guaymas exposed the fragility of

the Sonoran elite. Of the 216 contributors, only 13 families possessed capital in excess of ten thousand pesos.[120]

Matias Alzua	120,000
Francisco Aguilar	48,000
Francisco Espriu	48,000
Juan P. Camou	40,000
José Cobo	24,000
Agustin Bustamante	24,000
Wenceslao Loaiza	24,000
Vicente Oviedo	20,000
José Maytorena	14,400
Santiago Campillo	12,000
Jorge Martínez	12,000
Manuel Fransci	12,000
Francisco Yrigoyen	12,000

The wealth of these individuals represented either urban real estate or the value of existing stocks, not liquid capital. The increasing demands of a cash economy forced many in this group to adapt. To compete under these changing conditions, some merchants pooled their resources and formed partnerships. Before the 1860s, for example, Agustin Bustamante, Wenceslao Loaiza, Francisco Yrigoyen, and Rafael Escobosa had operated independently. Confronted by the changing demands of suppliers, by the early 1870s Bustamente and Loaiza merged operations, as did Yrigoyen and Escobosa, becoming two of Guaymas's most powerful merchant houses. Consolidations, though not always permanent, became common within business circles in Guaymas and Hermosillo. In Hermosillo, for example, such businessmen as Rafael Ruiz and Manuel Mascareñas found it necessary to join forces in order to strengthen their operations.

The 1875 commercial census indicated the growing trend toward mergers with other like-minded businesses or family members. Immediate and extended family structures, such as those of the Camou, Iberri, Latz, and others, continued to provide the core of many commercial enterprises. Of the twelve largest Guaymas businesses which handled orders in excess of three thousand pesos during February 1875, eight now involved partnerships or family-owned enterprises.[121]

Loaiza and Bustamante	58,000
Vicente Ortiz and Sons	55,000
Yrigoyen and Escobosa	16,000
Sandoval and Bülle	14,000
Emilio Clausen	8,000
Dominiciano Buston	8,000
Amado Fernández	6,000
Seldner and Von Borstel	6,000
Iberri and Huerta	5,000
Roundtree and Lubert	4,000
Martins and Bartning	4,000
Camou Hermanos	3,000

In addition to the continuing presence of foreigners in commerce, the report disclosed that only a handful of merchants had the capacity to function independently. By combining resources, either through mergers or by relying on family networks, the new larger firms quickly adapted to the changed market conditions and benefited from increased economic relations with the United States.

The actions of Sonora's merchant elite accelerated the changes occurring within their state. Although they still dealt with German suppliers, many now sought ties with San Francisco business interests in an effort to monopolize contact with key American suppliers. Guaymas merchants, including Camou, Escobosa, and Bustamante, traveled to San Francisco, becoming acquainted with the commercial operations and the business interests of the U.S. port.[122] As the relationship grew, San Francisco newspapers reported on events in Sonora and on the affairs of elite families. The commercial associations maintained by such merchants as Juan P. Camou and Rafael Escobosa reflect the growing economic interrelationship between economic interests in San Francisco and Guaymas.[123] Other Sonoran merchants actually found it more advantageous to relocate to San Francisco from where they supplied their former Sonoran counterparts. Wenceslao Loaiza, a respected Guaymas merchant, established operations in San Francisco and shipped American goods to Camou and others.[124]

Making use of their new American connections, Sonoran merchants, such as the Iberri and the Camou clan, entered into profitable arrangements with firms in San Francisco, New York, and later, Arizona. The

Iberris provide an example of this new arrangement. Besides a thriving enterprise in Guaymas, the family also managed to become the Mexican representative for several important United States and English firms including the British and Foreign Marine Insurance Company, the Union Insurance Society of London, the Mutual Life Insurance Company of New York, the New York Life Insurance Company, and the Judson Dynamite and Powder Company. Other family-run enterprises also became intermediaries for American firms. Miguel Latz and his brothers, who operated a store in Magdalena, also served as representatives for California Powder Works, the Studebaker cars, Black Diamond Steel Company, and Mutual and Travelers Insurance Company.[125]

As a select group of Sonoran merchants established themselves as agents for American business concerns, the ability of European suppliers to operate independently within the state diminished significantly. Trade with Europeans still took place, especially for luxury items, but they gradually lost ground to the Americans. Smaller Sonoran merchants, especially those in the interior, now found themselves purchasing most of their goods from the larger brokerage firms of Guaymas and Hermosillo, who maintained a monopoly over commerce and rigidly fixed the price structures. Credit transactions still occurred but were now controlled by a handful of important Sonoran entrepreneurs. The larger establishments, such as those owned by Bustamante, Loaiza, Iberri, Möller, Ortiz, Aguilar, and Camou, dominated commerce in the state.

Beside their monopolization of commerce and agriculture, the cultural and social orientation of the Sonoran elites also changed. Recognizing the economic predominance of the United States, they approved of increased relations with the north and functioned as a de facto lobby for United States interests in Sonora. This group increasingly depended on economic ties with the United States to advance their position. Free trade with the north became an economic imperative for their continued success. In 1870, for example, the Ortiz brothers from Guaymas sought permission for the American cavalry to operate freely between Magdalena and the American border in order to protect goods destined for the American territory.[126] In July of the same year, Guillermo Andrade and Nicolas Gaxiola proposed to establish a telegraph line between Hermosillo, Ures, and Tucson to facilitate orders from Arizona merchants.[127] Although the government rejected both petitions, these requests disclosed the growing importance that trade with the United

States had acquired for a new merchant elite. Ties with the north became essential for the continued success of this group.

PENETRATING MEXICO

With a relatively small population and weak internal markets, Sonoran merchants turned their attention to neighboring Mexican states and other Pacific ports. They sought to profit from their status as brokers between United States suppliers and Mexican buyers. Businessmen such as Rafael Ruiz, Manuel Mascareñas, José and Fermin Camou, and Carlos Nanetti of Hermosillo advertised their services as international brokers in such national Mexican publications as the *Almanaque Histórico de México of 1883, El Mundo Ilustrado, Artes y Letras,* and others.[128] In the absence of established banks, they also promoted their ability to exchange Mexican and American currency. Typically, Sonoran brokers received orders from miners and agricultural interests along the Pacific coast of Mexico for such things as mining tools, petroleum products, carriages, and farm implements. Mine operators along the Gulf of California, for example, the French concern at El Boleo, relied on Guaymas merchants for everything, including lumber, beef, coffee, wine, and heavy equipment.[129] This group also made significant profits selling Sonoran products—such as wheat, oranges, beef, and garbanzos—to Mexican interests in Baja California and elsewhere along the Pacific. Beside adding to the wealth of a new border elite, the promotion of Sonoran interests throughout Mexico alleviated the state's isolation from the rest of the nation. An economic incentive now existed for the state's integration with the rest of Mexico.

American investment, concentrated primarily in mining, did little to undermine the position of Sonoran merchants. Rather, local elites profited greatly from the establishment of large, American-owned mining operations. Mining centers, which paid relatively high wages and employed several thousand workers, provided merchants with new internal markets. The Camous did a thriving business selling clothing and other apparel to company stores in Cananea and Nacozari. Not limited to the confines of the Sonora, they also expanded operations, supplying goods to several Arizona mining centers such as Bisbee, Globe, and Wilcox.[130]

Despite their growing economic and political power, Sonoran business groups constituted a relatively weak class that was constantly vul-

nerable to fluctuations in the price of Sonoran raw materials and other economic factors. Notwithstanding attempts to diversify their holdings and acquire land and mines, most Sonoran merchants had little control over the market conditions on which they relied so heavily. As intermediaries, they depended on their ability to profit from expanded economic contact between the United States and Mexico. Increasingly they learned to straddle the economic norms and even the cultures of both countries. Since they profited from economic relations with the north, they had a vested interest in assuring that relations between the United States and Mexico remained stable. Profiting from this relationship, most local elites supported the early policies of the Sonoran triumvirate and their patron, Porfirio Díaz.

"To Be or Not to Be"

The Coming of the Iron Horse

Proposals to build a railroad in Sonora invariably transcended the traditional argument of economic benefits and incorporated issues of culture and identity.[1] In wrestling over the coming of "the machines of progress," as many referred to it, some Sonorans grappled with their fears of being absorbed by their powerful northern neighbor. As they deliberated over a series of railroad projects, many expressed doubts that their past traditions would survive. They viewed the iron horse in the context of a broader asymmetrical relationship developing between Sonorans and their North American neighbors. Others, however, scoffed at these concerns, insisting that the railroad represented progress as well as an opportunity to enrich the state.[2] Sonorans, one such commentator observed, were being "pushed by the forces of civilization arriving from the north," not from Mexico in the south.[3] A decade after the railroad commenced service, access to transportation had changed the state in many ways. Beside linking Sonora to the United States, the railroad ended the autonomous existence of the nine separate districts that formed the state. As ridership increased, Sonorans from throughout the state came face-to-face with each other. Ultimately, the railroad embodied the promise and perils of Sonora's new border status.

THE INSTRUMENT OF PROGRESS

For years, Sonorans had envisioned a railroad that would link their economy to that of the United States. State leaders believed that the rail-

road would provide solutions to their most complex problems—it would facilitate the movement of troops to defeat the Apaches and Yaquis, encourage expatriates to return, promote "white" immigration, increase the value of land, and above all, facilitate the exploitation of rich mineral resources.[4] With a railroad, Sonora would surpass Arizona, overtake California, and claim its place in the sun. By the late 1870s, a new sense of expectation gripped Sonorenses. The language of development, reflected in the use of slogans such as "a new era," "regeneration," "progress," "rebirth," and "modernization," filled the pages of Sonoran newspapers and punctuated speeches by local politicians.

EARLY RAILROAD SCHEMES

Early Sonoran railroad schemes envisioned a rail link not with Arizona but with California, Sonora's earliest trading partner. Mexico City favored a rail link between Guaymas and Paso del Norte, modern-day Ciudad Juárez. From 1854 to 1870, no less than five separate contracts to build a railroad in Sonora received approval from the state and federal government. Alejandro José Atocha acquired the first concession in July 1854 to construct a line from Guaymas to Paso del Norte.[5] From 1859 to 1861, the Chihuahuan general Angel Trías monopolized rights to develop a line over the same route.[6] In 1866 an American, John C. Fremont, entered into an agreement with President Benito Juárez to lay track from Guaymas to Arizona. Julius Skilton, the American consul general to Mexico with ties to the Pennsylvania Railroad, also vied for a concession in 1869.[7] Despite these schemes, by 1870 not one kilometer of track had been laid. Most foreign and Mexican syndicates had no capital for the project and simply speculated on the potential for mining in Sonora. An impoverished Mexican government agreed to the various concessions in the hope of deriving some benefits from economic activity in the northwest. Political instability, wars with the Yaqui population, the French intervention, and the lack of capital doomed most early railroad schemes.[8]

Sonoran railroad projects mirrored developments in the United States. During the 1870s, economic expansion in the United States Southwest gave rise to yet another wave of railroad schemes in Sonora. In 1872 James Eldredge, an American representing a British concern, visited Guaymas and promoted a rail line from the Sonoran port to Arizona. The state assembly and Governor Ignacio Pesqueira supported

the plan and actively campaigned for the Eldredge proposal. Pesqueira commissioned Ismael S. Quiroga, a Sonoran assemblyman, and Alexander Willard, the American consul at the time, to promote the project in Mexico City. Quiroga lobbied for the contract in the Mexican congress and Willard sought to influence American interest, hoping to garner support for the Sonoran proposal.[9] In a letter to the governor, a disillusioned Willard informed Pesqueira that the delegation had won few converts since there existed a near total lack of knowledge of the northern border in Mexico City.[10] The Mexican congress took no action on the Eldredge plan.

The 1872 railroad controversy highlights the changing relationship between Sonora and the capital. Angered by the inaction of Mexico City, state officials protested that Sonora should not have to submit rail contracts for approval to the federal government[11] and naively argued that no difference existed "between building a road from Ures to Guaymas and building a railroad north."[12] The federal government reaffirmed its authority to enter into contracts with foreign interests to build a railroad, and without the approval of the national government, investors refused to enter into agreements with state officials. In 1875 the federal government allowed David Boyle Blair, an Englishman, to acquire rights to the stalled Eldredge contract.[13] A last-ditch effort headed by Guillermo Andrade and backed by some California interests to build a railroad from Guaymas to Yuma, did not receive federal support.[14] On the surface, Andrade's plan appeared farsighted. He contended that a rail link between Sonora and Arizona would make the Mexican state dependent on its northern neighbor. Establishing a line directly to California, he argued, where no actual physical contact existed, would provide Sonora greater commercial freedom and prevent dependence on Arizona. For economic interests in California, it also would provide direct access to Mexican markets, bypassing intermediaries in Arizona. Andrade, however, lacked the political clout and resources with which to realize his elaborate plan. Still, he could take some consolation in the fact that after a few years, the Blair agreement also stalled.

CULTURAL DIMENSIONS OF DEVELOPMENTS

Railroad proposals and growing trade with the United States sparked a debate within Sonora and in Mexico City regarding the social repercussions of commercial dealings with the Americans. For its part, Mexico

City feared the implications of Sonora's ties to the United States, particularly the political and cultural consequences of constructing a railroad between an isolated and distant Sonora and its neighbor to the north. Memories of the loss of Texas remained fresh in the minds of many federal officials. President Sebastián Lerdo de Tejada underscored this fear when, in reference to a railroad between Sonora and the United States, he said that "between a strong nation and a weak one, the best defense is a desert."[15] The Mexican military also opposed plans for a railroad in Sonora. General Gaspar Sánchez Ochoa, chief of the engineer corps of the Mexican army, believed that "construction of a railroad in Sonora should wait until such time as the frontier states were united by railways with the valley of Mexico."[16] Otherwise, Sánchez Ochoa argued, Chihuahua and Sonora would be lost to the United States. Sonoran congressmen, such as Antonio Moreno, vigorously opposed this argument.[17]

In Sonora, discussion of the railroad also generated heated arguments. Fear of social and economic absorption by the United States framed most debates concerning the iron horse. Opponents of the railroad continued to make use of cultural arguments to attack foreign concessions and insisted that after construction of the railroad, Sonora would be flooded with "low class Americans" or "cowboys" who would transform the state into another Texas.[18] Critics warned that a railroad contract would result in the loss of Sonora to the United States. The state of Sonora, said one state assemblyman in 1869 resembled "a child besides a giant, a rabbit about to be devoured by a voracious boa constrictor. The United States is looking for a pretext to acquire our territory, only a pretext, because all the Yankees need are pretexts. This concession will cause innumerable complications . . . and bring about the absorption of our nation by the Americans."[19] A lingering bitterness over past aggressions coupled with concern over diminishing economic power permeated the debate. Beyond cultural arguments, other reasons existed for opposing the railroad. Many agricultural interests along the Sierra Madre, such as Sahuaripa, Moctezuma, and Alamos, would not benefit from the project. These groups feared that the iron horse would shift the balance of power in the state toward the areas traversed by the railroad, in particular the Guaymas-Hermosillo-Nogales corridor.

When the Sonoran state assembly considered the Eldredge proposal in 1872, an editorial in the state's official newspaper, *La Estrella de Occidente*, sought to allay fears of U.S. annexation by emphasizing that the operators of the railroad would be British and not Americans. The news-

paper insisted that the English would serve as a buffer between Sonora and the Americans, preventing annexation by the United States. To calm fears from landowners who might be forced to cede property to the railroad, the newspaper claimed that "even those left with a small piece of land will be millionaires."[20] The state newspaper labeled opponents as "retrograde," those who refused to let Sonora "go ahead" and instead sought to preserve the "status quo." It referred to the railroad as a "civilizing project" which would open Sonora to "the driving force of the American people," thereby ensuring the state's development.[21] Terms such as "go ahead" and "status quo" appeared in English, demonstrating the degree to which this language already formed part of the region's vocabulary.

Debates over the implications of increased economic relations between Mexico and the United States grew louder and eventually attracted the attention of Sonorans living in Tucson.[22] As negotiations progressed, the Mexican community in Tucson took sides on the railroad and two camps emerged.[23] Economic interests here, too, appeared to frame the debate. Newspapers like *La Sonora* led opposition to the railroad whereas *El Fronterizo* became a pillar of support for the railroad. *La Sonora* asserted metaphorically that "the first spike driven into the track would drive the wedge of annexation between Sonora and Mexico."[24] The editor of *El Fronterizo*, Carlos I. Velasco, who had extensive ties to the Sonoran government, insisted that "with the railroad, Sonora will be reborn like a Phoenix out of the ashes; its inhabitants have for many years anxiously awaited this rebirth."[25] Moreover, the newspaper insisted that "there was no reason to believe that the material progress of a nation entailed its loss of independence."[26]

By 1878 political and economic conditions favored the construction of a railroad. The perennial governor of Sonora, Ignacio Pesqueira, had been removed from office. Despite the turbulence which accompanied the interim government of Vicente Mariscal, political peace appeared at hand. The incessant conflicts that had engulfed the state during most of the nineteenth century had subsided. A new political bloc, tied to the Porfiriato and led by Ramón Corral, Luis E. Torres, and Rafael Izábal, formed the nucleus of a relatively strong and stable government. Moreover, two new British investors with access to financing, David Ferguson and Robert Symon, proposed to take over the stalled Blair concession.[27] From 1851 to 1871, they, along with Sebastian Camacho, controlled mints at Alamos and Hermosillo, amassing substantial profits.[28] During 1879 they also operated mints in Sonora and Sinaloa.

Mexican critics, such as Alberto F. Pradeau, charged that profits from these operations financed the Sonoran railroad, not foreign capital.[29] After a long protracted debate, the Mexican congress refused to grant Ferguson and Symon's request. The body deadlocked over the merits of building a transoceanic rail line that would unite Veracruz, Mexico City, and a port on the Pacific and over authorizing rail line from Mexico City to the northern border. Despite objections from Alfredo Chavero, president of the Mexican congress, in 1879 Porfirio Díaz arbitrarily transferred the old Blair contract to Ferguson and Symon, authorizing construction of the Sonoran railroad.[30]

Proponents of the railroad still faced resistance from those worried about economic and cultural displacement. An editorial in *La Constitución,* the state's new official newspaper, summarized the situation which confronted Sonorans this way:

> We are in the presence of a great and powerful race, that although friendly tends to absorb us. We are called upon to wage a titanic battle, to defeat them with their own weapons or to shamefully succumb to them. Without realizing it, we have fallen into the terrible dilemma faced by Hamlet: 'To be or not to be' [original in English]. Let us demonstrate to the foreign nations that today fear for our nationality, that by Americanizing ourselves, we Mexicanize ourselves more and more, because by educating ourselves in their schools we will become stronger, respectable and will be able to better defend the integrity of our national territory.[31]

This enigmatic assessment captured the apprehensions that had distressed Sonorans since the Pesqueira government. If the state did not achieve even a modicum of economic development, they argued, its population would continue to search for opportunity in Arizona, as it had since 1856. State officials had traditionally warned that the real danger of absorption came from allowing the northern states to wallow in despair, "destroyed by the barbarians [Apache] and depopulated as its people are drawn by offers of work on the other side of the border. Therein lies the real danger of annexation."[32] The 1869 census noted a dramatic decline of population from a previous high of 150,000 to fewer than 108,000 inhabitants. By 1876 the American consul believed that the population had fallen even further, down to fewer than 90,000, one-third of which represented the indigenous population.[33] Debilitated by wars with the Yaquis and confronting out-migration, Sonora would continue to stagnate. Sonorense political leadership argued that a weak state, lacking viable social or political institutions, would be unable to

negotiate terms of trade and would succumb to United States interests.[34] The growing flood of contraband along the northern brought this point home. "Americanization," as they saw it, implied not the unmitigated assimilation of an American way of life, but rather the appropriation of American expertise and technology. To "defeat [Americans] with their own weapons," Sonora, they argued, had to develop.

CONSTRUCTION OF THE SONORAN RAILROAD

With the contract approved and financing secured from the Atchison-Topeka, and Santa Fe Railroad, construction of the railway from the port of Guaymas north to the United States border began in earnest in 1880. Few could have anticipated the extent to which their society would be transformed in the ensuing years. The organization of the railroad mirrored the newly emerging social order in Sonora. The board of directors of the company did not include any Mexicans. Although the first annual report of the Sonoran Railroad in 1881 listed Governor Luis E. Torres on the board, the company dropped him once formal negotiations with the government had been finalized.[35] Sebastian Camacho, who functioned as a liaison with the Mexican government, was the only non–Anglo-American in the upper echelons of the railroad organization. In Sonora, American engineers Daniel B. Robinson and W. R. Morley supervised the daily construction of the enterprise. According to one source, Colonel Antonio Moreno, an engineer assigned by the Mexican government to oversee the project, had become a de facto company employee. The *Monitor del Comercio*, a Guaymas newspaper, alleged that in addition to a government salary, he received 400 pesos a month from the company and had become foreman of a crew in charge of grading the track.[36]

To facilitate the arrival of building materials, construction commenced at the port of Guaymas. Lumber for the project came from Oregon, while rails, cars, and locomotives arrived from the United States East Coast. To oversee construction, the company brought its own crew of American supervisors, and for the grueling manual labor, the company recruited Yaquis and Mexicans. To assure an initial supply of workers, they also retained two hundred American blacks, many of whom later married and settled in the state.[37] If an ample supply of labor could not be secured locally, the railroad threatened to import Chinese workers from California.[38] Since hundreds of Yaquis and Mexi-

cans deluged the railroad offices seeking work, the feared labor short-age never materialized. By 1883 the railroad listed 1,949 employees, in-cluding 664 Mexican, 810 Yaquis, and 475 Americans.[39]

RACIAL STRATIFICATION

Employment patterns on the railroad represented deep-seated racial inequities which later confronted Mexicans throughout the state. A graduated wage structure developed for Mexicans, Yaquis, and Anglo-Americans performing the same work. Americans received the top pay, Mexicans the middle levels, and Yaquis the lowest. At the Guaymas yard, for example, the thirteen Mexicans classified as shop workers re-ceived a maximum wage of two pesos a day, whereas the fifty Ameri-cans under the same classification obtained four pesos a day.[40] Be-yond the typical three-tier wage arrangement, a racial occupational hierarchy also became apparent. Anglo-Americans held the majority of professional and skilled positions, monopolizing office assignments and trades such as machinists, train conductors, and carpenters. Mexicans who held office positions remained, by and large, station attendants, who were hired as cultural brokers, to translate for non-Spanish-speak-ing Americans station managers.[41] American construction supervisors also employed Mexican interpreters in order to facilitate communica-tion. Only a handful of Mexicans actually held skilled or professional positions, mostly as carpenters, whereas the majority, 420, held con-struction jobs. Yaqui Indians occupied only two positions—track re-pairmen and construction laborers.[42] Over time, this triple-wage and employment hierarchy became a point of contention between Mexi-cans, Yaquis, and Anglo-Americans.

GUAYMAS VERSUS NEW GUAYMAS

Guaymenses looked forward with great anticipation to the construction of the railroad. City leaders expected that construction would stimulate the economy of their city, encourage business, hotel construction, and other improvements. Promises made by both American and Mexican railroad promoters buoyed Guaymas merchants. To gain support, the Atchison-Topeka and Santa Fe advanced the idea that the Sonoran rail-road would give the United States East Coast access to Asian markets. The *New York Times* reported that the railroad franchise would grant the Boston-based firm a "virtual monopoly of the Australian, New Zea-

land, and South and Central American business."[43] By significantly reducing distances to the east, Guaymas would undermine San Francisco's monopoly on Pacific trade. The paper further indicated that the
Sonoran railroad would bring "Australia and New Zealand 1,000 miles
nearer to this city [New York] than they now are."[44] Guaymenses, eager
to see their port become an important center of Pacific trade, embraced
these claims.

When the railroad fired up its first locomotive and tested the tracks,
the entire town of Guaymas flocked to witness the spectacle. One newspaper indicated that everyone, "rich and poor, young and old crammed
into the carriages like sardines . . . while others went by launch" to
view the test. After several trial runs, the company hosted a party for
all present, serving the "women guests champagne, and the men cognac
and beer and English nic nac cookies."[45] For the townspeople, most of
whom had never seen a locomotive, the afternoon spectacle seemed to
verify the promise of the railroad. The exhilaration, however, proved
short-lived. From the outset, railroad construction became mired in
controversy. Instead of building in Guaymas, company engineers began
construction of a station south of the city, next to the island of Ardilla
and Punta Arena at a place later called Empalme, where they built their
own wharf to unload materials arriving from the United States. Appalled at this slight, the Guaymas town council proposed that the station be built at a place known as Punta de Lastre, which was closer to
the city. In 1880 notables, including the senior José Maytorena, dispatched a letter to the governor and to Mexico City demanding immediate action.[46] Other Guaymenses threatened to block construction if
their demands were not addressed. *El Monitor del Comercio* began to
criticize American actions, insisting that the "New Guaymas would
ruin old Guaymas as all the trade and commerce would go to the New
Guaymas."[47] In 1880 the *New York Times* noted that "bad blood was
brewing between Mexican and Americans."[48] The central Mexican
government appointed a high-level committee composed of Carlos R.
Ortiz, Robert R. Symon, and Luis E. Torres to resolve the issue.

The Sonoran governor sent his own version of accounts to Mexico
City. He indicated that trouble began when several leading families
in Guaymas had tried to sell their indebted laborers to the railroad in
hopes of making a profit and had been rebuked. News of hiring, however, had produced a flood of applicants, and the railroad did not need
the indentured laborers.[49] Since then, Guaymas notables, according to
the governor, had grown resentful of the American operators and sup

ported the *Monitor del Comercio* in order to attack the railroad.[50] The official state press criticized local notables and lauded the efforts of the American company insisting that since it began hiring, the streets of Guaymas and Hermosillo had been rid of most vagrants and drunkards.[51]

Beyond issues of labor, many Guaymenses objected to the near total insensitivity of the Americans. Mexicans had never anticipated being displaced by foreigners, expecting instead that business and social practices would remain unchanged. To placate the Guaymenses, the railroad, at the insistence of Ortiz, staged a large public celebration at which it provided food and refreshment and permitted residents to climb on board the newly arrived trains.[52] Eventually the company also agreed to relocate the station to Punta Lastre. Despite the move, however, they continued to build storage facilities and a new town for American employees at the southern location. In 1882 the Guaymas merchant elite, including Camou, Maytorena, Aguayo, Iberri, Huerta, Chisem, and Aguilar, circumvented the governor and requested the intervention of the secretaría de fomento (minister of development). They complained that despite an earlier agreement, the railroad continued to maintain a station two miles south of Guaymas and had also constructed an alternative town, which the Americans called Morley City in honor of the company superintendent. The merchants claimed that the new city undermined Guaymas, attracted new immigrants, depressed property values, and ruined commerce.[53] In addition, José Maytorena, an influential hacendado and member of the Guaymas town council, maintained that with a private dock, Americans brazenly trafficked in contraband.[54] The merchants argued that the establishment of a new town assured American dominance over the operation of the railroad. They maintained that placing these operations within a Mexican community guaranteed a balance between native and foreign interests.

Despite the storm of protests, the railroad carried the day, and Junction City, as the Americans later called it, became a thriving foreign enclave in Sonora. The Mexicans later christened the town as Empalme, Spanish for "junction." Travel brochures and Americans in Sonora portrayed the settlement as a "pretty little American town."[55] The *New York Times* described it as having streets christened with American names.[56] The urban layout of Empalme betrayed its American origins since its streets were named after prominent American citizens: Calle Willard, named after the American consul; Calle Morley, named after

the company superintendent; and Calle Symon, named after the president of the railroad.[57] Home construction followed American design — raised wood-frame homes with fireplaces, white picket fences, and front and back yards. In addition, the railroad built a two-story social club for its American employees and an eighty-room hotel costing more than $100,000.[58] Stores in Empalme sold imported American consumer goods brought in duty-free by the railroad. As Empalme became more prosperous, Guaymas suffered. For Americans, life in Empalme revolved around the railroad. Beside working for the company, the wife of an American employee noted that in their spare time they had many activities: "tennis, golf, boating, swimming, dancing, playing cards and with gossip the men are content and the women try to be."[59] Except for work, Americans seldom left the protection of the town and resented old Guaymas, describing it as "a city of yesterday in the land of mañana."[60] On repeated occasions, striking Mexican railroad workers referred to the American compound at Empalme as "Yankilandia."

NORTH TO HERMOSILLO

After leaving Guaymas, the laying of track proceeded quickly over the flat scrubland between the port and Hermosillo. Railroad construction, however, brought together large numbers of workers, and on payday, drunkenness, thefts, and even murders became commonplace in the temporary camps that dotted the route. Cy Warman, an American engineer, warned that "on a night that followed pay day, thoughtful men slept in storm cellars."[61] To conserve the peace, Governor Torres appointed a special railroad police. Finding it difficult to restore order, the police eventually prohibited the sale of alcohol to railroad employees.[62]

Despite the troubles, by November 1881 the railroad had reached Hermosillo and opened limited service between the capital and the port. To celebrate the occasion, both cities planned extravagant celebrations. The first excursion of the railroad was publicized throughout the state, and in anticipation, people flocked to Guaymas and Hermosillo. To accommodate the large crowds wishing to make the trip, government officials convinced the railroad to outfit several extra cars. The company decorated the stations in both cities and built a special platform for dignitaries and bleachers for the public. On the morning of November 4, 1881, the train departed Hermosillo for Guaymas. After a brief stay in Guaymas, the passengers returned to Hermosillo for a celebration that involved the entire city. City officials ordered lights

placed on all houses for a parade; a public dance and fireworks took place that night in the town square; and dignitaries attended a special ceremony at the Hotel Frances.[63] Despite the mood of exhilaration that pervaded the crowd, a brief scuffle between an American conductor and a handful of Mexicans trying to board the train threatened to mar the celebrations. State officials tried their best to downplay the incident, while critics insisted that the dispute represented a harbinger of things to come.[64]

BORDER LAND RUSH

Construction along the mostly unproductive flatland leading from Guaymas to Hermosillo did not give rise to fierce speculation in real estate. The same, however, could not be said about the move north toward the border. Anticipating important social and economic changes, the state government in 1880 sent a circular to all prefects and leading businessmen. It warned that "now is not the time to be "inactive . . . the completion of the railroad will bring a flood of immigrants that will absorb everything if we do not hurry and learn to exploit our own assets."[65] Sonorans with resources, however, did not need the advice. Behind the scenes, they had already prepared for this day. By 1880 merchants and hacendados had firm control of city councils in Guaymas and Hermosillo. Merchants José Iberri, Juan P. M. Camou, Juan Bringas, and David Spence controlled Guaymas, and Manuel Mascareñas, Agustín Pesqueira, Carlos Nanetti, and Ramón Ayon held power in Hermosillo.[66] Beside engaging in politics, on various occasions since the sale of the Mesilla in 1853, they had openly speculated in northern real estate. With news of the iron horse confirmed, notables engaged in the largest land grab in the state's recent history, laying claim to huge tracts along the northern border.

Land which for decades had laid fallow acquired importance literally over night.[67] The weekly edition of the state newspaper, *La Constitución*, grew thicker as it published long lists of *denuncias* (land claims). The Camou clan purchased thousands of acres in Magdalena, Arizpe, and Altar and prime land next to the border in Nogales and Agua Prieta. In September 1880, for example, José Camou, Jr., claimed ranchos known as Agua Prieta, Santa Barbara, Nardenibacachi, Agua de Baltazar, La del Gato, La de Tomas Romero, and La de las Mesteñas in the district of Arizpe.[68] All family members, including their children, had land claimed in their name.[69] After the dust had settled, the

Camous and a handful of Sonoran elites controlled thousands of choice northern acreage. By 1881, *La Constitución* reported that little if any unclaimed land could be found in the north.[70]

Not all stood to benefit from the railroad. The indigenous and small rancheros throughout the north felt besieged by the onslaught of speculators. Most treated indigenous lands as *terrenos baldíos* (empty lots), disregarding their traditional owners.[71] In Nacori Chico, for example, Francisco Valencia had claimed all lands owned by the Indians as his own. Incensed, the indigenous people protested, but to no avail. Rancheros also railed against incursions onto their land by railroad engineers and buyers who disrupted the ranches' operations. Owners of the Santa Ana and Santa Marta ranches complained to the prefect of Magdalena that their fences had been torn down, crops damaged, trees cut, and animals scattered by the actions of the road crew. The prefect, Joaquin Monroy, promised to work for an amicable solution that would please both parties.[72] State officials did not share Monroy's view and repeatedly decided in favor of the railroad company. On more than one occasion Luis Torres insisted that nothing would stand in the way of the railroad.

A NORTHERN ORIENTATION

The railroad and the economic growth it inspired propelled a sweeping physical realignment in the state toward the north. For many Sonoran notables and middle-class persons, progress and growth became synonymous with commercial links to the United States. With access to transportation and American investments, the once depopulated northern districts became centers of mining, cattle production, and agriculture. The potential of the border districts appeared unlimited: copper mines in Arizpe, cattle production in Magdalena, orange groves in Hermosillo, gold and silver mines in La Colorada. The north became a magnet attracting hundreds of Mexican and Yaqui laborers. This movement initiated a fundamental reorientation for a state and its people, which previously did not have border settlements.

By 1885, events occurring in the port of Guaymas highlighted the realignment taking place within Sonora. Traditionally, the merchants of Guaymas and Hermosillo had enjoyed a virtual monopoly on trade within the state. As Sonora's principal port, Guaymas had been the state's door to the outside world. Its strategic location on the central coastal region allowed both Hermosillo in the north and Alamos in the

south to share equally in its benefits. Instead of a boom in Guaymas, the railroad which provided access to the border altered the status of the old port city. The emergence of border towns caused the town to lose its stature as the "door" of Sonora as merchants and miners turned their attention north toward Arizona. Dramatizing the change that affected Guaymas, in 1885 the Sonoran railroad decided to move its headquarters from the port city to the border at Nogales.[73] Guaymenses, as they had done previously, vigorously protested the action of the railroad company. Led by the venerable opposition leader, José M. Maytorena, they sent a petition signed by several hundred notables to President Díaz demanding that the railroad not relocate its offices. American interests, they argued, wanted to move their offices to the border in order to avoid Mexican oversight. According to them, Sonorans should keep the railroad offices in the interior, away from the northern border and undue American pressures. Díaz expressed sympathy with the plight of the Guaymenses but refused to halt the move.

Following the lead of the railroad, merchants hoping to capitalize on the growing economic importance of the border also left the port and opened stores in the new border towns. Newspapers, such as the *Monitor* and the *Estado de Sonora*, soon followed, moving their publications to Nogales. In 1889, even the United States downgraded its office in Guaymas and moved the consul general to Nogales.[74] Although the port's social and economic importance diminished, it continued to be an important regional trading center.

In many ways, the practices of the railroad and the lack of access to Mexico City continued to ensure the port's future. Some merchants found it cheaper to import heavy products by sea from San Francisco than to transport them by rail from Arizona. In addition, since no rail link existed to central Mexico, European products imported through Guaymas also remained competitive in Sonora. As Díaz Duffo points out, without a railroad linking Mexico City to the Pacific, "Scandinavian paper imported via de Cape Horn was cheaper in Guaymas and Mazatlán than that produced in Mexico City."[75] Records kept by the United States consul bear out this contention. In 1883, the first full year of operation, Willard reported that merchandise imported through Guaymas amounted to $1.4 million while Nogales only recorded $157 thousand.[76] Goods smuggled across the border, over $200,000 worth by one estimate, remained greater than that which passed legally through Nogales. This trend persisted in following years.[77]

The decline of Guaymas occurred gradually. Merchants did not sim-

ply abandon the port, but rather they diversified, keeping outlets in Guaymas while expanding operations to the north. Moreover, the port continued to supply the needs of the gulf region, exporting agricultural products to Sinaloa, Tepic, and Baja California. Its monopoly over Sonoran trade diminished as even European merchants found it cheaper to dock at New York and ship their goods by rail to Sonora rather than make the trip around Cape Horn.[78] Beyond eclipsing Guaymas and overshadowing southern Sonora, the railroad produced other, more fundamental social changes within the state.

SOCIAL AND ECONOMIC INTEGRATION

With the railroad completed, Sonorans expected to have access to cheap, reliable, and relatively safe transportation. Their expectations, however, failed to materialize. To recoup its losses, the railroad charged comparatively high rates for passengers and cargo. In a letter to the secretaría de fomento, Sebastian Camacho made the railroad's position clear. Hoping to compensate for the short length of the line, 422 kilometers, and the small and dispersed Sonoran population, the company planned to charge higher than normal fares.[79] Making matters worse, in 1883, the first full year of service, the railroad only offered first-class tickets, calculated at three cents per kilometer. Second- and third-class tickets, mandated by the contract with the Mexican government, costing two and one and a half cents per kilometer, respectively, were not offered.[80] Under these conditions, laborers and merchants paid the same rate. Beside inflated fares, passengers also complained of only being allowed thirty-five pounds of baggage and paying elevated rates for anything in excess. The United States consul reported that the Sonoran railroad charged higher rates than most American railroads.[81] Complaints soon deluged government officials in Hermosillo and Mexico City.

After years of anticipation, few people could actually afford to travel on the new railroad. A one-way trip from Guaymas to Nogales, a distance of 442 kilometers, cost $12.75, beyond the reach of all but the wealthiest Sonorenses. Ramón Corral, then secretary of state, sent a complaint concerning the high rates to the minister of development.[82] Beside the problem of fares, the railroad's schedule did not reflect the needs of most Sonorans. In 1883, on the northern portion of the trip, the train left Guaymas at 12:45 p.m., not arriving at Nogales until 3:30 a.m. On the southern leg, it left Nogales at 9:00 p.m., reaching Guaymas at 11:45 a.m. The company operated its schedule in order to con-

nect with the Southern Pacific and Santa Fe lines at Benson, Arizona, and expected the Mexicans to adapt to its requirements.

Confronting a storm of protest, in 1885 the company altered its itinerary and offered new fares. The establishment of lower prices increased ridership, and Sonorans began traveling throughout their own state. For the first time in their lives, large numbers of Sonorenses had access to slow but reliable transportation. Ridership grew from a low of 33,000 during the first full year of operation to a high of 253,495 by 1911. The year the railroad commenced operations, the state census recorded 108,000 inhabitants, and by 1910 the population reached an all-time high of 220,000. The numbers of people using the railroad appeared exceedingly high in proportion to population figures. Table 1 shows the total number of passengers using the railroad.

Several factors influenced the slow rise in ridership during the first fifteen years. Mining and agriculture interests in the region responded slowly to the presence of the railroad. Following completion of the line, Sonora's economy did not demonstrate a dramatic increase in the export of either mining or agricultural products. Rather, as it had in the past, the state continued to experience repeated economic contractions. Sonora endured several months of drought, and the port of Guaymas experienced a serious outbreak of yellow fever, which brought commerce to a standstill in the region. Wars against the Yaquis continued to take their toll. According to the American consul Alexander Willard, unstable conditions continued until 1887.[83] While speculators actively promoted properties and mines, larger foreign investors moved slowly. Mining concerns such as Minas Prietas/La Colorada, Planchas de Plata, and Cerro Colorada did not fully develop until the late 1890s, and the boom at Cananea and Nacozari awaited the first decade of the twentieth century. After 1900, fluctuations in ridership, such as the increases in 1905 and 1906 and decreases in 1907 and 1908, responded to the economic boom-and-bust cycle repeatedly experienced by the Sonoran mining economy.

Yet even after accounting for travel by merchants, salesmen, and others whose livelihood depended on the railroad, the extensive ridership suggests that diverse social groups made use of rail transportation. After 1885, as wages continued to increase and rate structures stabilized, elites no longer had a monopoly on travel. At one and a half cents per kilometer, it cost a little over six pesos to travel the entire distance of the railroad from Guaymas to Nogales.[84] The railroad serviced twenty-six different stations, and company records indicate that most

TABLE 1. RAILROAD USE, 1883–1910

	Number of passengers	Cargo (thousands of tons)	Average miles traveled by passengers	Average miles traveled by cargo
1883	33,464	24,202		
1884	36,428	21,115		
1885	47,271	29,927		
1886	45,298	33,639		
1187	38,189	34,660		
1888	38,335	37,621		
1889	44,691	43,321		
1890	48,196	46,167		
1891	55,565	53,947		
1892	54,072	64,510		
1893	52,678	63,687		
1894	—	—		
1895	63,380	67,982	93.81	123.63
1896	76,418	87,535	97.36	201.95
1897	94,859	83,153	89.76	196.42
1898	100,227	108,400	88.57	227.20
1899	107,538	108,177	—	—
1900	96,694	136,051	102.75	123.44
1901	104,897	147,075	106.32	123.07
1902	118,106	145,999	105.29	206.56
1903	133,817	145,503	104.12	204.43
1904	142,191	156,880	100.53	192.00
1905	138,340	176,259	96.19	223.28
1906	174,181	331,145	93.59	188.65
1907	198,425	323,320	92.44	230.10
1908	191,834	348,669	83.27	215.89
1909	257,563	312,537	68.26	354.33
1910	253,495	234,532	70.08	209.25

SOURCES: AGN, SCOP, no. 6/70-1, no. 219, June 2, 1892, Manueal Velasquez, "Datos sobre Ferrocarril de Sonora, Secretaría de Conunicación y Obras Públicas": AGN, SCOP, 6/42-1, June 4, 1898, J. A. Naugle to SCOP, report; AGN, SCOP 6/42-1, Annual Report Sonora Railroad, 1882 to 1911. Also see AGN, SCOP, 6/42-1, December 27,1920, J. A. Naugle to SCOP, report; AGN, SCOP, 6/42-1, April, 5, 1904, J. A. Naugle to SCOP, report. In 1902 the company included statistics on express service. They shipped a total of 600,000 kilos.

passengers bought third-class tickets to travel short distances. For example, in 1892, of the 54,072 passengers that used the railroad, 34,086 or 63 percent purchased the lower-class tickets. In 1905, of the 138,340 who traveled, 97,717 or over 70 percent paid third-class. These figures remain consistent from year to year. The average kilometers traveled by passengers went from a high of 106 in 1901 to a low of 70 in 1910 and indicate that most journeys remained restricted to the confines of the state.[85] Stations such as Guaymas, Hermosillo, and Magdalena saw the greatest amount of traffic. Leopoldo Zamora, the Mexican administrator, reported that in the first few years of operation, 86 percent of travel tended to be local. Less than 14 percent of travelers made the trip as far north as Nogales. Of those, according to Zamora, the majority were Americans.[86] Rather than a mass exodus to the north, travel by railroad seemed to have increased levels of social interaction among the once-isolated Sonorans.

Several reasons existed for this increased social interaction. The traditional factors which compelled people to migrate—Apache attacks, political acrimony, and the lack of jobs—had been mitigated. By the mid-1880s the issue of Apache raids had all but been resolved. However unpalatable the rule of the Torres-Corral-Izábal triumvirate may have been to some groups, it had inaugurated a period of relative political stability. The completion of the railroad allowed Sonora to experience a mining boom of unprecedented proportions.[87] With foreigners providing an infusion of capital, operations at Minas Prietas, La Colorada, Nacozari, Cerro Colorada, and later Cananea quickly expanded, becoming major employers. With access to transportation, cattle ranching and agriculture provided jobs for hundreds. Although working conditions continued to be deplorable, employment could be found throughout the state. More importantly, for the average person, few reasons actually existed for traveling to the border. Since merchants throughout the state carried large quantities of European, Mexican, and American merchandise, Sonorans no longer needed to travel north to acquire consumer goods as they once did.

The railroad facilitated the integration of the once-fragmented Sonoran economy. Although Guaymas, Hermosillo, Magdalena, and Nogales remained the most important commercial terminals for the railroad, the intermediary stations played important roles in unifying the Sonoran economy: the Maytorena station serviced the adjacent cotton district; the stop at Pesqueira handled goods for the Los Angeles textile mill at Horcasitas; and the Ortiz depot received coal from mines

at La Barranca and Suaqui which made its way to smelters in Sonora and Arizona. At Torres a spur line brought silver and gold from the rich La Colorada and Minas Prietas mines, and the Santa Ana branch attended to the Altar district.[88]

The average miles traveled by cargo, approximately two hundred, underscored the active import-export economy which the railroad fueled. From Nogales, the ledgers of the American consular officer included an ever-growing list of manufactured consumer goods, clothing, beer and liquors, luxury items, and heavy machinery. Likewise, Sonoran raw materials and goods flowed to the United States in ever increasing quantities. From Guaymas, J. A. Naugle, the company manager, noted regular shipments of iced fish and oysters. Hermosillo sent pelts, wheat, corn, tobacco, mescal, and other agricultural products, mostly for internal consumption. Oranges loaded at Hermosillo and Guaymas, the only real fruit Sonora exported, reached California, New Mexico, Arizona, and as far east as Chicago.[89] Magdalena and Ymuris furnished cattle on the hoof and horses for export to the United States. Bulk cargoes of copper, gold, silver, antimony, and coal streamed north to processing plants in Arizona.[90]

Besides economic integration, the railroad also ended the state's geographic isolation, bringing large numbers of Sonorans face-to-face with each other. Mining and access to transportation stimulated internal migration, and in the final two decades of the nineteenth century, Sonora experienced sustained patterns of urban growth. By taking people from isolated valleys and small hamlets and bringing them into contact with one another, the contours of a regional culture slowly emerged. Interaction between Sonorans also permitted a greater standardization of cultural practices in dress, food, sports, and language. People from Guaymas found out how people from Hermosillo and Magdalena lived and worked. Dietary patterns became more diversified. Fish and oysters from Guaymas could now be sold in Hermosillo. Products from the ranchos and haciendas around Hermosillo made their way to Guaymas in sizable quantities.[91]

Social interaction, including interpersonal contact, music, and sports, also increased. Musical groups or *conjuntos* traveled from one mining center to another entertaining workers. The northern elite and even some of the common folk commonly vacationed on the beaches surrounding Guaymas.[92] On special occasions, such as the festivities honoring Saint Francis at Magdalena or New Year's in Hermosillo, the Sonoran railroad added additional passenger cars to meet the rising de-

mand.[93] For certain events like the carnival in Guaymas or concerts and political rallies, the company ran special passenger trains.[94] In 1893, for example, it advertised special fares from Nogales during the last two weeks of February to attend carnival in Guaymas. For a round trip fare of 15 pesos in first class and 10 pesos in second class, passengers could travel to Guaymas and stop at any station along the route for as long they desired.[95] Regional festivals, once limited to a given area, became statewide events, adding to the region's folklore. Except for the still-isolated mountain regions of Sahuaripa and Moctezuma and Alamos in the south, contact among Sonorans dramatically increased from 1883 to 1910.

With the establishment of regular transportation, most communities along the route geared their commercial and even social activity to the arrival and departure of the railroad. Writing to Mexico City, Zamora reported that most towns along the line now "tacitly operated on the railroad's schedule."[96] The tempo of cities such as Hermosillo, Guaymas, Nogales, and Magdalena revolved around the arrival and departure of the railroad. The blaring steam whistle of the railroad announced to the entire town the arrival of the iron horse. The train station became the hub of economic, social, and political activity, usurping the previous role of the central plaza. Municipal authorities went to great pains to build and maintain impressive depots. Employees from merchant houses lined up to receive new stocks. Families congregated to greet visiting relatives. Political rallies greeted local and national dignitaries. Buggy drivers eagerly awaited the arrival of passengers. Competing hotels offered free transportation to arriving guests. Vendors hawked their wares and food. Newspapers reported passenger traffic, their nationality, purpose of trip, and length of stay. A new orientation toward business time, set by the railroad schedule, increasingly dictated activities in towns traversed by the railroad.

BREAKING THE ISOLATION

For Sonorans the presence of the railroad produced one additional benefit—it shortened access to Mexico City from over thirty to less than four days. To travel from Hermosillo to Mexico City, Greenville Holms, an American journalist, found it necessary to "return to the United States and make a weary journey through Arizona and New Mexico to El Paso whence the Mexican central Railways runs down to the capital."[97] By following this rather circuitous path, travelers

boarded the Central Mexican railway at Ciudad Juárez and arrived in the capital in less than two days. After 1884, dispatches to or from Mexico City proceeded by this route, as did most political and military appointees. Reversing the roles of years prior, the United States government also granted special permission to the Mexican government to transport troops and equipment from El Paso to Nogales. Finished goods and agricultural products from interior of Mexico also reached Sonora in this manner. Underscoring the dependency implicit in this relationship, whenever American railroad workers went on strike, as they did in 1894 and in 1902, Sonora lost contact with the Mexican capital.[98]

For notables, connections with United States railroads expanded their political vistas and economic orientation. A trip to New York took less than six days and to San Francisco only two.[99] Business interests in American cities took note of developments in Sonora. A reception for the Mexican ambassador, Matias Romero, by New York business circles in 1891 included remarks on the life of Sonoran Carlos Conant and investments in the Yaqui valley.[100] Sonoran politicians and wealthy merchants such as Corral and Camou became regular visitors to American cities. When Corral married Amparo Escalante in 1888, the event appeared in both the *San Francisco Examiner* and the *New York Times*.[101] Other notables also traveled extensively. In 1908, Alberto Cubillas temporarily assumed the governorship when Torres departed for Europe and Izábal for Mexico City. Elites began to vacation outside of the state. The Sonoran railroad offered special excursion fares to Long Beach, Catalina Island, and a host of other tourist attractions.[102] On several occasions, José Camou and his brother visited Hot Springs, Arkansas, and received treatments from the town's clinics before traveling to visit Niagara Falls. They regularly made business trips to San Francisco, Chicago, and New York. No longer imprisoned by natural barriers, Sonoran elites developed broader perspectives of the world around them.

The history of the Sonoran railroad embodies both structural as well as social dimensions. It underscores the relationship between the northern Mexican desire for economic development and the ever-present fear of cultural absorption by the United States. At every turn, proponents of increased relations with the north confronted critics who feared a loss of Mexican identity. This issue did not disappear with the completion of the railroad. As skeptics had feared, economic activity permitted local Porfiristas to solidify their grasp on power. Likewise,

notables consolidated their control over northern land and commerce. As could be expected, new power centers in the north, such as Hermosillo, grew while those in the south languished. In the northern urban areas, commerce and economic activity with the United States increasingly dictated the tempo of city life. While accentuating economic relations with the Americans, rail transportation also permitted the integration of the northern Sonoran economy, bringing significant numbers of state residents face-to-face with each other. Beside cultural exchange, this unexpected outcome provided the foundations for broader political participation and collective action.

Despite the rhetoric of their earlier speeches, state politicians did little to actually strike a balance between American investments and Mexican interests. Their decisions on issues that pitted Mexicans and Americans against each other betrayed their growing partnership with the foreigners. The state government urged Sonorans to go out of their way to welcome Americans entering the state since they were "the agents of progress."[103] For their part, state leaders announced they would do everything in their power to facilitate American investments, and the history of the Sonoran railroad verified this assertion.

Between Cultures

Towns on the Line

After 1880, increased trade and the completion of the Sonoran railroad led to the founding of border towns such as Nogales, Sonora, and Nogales, Arizona. Prior to this period, no communities had existed along the Sonora-Arizona border. Cross-border relations did not develop along a linear plane, and face-to-face contact did not lead to acculturation and the emergence of a new border culture shared by all *fronterizos* (border residents). Rather, border society reflected an ongoing process of conflict, exchange, adaptation, and reinvention propelled by class, the character of economic exchange, the area's relation to the national economy, gender, and immigration. These factors influenced the nature and character of border relations and the development of common sets of practices between border towns.

Class interest appears critical to an understanding of early relations along the Sonora-Arizona border. Ambos Nogales, the American and Mexican communities, owed their existence to economic exchanges between both countries. Unlike their counterparts along the Rio Grande, and later in California, Arizona's settlements depended almost exclusively on trade or mining with Mexico for their survival.[1] Mexican and American merchants established an early rapport, influencing relations between both towns. Economic interdependence forced a degree of accommodation not usually witnessed elsewhere along the United States—Mexican border.

Economic integration also established the framework for a broad exchange of social and cultural practices between American and Mexican border towns. To speak of a distinct border culture shared only by fronterizos remains problematic. Rather it would appear that direct exposure to Mexican and American culture expanded the cultural repertoire of fronterizos, permitting each to function in the world of the other. Americans incorporated Mexican customs yet still preserved their own traditions. Likewise, Mexicans adapted American practices while retaining their previous norms. Mexicans did not become Anglicized any more than Americans became fully Mexicanized. Rather than cultural stripping, this sharing produced a complex layering of culture.[2]

The often-cited notion that people along the border forge their sense of identity only in relation to the other, to the American or the Mexican, does not fully capture the complex social layers found in border society. Here again questions of class, generation, immigration, and other issues complicate how individuals, or even a society, view themselves or their relation to others. In particular, class must be considered in an assessment of identity and border relations. Elites and the middle classes whose livelihood depended on economic exchange had a vested interest in promoting good relations. Economic interests on both sides shared a common vision and sought to impose their views on the local communities. In the early years, while the towns population remained small, they succeeded in implanting their perspectives. Other social groups, especially recent arrivals, did not see a direct benefit from close exchange and, at times, impaired elite plans. As populations increased on both sides of the border and interaction led to conflicts, officials of both nations sought ways to limit contact between Mexicans and Americans.

RANCHO LOS NOGALES

Prior to the arrival of railroad workers, a patch of walnut trees along a small stream marked the site of the future Nogales. Acquired in 1841 by José Elías, the area known as Rancho Los Nogales straddled both sides of the future border. The property changed hands on several occasions, a portion being purchased in 1857 by Tomas Robinson and finally by José Camou of Hermosillo in 1871. The demarcation of the border in 1853 began the transformation of the once peaceful walnut groves. William Emory, a member of the United States Mexican bound-

ary commission, reported visiting "Los Nogales" sixty-nine miles south of Tucson to begin survey operations on the border. He described the area surrounding Los Nogales as "refreshing to the senses, . . . clothed with green verdure."[3] After completing its mission, the United States–Mexican border commission erected a stone monument at the site of Los Nogales, officially demarcating the territory between both nations. With the American acquisition of Arizona, title to the land on the American side became mired in controversy.[4]

To control the growing contraband trade, the Mexican federal government in August of 1880 declared Los Nogales an aduana. The first Mexican agent assigned to the site, Jacobo Andonaegui, operated the customshouse from a under a tattered tent.[5] Not long after, Nogales began to draw the attention of Mexicans and Americans. On the Sonoran side, José Juan Vásquez opened a small store and a rustic *posada* (inn) for travelers.[6] On the Arizona side, Jacob Isaacson established a shop, operated a post office, and tried to function as the de facto authority of the American camp. Even with the arrival of the customs station and the presence of Vásquez and Isaacson, the future of Los Nogales remained in doubt.[7]

The initial railroad contract with the Mexican government called for a line to El Paso, not Nogales. As tracks moved north, the company convinced the federal government to abandon the Texas route and proceed directly to Arizona. In part the decision reflected the rapid pace of rail construction in Arizona by the Southern Pacific (from California) and by the Santa Fe (from New Mexico). Engineers still had not resolved a crossing point into the American territory, and no consensus existed as to where to lay the tracks. Originally the company proposed to run the line from Hermosillo toward Ures and then Bacuachi, following the course of the Sonora River. The area was home to powerful hacendados and included some of the state's most productive lands. Still, the valleys and steep mountainous terrain would dramatically increase the cost of construction. The Mexican engineer assigned to the project, Leopoldo Zamora, estimated that the Sonora River line would cost $850 thousand compared to $496 thousand for the flatter Magdalena route. Cost carried the day and assured the future of Nogales and the demise of communities along the Río Sonora, including the old state capital, Ures.

As railroad crews moved north and made their way through the Cocospera Canyon in the district of Magdalena, people began to trickle

into Nogales. Railroad workers and a few shrewd merchants constituted the first wave of residents. Even during this embryonic phase, differences between both settlements became apparent. One of the first permanent settlers of Nogales, Arizona, John T. Brickwood, recalled that buildings on the American side had been constructed from wood frame and on the Mexican side from adobe.[8] Still most observers did not think the settlement had much of a future. In October 1882 the Mexican consul at Tucson reported to Mexico City that the encampment along the border had no importance whatsoever: it consisted mainly of railroad workers who established there a small outpost "which they will undoubtedly tear down as soon as the work is completed."[9] Several American observers who visited the site echoed the consul's sentiments. Ripley Hitchcock, a railroad engineer, described Nogales as "a dozen shacks and tents and as many mountains of empty beer bottles."[10] Since male railroad workers constituted the core of the early population, the encampment had a considerable number of gambling saloons, dance halls, and brothels.[11] A retrospective of the town done by *El Monitor,* a Nogales newspaper, claimed that the early camp had few redeeming qualities since workers squandered their earnings at two temples, one to Bacchus and the other to Venus.[12]

October 25, 1882, the day anxiously awaited by both Sonorans and Arizonans, finally arrived. With great fanfare, the two rail lines met at Los Nogales thereby assuring the future of both towns. Agnes Morley, daughter of the American engineer in charge of the project, described the meeting of the rails.[13] Mexican flags draped the engine of the Sonoran railroad as it approached Nogales, where American and Mexican women smashed bottles of champagne on the locomotive. Within two years, Nogales, Sonora, had a population of over one thousand residents and officials declared it a state municipality.[14] To secure land for the Mexican town, the Sonoran government signed a formal contract with the Camou family. J. J. Vasquez became the Mexican town's first police *comisario,* a post he held for many years. Whereas towns throughout the interior of Sonora waited years to be declared a municipality, Nogales achieved this status in short order.

The federal government assured the future of Nogales by granting the northwest special trading status. Building on earlier policies initiated by Benito Juárez, Porfirio Díaz extended the Zona Libre to include the most important ports of entry in the Mexican north: Matamoros, Nuevo Laredo, Piedras Negras, Paso del Norte, and Nogales.[15] In 1884

Díaz decreed that foreign goods stored and consumed by border cities would not be subject to taxation,[16] and in November of that year, the federal government assigned new customs agents to take charge of the Nogales aduana.[17] Despite American pressures, the Zona Libre eventually incorporated all of the northern border.[18]

EARLY SETTLEMENT PATTERNS

The population of Nogales, Sonora, did not resemble the stereotypical mining or frontier boom town. In its early phase, the number of immigrants seeking work remained small. While the growth of cattle, agriculture, and smelting served to entice laborers to El Paso–Ciudad Juárez, similar conditions did not exist around Nogales.[19] Sonora's principal mining and refining operations lay inland at Minas Prietas, Nacozari, and Cananea. Economic activity in Nogales centered on trade and cattle, neither of which required large numbers of workers. The records of the largest ranches in the area, La Arizona and Santa Barbara, showed a stable number of laborers, mostly Yaqui Indians.[20]

Nogales's earliest residents included a sizable number of aspiring merchants as well as former government officials seeking to take advantage of expanded ties with the United States. Many of these, like the Camou family, had already profited from trade with Arizona and moved to the border either to expand operations or to initiate new ventures. Because the town was at an altitude of over 4,000 feet and had a mild climate, many of Sonora's affluent families, some from as far away as Guaymas, built summer residences in Nogales. The border town became a favorite retreat for Sonorans trying to escape the hot July and August nights of Hermosillo and Guaymas. These merchants and their allies in the aspiring middle classes, took over the reins of this nascent community and charted the town's development. Nogales' relatively small population—by 1893, for example, it still only had about 4,000 inhabitants—facilitated their control of the border community.

Among Nogales' first influential settlers were Manuel Mascareñas, a hacendado and politico, Ignacio Bonillas, an engineer born in Tucson, and businessman Próspero Sandoval. Most of these individuals had been minor players in the interior. On the border, however, they acquired status as international traders or customs brokers, selling and ordering goods from the United States for Mexican clients and shepherding the goods through a maze of customs regulations instituted

by both countries. With its majestic marble pillars and bell tower, the Mexican customshouse in Nogales, Sonora, dominated the urban landscape, symbolizing the importance of commerce to the survival of border towns.

Manuel Mascareñas Porra appears typical of the Mexicans who established operations in Nogales. He arrived in Guaymas from Durango in 1873 and married Luisa Navarro, spending most of the decade of the 1870s in the port, where he dabbled in commerce and politics. He served several terms on the Guaymas city council. Subsequently, he moved to Hermosillo where he formed a partnership with Rafael Ruiz and opened a small retail business. Mascareñas continued to take part in politics, being elected several times to the Hermosillo town council. In 1883 he joined the land rush to the north and purchased the hacienda *Santa Barbara* which consisted of more than 15,000 hectares. By 1900, after acquiring adjacent lands, he had amassed more than 36,000 hectares.

At first Mascareñas focused his attention on cattle ranching, importing American Herefords to breed with Mexican cattle. In a few years he had one of the most productive and profitable cattle enterprises in the north, exporting large amounts of beef to the United States by rail. The ranch also produced wheat, corn, and other agricultural staples, which grew along the fertile bottom land adjacent to the Santa Cruz River. Together with the neighboring *La Arizona* ranch, owned by Guillermo Barnett, *Santa Barbara* supplied much of the agricultural products consumed by the two Nogales.[21] It wasn't long before Manuel Mascareñas became involved in Nogales politics. By 1887 he had been elected municipal president of Nogales, later becoming the Mexican consul in Nogales, Arizona, and serving in that capacity until the outbreak of the Mexican Revolution.

Anglo-American inhabitants of Nogales, Arizona, had previous experience in trade and mining in California and Nevada. Settlers in Nogales included long-time miners in the southwest such as John T. Brickwood, John J. Noon, and George Christ, as well as recent immigrants from Europe such as Luis Proto. John Brickwood reflected the experiences of many of the first Anglo-Americans who settled at Nogales. Born in Illinois in 1849, he migrated first to California in 1869. After less than one year, he relocated to Prescott, Arizona, where he continued to work in mining. Attracted by the news of railroad construction in the southern portion of the state, he moved to Tucson

in 1879 and, in his words, became involved in the "saloon business." He arrived in Nogales in 1882, married a Mexican woman named Guadalupe Cañes, and had ten children with her. Beside a saloon and hotel on the border, he also acquired more than eighty acres of land along the Santa Cruz River which produced wheat and corn.[22] He took an active role in politics and served as mayor of Nogales. Born in Greece in 1854, Luis Proto emigrated to California in 1878. After a stint in Tombstone, he relocated to Nogales, Arizona, where he opened a grocery store. As appeared to be the case with most American settlers, he acquired land in the Santa Cruz valley and also owned several mines in Sonora.[23]

AMBOS NOGALES

On the United States and the Mexican sides, several different names surfaced for the new towns. The Mexicans settled on the name Nogales. In 1889 the Mexico City Club Democrático Romero Rubio attempted to have the city renamed Ciudad Dublán, after the Mexican finance minister Manuel Dublán. Ramón Corral, then governor, opposed the name change, and the state legislature never acted on the proposal.[24] On the American side, the local postmaster, Isaac Isaacson, sought to name the town after himself. Isaactown, however, did not prove popular among early residents and the name quickly faded. Most early residents began referring to the American town as Line City, denoting its border status. Eventually, Americans also christened their town with the name Nogales. The change in name underscored the growing interrelationship between the towns.

From their inception, the two Nogales became links in the thriving copper mining and commercial trade between Sonora and Arizona. Economic activity in Sonora, principally in mining and agriculture, became the motor which sustained these communities. The limited mining and cattle ranching on the American side could not ensure the growth of the Arizona community. The number of stores in the Arizona town surpassed the demand of the local community and the Santa Cruz Valley. With most economic activity centered south of the border, merchants in the American town slowly grew dependent on their Mexican customers. Reliant on trade with Sonora, Americans in Nogales, Arizona, had a vested interest in promoting cordial relations between the two cities.

ECONOMIC AND SOCIAL COOPERATION

The pattern of stable relations is attributable in part to the lack of direct competition between American and Mexican business interests. Arizona merchants specialized in products not easily obtained in Mexico, such as mining equipment, agricultural implements, and a wide array of American consumer goods, and the large Mexican houses featured imported European products and luxury items made prohibitive in the United States by elevated import duties. In addition, Mexican businessmen also established small-scale textile operations, importing American fabrics and manufactured clothing which then, much to the chagrin of merchants outside the Zona Libre, reappeared as Mexican goods.[25] Americans and Mexicans enjoyed the benefits of border commerce. Mexicans purchased many of their consumer goods on the American side, and Americans walked across to the Sonoran side to buy Parisian fashions at emporiums like "La Moda," owned by merchant José Camou. Mexican bakers, butchers, and grocers sold their products on the American side.[26]

Saloons, dance halls, and other establishments of ill repute also proliferated in both towns. Initially, some of these businesses, such as Brickwood's Saloon, actually straddled the border; patrons could evade the laws of either country by simply moving from one side of the room to the other. By sitting astride the border, Brickwood's Saloon, known as the "Exchange," developed an ingenious method of circumventing the laws of both countries. For instance, if American customers wished to purchase imported cigars prohibited in the United States, they simply moved over to the Mexican side of the counter to make their purchases. First-time American visitors to Nogales were urged to "eat and sleep on the Arizona side and drink and smoke on the Mexican side. The purchasing power of the American two bits doubles on the Mexican side of the line."[27] In the opinion of the American journalist, John Reed, "the inhabitants of the American town go across the line to get good things to eat, to gamble, to dance and to feel free; the Mexicans cross to the American side when somebody is after them."[28]

The early American residents of Nogales, Arizona, recognized the importance of maintaining good relations with Mexico and its people. Unlike the history of conflict which marred border exchanges in Texas, the Americans of Nogales spoke of a growing interrelationship with the Mexican town. Local officials took pride in the fact that no physical barriers separated their towns. In describing their interdependence, the

Oasis, a Nogales, Arizona, newspaper, asserted that "we speak of the two towns,—as one, for they are really such, being divided by an imaginary line only, which passes along the center of the international strip, or more properly speaking street."[29] A stone marker in the middle of Calle Camou on the Mexican side and International Street on the American side delineated the limits of both towns.[30]

Out of practical necessity, business interests in Ambos Nogales learned to cooperate with each other. Retailers on both sides formulated agreements to regulate the hours that stores opened in order to avoid undue competition and "the mid-day heat."[31] By closing during the noon hour, American businessmen incorporated a Mexican custom. American and Mexican merchants also freely accepted either the peso or the dollar in commercial transactions, a practice frowned upon elsewhere in Arizona.[32] The merchants of Nogales, Arizona, directly competed with their Tucson counterparts for control of the Mexican trade. The absence of a direct rail line to Tucson until 1907 and the refusal of many merchants in the old presidio to accept the Mexican currency benefited Nogales merchants.[33] As competition for Mexican business increased, the Nogales *Monitor* argued that Mexicans should shop where their currency is accepted and where merchants treated them with respect.[34]

Border newspapers recognized the economic advantages of publishing bilingual editions. In 1885 John Ginn announced that his publication, the *Nogales Frontier,* had become the "leading paper of Southern Arizona and the Mexican state of Sonora, being a bilingual journal published immediately on the border."[35] Since Ginn had no competition, his claim went unchallenged. Not long after, in 1886, *El Monitor,* a Mexican publication also began to print an edition in both languages, proclaiming that it was the only Mexican "bilingual paper this side of the Rockies, with circulation in both the United States and Mexico."[36] While not printed in Spanish, the enduring *Oasis* newspaper, published by Allan T. Bird, maintained a regular section entitled "Sonora Shifting," which reported the latest news from the Mexican state. Bird became a de facto publicist for Sonora. His *Land of Nayarit,* published by a local business group, and *Sonora, Mexico,* sponsored by the Sonoran railroad, promoted trade with Mexico and received wide distribution throughout the United States.[37]

Spanish became as common on the American side as it was in Mexico. Delos Smith, the United States consul at Nogales, recognized the advantage of having Americans learn Spanish, arguing that it "would

secure to [Americans] the double advantage of business and pleasure."[38] Out of necessity, American merchants and their employees learned Spanish. Most hired Mexican employees, while others went even a step further. Charles Bracker, scion of one the Arizonan town's merchant families, eventually began sending his children to Mexico City to the *Colegio Franco-Español* to learn Spanish. Upon graduation his off-spring returned to work in stores which served the ever-growing Mexican community.[39]

ELITE CONSENSUS

Mexican and American civic leaders met regularly and exchanged views on matters involving their towns. Many, like A. L. Peck, George Marsh, Edward Titicomb, Anton Proto, Ignacio Bonillas, Manuel Mascareñas, and Prospero Sandoval, belonged to the same social clubs. The Nogales chapter of the Masons, Lodge 9 of the Free and Associated Masons, promoted the rapport between both towns. Arizona's "pioneer lodge," the Aztlán chapter, received its charter in 1886.[40] Since no Masonic organization existed on the Sonoran side, the American group sought and obtained special permission to accept Mexicans as members of their lodge.[41] Mexicans such as Manuel Mascareñas, Ignacio Bonilla, and others became officers, achieving the highest ranks of the organization.

The growing rapport between Ambos Nogales extended to the government of both cities. Town leaders sought to resolve local matters on a personal basis without involving officials from their respective governments. A letter from the leaders of the Masonic lodge of Nogales, Arizona, to Mascareñas, then president of the Nogales, Sonora, city council recognized "that petty international questions are almost unavoidably owing to our peculiar international situation. We believe that such questions, not affecting the dignity of either nation can best be settled among ourselves without involving our respective governments in vexatious international controversies."[42] This collaboration included practical matters, such as commerce, defense, the law, and even personal favors among leading residents of both communities.

Mexicans and Americans developed separate social and political organizations yet openly cooperated with each other. Here again, the elites who led these organizations played an important role in assuring cooperation. In 1890 a group of leading Mexican citizens of Nogales, Sonora, founded the Sociedad de Artesanos de Hidalgo and the Club Filarmonico. Mascareñas served as the first president of the society.

On the Arizona side the men's athletic club, which was established in 1898, sponsored fencing exhibitions and weekend dances attended by Nogalenses from both sides. Affluent youth also formed the Nogales Yacht Club, and when the rain-swollen Santa Cruz River permitted, they tried to sail flat bottom boats to Tucson.[43] The Nogales Arizona Women's Beneficence Club, and later the Woman's Auxiliary, brought together elite women from both sides of the border. Its leaders included Adelaida and María Camou, Luisa Mascareñas, and other prominent Mexican women.[44] The Nogales Women's Club sponsored programs on the culture on both countries, including offerings on "Mexican music" and on "American Negro folk songs."[45] Mexicans and Americans could be found at activities sponsored by any of the area's social clubs. When the women's club staged a fund-raising dance, the *Estado de Sonora* reported that the hall was filled with "bankers, merchants, government employees and the cream of the youth of ambos Nogales."[46]

Over time, relations between Ambos Nogales extended beyond economic self-interest to include family and a lifestyle which drew strength from both sides of the border. Since the Mexican municipio lacked funds, many Sonoran children attended school on the American side. According to Ada Jones, an early school teacher, the first school in Nogales, Arizona, started by gathering all the Mexican children in the towns, whether they were citizens or not.[47] Teachers in Nogales, Sonora, regularly crossed the border to work in private American schools that paid higher wages. The American consul at Nogales boasted that family relations straddled the border and most residents had relatives on both sides.[48] Marriage among Mexicans and Americans also occurred frequently, especially among American and Mexican notables. By marrying the sister-in-law of Ramón Corral, Captain James L. Mix, a building contractor and mayor of Nogales, Arizona, acquired important political and economic connections.[49]

As social interaction increased, American practices became familiar on the Mexican side, and Arizonans gradually adopted traditional Sonoran customs and diet. Americans regularly patronized public events held in Nogales, Sonora.[50] During Christmas, Americans frequented dances and posadas held on the other side or "el otro lado."[51] One Christmas, Nogalenses from Sonora actually raised funds to buy an American Christmas tree and had it shipped from Oregon. The fully decorated tree was displayed in the city's central plaza.[52] Mexican festivities commemorating the Battle of Puebla and Mexican independence on September 16th usually drew large numbers of North Ameri-

cans.[53] Processions for the festivities invariably crossed the border as both towns joined in the celebration.[54]

On occasion, the cities cooperated and staged joint events. Efforts to promote commerce and tourism fueled much of these early cultural exchanges. Beginning in 1895, Ambos Nogales sponsored a "Latin American" carnival. Promoters on the American side compared the border celebration to the New Orleans' Mardi Gras and launched a campaign to attract tourists from nearby states. Accordingly, they announced that "the fiesta will be remarkably successfully and will draw a large concourse of people from all parts of Arizona, New Mexico and Sonora."[55] The sight of Americans and Mexicans dressed in costumes, riding on carros alegoricos and "throwing flour on each other" even attracted the attention of the *New York Times,* which described the event as "an international episode of the most commendable sort."[56] The next year both towns once again sponsored the event, which this time culminated in a masquerade ball in Nogales, Arizona.[57]

Festivities provided the opportunity for the beginning of a new political tradition, the meeting of American and Mexican presidents, as well as governors, on the border. The first such formal meeting between the governors of Sonora and Arizona occurred on the occasion of carnival in Nogales in February 1895. Sonora's governor, Rafael Izábal, accompanied by Ramón Corral and Arizona's governor, L. C. Hughes, and several military officers exchanged views on trade and commerce in Nogales. Hughes's final public comments summarized the character of the exchange between the governors: "I believe the time is coming . . . when this Western hemisphere will be a sisterhood of republics, will be bound together by international bands of steel reaching from Hudson Bay to the uttermost ends of Tierra de Fuego. Then will the destiny of the Western Hemisphere be fulfilled."[58] One hundred years later, this view still dominates public discourse between border officials.

BORDER LAW ENFORCEMENT

With no fences between Ambos Nogales, the enforcement of two sets of laws had the potential of complicating relations between both towns. American and Mexican officials regularly circumvented laws to apprehend prisoners without concern for formal legalities. In 1885 Mexican municipal authorities arrested J. J. Vásquez, the Nogales, Sonora, chief of police for having delivered an American, John DuBois, to the United States sheriff without formal extradition proceedings. Corral, the gov-

ernor of Sonora, ordered him released, insisting that Vásquez served as his "personal extradition officer."[59] In another case, Sheriff Roberts, of Nogales Arizona, crossed the line to break up a fight between two intoxicated Mexicans. Both spent the night in the American jail. The next morning Roberts turned them over to his Mexican counterparts.[60] Despite local protest, police continued this informal cooperation.

Cross-border exchanges involved more than just criminals and attest to the level of accommodation which existed between authorities of both towns. In one instance, Sonoran officials, including the governor and the Mexican consul, conspired to transfer a mentally impaired individual from Guaymas, where no medical facilities existed, to Phoenix, where a new territorial mental hospital had just opened.[61] The person was moved from Guaymas to Nogales on the night train "so that suspicion could be avoided." At the border, Mascareñas arranged an elaborate ruse with the Nogales, Arizona, constable James Speedy, a Chilean by birth, to sneak the man over and then have him arrested.[62] Mascareñas informed Governor Corral that "the precautions which we took to bring him on Wednesday are because at night the Odd Fellows are sponsoring a dance to which all the police force belongs, thereby leaving the streets empty for this discreet effort."[63] Although Speedy arrested the man, the scheme did not go as planned. The next day at the "arranged" court hearing, a visiting territorial officer, Sheriff Brochman, wanted proof of the detainee's nationality. His actions forced a local judge to release the imprisoned Mexican. Mascareñas quickly intervened and under orders from another judge, the authorities rearrested the man. In a touch of poetic justice, the presiding magistrate, a personal friend of Mascareñas, ordered the territorial sheriff who had derailed the plot to personally accompany the man to the asylum in Phoenix.

Not everyone in Mexico viewed the growing cooperation between Mexicans and Americans with approval. After the completion of the railroad, differences between Sonorans and officials in Mexico City surfaced. With the union of the Sonoran railroad with the Atchison-Topeka and Santa-Fe, local officials commissioned the construction of a depot at Nogales to be shared by both nations.[64] Without a formal station, the depot and express offices had been operating out of a train car.[65] In order to facilitate cargo and passenger inspections, Sonoran officials built the station atop the actual border, one half of the structure in Mexico and the other half in the United States. As usual, local authorities forwarded copies of the building's blueprints to the secre-

taría de fomento for approval. Officials in Mexico City became out-
raged, and after consultations with President Díaz, the minister of de-
velopment informed the governor that under no circumstance would
the federal government approve "a common station for both coun-
tries."[66] Sonoran officials won a temporary reprieve complaining that
funds did not exist to build a new station. Eventually, however, the old
station fell, and a new structure built "exclusively on Mexican terri-
tory" was approved.[67] For merchants of Ambos Nogales, placing the
station astride the border represented good business practices—ques-
tions of sovereignty did not intrude into their thinking. The Mexican
federal government closely monitored developments along the border,
and Sonoran officials gradually lost their previous autonomy.

NACO AND AGUA PRIETA

By the 1890s the expansion of mining in Northeastern Sonora, princi-
pally at Cananea and Nacozari, led to the founding of other border
towns, such as Naco and Agua Prieta. American counterparts to these
communities soon evolved. Opposite Naco, Sonora, appeared Naco,
Arizona, and across from Agua Prieta sprang up Douglas, Arizona. As
had been the case in Nogales, modifications in language and customs
became readily apparent in these communities.[68] After its initial settle-
ment in 1899, Naco, Sonora, grew rapidly. Railroad workers and em-
ployees of the new aduana became its first settlers.[69] The first census
recorded a total of fifty-nine Mexican residents—fifty-one men and
eight women. The numerical imbalance between men and women re-
sembled that in other new northern settlements. Usually men settled
first and families followed after the town's founding. The establishment
of a new border settlement also lured foreigners including seven French
and seven American men as well as three French women.[70] Naco at-
tracted established figures as well as young upstarts who hoped to du-
plicate the earlier success of Nogales. Wealthy merchants such as Leon
Horvilleur and the Donnadieu brothers established operations in Naco.
Both ran stores in Nogales—Horvilleur in partnership with the Camou
family and the Donnadieus as a family business. The 1899 census also
recorded the presence of a young Plutarco Elías Calles, who hoped, as
did many residents, to improve his fortunes by settling in the new bor-
der town of Naco.[71] Calles later became mayor of Agua Prieta, another
nearby border town.

The first urban plan drawn up for Naco, Sonora, coincided with the

layout of Naco, Arizona. Blocks were mapped out identically on both sides of the border so as to give the towns a degree of continuity and "symmetry pleasing to the eye and providing greater access."[72] Streets on the Mexican side corresponded with streets on the American side. In this manner, homes on the Mexican side faced north and on the American side faced south. On the Mexican side, behind the homes, back alleys ran east to west. By incorporating alleys, Mexicans adopted a typically American construction design to keep unsightly trash out of view. But with few public services, they soon became deposits of refuse, according to the district prefect.[73]

Manuel Terra, the prefect of Arizpe, oversaw the initial development of Naco, Sonora. Beside alleys, homes in Naco represented the pattern of construction design along the border—half the homes were made of wood frame and half of the traditional Mexican adobe.[74] The first settlers built their dwellings in conformity with this plan. Unlike Nogales, Naco and Agua Prieta had sources of employment across the border. American smelting and mining operations attracted people to the northeastern Sonoran border. As newcomers arrived, the initial urban scheme quickly broke down, and the police constable, the highest authority in the town, allowed immigrants to build homes as their means allowed. As property along the border acquired value, most border towns, including Naco and Agua Prieta, witnessed long, drawn-out conflicts over land ownership. The price of land, especially on the Mexican side, became prohibitive as Mexicans and Americans speculated with border property.

Allegedly concerned by the haphazard manner in which Naco developed, in 1899 the state government ordered engineer Ignacio Bonillas, a trusted ally, to draw up a reorganization plan for the settlement. This review of Naco appears to have been conducted at the behest of American interests who owned the land. In drawing up the urban plan, Bonillas ceded property to the municipal authorities for public buildings and a central plaza. Under instructions from the American company, he then planned to review property titles, expel those who had settled illegally, and sell the remaining lots to the many newcomers. The new plan also reduced the size of lots to accommodate the growing population. In reality, the American company simply wanted to profit from its property, which had increased in value since the settlement of the town.

The problem at Naco had many layers of complexity. More than sixty men and women sent a letter to the governor, pleading that their dwellings should not be adversely affected so that "newcomers could

take over from the people who had struggled in this place when times were difficult."[75] Ironically, the complaints included the wealthiest merchants, such as Horvilleur, Donnadieu, and Sandoval, who feared that their business interests would be harmed by the changes Bonilla envisioned. They had other reasons for concern. In the early months of the town's founding, they claimed possession of upwards of five lots on the principal streets, hoping to speculate on future property values and expand their commercial operations as the town grew. Unable to own the land outright, they acquired the lots employing the age-old practice of presta nombres. Jacobo Mendoza, the local police constable, confirmed that several leading merchants obtained lots using other people's names.[76]

Beside protection of their land holdings, another issue appeared foremost in the minds of merchants. They did not want a new urban plan to upset Naco, Sonora's symmetry with Naco, Arizona. Instead, they hoped that physical continuity between the towns would facilitate interaction and attract American customers to their stores. They feared that urban growth, especially giving land to poorer residents, who would build haphazardly, would upset their plans. The constable wrote Hermosillo for direction on how to proceed. The governor's office instructed Mendoza that the Americans "were within their rights and could proceed in the defense of their interest as they saw fit."[77] Not satisfied with the response, the wealthy merchants continued to apply pressure on the state, blaming the local comisario for the town's problems. The state eventually drew up a new urban plan, but it did little to resolve the predicament faced by Naco. Residents continued to complain that a few influential individuals monopolized land and they could not obtain title to their lots.[78]

Nearby Agua Prieta confronted similar problems, in this case inspired by Juan P. Camou, who sought to profit from the land he had purchased earlier. Camou won clear title to the property after the state government denied a claim by Plutarco Elías, Sr. After winning the case, the older Camou set about demarcating town lots and trying to sell them at inflated prices. Eventually, even members of his family took issue with his practices. They argued that the Camous should strive to control the commerce of the fifteen hundred residents, not monopolize the town's land. In one letter, Rafael Camou chastised his father, arguing that "with the prices you are charging not only are you not selling lots, but families are beginning to move to the other side."[79] The elder Camou's plan to profit backfired. Facing outrageous prices in Agua

Prieta, Mexicans moved in larger numbers to Douglas, Arizona, where they could purchase lots from Americans for fifty pesos, paying in installments of five pesos a month. The avarice of Sonoran notables drove some Mexicans from their own country.

Cultural dilemmas also surfaced. During a *visita* (official inspection) in 1901, the new district prefect, Ramón Cárdenas, reported that in Naco no one used the metric system—lots for houses had been measured in feet, and merchants sold goods by the pound, not the kilo. The signs in stores, cantinas, and hotels were in English. Merchants charged for goods in *oro* (American dollars), not Mexican pesos.[80] Fearing a loss of sovereignty, the prefect ordered that all lots be measured only in meters and that English signs were to be taken down, but few merchants paid attention to his orders. In Agua Prieta similar changes also transpired. Forty-five residents signed a petition in 1907 complaining that the town's principal avenues had become a haven for saloons, prostitutes, and opium smokers.[81]

PHYSICAL ASYMMETRY

Gradually, urban conditions in border towns like Nogales became unequal. The American town slowly acquired advantages in many areas including school buildings, public administration, and municipal services such as lighting. For Sonorans, the American towns invariably became a point of comparison for their own conditions. Many could not understand why their community could not keep pace with changes on the other side. An editorial in the *Estado de Sonora,* a local publication, summarized the view held by many Mexicans and argued that Sonorans should be entitled to the same advantages enjoyed by the neighboring Arizona community.[82] To keep in step with the Americans, they demanded that Nogales be assigned a judge of the first instance and that the local school be improved. When the city council of Nogales, Arizona, approved an ordinance for licensing dogs, the Mexican town, not wanting to be left behind, quickly passed a similar law. Since canines did not respect international borders, both cities eventually recognized the other's licensing system.[83]

CLASH OF CULTURES

Local notables could not always ensure harmonious relations between border towns, and at times, differences between Americans and

Mexicans erupted into open conflict. Although commonly described as "twin sisters," Ambos Nogales, according to the *Arizona Graphic,* a Phoenix magazine, still maintained different public identities, "one blonde and the other brunette."[84] Shared locale or not, Nogales, Sonora, still represented the traditions of Mexico, and Nogales, Arizona, those of the United States. Border life involved a intricate balance of diverse cultures and interests. As the border attracted immigrants from the United States and Mexico, life along the line became increasingly complex. With no obstacles barring contact, conflicts between individuals frequently spilled over the border. Clashes ran the gamut, including those between estranged couples, common fistfights, and on occasion, even major international confrontations such as occurred during the Mexican Revolution. Local government officials—Mexican and American—repeatedly tried to negotiate amicable solutions to disputes between Sonorans and Arizonans. If not resolved quickly, personal clashes between Mexicans and Americans could escalate into international incidents.

One such case occurred when the commander of the Mexican federal garrison in Nogales, Colonel Francisco Arvizu, who was romantically involved with a Mexican woman living on the American side, dispatched a squad of men under Lieutenant Benjamín Gutiérrez to bring her to him.[85] Once on the American side, the troops engaged in a shootout with the sheriff of Nogales, Arizona. Although the Mexican soldiers escaped with only light casualties, "excitement ran high on both sides and further trouble was anticipated."[86] Town leaders tried to diffuse the crisis, but to no avail. In the middle of the night, Colonel Arvizu returned to the American side, commandeered the saloon, and "threw a glass of liquor into the face of a Mexican woman, claiming that she was too friendly with Americans."[87] Authorities had hoped to contain the matter locally, but newspapers quickly reported the incident throughout the Southwest. Sensationalist headlines in West Coast newspapers proclaimed "Frontier Fight, one of the trespassers shot dead, the greasers threaten more trouble."[88] A contingent of the United States cavalry from Fort Huachuca arrived, and tensions along the border heightened. To resolve the incident, President Porfirio Díaz dispatched the governor of Sonora, Luis Torres, to Nogales where he remained for nearly two months.[89]

For many Sonorans, the Arvizu case exposed the duplicitous nature of the Sonoran government. In Nogales, Governor Torres, who in his words had sought to make Sonora "safe" for foreign investors, publicly

regretted "that a bunch of soldiers under a drunken commander should ruin in a moment, what has caused me years to accomplish."[90] Torres came under intense attack for attempting to appease the Americans. *El Eco de la Frontera,* which supported the candidacy of José M. Maytorena in upcoming elections, attacked him for "groveling before the Americans."[91] As criticism mounted of Torres' handling of the Nogales incident, the governor ordered a general crackdown on the opposition press in his state. In Guaymas the editors of *El Sonorense,* Alejandro Wallace, David Oviedo, and Miguel Campillo, were incarcerated. Likewise in Hermosillo, authorities apprehended the staff of *El Pueblo,* including J. M. Salido and Agustin Pesqueira. The arrests made the front page of the *New York Times,* which predicted that further reprisals could be anticipated.[92] Publishing from the safety of Arizona, *El Eco de la Frontera* continued to criticize Torres, accusing him of embezzling government funds from the recent sale of several mines to Americans. Unlike many Sonorans, however, officials in Arizona looked positively upon Torres' intervention in the Arvizu matter. When he continued to be attacked by *El Eco de la Frontera,* Arizona officials obliged his request and suppressed circulation, declaring the Spanish-language publication to be libelous.[93]

The Arvizu incident symbolized the asymmetrical relationship between Mexicans and Americans, and the case tapped into a deep-seated stream of popular resentment against the Americans. In referring to conflict between Mexicans and Americans, newspapers commonly made mention of Arvizu.[94] Torres' handling of the Arvizu case made him a political liability in the upcoming elections. Díaz ordered him to remain in Nogales until tensions decreased throughout the state. Lorenzo Torres, (no relation), a military commander who had gained fame in fighting Apaches, became the government's candidate in 1887. After winning the election he requested a leave, and Corral assumed the governorship. Don Luis took an extended vacation to the United States.

Government troops eventually captured Arvizu and his men. Díaz instructed that under no circumstance should Arvizu be turned over to American authorities, indicating that "although he is a miserable man, he still is Mexican."[95] Díaz ordered that his trial be held in the interior of Mexico, away from the border and the American press.[96] A military tribunal eventually sentenced both men to die by firing squad. Merchants in Nogales, Arizona, recognized that the death of Arvizu might permanently sour relations between both towns. Already one attempt had been made to assassinate the American sheriff involved in the inci-

dent with Arvizu.[97] To diffuse the conflict, a group of Nogales, Arizona, merchants approached Mascareñas and suggested sending a letter to Díaz asking that Arvizu's death sentence be commuted. Díaz eventually acquiesced, and both men spent their remaining years behind bars.

CONFLICT DEMARCATES THE BORDER

As friction continued, Sonoran officials proposed various ideas to lessen the likelihood of direct contact between Americans and Mexicans. In the aftermath of the Arvizu fracas, Governor Torres proposed to President Díaz that the federal government establish a special zone of approximately 100 meters on the Mexican side to be designated a "neutral zone" between the two towns in order to prevent future confrontations.[98] In addition, he suggested transferring the federal troops, who were seen as outsiders by the Nogales population, and having their duties assumed by local authorities. Rather than federal troops under the direction of Mexico City, Torres suggested an increase in municipal police who reported to local authorities.[99] After a baseball game between American and Mexican teams at Naco degenerated into a brawl, Consul Mascareñas proposed the construction of a "steel fence between all neighboring border cities" in order to prevent potential conflicts.[100] In addition to limiting conflict, Mascareñas believed that the fence would end "jurisdictional problems on the border, deter contraband and prevent cattle rustling."[101] Other factors also motivated Mascareñas.

The Arvizu case and the Naco incident revealed the underlying tensions that existed between the border communities. Despite the perception of social harmony promoted by Mexican and American notables, not all residents of the area shared this experience. Border life consisted of many levels of interaction, and the reality confronted by common Mexicans and Americans did not correspond to the tranquil image projected by those in power. Disparities in treatment, racial prejudice, and diverse cultural experiences and attitudes toward life strained community relations. Elites recognized the potential for conflict. Business, governmental, and social institutions promoted the model of harmonious relations. But these institutions had limited power, and when they failed, officials took more drastic measures. Business interests relied on the perception of peace and stability and feared that unrestricted contact could degenerate into clashes. By using force, separating communities, constructing a fence, and regulating exchanges, elites hoped to

limit contact between Mexicans and Americans. At first President Díaz rejected any unilateral proposals that might be seen as ceding land to the Americans. Eventually, however, the federal government ordered all structures adjacent to the border removed.[102] A few years later the Arizona settlement followed suit when the American president required a space of sixty feet to be cleared from the border.

In 1893 the residents of Nogales, Arizona, had reason to celebrate. In that year, federal judges accepted the position of the Nogales Protective Association and ruled against the Camous claim to the land of Nogales, Arizona. The magistrates' decision appeared to be a foregone conclusion. To rule in favor of the Camous would have devastated American interests. Much of the case presented to the courts rested on the work of Lieutenant Henry Ossian Flipper, the first black American to graduate from the West Point military academy. The government introduced the surveys drawn by Flipper and used him as their only witness.[103] Flipper had opened a surveyor's office in Nogales in 1891 and operated a lucrative business surveying property in the United States and Mexico.[104] He lived with Luisa Montajer, acquired knowledge of Mexican mining laws, and learned some Spanish.[105] Other American blacks also settled in Nogales. Many Buffalo Soldiers (American blacks) stationed in the town during the Mexican Revolution married Mexican women and settled there. By 1917, according to Doris Mcguire, an early supervisor of the city's elementary schools, the American city established a segregated school for blacks, known as "Frank Reede . . . in honor of a local Black killed in World War I." It became known as the "colored school," since most of the students "were descendents of the soldiers stationed at Camp Little, many of whom had married Mexican women."[106]

INSTITUTIONAL RELATIONS

With the land dispute settled and the Arvizu case fading from memory, relations between Ambos Nogales resumed their previous course. Most early cooperation between both towns had been informal. When a handful of Yaquis who were associated with Teresita, a local spiritual leader also known as the Santa de Cabora, attacked the Sonoran aduana in 1896, Americans sent reinforcements to help their Mexican neighbors.[107] By the early 1900s, with the rise of such organizations as the Nogales and Santa Cruz Board of Trade, the Nogales chamber of

commerce, and the Wonderland Association, relations between both towns became institutionalized. Trade associations took the lead in promoting a positive perception of the border throughout the United States. When in 1906, in the wake of strikes at the Cananea mine, the *Los Angeles Examiner* reported that a revolution in Mexico threatened United States companies, the Nogales and Santa Cruz Board of Trade fired off an angry telegram to the newspaper: No "revolution is on in Sonora and [reports] that two thousand men march on Mexican town [is] considered utterly false and without foundation. Such reports are very damaging to this section and we strongly condemn such action of the *Examiner* in publishing such article."[108] Since negative perceptions of Sonora would prove damaging to American interests operating along the border, Arizona business groups came to the defense of Mexico.

THE MEXICAN REVOLUTION

Confrontations during the Mexican Revolution temporarily derailed the cooperation that existed between Ambos Nogales. However, Mexican and American leaders proved adept at negotiating the troubled waters of the revolution. With access to arms, Nogales inevitably became a target for both revolutionary and federal forces. Fighting on the Mexican side between the forces of Alvaro Obregón and Emilio Kosterlistky in 1913 and between Obregón and Pancho Villa in 1915 spilled over to the American side. Along International Street, people ran for cover as "bullets fell on the American side."[109] Neither encounter directly involved Mexicans and Americans.

In response to these early conflicts, the United States government stationed troops along the border to ensure that fighting in Mexico did not "spill over." Hundreds of soldiers from Utah, Colorada, California, and other states arrived at Nogales, Arizona. In addition, the army stationed a contingent of the Buffalo Soldiers in Nogales, to serve as border sentries. Soldiers bivouacked outside the town at a site known as Camp Stephen Little, named after an American killed by a stray bullet during the 1915 border fight between Villa's and Obregón's forces. With the experiences of Veracruz still fresh in their memories, many American soldiers did not hold Mexicans in high esteem. One publication which circulated among the soldiers in Nogales, Arizona, summarized the earlier American invasions of Habana, Manila, and Veracruz, and declared,

Out there are the dam' Mexicanos
That sneered at the Red, White and Blue,
Here's ten thousand Yanks, that's asking no thanks
But are spoiling for something to do.[110]

Local Nogales authorities, who for years had managed to orchestrate relations between both towns, became subordinate to the new military commanders. Arizona's adoption of strict prohibition laws in 1914 also increased confrontations.[111] With no liquor available in Arizona, those who wanted to drink, especially American soldiers, regularly crossed the border into Mexico and patronized the numerous cantinas that had opened along the international strip. Whether induced by alcohol or not, conflict between American soldiers and Mexicans became common.

With no barrier between both towns, the U.S. Army began stationing soldiers every one hundred yards along International Street, thereby ending random traffic between both communities. Border crossing became formalized and could only take place next to the railroad station, where Americans had established a new immigration checkpoint. The Mexicans followed suit and also established a border-guard station, and restrictive immigration policies soon went into effect. Mexicans who worked in the United States and lived in Sonora could only cross the border twice a day.[112] Other Mexicans would only be allowed access to the Arizona side once a week. For a community long accustomed to free movement across the border, these restrictions proved difficult to accept. Mexicans complained of the treatment they now received from the new military border guards who did not speak Spanish. A report prepared by Brigadier General D. C. Cabell affirmed the Mexican charges, indicating that "Mexicans are peculiarly sensitive to rude treatment and bitterly resent the loud, contemptuous and sometimes profane language of American customs guards."[113] The Mexican consul at Nogales, Arizona, José Garza Zertuche, echoed these complaints, insisting that soldiers regularly ridiculed Mexicans unacquainted with the forms required to cross the border.[114]

By the summer of 1918, clashes between border guards had already left two Mexicans soldiers dead.[115] For civilians the new restrictions also produced tragic results. Several Mexicans who continued to use the old Bonillas Bridge to cross over the border had been killed by American border guards. In one particular case, Gerardo Pesqueira, a deaf-mute who did not obey a command not to cross over the bridge, had

also been shot and killed by American soldiers.[116] The death of Pes-
queira, son of ex-governor Ignacio Pesqueira, sent shock waves through
the Mexican border community. As border incidents became common,
anti-American sentiment increased on the Mexican side.

On August 28, 1918, months of frustration exploded into open con-
flict. An altercation involving a certain Severiano Gil precipitated a fire
fight between American and Mexican guards and brought both towns
to the edge of war. In English, American guards demanded that Gil stop
and submit to a search before he crossed the border into Mexico. The
Mexican guards who witnessed the event urged him to continue. When
an American soldier drew his pistol and pointed at Gil, the Mexican
guards opened fire. After Mexican and U.S. border guards exchanged
gunfire, American military troops joined the fracas and crossed over
into Mexico.

The regular Mexican army stationed in Nogales under Captain
Adalberto Abasolo refused to participate in the clash. With resentment
already running high, Mexican civilians took up the fight against the
Americans. One group captured the American consul and held him hos-
tage. Amidst the chaos, Mexican snipers took aim at American busi-
nesses in Arizona. Bullets riddled most homes in the vicinity of the bor-
der, including the house of General Obregón. His wife and daughters,
inside the house at the time, sought shelter with American friends.[117]
The Battle of Nogales, as it later came to be known, lasted until 5:45
p.m., when military officials on both sides agreed to a conference. The
officers agreed to a cease-fire, and the American troops returned to the
Arizona side. In the conflict many Mexicans and Americans died, in-
cluding the municipal president of Nogales, Felix Peñalosa, and the
American captain of the 10th Cavalry, J. D. Hungerford. The cease fire
did not hold, and throughout much of the night Mexicans continued
firing on the American community. Venustiano Carranza, the Constitu-
tionalist president of Mexico, dispatched Plutarco Elías Calles, then
governor and military commander of Sonora, to Nogales. The United
States ordered General C. Cabell stationed at Douglas to the border.

On the afternoon of the twenty-ninth, Calles and Cabell conferred
and tried to resolve the issue amicably. After several meetings in which
both expressed regret over the course of events, Calles convinced Cabell
that the entire incident had been the work of German spies and several
disgruntled Mexicans who had since fled the area. Privately, however,
American military communiqués continued to insist that Mexican bor-
der officials were responsible for the clash. One American intelligence

officer blamed Zerabia Aguirre, a customs agent who had been involved in a similar border clash at Ciudad Juárez and El Paso.[118] Mexicans insisted the affair resulted from months of ill treatment on the part of Americans.[119] The American consul in Nogales refused to acknowledge the pattern of abuse, focusing instead on the immediate border clash.[120] Officially, however, both countries circulated the account of German spies, and slowly the hostilities ebbed. To ensure the peace, Calles declared martial law over the Mexican community and ordered all weapons held by civilians confiscated. To prevent future altercations, General Cabbel recommended that a permanent fence be built to separate both towns. The Mexicans built a monument to honor their dead; American soldiers received "Mexican service badges" for their involvement in the incident.[121] The most lasting legacy of this episode became the construction of a permanent fence separating both communities.

NORMALCY

After the clashes of the revolution, local business groups did everything in their power to resume normal relations between both towns. For business interests in Ambos Nogales, there was simply too much at stake to let the conflict escalate. Heading south from Guaymas, the Sud-Pacifico railroad had reached Mazatlán by 1912, opening up the fertile agricultural valleys of Sonora and Sinaloa. In addition to agriculture, leaders of Ambos Nogales also saw opportunities to expand tourism, still a nascent industry on the west coast of Mexico.[122] As the Sud-Pacifico railroad extended south, Nogales promoted itself as the "key" city to the entire west coast of Mexico. Sonoran interests hoping to capitalize on the increased trade shared their counterpart's view. By the early 1900s, most important business concerns in Sonora had established outlets in Nogales. The Nogales, Sonora, chamber of commerce, founded in 1918, actively cooperated with their colleagues on the American side to improve relations. Alvaro Obregón, who had established an office in Nogales to promote the sale of his garbanzos to the United States, became the Mexican chamber's first president.[123] The chamber publication summarized the consensus between leaders of both towns insisting that "at no other port on the Mexican border is there that happy relationship of cooperation and good will as exist between Nogales Arizona and Nogales, Sonora. This had been brought about through the influence of the Nogales, Arizona Chamber of Commerce, an organization of business men which first of all respects the

viewpoints of Mexicans. This is good business and fair dealing."[124] The chamber spent thousands of dollars to place advertisements in magazines such as *National Geographic, Forbes, Colliers,* and the *National Business Journal.*[125] In letters to business groups throughout the country, chamber members regularly championed the benefits of Nogales, highlighting access to cheap labor and the burgeoning markets of the west coast of Mexico. The chamber of commerce maintained an immigration and international committee to promote better relations with Sonora and the fair treatment of Mexicans in the United States. The chamber's various committees actively lobbied in Washington against all legislation which placed a quota on Mexican immigration. They maintained a watchdog committee to oversee the treatment that Mexicans received from American immigration officers, and they pressured United States officials to allocate funds so that the border could remain open twenty-four hours a day. To encourage trade the chamber regularly dispatched delegations to surrounding Mexican towns, such as Cananea, Magdalena, Altar, and Santa Ana, inviting Mexican officials to visit the border.[126]

With the support of both Obregón and Calles, the chambers of commerce of Ambos Nogales sponsored joint railroad excursions of Sonora and Sinaloa in order to "develop a deeper spirit of mutual trust, comprehension and friendship between merchants and businessmen of Mexico and the United States."[127] This was not a new practice—on several previous occasions the Porfirian government had sponsored railroad excursions throughout the state by American businessmen.[128] As a declared presidential candidate, Obregón sought to normalize relations with the United States. His previous contact with the Nogales, Arizona, chamber of commerce proved useful. Sonoran business interests supported Obregón's attempt at rapprochement with American interests, especially since many had retreated after the revolution. They hoped to show American investors that Mexico had achieved peace and stability. Calles, as governor of Sonora, ordered local officials along the route to cooperate fully with the chamber's excursions. The American excursionists, from Nogales, Tucson, and Phoenix, stopped at all the major towns along the Pacific coast, where local officials staged sumptuous celebrations.[129]

When Obregón became president of Mexico, the Nogales and Tucson chambers of commerce sent a special delegation to Mexico City to attend his inauguration. To show his gratitude, Obregón presented the chamber a huge Mexican serape with an embroidered portrait of

George Washington. The policies pursued by elites of Ambos Nogales
yielded positive results. By 1920, agricultural exports from Sinaloa and
Sonora had reached significant proportions. City leaders boasted that
Nogales had become the largest port of entry on the "Mexican bor-
der exceeded only in import business with Mexico by New York."[130] At
the root of this success continued to be the economic interdependence
which fueled the existence of both towns. Isolated from the rest of the
state, Nogales, Arizona, needed trade with Mexico. Economic ties with
its southern neighbor remained Nogales's principal asset. Unlike other
border towns, where asymmetrical relations became pronounced, in the
case of "Ambos Nogales" a climate of cooperation endured throughout
the first half of the twentieth century.

"The Greatest Mining Camp in Northwest Mexico"

Minas Prietas and La Colorada

As American investments increased, new mining centers appeared throughout the once desolate Sonoran countryside.[1] Nowhere did contradictions between Mexicans and Americans become more apparent than in the proliferation of company-controlled mining towns that dotted rural Sonora. Long before Colonel William C. Greene established operations at Cananea, most observers considered the mines at Minas Prietas and La Colorada to be the "greatest camp in north-west Mexico." Yet mining centers did not experience uniform patterns of development. Cananea and La Colorada represent two variants of the northern Mexican mining experience. Recent studies have shed light on developments at Cananea, but little is known about other enclaves such as those at Minas Prietas and La Colorada.[2]

American interests hegemonized all major economic activity in Cananea. With the tacit approval of Sonoran authorities, company officials kept a tight reign on activity in the mining town. In matters of importance, American company officials bypassed the district prefect and consulted directly with the governor. In addition to the mines, Colonel Greene owned surrounding haciendas, controlled cattle and agricultural production and lumber supplies, and dominated most busi-

ness in the town. Cananea, however, does not fully represent developments that occurred in other mining areas of northwestern Mexico. Mining enterprises in Sonora and Baja California ran the gamut from the massive works at Cananea, intermediate operations at Minas Prietas-La Colorada, Nacozari, and El Boleo and moderate enterprises at El Tiro or Cerro Colorado.[3] In contrast to Cananea, Minas Prietas–La Colorada experienced a different set of conditions in which American and British capital concentrated their efforts primarily on mining. Under these circumstances, their investments served as an economic catalyst for the surrounding region, allowing Mexican elites and smaller foreign concerns to build subsidiary industries and generate significant profits.

Mining activity had taken place at Cananea, La Colorada, Nacozari, and Minas Prietas since the colonial period. Typically, when foreigners or Sonoran gambucinos (prospectors) departed, the indigenous population regained control of the territory—early mining activity produced no permanent Mexican settlements at these sites. Since most new mining camps remained distant from established Mexican settlements, the American presence stamped the social and cultural character of the new towns. In Cananea, for example, beside typical Mexican festivities, Americans held public celebrations for the Fourth of July, Thanksgiving, and other such American holidays.[4] Isolation also precluded the integration of mining areas by established Mexican communities. Had mining taken place in the vicinity of Hermosillo, Guaymas, or Alamos, the larger Mexican community could have absorbed the foreign population and forced a degree of accommodation not witnessed in the isolated countryside. Instead, with the support of compliant Porfirian officials, foreign investors had a free hand in determining the character of the towns which evolved around the rural mines. The history of the mining complex at Minas Prietas and La Colorada dramatically illustrates this pattern of development.

EARLY SPECULATION

The indigenous population and the Sonorans vied for control of the area around Minas Prietas. Since the 1740s, under the supervision of the Jesuits, laborers worked deposits in the general vicinity of Minas Prietas and La Colorada, an area which encompassed several mines known as the Real de Aigame.[5] For more than eight years, miners held out against extreme hardships. A low water table and raids by

Yaquis and Apaches eventually forced the site to be abandoned.[6] Despite the obvious perils, lucrative gold deposits continued to generate interest, and miners returned sporadically. The inability to surmount technological problems derailed early attempts to exploit these rich mines: "[W]ater compelled abandonment as the primitive methods of carrying water in rawhide buckets upon the backs of men climbing rude ladders, (notched poles) was not calculated to cope with the subterranean flow."[7] Recurrent underground flooding and clashes with Yaquis continued to plague the mines even during their heyday in the 1890s.[8]

For most of the nineteenth century, local Mexican elites tried unsuccessfully to convince foreigners to invest at Minas Prietas. When the French merchant C. Combier visited Sonora in 1829, J. P. Camou hosted several parties for him in Hermosillo and then gave him a tour of Minas Prietas. Combier did not think the site had much potential. He described the mine as desolate, where all the laborers appeared to be indentured Yaquis who toiled under atrocious conditions. Combier warned foreigners to guard against *tracaleros*, swindlers who promised fabulous returns on potential mining investments.[9] By 1850, according to José Velasco, only two or three lone gambucinos remained at Minas Prietas.[10]

In the 1860s, Ricardo Johnson, with the financial backing of the wealthy Ortiz merchants of Hermosillo, acquired the rights to the mines. For several years Johnson worked the site, but his presence did not lead to any formal settlement in the area. Like many Sonoran elites of the time, Johnson and his benefactors did not have any long-term interest in actually exploiting the mine but rather hoped to profit by selling it to foreign investors.[11] In 1886 he sold his claims to several Americans.[12] Other Sonoran notables, including Ramón Corral, Ignacio Bonillas, Pedro Negro, and Pedro Pinelli, also joined the early rush to claim mines at Minas Prietas.[13] Corral did not mind using public office to enrich himself and his close associates.[14] In 1896 this group sold their interest to the Gran Central and made a handsome profit. The company retained the services of the governor as their consul and paid him $250 a month until 1906.[15] They also engaged engineer Ignacio Bonillas, a close friend of Corral, to survey their property and map out the operations.[16]

Eventually two large concerns, the London Exploration Company, owner of the Grand Central Mining Company, and the Ohio-based Crestón Colorada Mining Company bought out a host of smaller operators and acquired a mining complex which extended over several

miles between Minas Prietas and La Colorada.[17] Besides these large-scale operations, the areas around the mines also included over one hundred separate mining claims operated by Mexicans and foreigners.[18] Firms like the Pan American Mining Company operated smaller diggings in nearby hills, while others bought and reprocessed tailings from the Crestón Colorada.[19] This arrangement allowed smaller, less capitalized enterprises to profit.

In the first few years of operation, the lack of drinking water hindered work at the mines. In the shafts below the surface water appeared abundant, yet above, in the dry Sonoran environment it remained scarce. In 1895 water had to be brought to the town in barrels and large leather pouches.[20] As operations and population increased so did the shortage of water.[21] The company finally commissioned Engineer Bonillas to draw plans to divert the Matape River and build a dam above the mine to supply the town with water. In 1897 the facility had to be doubled in size to meet the growing demand of the camp.[22] Not long after, another stream, the San José, was also diverted to supply the dam.[23] Only with the addition of the San José did the company resolve the town's water shortage. With a monopoly over the dam, the operation of the Minas Prietas Water Company proved to be another profitable venture for the mining concern.[24] Still, to become fully operational, Minas Prietas and La Colorada needed a railroad to transport minerals and supply the mine.

ESTACIÓN TORRES

Federico Seymour, a British citizen, seized the opportunity to monopolize transportation and in 1895 financed the building of a narrow-gauge rail line to Minas Prietas.[25] Seymour and J. A. Naugle, the superintendent of the Sonoran railroad, traveled to Chicago where they purchased an engine, flat cars, and coaches.[26] Before this, all supplies had arrived by wagon or mule trains. A telegraph line ran parallel to the tracks and connected the mines to the rest of Sonora and the United States. Seymour also operated a network of teamsters along the route, allowing him to control access to the wheat fields and coal mines of Sahuaripa and Ures. Over time, the entire territory depended on Seymour for transportation. With the railroad in place, Wells Fargo also opened depots at both sites and operated an express service to the United States. The station became one of the busiest stops on the Sonoran railroad, attracting a coterie of individuals hoping to profit from the new boom town.[27]

Estación Torres, named in honor of the governor, became a company town in the same manner as Cananea or La Colorada.[28] Americans held all managerial positions on the railroad and Seymour's son Gordon, a seventeen-year-old novice, became the train conductor. With the profits earned from the railroad, Seymour invested in gold mines in Sahuaripa and became a senior spokesman of the foreign community in Sonora.[29]

By 1895 the train station and settlement had attracted 854 people, most of whom worked, directly or indirectly, on the line and serviced the needs of those en route to the Minas Prietas mines.[30] The company employed 130 laborers, mostly Mexicans, to tend to the tracks and service the trains. The establishment of a separate *comisaría* (police constabulary) at Estación Torres permitted Seymour a free reign in controlling the community. Raúl Montijo, a small-time merchant and a personal friend of Seymour, presided as police comisario. Seymour also controlled access to the train depot, and only his friends and associates were allowed to establish stores and hotels in the vicinity of the station.[31] Mexican merchants complained that Seymour did not permit them to set up shops near the terminal or sell foodstuffs to travelers.

With access to slow but reliable transportation, American and British investors at Minas Prietas introduced new technology which allowed previous surface mining to reach new depths. With electricity to power compressors for drilling and pumps to drain water, a network of shafts several miles long reached into the bowels of the earth.[32] The tunnel at the Gran Central became the cornerstone of the mining operations, reaching a depth of over 1,140 feet and sustaining eight horizontal shafts.[33] Its underground caverns connected it to other mines, especially to the important Las Amarillas. Overhead a one-thousand-foot long tramway connected the Amarillas and Gran Central and hauled ores to the company mill.[34] As processing operations increased, the company added two additional tramways.[35] Several mills operated at the site, one owned by the company and another which subcontracted with the mine to process the ores. A powerful metal cage elevator lowered workers and equipment deeper and deeper into the mines.[36] In a daily ritual, hundreds of Mexicans miners lined up at the elevator shaft and awaited their turn to enter the mine. The elevator stopped at each of the eight levels to unload its human cargo. Smaller carts on rail tracks moved men and equipment throughout the network of internal tunnels.

By 1889 Minas Prietas, which in the previous decade had not appeared on state census records, had attracted over 500 people and state

officials formally declared it a municipality.[37] Feliciano Monteverde, a
rich hacendado who held lucrative contracts with the mine operators,
became municipal president of Minas Prietas.[38] With substantially less
population, La Colorada remained a comisaría. As word spread of these
developments, Mexicans, Yaquis, and foreigners began to arrive at the
mines. By 1890 the population of the two towns had increased to
2,902, more than doubling in less than five years.[39] Despite this growth,
before the construction of the railroad mine owners found it difficult to
attract a stable labor force, and many jobs remained vacant. To lure
Mexican workers, the companies often placed advertisements in the
state press. In 1894, for example, several newspapers announced that
the Crestón and Amarilla mines desperately needed 200 miners.[40] And
as late as 1895, La Crestón, one of the larger operations in the state,
still employed only 150 workers.[41] The mines had no trouble attracting
Americans, who flocked to the new camp hoping to attain high-paying
skilled jobs.[42] Minas Prietas became "the Mecca of many a poor devil's
pilgrimage, where men have headed for from every point of the com-
pass."[43]

By the end of 1895, with the rail line in operation, the labor shortage
was resolved and the population of the mining complex increased to
5,604 persons.[44] Around the network of mines, two towns, a little over
a mile apart from each other, slowly took shape. Americans christened
the road which connected Minas Prietas and La Colorada as "main
street."[45] The traditional urban schema around which most Mexican
towns formed—a plaza, a church, and government buildings—had lit-
tle meaning in the new mining towns of rural Sonora. The town square
at La Colorada, built with company funds and named not coinciden-
tally Plaza Luis Torres, did not appear until the first decade of the new
century.[46] The towns themselves consisted of an assortment of dis-
jointed one-story whitewashed adobe houses, wood-frame structures,
tents, and rustic shacks. The haphazard nature of the town betrayed its
rapid expansion. In 1895 there were over one hundred adobe houses
being built every month.[47] Since the company provided no housing,
most Mexican laborers lived in simple rustic *jacales* around the perime-
ter of the villages. On the fringes, next to the hills of the mine, a shanty
town housing primarily Yaquis marked the outer reaches of the settle-
ment. On a hill overlooking La Colorada, the imposing white buildings
of the mining company, including a large multistory smelter, and
stamping plant, and the surrounding mountains of *jales* (tailings) cast
a long shadow over the urban landscape below. Beyond these buildings,

a complex of ornate brick structures housed the foreign managers of the mine.

The company influence permeated daily life at both towns. The steam whistle, the sound of the mills, and the grinding of the stamping plants announced the beginning of the work day. Beyond basic employment, symbols of the companies influence dominated other aspects of life. At Minas Prietas the municipal building had been financed by Oscar Raintree, the treasurer for the American mine.[48] The Crestón also contributed $16,000 a year to maintain a constabulary force at La Colorada.[49] Land for a cemetery had also been provided by the company.[50] The firm also endeared itself with Mexican officials by providing school supplies and utensils to the local municipality at reduced rates.[51] It subsidized the salaries of teachers and maintained a five-thousand-book library. The military garrison stationed at the mines, a regiment of the 11th Battalion of Rurales, received many of its supplies from the company. The small municipal police force also relied on the largess of the company. For its charity, the company paid no taxes on the goods it imported into town and could count on the unswerving loyalty of municipal officials and the state government.

For state officials, such as Ramón Corral and Luis Torres, the La Colorada–Minas Prietas complex symbolized the fulfillment of their plan to attract foreign capital. It attested to their ability to pacify the countryside and provide stability to foreign mining operations. They regularly publicized the success of the mining camp in the state press and in public speeches. Corral, Torres, and Izábal commonly visited the mines to inaugurate new projects.[52] In 1895, for example, Izábal traveled to La Colorada to observe the opening of a new mill.[53] When General Mariano Escobedo, a hero of the war with the French, visited Sonora, Corral took him on a tour of La Colorada.[54]

YAQUIS AND MEXICANS

A review of the social structure of these two towns reveals the broader changes experienced in the Sonoran countryside in the late nineteenth century. Sonorans and Yaquis made up the majority—close to 90 percent—of the population of 5,030, which included 2,556 males and 2,474 females. Census statistics do not, however, provide an adequate method of assessing the precise number of Yaquis who worked at the mines. Government records report the presence of 265 persons who spoke only Cahita, the language of the Yaquis.[55] By 1895, however,

large numbers of Yaquis had become bilingual, speaking both Cahita and Spanish. Despite the absence of formal documentation, municipal documents, company records, and judicial proceedings reveal the presence of a substantial Yaqui work force.[56]

The promise of higher wages attracted Mexicans from throughout the republic. At La Colorada, depending on the job, wages for miners ranged from a peso and a half to five pesos a day.[57] At first the number of Mexican emigrés appeared small, about 275 persons, or 4.9 percent of the population. These migrants, mostly men, gradually became an important element of the labor force. Although they arrived from all regions within Mexico, nearby states, such as Sinaloa (131), Baja California (36), Chihuahua (22) and Durango (16), contributed the greatest numbers:[58]

Aguas Caliente	1	Nuevo León	1
Coahuila	2	Oaxaca	1
Colima	4	Puebla	1
Chihuahua	22	Queretaro	1
Durango	16	San Luis Potosí	1
Guanajuato	6	Sinaloa	131
Guerrero	1	Tamaulipas	1
Hidalgo	1	Veracruz	1
Jalisco	26	Zacatecas	5
Mexico	2	Distrito Federal	5
Michoacan	1	Baja California	36
Morelos	1	Tepic	6

The small number of Mexican emigrés reflected the ongoing difficulty associated with travel between Sonora and the rest of Mexico, and like their Sonoran brethren, in the beginning, most remained confined to the lower ranks of the labor force.

Invariably, mining towns drew a large number of single men, but in the case of Minas Prietas–La Colorada, they also attracted a significant number of families. The 1895 census reveals that over 30 percent of the population, or 1,689 people were married couples. The large number of children, about 1,988, further corroborated the presence of families at the mines.[59] Single men numbered 945 and made up about 17 percent of the inhabitants, and unmarried women, totaling 667, com-

prised 11.9 percent of the total population. The numbers of married 1,689 (30.1 percent) and unmarried 1,612 (28.7 percent) appear almost equally divided:[60]

Married men	882	Married women	807
Single men	945	Single women	667
Minors boys	1,068	Minors girls	920
Widowed men	83	Widowed women	232

Only a small number of children actually attended school, 288 boys and 254 girls, indicating that the great majority worked at menial jobs around the town or with their parents.[61] Adolescents found employment throughout the town, delivering goods for the stores and peddling food and other products to the miners between shifts.[62] Complaints by the local schoolmaster indicate that most children worked, rather than attend school. Although authorities published several edicts stressing school attendance, few parents heeded the call.[63]

FOREIGN PRESENCE

Besides Yaquis and Sonorans, people from throughout the world arrived at the mining complex. The 1890 census recorded 58 foreigners at Minas Prietas, including 16 British and 22 Americans.[64] By 1895 the number of foreigners had grown to 299, accounting for less than 0.05 percent of the total population. If not for their social and economic standing, the number of foreigners appeared largely insignificant.[65]

United States	128	(90 men, 38 women)
China	84	(75 men, 9 women)
Italy	27	(25 men, 2 women)
England	23	(21 men, 2 women)
France	13	
Spain	7	(5 men, 2 women)
German	7	
Austria	3	
Russia	2	
Switzerland	2	

Venezuela	2
Chile	1
Ecuador	1
Total	300

In 1895 Americans composed the largest group of foreigners with 90 men and 38 women or 42 percent of the non-Mexican population. Chinese immigrants represented 28 percent of the foreign community, with 75 men and 9 women. The Italians appeared a distant third with 25 men and 2 women or 9 percent, and the British with 8 percent, 21 men and 2 women, were the fourth largest group. The remaining foreigners, 13 percent, included a handful of Europeans from Austria, Spain, Germany, Russia, and France and a smattering of South Americans from Ecuador, Chile, and Venezuela.[66] Women, numbering 53, accounted for 17 percent of the total foreign population. The number of persons holding important managerial and skilled positions corresponds to the number of non-Mexicans in the town. Other European immigrants functioned as mine assayers and merchants.[67]

A small circle of British and Americans oversaw the operations of the Grand Central and Crestón Colorada. The British managers had previously operated mines in South Africa, and the Americans in Chihuahua.[68] Beside high level managers, the Americans and British also filled positions such as engineers, bookkeepers, mechanics, machine operators, blacksmiths, and carpenters.[69] To supervise the Mexican work crews, the companies relied largely on German, Italian, and other European foremen.[70] As Ralph Ingersoll found at Nacozari, authority at the mine rested on a racial hierarchy—foreign employees usually had "a helper at [their] side and authority at [their] back."[71] Dressed in blue overalls and usually sporting a tie, European and American foremen with an *ayudante* (helper) supervised Mexican work gangs and oversaw operations in the mine shafts. With few exceptions, Mexicans and Yaqui composed the bulk of the labor force, either as miners or employed as *peones de campo* in the ranches and haciendas that supplied the mining complex.

Although mining had a long tradition in Sonora, most operations had been performed by *cuadrillas* (small gangs of miners) and had never involved hundreds of workers. Few if any Sonorans had prior experience with these methods of production. For most, mining had been a sea-

sonal occupation, permitting Sonorans time to plant and cultivate their crops. In the first years of operation, the company had difficulties with workers who insisted on taking time off to tend their harvest.[72] As soon as the planting passed, there would be plenty of workers.[73] The higher wages offered by the mine gradually undermined this long-standing practice. Other customs did not die as easily. Company officials repeatedly complained about problems with time management and having to stop operations for observances of traditional religious and regional celebrations. As long as mining continued to be a profitable venture, foreign officials made exceptions and even contributed to local fiestas. In times of crisis, however, such as the turbulent years after 1907, company officials restricted and even prohibited this type of activity.[74]

The mines at La Colorada–Minas Prietas engendered a broad spectrum of economic activity. In 1895 the various companies employed 594 miners, mainly Sonoran and Yaqui men. The ranchos and haciendas that supplied the mines provided employment for another 814 peones de campos. Aside from drillers and laborers, mining required a host of skilled occupations, including carpenters, foundry workers, machinists, and mechanics.[75]

1 architect	1 lawyer
1 assayer	9 laundry workers (6 males, 3 females)
23 blacksmiths	2 machinists
18 bakers	30 mechanics
14 barbers	594 miners
1 beam makers	13 musicians
10 belt makers	814 peones de campo
18 brick masons	1 printer
5 buggy drivers	72 private employees
18 butchers	97 property owners (74 males, 23 females)
57 carpenters	4 prostitutes
1 candy maker	3 public employees
1 cigarette maker	58 ranchers
167 merchants (136 males, 31 females)	52 seamstresses

3 dependents	4 silversmiths
2 dress makers	5 tailors
295 domestics (83 males, 212 females)	3 teachers
11 engineers	542 students (288 males, 254 females)
1 foundry worker	6 water carriers
2 import agents	1 wagon driver
1 ironer	13 unemployed males
2 hat makers (females)	1,434 unemployed females
2 healers	1,173 unemployed children

Despite the wide variety of occupations, mining, directly or indirectly, provided employment for approximately 88 percent of the available male labor force. The remaining population, both male and female, pursued subsidiary occupations. Within the urban setting, Mexican laborers of both sexes made up the majority of semi-skilled and skilled positions, including domestics, seamstresses, water carriers, bakers, and teamsters. Upper-class Mexicans, Europeans, and Chinese controlled a host of other enterprises.

COMMERCE

The Prietas Store and the Gran Central Stores, the two company-operated *tiendas de raya* (company stores), did not monopolize all commercial economic activity in the towns.[76] Workers received a combination of wages and *boletas* (coupons) which they redeemed for products at the company store. Despite charging inflated prices for most basic items, the availability of credit continued to attract many workers. Faced with a surge of counterfeit coupons, Gran Central abandoned the boleta system after 1897 and paid its workers in cash. For those with money, several alternatives existed to the traditional company store. In the town, Chinese, Mexican, and a handful of European merchants vied for control of local commerce. In a pattern typical throughout Sonora, few if any Americans owned or operated retail stores.

Within Sonora, a clear division developed between Mexican and European merchants on the one hand and Chinese retailers on the

other. Established Sonoran retailers and agents, representing Mexican companies, opened stores and franchises at the mines. Merchants such as Seldner and Company, García and Bringas, and Anibal Mancini of Guaymas established outlets at La Colorada. These major establishments catered to foreigners and Mexicans with economic resources, selling both luxury goods as well as basic necessities such as underwear, shirts, pants, boots, sugar, and coffee.[77] One store even imported fresh oysters packed in ice from Guaymas for sale at the mining camp. The German-owned Cervecería del Pacífico also placed a distributor, Miguel Cervantes, at La Colorada to sell beer.

CHINESE PRESENCE

Unlike their Mexican counterparts, Chinese merchants usually sold inexpensive items, such as low-cost apparel, which miners could afford. More important to the Mexican workers at La Colorada, many Chinese also sold goods on credit, a practice frowned on by Europeans and other larger Mexican merchants. Stores such as those operated by Sam Lee at Minas Prietas and Fong Hong at La Colorada maintained copious credit records for their clients. On the wall of the store, small boxes with the names of the clients recorded a person's debts. In this capacity the Chinese prospered and quickly established a monopoly over the lower spectrum of the consumer market. Of the forty-one stores listed in both towns in a 1901 commercial census, the Chinese owned seventeen. By 1907 they owned thirty-four establishments.[78] Chinese also operated hotels, bakeries, laundry facilities, and several cantinas.[79] Over time many Chinese merchants made small fortunes and diversified their holdings. La Central, Colorada's principal hotel, an elegant two-story building, belonged to Fong Kee.[80]

HACIENDAS

In addition to commerce, the Mexican elite found other lucrative enterprises. With the foreigners concentrating efforts on mining, Mexicans notables established profitable ventures to service the mining operations and its laborers.[81] Acquisition of large areas of land by Americans, of whom there were many, represented relatively new export-oriented agricultural ventures. These enterprises, such as those in the Yaqui Valley or others in Altar, encroached on indigenous lands or the property

of smaller rancheros. The network of haciendas and ranchos which developed around Minas Prietas–La Colorada were owned by Sonoran families.[82]

Cabecera Minas Prietas	1,742	Rancho Carrizal	24
Mina Amarillas	305	Rancho Chivato	114
Mina Colorada	1,663	Rancho Ladrillera	118
Mina Gran Central	177	Rancho Los Mayas	8
Mina La Verde	23	Comisaria La Placita	107
Mina Zaragoza	76	Rancho Pozos de Pitaya	45
Estación Torres	854	Rancho Los Pozos	110
		Rancho Represo	8
		Rancho Represito	22
		Rancho Sarpullido	65
		Rancho Uvalama	17
		Hacienda Zubiate	126
Total	4,840	*Total*	764

The twelve ranches and haciendas that operated in the vicinity of the mine accounted for a large number of the municipality's population. The hacendados maintained a stable work force composed mainly of Yaquis. The activities of Feliciano Monteverde, municipal president of Minas Prietas, and the Rodríguez clan underscore the ability of Mexican hacendados to profit from the foreign mining enterprises. Monteverde and the Rodríguez family, comprising four brothers, bought several ranchos in the area. Monteverde first acquired ranches at El Represo and El Represito, about 6 miles from Minas Prietas, and his holdings encompassed close to 9,000 hectares of land on which he raised cattle, horses, and mules. On their part, the Rodríguez family acquired 9,833 hectares and also raised cattle.[83]

Beside supplying beef and draft animals, the most profitable ven-

tures for both ranches proved to be the sale of lumber to the mines. As a member of one of the most powerful families in Sonora, related by marriage to Governor Luis Torres and Rafael Izábal, Monteverde acquired a lucrative contract to supply wood to the Crestón Colorada. The Rodríguezes also received a similar contract. Mine operators desperately needed timber to build rail lines, to shore up shafts, and to power steam generators. Finished lumber products arrived from Puget Sound at Guaymas and were transported to the mine by the Sonoran railroad.[84] These *ranchos leñeros* (lumber ranches), as they were called, depended on the mines for their survival. To meet these needs, laborers in the employ of Monteverde and Rodríguez scoured the hillsides and valleys for lumber to deliver to the mines. To bring the wood from the adjoining countryside to El Represo, Monteverde and Rodríguez operated a fleet of mule-driven flatbed wagons. At the end of each day a long procession of these made their way into the town to resupply local stocks.[85] The United States consul estimated that yearly the mine consumed "1,000,000 feet of lumber . . . and over 20,000 cords of wood."[86] As local timber supplies diminished, the mines began to import coal from Gallup, New Mexico, to power their generators.[87]

With the lumber on his immediate lands depleted, Monteverde began to procure surrounding acreage, acquiring a virtual monopoly of land in the area. In addition to his first two ranches, by 1905 he had added San Feliciano with 2,982 hectares, Las Rastruitas with 8,717 hectares, Moradillas with 840 hectares, Mina de Agua with 2,942 hectares, and Rancho Minas Prietas with 2,757 hectares. In total he owned close to 30,000 hectares in the area surrounding the mines. On San Feliciano he built his ranch house, laborers quarters, tienda de raya, warehouse, and barn. To ensure a supply of wagons he employed carpenters and blacksmiths to build them. The barren, deforested hills surrounding the mines stood as testament to the effectiveness of Monteverde's operations. To supply the mines' constant demand for lumber, long, mule-driven caravans moved into the adjoining districts of Ures, Moctezuma, and Sahuaripa to continue their work of deforestation.[88] Seymour eventually extended the railroad to the outskirts of the ranch at El Represo. Beside currying favor from Monteverde, Seymour had other reasons for extending the rail line to El Represo—in the process he also managed to monopolize the transport of goods destined for the interior provinces of the Sierra, especially to the lucrative coal fields in Sahuaripa and Ures.

CAMP LIFE

As the century drew to a close, a bustling community had taken shape around the mines. La Colorada even had its own newspaper, *El Explorador*, published by a mining engineer, Rodolfo Zúñiga.[89] As in most mining centers, an assortment of shops, cantinas, brothels, and minor commercial establishments dominated the principal streets in the towns. By 1899 the comisario of La Colorada, Miguel Hermosa, reported that, including formal cantinas and tendejones, forty-six liquor establishments had opened. Many of these tendejones were nothing more than rustic wood structures, and in many cases simply canvas tents, where miners purchased cheap liquor. Caravans from interior districts such as Bacanora kept the camp stocked with large amounts of mescal.[90] Constantly short of funds, the municipal government taxed every form of activity. To sponsor musicians and dances, saloon and bordello operators paid a nightly event tax. These establishments also profited from gambling operations that they regularly staged under the guise of legal lotteries and raffles for which they paid taxes.[91]

For tax purposes, authorities divided bars into three separate categories: first, second, and third class. First-class establishments, such as the Cantina de Manuel Montijo, operated in Fong Kee's Hotel Central and offered musicians, pool tables, a wide assortment of imported liquors, and cigars.[92] The Salon de los Hermanos Quiroz staged nightly musical performances and became an important gathering center.[93] These well-adorned saloons also became retreats for foreigners and moneyed Mexicans. In addition, foreigners also formed a lodge of the Free and Associated Masons and the International Foresters. Unlike Nogales, the membership and the officers were predominantly Americans.[94] The organizations even had their own exclusive cemetery supplied by the company.[95] Most Mexican laborers with limited resources frequented the common tendejones which proliferated throughout the towns. Fueled by mescal, fistfights and other altercations became commonplace. Despite attempts by the local comisario to restrict the hours in which bars and brothels could remain open and liquor sold, public drunkenness and street brawls occurred with persistent regularity.[96]

WOMEN

Men did not have a monopoly over commerce or the ownership of saloons or bordellos. According to the 1895 census, women controlled

thirty-one "commercial" establishments, including several saloons and bordellos.[97] Columba Tamayo, Luisa Alvarez, and María Batiz, for example, owned and managed cantinas.[98] With close to a thousand single men, houses of prostitution proliferated throughout the towns. Prostitution became a major enterprise in mining centers such as La Colorada, and officials quickly moved to regulate and tax the activity. Prostitutes had to register with municipal officials and submit to regular medical examinations by a "medico inspector." After completing the procedure, they received an identification card, which also documented their medical history.[99] Since their activity provided income to the municipal government, authorities kept precise records on the activities and location of the prostitutes. Women who repeatedly tried to evade restrictions and operate independently faced arrest and expulsion from the town.[100] When women left town, as they often did, to work in Cananea or another mining town, their whereabouts became part of the municipal record.

Movement among prostitutes implied an organized network in which some women frequently traveled between important mining centers. Rather than a haphazard operation, prostitution appears to have been a well-planned activity constituted in such a way as to take advantage of the different pay schedules at the various mines. The bordellos that operated in most mining and urban areas offered immediate employment to women who traveled from camp to camp. Eventually officials divided prostitutes into two classifications. Those who operated from established bordellos, such as the Burdel La Esperanza in La Colorada, were classified as "first class," while those who operated in bars or on their own were considered "second class."[101]

Women who engaged in prostitution did not appear to have suffered any long-term stigma from their profession. Mexican, American, and Chinese men frequently established common-law marriages or even entered into formal matrimony with former prostitutes. The large number of unmarried men and the limited number of single women invariably contributed to the acceptance of this situation. But other factors also promoted these social attitudes. The very transient nature of most mining towns, where religious institutions held little if any sway, produced less restrictive moral attitudes and a different social climate. Whatever the reasons, municipal authorities regularly approved requests by Mexicans and foreigners to live with former prostitutes. In 1907, for example, Arthur Edwards, a United States citizen, informed the municipal president that he wished to live with Luisa Moreno and requested that

her name be removed from the tax roles as a prostitute.[102] Walter Guth-far, a German who lived with Estela Alvarez, made a similar request. For Asian men, who encountered a near total absence of Chinese fe-males, Mexican women, including prostitutes, became a socially ac-ceptable alternative.[103] Requests from Chinese men, such as the case of Chale Wong Sam and Elvira Terminel in 1908, appeared frequently.[104] Terminel had been engaged in prostitution for at least five years before she entered into formal relations with Wong Sam.[105] Within a year of taking residence with their new-found male patrons, many former pros-titutes reappeared on the tax roles.

CRIMINAL ACTIVITY

Criminal records in La Colorada–Minas Prietas reveal the daily chal-lenge which law enforcement officials confronted in trying to enforce order in such a heterogeneous population. Crimes ran the gamut from simple matters such as public inebriation to complex issues such as theft and murder. Public drunkenness and liquor-induced brawls, *ebrio y riñas*, appeared daily on public records and represented the most com-mon infractions. For minor crimes, authorities usually made the culprits serve two or three days in jail and pay a small fine.[106] Labor still re-mained a precious commodity, and long sentences for petty crimes in-volving workers proved detrimental to the mining company. Women also engaged in illegal activity, and they were regularly arrested for drunkenness, fighting, and violent crimes.[107] Repeat offenders, either female or male, faced expulsion from the town. Violent crimes also took their toll. Routinely, the number of people killed in barroom alter-cations rivaled the number who died in mining accidents.[108] Those charged with severe crimes, such as murder or serious theft, were held over for trial and shipped off to Hermosillo to face a judge. With scarce resources and personnel, most prisoners were sent by *cordillera*, a sys-tem by which guards escorted their prisoner to the nearest town, from where local authorities would repeat the process until the accused ar-rived at Hermosillo.[109]

Three levels of law enforcement operated in these rural municipali-ties. Each town maintained a police force while the Guardia Nacional and the federal *Rurales* patrolled the area around the mines. Rather than law and order, the Rurales and the guardia added to the sense of lawlessness felt in the towns.[110] Crimes involving common soldiers and high-level officers happened with problematic frequency. Forcibly re-

cruited, many soldiers of the guardia typically deserted at the first possible opportunity.[111] In one case in 1907, opposing guardia units opened fire on each other on the main street of La Colorada.[112] Rurales presented another set of problems. Hardly a month went by in which the Rurales were not implicated in some criminal activity. Many subsidized their pay by engaging in illicit enterprises, by trafficking in confiscated property and stolen animals, and even by selling weapons. They also robbed and even killed with relative impunity.[113] Due to constant complaints, in 1907 the governor ordered Colonel Manuel Tumborrell to investigate Captain Jesús Belma, who had been accused of repeatedly selling stolen burros and horses.[114] At all levels the Rurales took part in illicit activity, and their public conduct destabilized the already tenuous social order. In November 1906, a drunken band of Rurales attacked the local comisario when he ordered them to stop firing their weapons in the town. The Rurales and the local police faced off against each other before town leaders managed to pacify both sides.[115]

FOREIGNERS AND MEXICANS

Random violence against foreigners, especially Americans and Chinese, represented an even greater challenge to the tenuous social order of the mining town. In most settlements, local authorities had to grapple with the problems posed by the widely diverse ethnic population, especially one in which foreigners held most positions of power and authority. To the north in Cananea, the municipal president echoed the sentiments of his cohorts in La Colorada—Filiberto Vásquez Barroso complained about the "constant wave of humanity from all over the world that flocks to this place to eke out an existence. Efforts to coalesce this heterogeneous and dissimilar population present us with a never ending problem."[116] In Minas Prietas–La Colorada, officials tried to keep a tight rein on the populace, enforcing a marked order which placed Americans and Mexican elites at the top of the social hierarchy, followed by Germans and Italians employed as mine foremen and engineers, by Chinese who represented the small merchants of the town, and finally by Mexicans and Yaquis, who composed the general labor force. Despite their efforts, clashes between Mexican and foreigners occurred frequently.

Antagonism between Mexicans and foreigners included petty infractions, cheating the company store, stealing gold, and violent confrontations. To circumvent the tienda de raya, many laborers began falsify-

ing the boletas that workers used to acquire goods.[117] A lucrative black market in counterfeit boletas plagued the company store.[118] In addition, frustrated by low pay and seeking an opportunity for immediate remuneration, many workers developed ingenious ways of stealing small amounts of gold from the mine. Methods of stealing included ingesting gold nuggets, using body cavities, and hollowing out candles and tools.[119] Foreign operators, as Ramón Ruiz argued, assumed that all Mexican workers were potential thieves.[120] To combat theft, the foreign companies resorted to humiliating public strip searches, which offended Mexican workers.[121] Beyond the high prices charged at company stores, Mexicans and Yaquis resented the low pay, dangerous working conditions, and above all, the ill treatment they received at the hands of the foreigners.

As shafts protruded deeper into the earth, mining operations became more hazardous. Accidents caused by falling rocks or premature dynamite explosions became common.[122] Mexican and Yaqui miners insisted that they performed the most dangerous assignments while receiving the lowest pay. The record of those injured at Minas Prietas supports their contention.[123] At mines in La Colorada, Nacozari, and Cananea, injuries became a daily occurrence.[124] Fatalities also took place with alarming regularity. During a shift change in October 1897, thirteen Mexican miners perished in a premature explosion as their elevators passed the 400-foot level.[125] In January 1898 eight other Mexican workers died in a fall of 500 feet.[126] At La Colorada, from December 1898 to September 1900, at least one miner died every month. For example, on April 26, 1900, Manuel Gardillas, Lázaro Ballesteros, and Francisco Costa were crushed by machinery which fell in tunnel six of the Crestón Colorada.[127] Deeper shafts invariably produced more accidents. For protection, Mexican miners erected shrines, crosses, and images of the Virgin of Guadalupe and burned ceremonial candles throughout the mine shafts.[128] In addition, on La Colorada's most important holiday, the day of the Holy Cross, celebrated on May 3, those who toiled underground made special offerings for their safekeeping in the shafts. Miners and their families staged an annual ritual procession to the cross built above the town, lit candles, and prayed for protection.[129] After the procession, the festivities continued in the town square for the remainder of the day.

Beside mining accidents, nothing perturbed Sonorans more than the issue of differential wages between Mexicans and foreigners performing similar operations.[130] Even without formal unions, wage discrepan-

cies led to numerous labor disputes and even strikes. When Yaqui work-
ers who received $1.00 a day at the Pan American Mining Company
learned that another treatment plant paid $1.50, they went on strike.
The company superintendent held out for a few days but finally granted
the Yaquis' wage demands.[131] Another area of dissatisfaction involved
"down time" when machinery failed to function and workers received
no compensation for the day. On August 28, 1897, for example, the
elevator on the main shaft of the Crestón broke down and a replace-
ment from the United States did not arrive at the site for three weeks.[132]
The companies refused to pay for work not performed, yet insisted that
miners remain on call. With no compensation forthcoming, miners in-
creasingly became indebted to local merchants, especially the Chinese,
who extended credit.

Aside from wages, Mexican miners resented the treatment they re-
ceived from European and American foremen, many of whom spoke
little if any Spanish. With this tense atmosphere, verbal clashes and
even fistfights between Mexican workers and foreign foremen often oc-
curred in the mines. In May 1897, for example, authorities arrested
Francisco Valenzuela for insulting a foreman at the Amarillas mine.[133]
Physical altercations between these two groups also transpired fre-
quently. Showing disrespect to a foreigner, *faltando el respeto a un ex-
tranjero,* became one of the most common reasons cited by authorities
for arresting Mexicans workers.[134]

As antagonism against foreigners intensified, the Chinese, in particu-
lar, became targets of Mexican hostility. In contrast to the powerful
Americans, who were protected by state officials, the Chinese appeared
vulnerable. Their commercial activity placed them in daily contact with
Mexican laborers. For many Mexicans the Chinese represented a dis-
tinct culture with which they had little in common. In La Colorada,
a town with free-flowing liquor and widespread vice and prostitution,
Mexican newspapers accused them of contributing to the moral decay
of the youth. In 1901 one publication reported that under the cover of
a saloon, several Chinese operated an illicit gambling establishment and
an opium den where the youth passed the time.[135] Besides verbal and
physical abuses, the property of the Chinese also suffered attack. In
March 1897, Manuel Encinas set fire to a store owned by a Chinese
merchant in La Colorada.[136] In response to repeated assaults and the
death of several Asians, Chinese merchants complained to their em-
bassy in Mexico City, which in 1907 dispatched an emissary to investi-
gate conditions at Minas Prietas.[137]

As the century came to an end, the Chinese were not the only group that drew the ire of the Mexicans. Despite their privileged position, Americans did not escape the Mexicans' outrage.[138] One case which jolted the entire town involved the bombing of the house of Thomas Hughes, an official of the American company. On the evening of September 23, 1900, while Hughes hosted two prominent Mexicans, an unknown person threw several satchels of dynamite at the house. The explosives detonated as Hughes' wife stepped out to the patio, and she received severe injuries to her arms and face.[139] Both Mexican officials and Americans were enraged by the incident. The governor ordered the municipal president, Feliciano Monteverde, and the prefect, F. M. Aguilar, to give this matter their utmost attention. In spite of a long investigation, the perpetrators eluded authorities.

THE MINE DETERIORATES

Despite the growing antiforeign sentiment, mine operators had other pressing matters of concern. After years of excavation, the productivity of the Minas Prietas mines, once the largest in the area, declined. A low water table and collapsing tunnels took their toll. After 1905 a gradual shift took place from Minas Prietas to La Colorada. Shops and other commercial establishments closed or transferred operations to the neighboring town. As the population dwindled, in December 1906 the state government reduced Minas Prietas to a comisaria and made La Colorada the municipal seat.[140] Minas Prietas never fully recovered and languished in the shadow of La Colorada.

Mining camps such as La Colorada did not escape the climate of political polarization which characterized the late Porfiriato. The town witnessed a rise in political activity, especially the founding of electoral clubs. In July 1900 for example, several individuals formed the Club Politico Bernardo Reyes in honor of the popular general and staged a march from Minas Prietas to La Colorada.[141] The inequities found at mining camps served to politicize some of Sonora's future revolutionary leaders. In preparation for the traditional fiestas patrias, the municipal president, Feliciano Monteverde, formed a committee in August 1901 to celebrate Mexican independence. Monteverde and Miguel Flores Hermosa, a disliked colonel of the Rurales, assumed the top posts on the committee.[142] Political opponents, led by Gilberto López and Manuel M. Diéguez, formed an alternative Junta Patriotica and staged a separate commemoration of Mexico's independence.[143] This growing

polarization concerned Americans and state authorities who worried that it might eventually lead to labor problems. When the Cananea strike of 1906 erupted, they feared that labor troubles would spread to other mining camps in northwestern Mexico. In the aftermath of the strike, Governor Torres warned officials at La Colorada and elsewhere to ban all political activity, claiming that they had uncovered a plot to embarrass the government during the fiestas patrias.[144]

EL DERRUMBE

The beginning of the end for La Colorada came in 1909, not by the hand of labor, but from the forces of nature. For years miners had repeatedly battled cave-ins caused by porous soil and a low water table. At eleven o'clock on a spring morning, the shrill sound of the company whistle alerted the village that something had gone wrong at the mine. Hundreds of the townspeople flocked to the entrance of the Gran Central. There they found that an entire shift, comprising over one hundred workers, had been trapped when a lower section of tunnel collapsed at the Gran Central, La Colorada's principal mine.[145] Due to the depths of the shaft and the surging water, the company made no formal attempt to rescue the miners and they remained buried in the mine. The tragedy devastated the entire town and several days of public mourning followed. In the aftermath of the accident, important sections of the Grand Central remained under water and mining continued to decline.[146]

Besides the dramatic impact of the collapsing tunnels, the mining operation had also done long-term damage to the environment surrounding Minas Prietas and La Colorada. Adjacent to the mines, the barren hills and desolate plains, where only the hardy cactus stood, bore testament to the near total deforestation of the area. Obtrusive mountains of chemically leached tailings dominated the urban landscape. Lakes of polluted water containing potassium cyanide used to process the gold surrounded the mill and drained into adjacent farmlands. Clouds of black smoke bellowed from the mill and blew over the town. The American consul at Hermosillo reported that the mine consumed annually nearly 1.8 million pounds of lime, 54 thousand pounds of cyanide, and 100 thousand pounds of zinc, the remnants of which could be found in the topsoil surrounding the camp.[147] The nearest rivers, the San José and the Matape, had been re-routed with pumps to drain into a company-built cement reservoir in the valley above the mill.[148] The

town's water supply, drawn from the dam and from an old abandoned mine shaft, contained dangerous heavy metals. Crop failures and illness among cattle became common in La Colorada and other mining towns.[149]

The value of working in the mines became tarnished and life in La Colorada deteriorated. Many people began to stream out of the camp and search for work in Hermosillo or in other mining centers.[150] The government's indiscriminate campaigns against the Yaquis forced many to abandon the mine.[151] Gradually stores and saloons began to close,[152] and what little there had been of law and order degenerated. Desperate for troops to fight the Yaquis, the government forcibly drafted young men from La Colorada, a practice they had avoided earlier when the mine needed laborers.[153] In October 1909, a group of residents protested that they no longer felt safe in the town. They complained to the municipal president that the police, headed by Manuel Monteverde, did nothing to protect their interests. Although authorities replaced the police commissioner, the town continued its downward spiral.[154]

VILLA'S RAID

The revolution dealt the mining camp its final blow. During his ill-fated expedition into Sonora in October 1915, Francisco Villa raided La Colorado and ransacked the town. After suffering a bitter defeat at Hermosillo at the hands of General Diéguez, a former resident of La Colorada, Villa's army turned southeast and descended on the unprotected mining town, which had received advance warning of his approach. Alarmed by his reputation, many of the remaining foreign residents panicked and hid in the network of mine shafts to avoid capture. Not all, however, managed to escape. Villa's forces apprehended several Chinese, whom they publicly hanged, and others, whom they shot on the outskirts of town.[155] Reeling from defeats in Agua Prieta and Hermosillo, Villa's soldiers took anything of value within their reach.[156] They also destroyed the pumps which kept the mine dry, allowing the water to flood most lower chambers.[157] Unlike social bandits of popular lore, Villa's men did not distinguish between Mexicans and foreigners, rich or poor. His forces took store merchandise, horses, and burros from the local Mexican populace. The army that had been denied an opportunity to take Hermosillo vented its frustration on what remained of La Colorada before continuing on its journey toward Chihuahua.

After the attack by Villa's forces, the town never again regained its

previous splendor. For the next five years, several American investors made vain efforts to resume mining operations, but none proved successful. Mining continued sporadically until the early 1940s, when it ceased altogether. Operators lost the battle to repeated cave-ins and an ever-rising water table. Eventually the diggings became the domain of the gambusinos, who scoured through the tailings hoping to find traces of gold or silver. Today La Colorada is but a shadow of its former self. Empty shafts reaching miles into the bowels of the earth and towering mountains of swarthy tailings stand as mute testimony to the previous mining activity. With only one major street, the handful of residents that remain tends to crops and cattle while occasionally prospecting. Stories of rich veins waiting to be tapped abound, and most people dream of seeing the town return to its former grandeur. Most continue to cling to the hope that like a mythical phoenix, La Colorada–Minas Prietas will once again arise from the ashes.

"The Yankees of Mexico"

When Sonoran notables learned that Vice President Ramón Corral planned a visit to the state in 1904, they formed a committee to welcome him home.[1] As the presidential train pulled into Nogales at 1:15 a.m., a delegation of the most influential merchants, bankers, ranchers, mine owners, and foreigners in the state awaited Corral. Besides his wife, Amparo, those on board the train represented the groups which had most benefited from the Porfiriato in Sonora. The vice president's retinue included long-time politicians Rafael Izábal and General of the Northwest Luis Torres, merchants and land owners Juan P. Camou and Alejandro Lacey, and an influential American investor, Captain L. W. Mix. Despite the late hour, the reception committee greeted Corral with champagne, fireworks, and a ball which lasted into the early morning. The lavish ceremony at Nogales paled by comparison to what awaited Corral and his entourage at Hermosillo and Guaymas. As the train passed the small towns which dotted the northern countryside, hundreds of people lined the tracks to welcome Corral and his entourage.

Every town along the train's route from Nogales to Hermosillo planned receptions and erected elaborate arches under which the vice president's train passed. The arch at the town of Imuris proved especially instructive since it reflected the vision of a large segment of the Sonoran elite. Labeled "Barbarism flees Progress," the structure portrayed a train named Ramón Corral in pursuit of a retreating Apache. American flags decorated both sides of the edifice. The symbolism did not appear accidental. Notables applauded the demise of the Apache

and believed their success rested on their continued ability to attract and manage American investment.

From all indications, by 1904 the Sonoran elite had reason to celebrate. In politics the triumvirate composed of Torres, Corral, and Izábal dominated politics while ensuring order and stability. In twenty years, from 1880 to 1900, the state had witnessed striking political and economic change as a new export economy with the United States took root. On the surface the state seemed to benefit from the exchange with Americans. In mining, foreign-owned enterprises in Cananea, La Colorada, and Nacozari provided employment for thousands of workers. To ensure a steady supply of labor, mining companies paid among the highest wages in Mexico, in turn invigorating local commerce. Rural areas traversed by the railroad witnessed the rise of large-scale, export-oriented cattle ranching and commercial agriculture. In dealings with foreign interests, Sonoran land owners, mining brokers, merchants, and high government officials made handsome profits. Most anticipated that the boom which had elevated the state into national prominence would continue indefinitely. Moreover, they expected that Vice President Corral would succeed the aging Díaz, and Sonora's future would be assured.[2]

By the turn of the century, Sonora had become one of the wealthiest and most prosperous states in Mexico and the largest recipient of United States mining investments. American interests had invested $37.5 million in Sonora, "of which $27,800,000 was in mining."[3] The presence of German, French, Spanish, British, American, Spanish, and even Guatemalan consular offices in Sonora attested to the state's new found importance.[4] Economic interaction with the United States had produced profound cultural changes. American ideas, one United States consul wrote, had sunk deep roots in Sonora. By early 1900, Sonorenses had been stamped as the "Yankees of Mexico, because of their thrift, advancements and close relations to the Americans."[5]

A coalition of merchants and hacendados, a small but ambitious middle class, and government functionaries focused on the day-to-day tasks of running a complex export economy. To accomplish this objective, they exalted practical and economic achievements, redefining many traditional cultural practices and social norms. The arts, music, and other cultural activities, which in past had been signs of status, were recast in a new light. Notables refashioned both their cultural as well as their physical environment. They established exclusive clubs where they interacted and exchanged social views. Changes occurring

in language, food, and dress initiated by these groups eventually affected broad segments of the population.

THE LANGUAGE OF BUSINESS

Sonora's growing economic and social ties with the United States made learning English an imperative.[6] Private schools had previously offered English instruction, although it had not been given a priority.[7] In 1852, for example, the *Colegio de Sonora* in Ures offered courses in German, French, Italian, and English.[8] Sonora's upper classes increasingly frowned upon the learning of Romance languages, such as French, and instead encouraged instruction in English.[9] Learning English became necessary to obtain a coveted administrative position with an American concern. A Guaymas newspaper, *El Noticioso,* argued that for the people of the border or *fronterizos,* "the learning of English had become a real avocation, because young people who speak it are assured good paying jobs in any business."[10] For the aspiring middle sectors of Sonora there existed a direct correlation between English-language acquisition and the possibility of employment with an American company.[11]

For Sonorans who dealt with American companies, English became the language of business.[12] Seldom did Americans learn Spanish, expecting instead that their Sonoran clients would learn their language. J. F. Darnall, a United States consul, reported that Americans not only expected Sonorans to speak English but also to become familiar with American business practices.[13] Despite early resistance, American customs made inroads, and by 1903 the consul wrote that "Sonora being so close to the United States its merchants are in almost daily contact with Americans and have become accustomed to American terms of credit and general manner of doing business."[14] With little choice, over time, Sonorans adapted. English words such as "taxes," "checks," "stock," "pipes," and "machines" became part of the Sonoran's business vocabulary.[15] When ordering a shipment of merchandise from his brother in Guaymas, José Camou ordered a "carload" of goods on the train.[16] To order a suit from Harris and Frank, a Los Angeles tailor, Camou used a blend of Spanish and English to describe his appearance: "[S]oy, regular, ni slim ni stout."[17]

Families eager to have their progeny learn English sent them off to Catholic boarding schools in the United States and Mexico City. Boarding schools in Los Angeles, Tucson, and Mexico City advertised their

services in the Sonoran press.[18] Manuel Mascareñas, a city councilman of Nogales, Sonora, sent his sons to a Catholic school in Los Angeles in order to further their education and, especially, to learn English.[19] The presence of family members or Sonoran immigrants in California and Arizona eased the transition for the children who studied abroad. Mascareñas, for example, relied on his "compadre" Don Mariano Román, who lived in Los Angeles to keep an eye on his offspring.[20] The merchant José Camou of Hermosillo and Alejandro Ainslie, a political figure, sent their sons to Mexico City to master English.[21] Camou's daughters went to study with American nuns in California. As a scion of an old merchant family, Camou confronted a perplexing dilemma. He hoped that his children would learn the language of his French ancestors but pragmatically he recognized that English had become the "language of business."[22] Torn by the issue, he resolved that French would have to wait.[23] For Sonorans engaged in commercial relations with the United States, French and other European languages no longer had any practical economic advantages.

By the 1870s, English appeared in common use throughout Sonora. At first, its utilization in commercial transactions and mining contracts became a concern for Sonoran officials worried about the legal and cultural ramifications that a foreign language could produce in the state. In 1881 the governor of the state prohibited the use of English in official documents and private contracts. To add teeth to the decree, the state government refused to recognize the legality of non-Spanish contracts. Also due to growing American influence, in 1884 the state reaffirmed "the metric system as the only valid measurement in commerce and real estate."[24] Yet English gained ground and gradually permeated the Spanish vocabulary, ensuring its commonplace use. Government officials at all levels received correspondence in English and had to either learn the language or employ translators.[25] Luis Torres and Ramón Corral, for example, two men who dominated Sonora for close to thirty years, spoke English.[26] Individuals who could speak both English and Spanish were in demand, and varying degrees of bilingualism became a notable feature of border life during the later half of the nineteenth century. Hoping to capitalize on the growing use of both languages, El Fronterizo, a Spanish-language newspaper in Tucson, offered an English-Spanish dictionary "especially created to suit the needs of the border area."[27]

Despite expressions of concerns over cultural sovereignty, govern-

ment policies contributed to the valuation of United States customs and to the use of English. Eager to imitate developments in the United States, Sonoran officials kept abreast of changing laws and government regulations in the U.S. Southwest. The government requested and received copies of state constitutions and municipal codes from Arizona, California, Texas, and New Mexico. To stay informed of American business practices, they acquired regulations pertaining to mining, cattle ranching, and agribusiness. The government presented these documents as models for municipal authorities contemplating changes in local codes. Government circulars urged Sonoran businesses to subscribe to American magazines in order to stay abreast of changing market conditions and economic new trends in the north. In one letter to ranchers in the district of Altar in 1895, Governor Corral urged local elites to subscribe to *Western Manufacture,* an American business magazine. The United States became a point of reference in matters relating to the economy and government, and this orientation served to accentuate the need for the incorporation of English.

ESTILO AMERICANO

Invariably, the use of English language represented a change in social attitudes and customs. Language, as Ward Goodenough pointed out, is not only a method of communication but rather it also "represents a cultural system," a distinct set of social norms.[28] Just as in the past the Sonoran vocabulary with antiquated Spanish phrases and indigenous adaptations had reflected a distinct regional frontier culture, the use of English now denoted the incorporation of new values. Language "then provides a set of forms that is a code for other cultural forms."[29] Changes in attitude and values became discernible in business practices. Stores, for example, advertised that they conducted business in the "American style." Labeling something as "American-made" attested to its quality. When a bottling concern in Alamos began to produce soft drinks, including ginger ale, they advertised that the product included fruit juice imported from the United States.[30] Several bakeries announced that they operated as "Panaderías Americanas," and sold *quekis* or *quequis* (cakes), a term still used in Sonora today.[31] Butchers purported to be "Carnicería Estilo Americano" (American style) and offered thick American cuts of beef rather than thinly sliced Mexican steaks. As customs changed, so did language—a choice slice of beef be-

came a *bistec* (beefsteak). Hotels such as the California in Guaymas, managed by Plutarco Elías Calles, advertised "Modern American style," which meant private lavatories, showers, pool halls, dining rooms, bars, and service to and from the railroad station.[32] Similarly, many restaurants claimed to serve American-style food. One establishment, a drug store with a very patriotic name, Botica de México de Benito Juárez, advertised "American, English, French and German" remedies, though not Mexican drugs.[33] Gradually these changes began to reshape the tastes and customs of middle- and upper-class norteños. Before long they influenced even the average Sonoran.

English not only influenced the local vernacular, it also placed greater emphasis on economic relations. Previous cooperation between economic groups slowly eroded under this new orientation. In responding to a very appreciative letter from a debtor in Guaymas, José Camou dispassionately responded, indicating "there is no need to thank me, after all business is business."[34] As competition increased, merchants in Guaymas who had traditionally operated by consensus, now found an increased level of competition permeating their relations. In particular, their tacit agreement over operating hours, closing during the noon hour to avoid the extreme heat, had been violated. Several ambitious merchants decided to stay open to monopolize trade while others closed. These gradual changes spread beyond the border regions, influencing Alamos in the south and northern Sinaloa.[35]

THE PRESS AND CULTURE

The prolific Sonoran press became an important instrument in the popularization of English. Despite its small population, Sonora had a disproportionately large number of newspapers. They existed in every major town in the state; those from Guaymas, Hermosillo, and Nogales enjoyed statewide circulation. For the aspiring middle class, the press helped redefine cultural practices and language in the state. Their pages devoted extensive coverage to fashions and social gatherings, and hundreds loyally followed its reporting. Writers sought to enliven articles with English words. Journalists referred to talks by politicians as *haciendo un speech,* or "giving a speech." The arrival of an American invariably became *la llegada de un gentleman.*[36] Here again the use of English emphasized a new social order. A gentleman, as described by the press, represented a well-mannered, educated individual in contrast

to the uneducated Sonoran ranchero. Reporting on an evening perfor-mance at the Teatro Noriega in Hermosillo, one paper chastised the crowd for making noise while "gentlemen" were in the audience. What would the "gentlemen" think of the city, the paper worried.[37] In report-ing on society events, the Sonoran press typically described them as gatherings of the "High Life."[38] Hoping to capitalize on the social status of this word, the Cerveceria de Sonora (Sonoran Brewery) in the 1890s named its lager beer "High Life."

Hotels, bars, and drug stores which sought to impress customers or cater to foreigners displayed signs indicating "English spoken here."[39] Not to be outdone, other businesses proudly announced "English, Ger-man, French and Italian spoken" in their advertisements.[40] Saloons and restaurants, eager to attract both Mexican and foreign patrons, adver-tised "lunch and sandwiches" as well as "bottled imported draft beer from St. Louis, Missouri, served day and night."[41] Some establishments which served a midday meal began referring to themselves as *loncherias,* lunch counters which served exquisite *sadwiches* (sandwiches).[42] This transformation not only implied a change in language but also more importantly a break from the tradition of eating a mid-afternoon meal.

The presence of Americans and the widespread consumption of products from the United States reinforced both foreign values and the use of English. By 1889 Hermosillo had over twenty cantinas, many owned by Americans or operating in the *estilo Americano.* One such establishment owned by Samuel H. Kraft, La Luz Eléctrica (The Elec-tric Light), a saloon in Hermosillo designed in the "Yankee fashion," included a bar and a stage with live entertainment provided by two American women who sang and danced nightly.[43] For the price of a beer, patrons saw a show by the *linterna magica* (the magic lantern), which projected slides of Niagara Falls and the Paris Exposition that the owner had imported from the United States.[44] At another estab-lishment, two black entertainers performed on stage nightly.[45] Saloons advertised Budweiser™ beer at fifty cents a bottle and Paul Masson™ champagne imported from California.[46] Patrons drank draft beer served in a *pichel* (pitcher) while they played on a *mesa de pool* (billiard table).[47] By the early 1900s Hermosillo even had a Kentucky-style whis-key distillery.[48] The owners of the distillery advertised their product as a medicinal drink, and drugstores became a common outlet for whis-key. One shrewd American distributor peddled an alcohol elixir at min-ing camps for those who were tired of the "struggle for life."[49] In rural

camps, where social tensions ran high, another astute seller proclaimed that the one thing that "worker and capitalist" could agree upon was the taste of Jesse Moore™ whiskey.[50]

Employed only to highlight or describe a particularly new phenomenon for which Spanish words did not exist, English never outrightly displaced Spanish. To explain a family Sunday outing in the 1890s, for example, the local press frequently used the word "picnic." To describe an afternoon social affair, it utilized "ice-cream party." Newspapers from Nogales to Ures reported that "picnics and ice-cream parties" had become the rage among young people on weekends.[51] Eager to attract business, the Orquesta Hernández of Nogales, Sonora, advertised its services in English for "parties and picnics."[52] As the use of English became popularized, it increasingly developed a Spanish intonation since Mexicans wrote English words the way they sounded to them. For example, names such as Hughes, became "Hugues," words like "thrift store" became "trist store," "discount" became "descount," and "fancy," "fancey."[53] Sonorans' Spanish adaptation of English guaranteed its permanent place in the state's vocabulary.

RELIGIONS

Protestant religious groups in the United States foresaw an opportunity to win souls along the border, and they gradually made their presence felt there. Non-Catholic religious orders had legally functioned within Mexico since 1861.[54] By the late 1860s Guaymas had an active Christian Association, which held Sunday-school ceremonies. Beside religious instruction, Protestants offered a wide variety of services to attract converts, including classes in English, math, and geography.[55] They aimed much of their message at the youth of Sonora, urging hesitant parents to at least send their children.[56] Feeling besieged, the Catholic Church responded by trying to fashion a greater public face, offering classes in religious instruction and advertising Sunday worship. Hoping to promote its interest, by 1900 the Church started publishing a newspaper entitled *El Hogar Católico*. The publication adopted a belligerent attitude toward Protestant groups, insisting that along the north, the defense of the Mexican nation "depended on the Catholic faith."[57] Their efforts bore little fruit, and Church officials complained about the "glacial indifference" norteños exhibited toward religious instruction.[58] With few clerics in the north, the Catholic Church could do

little to prevent Protestant penetration.[59] But Protestants, like Catholics, made few inroads and only in border towns did they gain converts.[60]

CHANGING CUSTOMS

The presence of foreigners introduced Sonorans to alternative cultural norms. In 1901, the year in which the United States formally established Thanksgiving as a national holiday, Americans throughout Sonora began to mark the occasion.[61] Since the mid-1870s, Mexicans living in Tucson, where many Sonorans had family, witnessed public celebrations of Thanksgiving.[62] For Sonorans, this holiday had no local counterpart and its purpose remained somewhat of a mystery to the Mexican population. *El Correo de Sonora* explained the meaning of Thanksgiving, describing it as a yearly "event in which you leave aside the hard tasks of daily life and in the company of your family celebrate the accomplishments of the year."[63] In Guaymas, *El Nacional* reported that "in Empalme, American families are hosting a magnificent feast to which many people have been invited. Turkeys, ready to go into the oven, are on their way from Kansas, Los Angeles and Phoenix in refrigerated cars."[64] In mining towns, company stores, such as those in Cananea, held "Thanksgiving Week Specials" in which they advertised imported and local products: "cranberries, apples, celery, pineapple, Roquefort and Edam cheese, fresh oysters and bananas."[65] In Cananea, the American copper giant declared Thanksgiving as an official company holiday.[66] For all but a handful of Sonoran elites who took part in celebrations with Americans, this festivity remained a hollow observance.

The American rendition of Christmas, which included the evergreen tree and the sharing of gifts on December 25, touched a sympathetic chord in Sonora. Americans invited Mexicans to their celebrations and slowly the custom sunk roots in many Sonoran communities. In border communities such as Nogales, Agua Prieta, and Naco, the evergreen tree became a symbol of the Christmas spirit for broad segments of the population.[67] *El Imparcial,* a Guaymas newspaper, reported that in the north Christmas was "celebrated in the American tradition by receiving and giving gifts."[68] The active participation of Mexican merchants fueled acceptance of the American holiday. Stores ran special Christmas sales in order to facilitate the new exchange of gifts.[69] In 1907, leading merchants along the border, including Mascareñas and Escalante, re-

quested permission to extend operating hours in order to accommodate the "Holiday Season."[70] The Spanish tradition of exchanging gifts on January 6, the Feast of the Epiphany, slowly lost ground.

BASEBALL

Sonorans of all social backgrounds developed an affinity for American sports, in particular, baseball. The origins of baseball in Sonora are usually traced to American sailors who played the game while on leave in the port city of Guaymas in the 1870s. Mexican children, who watched the sailors, played the game among themselves, and gradually, the sport spread throughout the state. The presence of Americans inevitably reinforced the game. In Empalme and Guaymas, for example, railroad workers formed teams that included both nationalities.[71] As interest grew, citywide leagues took shape. Travel by railroad facilitated games between cities and the formation of a statewide league.[72] Games between opposing towns became festivities that drew most townspeople, and baseball players became statewide celebrities. In 1894 Sonorans voted for the best players in the state and formed an all-star team.[73] American companies, such as Titicomb of Nogales, saw an opportunity to develop good will and sponsored Mexican teams, providing uniforms and equipment. As the sport increased in popularity, the language of the game soon developed a decidedly Spanish bent: adaptations like *match, honron, picher, strike, manager,* and *cacheo* became commonplace. The rise of baseball contributed to the demise of traditional sports, such as bull- and cockfighting.[74]

MEXICAN CRITICS

Changes in language and life style soon attracted critics who complained about the contamination of Spanish. A columnist for *El Imparcial* promised his readers that in his articles "you will not find phrases such as "chic," "sports," "creme," and other foreign words used by pedantic persons who want to appear well versed in three or four languages, but who in reality wind up butchering their own."[75] The commentator pledged to use only Spanish. Sonorans living in the United States were also similarly critiqued. Since the late 1840s, according to Horacio Sobarzo, Sonorans referred to Americanized Mexicans living either in California or Arizona as *pochos.* The term served to describe any person who spoke broken Spanish or had become *agringado,* or cul-

turally Americanized.[76] The harsh criticism did not appear to carry much weight with notables who continued to use English or with Sonorans who relocated to Arizona. Advertisements in newspapers commonly appeared in English. When the Sonoran caudillo Torres decided to rent his home in Hermosillo, the advertisement in the newspaper appeared in English.[77] Those wishing to profit by selling to Americans continued to advertise "for sale" and "dollars only."

The natural interaction that occurs when two cultures and two languages converge could account, in part, for the use of English in Sonora. Cross-border relations between distinct cultures invariably produce language variances and adaptations. In the case of Sonora, however, the asymmetrical relationship between Mexico and the United States recast the issue of language in a different light. Rather than the simple outcome of contact between two distinct cultures, the use of English in Sonora perpetuated unequal relations between Mexico and the United States. Language constituted only one component of the profound social and economic transformations which Sonorans experienced.

For the average Sonorans, the use of English accentuated the disparity between Americans and Mexicans. In protest over his firing by J. M. Hauser, an American foreman of the Cananea Mining Company, miner Jesús O. Ochoa filed a formal complaint with authorities. A local judge repeatedly postponed hearing the case. Ochoa objected to the unequal treatment he received, noting that even the language employed by the Mexican judge favored Americans. Why, he insisted, must Hauser be referred to as "Mister" and he was not. "Americans," he concluded, "were always Misters to officials."[78] In a letter to a local newspaper he claimed that Mexicans could never expect to "reach the sublime god of justice Athena as long as her hand was promised to the dollar."[79]

In marked contrast to developments in Sonora, Arizona's small Anglo population took concrete steps to restrict the cultural impact and political participation of Mexicans in the territory. In 1895, despite vigorous protest from *El Fronterizo* in Tucson and *El Monitor* in Nogales, the Arizona legislature prohibited publication "of any paper or magazine not in English."[80] In addition, any person seeking public office had to "be able to speak, write and read English."[81] Other laws prohibited Arizona hospitals and social agencies from treating noncitizens. These restrictions sought to enhance American political and cultural domination over the numerically superior Mexican population in southern Arizona.

English and American customs became part of the "personal cultural repertoire" of the elites and the emerging middle sectors.[82] Multiculturalism, as Goodenough pointed out, is the result of contact with foreigners, in this case Americans, or with members of their own society already competent with these norms. Knowledge of English and exposure to American norms did not imply that Sonorans only imitated American lifestyles and crassly mimicked their culture. The acceptance of English remained directly tied to the economic advantageous that the language provided to those who interacted with Americans. Likewise, important differences existed between the culture that operated among Sonorans and that which they employed with foreigners. Seldom did Sonorans speak English among themselves or resort only to American norms. The sphere in which they employed American customs, or their "cultural pool," remained limited to dealings with foreigners.

American economic dominance did not translate into total cultural hegemony. In Sonora, as in the rest of Latin America, French culture and norms still held sway among old elites. In matters of fashions, food, and literature, the French ideal retained prestige and provided an alternative to American influences. Commercial establishments in Hermosillo including bakeries such as the Panadería Francesa, drug stores such as the Botica Francesa, and hotels like the Hotel Frances bore witness to the French influence. Society matrons, such as Amelia Monteverde de Torres, wife of the governor, subscribed to Parisian couturier magazines[83] and French fashion continued to be the rage among notable women. When he sought to decorate his stately manor on the outskirts of Hermosillo, Governor Rafael Izábal ordered French paintings and wall panels depicting European hunting scenes.[84] In Hermosillo, the Casino de Comercio, a select club for elite men had also been furnished with French decorations.

French influences were also readily apparent in public and private celebrations of the elites.[85] To commemorate the reelection of Porfirio Díaz in 1888, Hermosillo notables prepared a sumptuous banquet. At a dinner for three hundred of the state's most powerful, the menu, printed in French, listed *Potage* (soup), a *Consomé aux Pates d'Italie* as appetizer, canned salmon from the United States Northwest, and as an entree, *Vol-au-vent a la Reelección* (stuffed pastry shells), *Filet de Boeuf,* and a ham dish. To add a regional touch, the guests were served *Créme de Glacee a la Fronteriza* and *Marmelade a la Bautachive* for dessert.[86] Drinks included cognac and champagnes from France. To ensure that all the state knew of the event, *La Constitución,* the govern-

ment's mouthpiece, printed a glowing report of the banquet. Not only did elites seek to affirm new social practices, they also increasingly distanced themselves from the population at large.

EDUCATION

A host of Mexicans scholars have traditionally portrayed norteños as people of action, not as philosophers or intellectuals.[87] Anthropologist Ignacio Bernal points out that "people from central Mexico considered the northerners . . . much more practical, enterprising and efficient."[88] The struggle for survival in a harsh environment and conflicts with the Indians compelled the Sonorenses to be "practical, not only in their thinking but also in their way of life."[89] The demands of an export economy and the influence of American values tended to reinforce the earlier practical orientation. Modifications in the educational system undertaken after the 1880s ensured the continued stress on the utilitarian.

Education, long neglected, underwent fundamental changes as Sonora sought to modernize. The chronic lack of funds meant that education had been reserved for a select few. Although the state possessed a formal school system, children, according to Ramón Corral, "only learned the most rudimentary basics."[90] School teachers often resigned for lack of pay,[91] and local funds simply did not exist to cover expenses, materials, and salaries. Furthermore, given the chronic labor shortage in the state, many parents did not allow children to attend school, sending them off to work instead.[92] Only cities such as Alamos, Hermosillo, and Guaymas, maintained schools on a semi-regular basis.

With access to American railroads, San Francisco and Los Angeles became affordable alternatives to costly European education. Those with resources sent their children north for an education.[93] A foreign education, however, had its critics. Corral, the state's point man on education, argued that "the small number of Sonorans, who are being educated, are receiving essentially an American education, contrary to our nature and customs, our necessities and contrary to our patriotic sentiments."[94]

Sonoran students in the United States, he insisted, at best only "learned English and superficial subjects."[95] Only the children of affluent families could afford schooling in Mexico City. Sonoran youth trained in Mexico City, according to Corral, did not receive an "adequate education since they spent the best years of their lives away from

the state . . . learning nothing of use to Sonora."[96] Several issues appear to underlay Corral's concerns. Education, he argued, must play a pivotal role in perpetuating Sonora's values and customs; it was the bulwark against cultural encroachment by the United States. Others also shared his perspective. A speech by General Crispin S. de Palomares, a native of Alamos, to a graduating class in Hermosillo summarized the view that education must become Sonora's principal "weapon" for preserving traditional society. Palomares argued that "all of society must promote public instruction because it is the only salvation of our independence. Some will tell me that what I say is not true; we are not under attack by any foreign power. However, I believe that we are; we are confronting the most dangerous invasion that can exist for us, that is why the education of our youth has a great social importance for us."[97] Cross-border relations and the penetration by American culture added a new urgency to the educational debate. Education must not only instruct, it must also reinforce traditional values. Beside cultural concerns, practical considerations also influenced the question of education. Sonora's pragmatic leaders believed that instruction must produce tangible results. Sonora did not need intellectuals, but rather "lawyers, doctors, statisticians, engineers, and bookkeepers"[98]—technical and professional careers became key for Sonora's "modernization" and development. Standards of social class and traditional concepts of an education no longer applied.

The positivist views which operated elsewhere in Mexico resonated in Sonora. Elites who at one time urged their children to be properly socialized and "cultured" now discouraged their offspring from spending time learning music or art. Professions such as geology, accountancy, mining, engineering, or telegraphy were extolled and intellectual or artistic endeavors frowned upon. The secondary school at Hermosillo, the Colegio of Sonora, offered degrees in "bookkeeper, telegraph operator, surveyor, assayer, and grammar school teacher."[99] This orientation invariably influenced social attitudes. When the children of José Camou, to cite one case, sought to learn art, painting, and piano, their father discouraged it, insisting that knowledge of the piano and art was "simply social embellishment."[100] Mascareñas, whose children studied in California, shared Camous' view. When one of his sons requested permission to take piano lessons, he objected. In a letter to Reverend Landry, the school principal at the Saint Vincent Academy in Los Angeles, he referred to knowledge of the piano as merely "a social ornament."[101] Back in Nogales, citing urgent business needs, he once

again prohibited his son from taking piano lessons.[102] This pragmatism influenced the generation which matured during the Porfiriato in Sonora.

Early attempts to establish a secondary school in Sonora proved disastrous. Governor Carlos R. Ortiz, who had been educated in Germany, dispatched a delegation to Europe in 1880 to recruit teachers and buy supplies.[103] The commission returned with several German instructors, none of whom spoke Spanish.[104] In addition, they had acquired a zoological and botanical museum which contained an assortment of stuffed animals, including an elephant. The Instituto de Sonora, or Sonoran Institute, which had been founded by Ortiz, soon became an object of ridicule and, increasingly, a political liability for the governor. The state did not have sufficient advanced students to warrant a large, sophisticated, secondary school,[105] and the inability of the instructors to communicate with the students aggravated matters. Opponents of the governor used this issue to show that he was out of step. After the ouster of Ortiz, the school closed and the animals and supplies gathered dust in the basement of the government building.

The subsequent administration of Torres and Corral succeeded where Ortiz's had failed. To revamp the educational system, the state invested large sums of money to buy material, mostly from the United States, and recruited teachers from throughout Mexico.[106] In 1887, according to acting governor Corral, there were 139 schools in the state with 3,859 boys and 1,675 girls in attendance. By the first semester of 1891, the number of schools had increased to 175 with 6,272 boys and 3,229 girls, an increase of approximately 60 percent in four years. Corral insisted that between 1887 and 1891 the state had distributed over fifty thousand books to students.[107] Still, a world of difference separated schools in large urban centers such as Hermosillo and those in isolated rural areas. In the interior district, school personnel struggled to acquire materials and to attract students.

In 1889 the state once again inaugurated a secondary school in Hermosillo, El Colegio de Sonora.[108] The preceding year they had also opened night schools to allow laborers to attend classes.[109] By 1900 the state boasted that "one out of every three pesos that the government spent was allocated to education, a total of $302.015."[110] Funds for schools came from many sources. On several occasions, American companies learned that their projects might receive prompt government attention if funds were offered for school construction. While in the process of negotiating a contract for El Copete mine, the Melczer brothers

of Phoenix saw fit to donate 5,000 pesos to the state's schools. The contract for their mine was approved two weeks later.[111]

Officials proudly pointed out that Sonora spent more per capita on education than any other state in Mexico.[112] The state government negotiated agreements with the American companies at Cananea and at Nacozari, establishing apprenticeship programs for skilled positions. It also sent students to Mexico City to study agronomy and other subjects not available in the state.[113] Attempts to improve education appeared genuine and struck a responsive cord among many in the population. In most major cities, educational clubs formed to raise funds and advance instruction. In Guaymas they sold books, maintained a night school, and published a monthly pedagogical journal covering such issues as morality and parental responsibilities and promoting full education rights for women.[114] In 1901 the editors of the *Revista Escolar* were Fernando F. Dworak, a local educator, and his young disciple, Plutarco Elías Calles.[115] Dworak and Calles had a long working relationship. During 1896 Calles had been Dworak's assistant at a public school for boys in Guaymas[116] and later became an assistant instructor at the state superior school, El Colegio de Sonora in Hermosillo. Instructors from Guaymas' schools contributed articles on agriculture, physics, psychology, and other subjects to the publication. An inexpensive price, ten cents, kept the magazine within reach of most students. The impetus given to education produced one additional benefit. It opened up a new area of employment for the aspiring Sonoran middle class who sought positions as administrators and teachers. The governor's office regularly received requests from determined job seekers. Likewise, graduates of Sonora's superior school hoped for positions in the state's growing educational bureaucracy.

Political leaders also set out to streamline the existing instructional system. In 1896, Corral signed into law a decree that divided education into first- and second-class institutions, thereby also creating two classes of students. In true pragmatic fashion, political leaders decided that average children who would work in mining did not need to undergo a lengthy educational experience. First-class school students obtained a six-year education and received instruction in varied subjects including math, languages, history, science, and geometry. In addition, they attended courses in physical education, hygiene, art, and song. Instruction in second-class schools revolved around a four-year program of basic instruction, excluding such areas as music, painting, hygiene, and physical education.[117]

Education reflected the orientation imposed on it by Corral and other state leaders. They promoted a version of history which extolled efforts by the Jesuits, and in particular Father Eusebio Kino, minimized differences between political leaders of the nineteenth century, and praised the present government for its "remarkable achievements." Corral's publication of his *Obras históricas* gave added impetus to this version of accounts.[118] In particular the work examined the Pesqueira administration and the life of the Yaqui leader José María Leyva Cajeme. By depicting Cajeme as a noble figure, Corral hoped to co-opt the defiant character of the Yaquis.[119] The state press serialized the work and it received widespread dissemination. Theses written by students graduating from the Colegio of Sonora reflected this version of Sonoran history.[120]

The hundreds of thousands of pesos spent on education did not dissuade the affluent from continuing to send their children abroad. Elites were not especially enamored with U.S. schools. Rather, a foreign education underscored their desire to have children become familiar with the American way of doing things and gain material advantages in their border economy. A foreign education, they believed, broadened their children's horizons and, more importantly, exposed them to American culture and practices. In addition, while abroad, students made important contacts which would later serve them in their state. One young Sonoran educated abroad summed it up this way: "[W]e understand you Americans better than you understand us, because so many of us speak English, and have lived or visited in the United States. Take my own case. I was educated in California. When I returned to Mexico as a young business man, I obtained the agency for certain American farm implements and in a few years I was worth a million pesos."[121] This dream remained limited to a select few of elite youth.

URBAN RENOVATION

In addition to education, state leaders also turned their attention to the renovation of the state's important urban centers. These efforts drew inspiration from developments in Mexico City, as well from urban changes they witnessed in cities across the border.[122] Befitting their new importance, cities such as Hermosillo, Guaymas, and Nogales underwent dramatic face lifts. For notables, construction projects such as the new government building in the state capital and elaborate jails in Guaymas and Hermosillo not only represented practical improvements,

but also stood as symbols of the state's new status. The pavement of streets and sidewalks, electrification, telephone service, piped water, and gas service announced that Sonora had come of age. Furthermore, urban changes became a means of imposing the elites' new vision over the population at large, forcing people to conform. In the words of *La Razón Social,* a Guaymas newspaper, urban improvements became the "best popular school for the imposition of a new cultural order."[123]

From Alamos to Nogales, *juntas de mejoras* (renovation committees) formed to plan urban improvements.[124] In Guaymas and Hermosillo the juntas drew up lists of urgent demands including paved sidewalks and streets, public markets, health restrictions on the sale of food, clean streets, parking regulations for carriages, and the formal numbering of streets.[125] Urban renovation provided the environment in which to affirm the new class position achieved by middle and upper social groups. The paved and illuminated streets and the city parks, with trees imported from Yucatán by Torres, allowed for increased interaction among the cities' social groups. A horse-drawn urban rail system now chauffeured people from place to place.

Construction projects provided state officials an opportunity to make handsome profits. To accomplish the pavement of Hermosillo's principal streets, city authorities contracted in 1898 with James Mix, an American engineer from Nogales, Arizona.[126] In addition to being the brother-in-law of Ramón Corral, Mix became a business partner with many wealthy families, such as that of Celedonio Ortiz with whom he operated the Hotel Arcadia. He regularly received building contracts from the state and municipal government.[127] Governor Corral and Mix operated as de facto business partners. Lucrative government contracts repeatedly went to a small circle of individuals linked either by family or politics to state leaders.

By the early 1900 most population centers had undertaken major urban projects. The *San Francisco Chronicle* commented positively on the changes, mentioning that Hermosillo now had modern architecture, much of it "built on the American plan."[128] From a city of adobe, Nogales had been transformed to one of brick and wood frame.[129] Even distant Moctezuma had its principal street paved, lights installed, and a beautiful kiosk constructed in the center plaza.[130] Beside the practical concerns, these improvements provided a placid urban environment in which various social classes mixed. The central plaza, or *alameda,* became the gathering place for the city's social groups, where according to one American observer, "merchants gathered and discussed the

trade of the day and the women to retell the gossip of the town."[131] At night, people had public places to congregate, to listen to the music played by the military bands, and to stroll during the evenings.[132] The Catholic Church frowned on some of the changes, insisting that for the young people, the evening walk had become an excuse for amorous encounters.[133]

As the Church foresaw, renovation efforts implied a new urban social order. Traditional practices, such as sleeping on city sidewalks on hot evenings, came under fire. One commentator complained that people could not stroll at night on the new city sidewalks while others lay there to sleep. Such behavior they argued tarnished the city's image and remained incompatible with the new social order. Critics urged the government to take measures to restrict such conduct.[134] Carnival and the customary cascarones and flour fights also came under attack, being labeled as uncivil and repugnant. During one carnival celebration, fights broke out between those who disliked the celebration and the festive party-goers.[135]

By adopting a host of regulations, city officials sought to eliminate rural traditions and practices from the urban environment. Authorities began to manage the slaughter of bovines, the milking of cows, and the possession of farm animals in city limits. Claiming to follow the example of the United States, city councils sought to regulate all commercial activity. In Guaymas and elsewhere they moved against street vendors, who, they claimed, degraded the city. In the future they would have to operate from the city's new market or face imprisonment. The councils also established specific rules regarding the sale of perishable items such as milk, cheese, and meats.[136] Rural traditions gradually disappeared from the new urban landscape.

Additional "improvements" sought to place restrictions on social behavior and prostitution. Since most urban saloons remained out of reach of common people, other establishments catered to this group. The existence of untold numbers of tendejones attested to the class division increasingly present in the urban environment.[137] These establishments, frequented by laborers and the urban poor, sold the more potent mescal and cheaper brands of locally produced beer. Urban reformers blamed these establishments for high incidents of public drunkenness, insisting that "vice and alcoholism grows day by day."[138] Despite their protest, the government found it difficult to shut down the tendejones.

In dealing with prostitution, officials did make inroads. Tradition-

ally, prostitution had been arranged through intermediaries, or "ambassadors, the women never insult public decency, remaining in their homes."[139] Although everyone knew it occurred, discretion remained of uppermost importance in such personal transactions. By the 1890s such pretenses had ceased and the subtlety no longer existed. With an influx of single men into the state and the higher wages offered by mines, prostitution became a public matter. In Hermosillo illicit transactions occurred openly and according to one newspaper, it is the rare "night that disturbances and scandals are not heard . . . Even in broad daylight obscenities abound." In Guaymas, a local publication claimed that the "principal streets of the city have been invaded by the priestess of Venus."[140] In urban areas such as Hermosillo and Guaymas, critics urged authorities to round up all the "horizontal" women and restrict their activity to one street.[141] Responding to these pressures, by 1899 most major cities established *zonas de tolerancia* (red-light districts) in an effort to regulate the prostitution. Restricting activity to a specific area did not dissuade patrons, and on several occasions, Corral and Torres had been observed on Calle Carmen, Hermosillo's principal red-light district.[142]

LEISURE

In Sonora, as throughout Mexico, upper classes sought new pastimes to denote their new-found importance and to solidify their social position. Public and private celebrations by the elite served to accentuate the growing disparities among social groups. Private social clubs, such the Casino of Hermosillo, beautifully decorated with French furnishings and ornaments, catered solely to notable Sonoran males. In cities such as Guaymas and Alamos similar institutions also opened. Beside recreation, these establishments served to affirm the notables' status, to make contacts, and to transact business dealings. Upper classes recast traditional activities, such as horse races, which in the past had included a broad spectrum of the population, as exclusive "sporting" functions of their social clubs.[143] Religious and public celebrations also became similarly stratified, with notables holding private festivities to mark the occasions. For young upper-class women, beauty pageants became the new vogue. Participants invariably included the daughters of wealthy merchants, hacendados, and political figures. Contests had become so popular that one newspaper referred to it as a "craze."[144] To hold their activities, the upper classes appropriated public government buildings.

The spacious ballroom of the new state building in Hermosillo became the setting for countless exclusive parties involving notables, Americans, and government dignitaries. The elite also organized lavish hunting and fishing expeditions. In Guaymas during 1896, for example, they commissioned three government ships and organized an extravagant fishing excursion. Two ships carried the participants and their families, and a third vessel carried servants and musicians as well as the food and liquor needed for a three-day excursion on the Gulf of California. During the day the men fished and hunted on small coastal islands, and at night the group staged dances on board the ships.[145] Pleased with the excursion, notables repeated the event on several occasions.[146]

The new urban landscape also became the playground of the aspiring social classes. These groups kept abreast of new inventions and changing fads. Shortly after they came in vogue in the United States and Europe, the bicycle, the phonograph, and the motion pictures found their way to Sonora. In the early stages, these innovations further demarcated the world of the affluent social groups from the common people. The appearance of the bicycle, which took the urban youth by storm, mirrored the increasing social distance in the society.[147] Arriving in the state in the early 1890s, cycling clubs had been formed in most urban areas within a few years. Shortly after it appeared, the two-wheel monster, as some called it, generated much controversy. The sight of a bicyclist riding down Hermosillo's streets caused a general commotion as horses spooked and people ran for cover.[148] Invariably, the bicycle added fuel to the conflict between the forces of tradition and modernization. Critics viewed it as yet another unwanted change, insisting that it would corrupt youth.[149] They indicated that only doctors and dentists could expect to benefit from the new craze and demanded laws against its use. Supporters promoted the two-wheel vehicle as part of the wave of modernization sweeping Sonora. According to one publication, the bicycle represented the progress of "modern science and mechanics applied to sport," and beside, it is "very nice as our primos" have said.[150] "Retrograde Sonorans," it argued, must learn to adapt if they hope to keep up with the latest fashions.[151] The bicycle eventually became another status symbol for the middle classes. One Guaymas publication reported that the social clubs of the "high life" required members to own a cycle[152] and regularly staged cycling expeditions to the countryside.[153] Rental agencies catered to those who could not afford to purchase the all-important cycle. Young women also joined in the sport,

actively took lessons, and attracted the attention of onlookers as they rode through city streets.[154]

Other innovations, such as the phonographs and silent films, also found their way to Sonora. Traveling American promoters set up shop at hotels, advertised in local newspapers, and charged people to listen to recorded music.[155] At first only a handful of elites actually purchased early phonographs and staged private parties, but by the late 1900s ownership had spread to most urban classes. The American consul, Louis Hostetter, estimated that three-fourths of those who could, already owned a phonograph.[156] Film exhibitions also reached broad numbers of people. In Guaymas a cinema operated by the hermanos Stahl sold out repeatedly.[157] In the countryside, however, films had an unexpected result. After one entrepreneur began showing films in the district of Magdalena, hacendados noticed a dramatic rise in absences among their laborers. They subsequently found that laborers had been spending countless hours watching movies in Magdalena rather than working.[158] Under pressure from hacendados, authorities in the district restricted film-showing to weekends.

Sonoran elites constituted the driving force behind the transformation which the state underwent. Positivist logic framed innovations in education, urban schema, and social relations in Sonora as they did throughout Mexico. The same "modernizing" ethos transforming Mexico and Latin America at the turn of the century also drove change in Sonora. Yet some differences are also evident. Sustained cross-border relations permitted a broader diffusion of Americans customs and practices. Conversely, Mexican norms influenced social practices in the border states of the United States.

By the mid-1900s Sonoran society had many layers of contradictions. Increased economic relations with the United States had produced significant social changes. Alterations in language, sports, fashion, food, and even customs were readily perceptible and influenced large numbers of people across classes, not only the elites. Interaction with Americans and the consumption of foreign products reinforced this process. Elites and middle sectors redefined the standards of social class. The changing outlook of the upper classes, in particular the stress on the practical, found expression in educational reform and urban renovation projects. The rapid economic transformation of the state raised expectations among Sonorans of all classes, in particular the urban middle sectors. As these expectations did not materialize, many in this group became critical of the policies of the triumvirate and the Porfiriato.

The Politics of Scapegoating in Porfirian Sonora

In addition to Americans, economic growth along the border attracted significant numbers of Europeans, Middle Easterners, Asians, and Mexican emigrants. The largest of these groups, Chinese and Mexicans from other states, had the most significant impact on the state.[1] Both groups represented divergent experiences, and their presence required Sonorans to make new cultural accommodations. Economic factors also influenced the character of relations between the Sonorans and the new population groups. Rather than being agricultural laborers or miners, many Chinese and Mexican migrants became small-scale retailers. New economic conditions favored their activity, and they gradually cut into the profits of the large Sonoran merchants. As a result, in times of crisis both groups became targets of disgruntled Sonorans.

The scapegoating of Chinese and Mexicans coincided with the interests of powerful Sonoran merchants. Long accustomed to a near total monopoly of commerce, competition frightened many Sonoran retailers. Most functioned as intermediaries who profited by inflating prices for merchandise they sold. With the support of the state, a handful of Sonoran merchant families had monopolized access to goods and thereby controlled commerce. During the early 1900s in Hermosillo, for example, ten large "general merchandise stores, three dry and fancy good houses and two hardware stores" still dominated most formal commercial activity.[2] The American presence had proved beneficial to large Sonoran retailers. By employing thousands of Mexican laborers, Americans augmented internal markets for Sonora's powerful merchants. The

records of businessmen such as Camou and Escobosa reveal that they prospered from large sales to the company stores in Cananea, La Colorada, and Nacozari.[3]

With access to goods monopolized by a small group of elites, only a handful of Sonorans ever sought careers as small-scale retailers. Traditionally, prosperity in Sonora had been associated with mining, cattle, or agriculture. Small producers typically sold their agricultural goods or animal products to the large houses which dominated commerce. Non-Sonoran Mexicans and Chinese altered this pattern. Whereas Americans had not challenged Sonoran merchants, Mexican and Chinese retailers cut into their sales. The presence of traveling salesmen who represented businesses in Mexico City allowed the Chinese and Mexicans to circumvent the monopoly imposed by large Sonoran merchants.

CHINESE

As relations with the United States grew, Sonoran officials anticipated the presence of large numbers of Americans. Government bulletins spoke of the impending arrival of the Yankees and stressed the need to adapt and learn English. To their surprise, Chinese immigrants also appeared in the state during the late 1870s. Although a handful of Filipinos had on occasion resided in the state as a result of colonial commerce with the Pacific, little experience existed with Asian immigrants.[4] Some of these new immigrants arrived in the employ of American mining companies, while others sought to take advantage of expanding economic opportunities in the Mexican north. A large number viewed Sonora as a temporary home while they negotiated entrance into the United States. After 1882, restrictive immigration policies in the United States forced hundreds to remain in northern Mexico.[5]

In 1881 the Mexican consul at Tucson informed officials in Sonora and Mexico City that several Americans mine operators had requested information on the "cost of taking Chinese to the mines they worked in Sonora."[6] Americans business interests made similar requests throughout the Porfiriato.[7] Following the communiqué, the Sonoran government ordered every district in the state to report on the status of the Chinese and their impact on labor and commerce. Although the number of Chinese entering Sonoran remained low, most being employed as "mine labor, cooks, gardeners, washers, and domestics," their presence caused concern among Sonoran authorities.[8] Communiqués between officials regarding the immigration of Chinese reflected nega-

tive stereotypes about Asians. Chinese, wrote the consul at Tucson, remain "inferior immigrants, they are prejudicial to natives, they foment prostitution . . . they do not stimulate commerce or industry."[9] These characterizations of the Chinese reappeared in communications between government officials throughout the nineteenth century. The Chinese fared no better in Arizona. Their arrival in Tucson caused a furor in the American community, and the press blamed their presence on a Mr. Lesinsky, who had gone to "San Francisco to buy out 100 Chinamen [sic]."[10]

Because there had been little previous contact with Asians, marked differences of opinion existed regarding the issue of Chinese immigrants. Northern districts, where labor traditionally remained scare, supported their arrival. In 1881 the prefect of Arizpe informed the governor that the "presence of Chinese would be of great service to the district."[11] Commercial centers such as Guaymas and Magdalena, where competition among business proved sharper, strongly opposed the Chinese presence. Carlos Randall, the prefect of Guaymas, wrote "that the entire society viewed Chinese with a pronounced repulsion."[12] For the Chinese, these early attitudes served as a harbinger of their future difficulties in Sonora.

During the 1880s the Chinese community in Sonora remained relatively small. The 1895 census only recorded 320 men and 11 women in the entire state. Even if officials undercounted the population, their numbers still appear scant in proportion to the larger Yaqui and Mexican populations. Most early Chinese immigrants settled in the port of Guaymas (126), in the booming mining camp of Minas Prietas (84), in the capital of Hermosillo (46), and in the northern city of Magdalena (16).[13] By the early 1900s the Chinese presence in the state had increased compared to that in previous years. A government census in 1900 placed their number at 855.[14] Enticed by opportunities in commerce, hundreds more settled in the state within a few years.[15] By 1903 a government report indicated that their numbers had nearly tripled, to 2,464.[16]

Altar	10	Hermosillo	409
Ures	11	Guaymas	427
Magdalena	350	Sahuaripa	5
Alamos	57	Moctezuma	39
Arizpe	1,156		
Total	2,464		

In addition to the Chinese, the account also indicated the presence of a handful of Japanese.[17]

ROLE IN COMMERCE

Numbers alone do not give an adequate picture of the growing importance of Chinese to the Sonoran economy. Wherever they settled, Chinese farmed truck crops, opened hotels, initiated cottage industries, and engaged in commerce. Initially, Chinese merchants did not compete against the large commercial houses which monopolized trade in Sonora. Instead they established a foothold as small retailers who catered to the ever growing number of Mexican laborers employed by foreign mines and agricultural enterprises. For example, of the twenty retail stalls available at the municipal market in Cananea, the Chinese operated eighteen.[18] In other mining towns they gained a similar foothold over local commerce. The Chinese "did not so much displace Mexicans or other foreigners as they met new demands for goods and services in a greatly expanded society."[19] Their position in Sonoran commerce did not remain static.

The role of Chinese in commerce reflects the inherent tensions which existed between formal, established sectors of the economy and newly emerging informal sectors. At this level, local merchants initially welcomed and even encouraged manufacturing efforts by Asians. As long as Asian manufacturers channeled their products into established Sonoran retail operations, their presence did not threaten local commerce. The Chinese, however, promptly recognized the vulnerability of Sonoran merchants who had neglected local manufacturing.[20] Starting as subcontractors for larger Mexican retailers of apparel and other consumer goods, the Chinese made inroads in manufacturing and then moved into retail operations which catered to Mexican laborers. Critics lamented that they monopolized the limited manufacturing which took place in the state.[21] The American consul to Hermosillo, Louis Hostteter, reported that by 1907 the "manufacture of men's furnishings, goods, such as shirts, overalls and clothing is in the hands of Chinamen (sic)."[22] In Guaymas, Hermosillo, and elsewhere, Chinese entrepreneurs operated clothing factories, made shoes, and even controlled several large commercial emporiums, not just small shops.[23] In Altar and La Colorada they owned the best hotels.[24] The government list of the leading merchants in the state invariably included several Chinese enterprises.[25] An economic census sponsored by the railroad listed their ven-

tures throughout the state.[26] As the number of Asian businessmen grew and the Sonoran economy experienced repeated contractions, competition among all business sectors stiffened.

SOCIAL TIES

Despite negative attitudes, the Chinese adapted quickly and took part in the civic life of the state. Rather than actively participate in local politics, they nurtured relations with prominent Porfirian officials. When Ramón Corral returned triumphantly from Mexico City as vice president, Chinese merchants turned out to welcome him at Hermosillo and Guaymas.[27] In Guaymas they erected a lavish four-story pagoda under which Corral's procession passed to the accompaniment of Asian musicians. At the evening ceremonies they presented him with an ornate gold medallion and a collection of embroidered silk tapestries.[28] Beside politics, the Chinese in Hermosillo and Guaymas participated in carnival and other celebrations. Merchant associations in urban areas sponsored ornate floats with Asian themes and took part in the public processions.[29]

The Chinese kept ties to their homeland and formed ethnic associations to defend their interests. In January 1912, for example, the Chinese in Sonora celebrated the recent downfall of the empire with parades and other celebrations. A procession in Hermosillo included floats for dignitaries, the state government's official band, and a large portrait of Dr. Sun Yat-sen, a leading opponent of the Manchu dynasty.[30] By the early 1900s, Chinese merchants formed the Fraternal Order of Chinese, a self-help and defense organization.[31] In La Colorada they formed the "Club Chino," where they gathered and socialized.[32] In Cananea, Chang Chee, a well-respected merchant, served as president of the Chinese Empire Reform Association.[33] As part of their activities, these groups wrote letters to local newspapers defending Chinese interests and urging Mexico to maintain an open immigration policy. Francisco Chiyoc, a leader in the association, insisted that the Chinese benefited the Sonoran economy by selling goods at cheaper prices, religiously paying their taxes, and staying out of politics.[34]

ECONOMIC COMPETITION

As they competed for new markets, the Chinese made powerful enemies, including notables and middle-level businessmen. In 1906, J. P.

Camou complained that his stores could not compete with the lower prices offered by the Chinese. He instructed Leon Horvilleur, his partner in Paris, not to send him certain kinds of products "because with the Chinese selling them, prices have plummeted and it is no longer profitable to handle these brands."[35] Government officials insisted that the Chinese merchants could offer cheaper prices because they trafficked in stolen goods.[36]

By the turn of the century, the influx of Chinese had become a cause of concern among Sonoran business groups and state bureaucrats. Porfirian officials worried about the growing Chinese presence and sought to limit their immigration. As the Sud-Pacific railroad began to lay track south from Guaymas, Governor Izábal requested Corral's advice about restricting the additional numbers of Chinese who might settle in the state.[37] Hoping to inflame public opinion, several newspapers published a weekly account of the numbers of Chinese who arrived at Guaymas.[38] In May 1901 *El Noticioso,* an advocate of Guaymas business interests, reported the arrival of thirty-four Asians and concluded that every time a Chinese opened a shop, a Mexican store invariably closed.[39] While accepting ads from leading Asian merchants, the Sonoran press blamed the Chinese for all the state's economic and social maladies.[40] The press made use of prejudices against outsiders to promote stereotypes. Maintaining that they did not reinvest profits in Sonora but instead sent earnings to China, one paper portrayed Chinese "as vampires."[41] Beside undermining Mexican commerce, newspapers blasted Asians for corrupting local morals by selling opium, promoting prostitution, and spreading diseases.[42] One popular stereotype portrayed the Chinese as unsanitary. When raw sewage appeared in Guaymas harbor, local authorities blamed the Chinese for polluting the bay and threatening the town's oyster beds. Northern newspapers in Nogales, Magdalena, and Cananea echoed the views of their southern counterparts. United States interests also joined in the attack against Asians. The *Cananea Herald,* a mouthpiece for the Cananea Copper Company, depicted the Chinese as a "bad weed which has taken spread throughout the state and is monopolizing all small business . . . they must be done away with."[43] With inflammatory headlines like "Wily Japs Escape" and "Chinks Attack British Ships," the pages of the *Herald* regularly published racist attacks against the Chinese and the Japanese.[44]

Stereotypes of Asians spread, fueling antagonism between Mexicans and Chinese. By the late 1890s a newspaper in Magdalena reported that

the authorities appeared helpless in preventing violence against Asians. An editorial in the *Correo de Sonora* indicated that for the previous three years, Chinese had been murdered in the district and authorities had brought no one to justice.[45] Even though local officials regularly arrested Mexicans involved in altercations with Asians, violence against the Chinese continued to escalate.[46]

The prominent role of the Chinese in commerce made them potential targets for disgruntled Mexicans of all social classes. More importantly, unlike the Americans they did not have powerful patrons in the state government or society. Porfirian leaders, fearing a further erosion of their political support, also joined in the chorus against the Chinese. As the Sonoran economy declined after 1907, conditions for the Chinese worsened. The antipathy they had incurred during the Porfiriato intensified under the rule of the revolutionaries who blamed the Chinese for Sonora's many economic problems. In this capacity the Chinese shared a similar experience with religious groups who settled in northern Mexico during the nineteenth century.

MORMONS

The Chinese experience parallels that of another group of foreign immigrants to northern Mexico, the members of the Church of Latter Day Saints. In an effort to escape United States polygamy laws, significant numbers of Mormons sought refuge in Chihuahua and Sonora between 1885 and 1912.[47] They contracted with the Díaz regime and established eight separate colonies in Chihuahua and Sonora, reaching a population of close to 5,000 settlers.[48] Unlike the Chinese, however, the Mormons preferred an isolated existence and had only limited contact with the Mexican population. Their settlements, like the Morelos and Oaxaca colonies in northeast Sonora, represented self-contained foreign enclaves in which the entire municipal authority rested in the hands of the Mormons, who reported directly to the governor.[49] The industrious Mormon colonists built water irrigation systems and placed large tracts of land under cultivation. Taking advantage of liberal Porfirian property laws, they expanded their original concessions, at times encroaching on nearby Mexican land holdings. When they sold surplus agricultural and manufactured goods, they earned the enmity of many Mexican rancheros and local merchants with whom they competed. Their overt support for the Porfiriato, including at times military assistance against bandits and political opponents, earned them

widespread antipathy from the forces that opposed the Díaz regime. Hostility against the Mormons increased after 1906 and gradually many returned to the United States. By 1912 the eight Mormon colonies in Sonora and Chihuahua had been all but abandoned.

MEXICAN MIGRATION TO SONORA

Opportunity created by border interaction and the promise of high wages in mining drew large numbers of Mexicans to the state and brought Sonorans face-to-face with their southern brethren. Mines in the north paid as much as five pesos a day; by comparison, workers elsewhere in Mexico struggled for a fraction of this sum.[50] Mexicans flocked to Sonora from neighboring states such as Sinaloa and Chihuahua and even from places as far away as Oaxaca and Michoacan. Few Mexicans had ever considered migrating to Sonora prior to the 1890s.[51] Sonoran contact with other Mexicans had been limited to a handful of Sinaloans and Chihuahuans.

Between 1888 and 1910 Sonora's population nearly doubled, from 150,391 to 265,383 inhabitants.[52] In part, this growth reflected the influx of foreign immigrants and the presence of other Mexicans. Local registers documented the significant increase in the number of out-of-state Mexicans.[53] The 1895 census recorded the presence of 6,954 Mexicans from other states, with most of the migrants coming from Sinaloa (2,347), Chihuahua (967), Jalisco (882) Baja California (506), the Federal District (368), and Guanajuato (315).[54]

Sonora had little previous experience with other Mexicans. Separated from the rest of Mexico by the Sierra Madre Occidental, the state possessed few ties to southern Mexico. What little exchange occurred, took place between southern Sonora, particularly in the city of Alamos, and northern Sinaloa. Alamenses maintained economic, familial, and even political ties with the Sinaloans, yet seldom did they migrate to the south. Moreover, for much of the nineteenth century, Alamos remained an isolated enclave in southern Sonora.[55]

Lured by economic opportunity, Sonorans migrated north either to California or to Arizona rather than south to the interior of Mexico.[56] The report of a commission entrusted with promoting immigration to Sonora in the 1850s underscores the distances that separated Sonora from the south. Settling the sparsely populated northern districts acquired new urgency in the wake of repeated incursions by the United States. In its deliberations, the committee considered the advantages of

promoting Mexican or foreign immigration to Sonora. They concluded that enticing Mexicans to relocate did not appear to be a viable option for the state. According to the commission, populating the border "with Mexican families is so difficult and time consuming that by the time they arrived and established themselves the land would already belong to the Americans."[57] The group concluded that little support existed for Mexican migration and that the state should instead attract Europeans living in California rather than Mexicans from the south.[58] Prevailing views of race, which favored European immigration over that of other groups, invariably influenced the commission's decision.

By the turn of the century, efforts by state leaders provide further insight into the kind of immigrants that business groups and authorities sought to attract. From Mexico City in 1903, Corral arranged a visit to Sonora of white South African Boers looking for land on which to establish a colony. Corral instructed Governor Luis E. Torres to spare no effort to attract these settlers–"there are no colonist[s] better suited for us than these, spend as much as you need to assure them a pleasant stay."[59] In keeping with his instructions, Torres personally gave them a tour of the Yaqui valley, visiting the towns of Medanos, Cocorit, Vicam, Torin, and Bacum, and hosted banquets and several public receptions for the Boers in the port of Guaymas.[60] Unimpressed, the Boers opted not to settle in the Yaqui valley. Efforts to attract other Europeans proved only mildly successful. Eventually, a handful of Italians settled in the coastal plains of Hermosillo, engaging in wheat and grape production.

The federal government contributed to the presence of Mexicans from other states in Sonora. The government stationed contingents of federal troops in the Yaqui and Mayo valleys to keep the indigenous population in check and ensure stability for foreign investments. Sonora continued to be one of the few places in Mexico where the military still actively waged campaigns against Indians. While ambitious officers sought to improve their standing in campaigns against the Yaquis, draftees saw no such advantages. Having been forcibly recruited in the interior of Mexico, many had no idea of what awaited them in the state. Conscripted soldiers complained about the atrocious conditions that they confronted in campaigns against the Yaquis.[61] The situation became so desperate that government officials even offered convicts reduced sentences if they volunteered for service in the Yaqui campaigns. Faced with numerous hardships, low pay, an unfamiliar terrain, and the prospect of engaging the dreaded Yaqui in battle, draftees de-

serted at the first opportunity.[62] The presence of these conscripts became a common source of friction between Sonorans and other Mexicans. After serving their stint in the military, hundreds settled in the state. They flocked to the booming mining towns of the north or sank roots in the new southern farming communities taking shape in the Yaqui and Mayo valleys.

As individuals from throughout Mexico continued to arrive, tensions soon surfaced and cultural differences became points of conflict. The Mexican presence led to a rise in regionalistic sentiment. Scores of Sonorans objected to the presence of "outsiders" and referred contemptuously to the federal soldiers and their families as *guachos*.[63] By the turn of the century this portrayal and a host of other derogatory terms had gained popular acceptance despite government attempts to deter their use.[64] In time, Sonorans employed the word *guachos* to describe most Mexicans from the center of the country.[65] Beside indicating that an individual was an outsider, the term also possessed other negative connotations. It implied a host of characteristics, including differences in language, phenotype, diet, dress, and social comportment.[66]

These stereotypes framed how some Sonorans viewed their southern brethren and in some cases legitimated abuses against other Mexicans. When a fight broke out in Guaymas in 1901, the local press reported it as "an altercation . . . between a man [Sonoran] and a guacho [non-Sonoran]." The local press's characterization of the individual appeared as important as the fact that the brawl took place. Beside starting the fight, the southerner had struck a twelve-year-old girl in the head with a rock. Authorities arrested the guacho.[67] Contact between Sonorans and other Mexicans also led to humorous incidents. In Guaymas the police intervened to break up a confrontation between several Sonorans and Jalisences arguing over the merits of bacanora, a local mescal drink, and Jalisco's beverage, tequila.[68] The officers advised the group to take the train north and continue the fight on the American side of the border. Fueled by cultural differences and economic competition, stereotypes concerning southern Mexicans continued to spread.

This growing regionalistic prejudice posed a problem for state and federal officials. With a firm grip on power, federal officials had ignored the advice of Díaz's earliest emissary, General José Guillermo Carbó, that only Sonorans should fill important posts in the state government.[69] Beside the labor force, by 1900 non-Sonoran Mexicans could be found in the ranks of the officer corps and among customs and tax

officials. At this level, anti-southern sentiment coalesced with a grow-
ing backlash against the Porfiriato. Attacks on central Mexicans invari-
ably also undermined state authorities. When a Magdalena newspaper
in 1909 published a poem entitled "Who Is Afraid of the Guachos[?],"
the governor reacted swiftly. He ordered the prefect of the district per-
sonally to suppress the newspaper's circulation.[70]

The presence of Mexicans from other states presented business
groups with an interesting paradox. Fearing chronic labor shortages ex-
acerbated by the state and federal government campaigns to deport
Yaquis, business leaders and hacendados had welcomed most new-
comers. During Corral's 1904 visit to Guaymas, Victor Veñegas, a lo-
cal newspaper editor, timidly addressed the subject in a speech. He ex-
pressed concern about the impending labor shortages. To replace the
deported Yaquis, he requested Corral's assistance in attracting "suit-
able" Mexicans to the state. Sonora, he argued, should be careful to
attract the right kind of immigrant—those educated and willing to
work and not the throngs that, according to Veñegas, had descended on
other states such as Yucatán or Zacatecas.[71] Notables wanted laborers
but hoped to avoid the deluge of migrants which might be attracted by
unscrupulous *enganchadores* (labor contractors).

Sonoran notables feared that the rapid influx of *sureños* (southern-
ers) might prove politically disruptive. Despite their best efforts, they
could not determine the numbers or characters of the migrants who
arrived in the state. Neither could they control the cultural or eco-
nomic outcome of interaction between Sonorans and other Mexicans.
By the mid-1900s, as outsiders engaged in commerce and competed
for jobs, especially as small retailers, some Sonoran business interests
openly complained about the rising numbers of migrants in their state.

Scores of ex-federal soldiers settled in the lands of the Yaqui and
Mayo valleys and opened small shops. In towns throughout Sonora
they became small-scale retailers, or *bodegueros*. Stores with such
names as El Sinaloense, Michoacán, La Malinche, and El Pabellón
Mexicano attested to the economic presence of Mexicans from other
states.[72] The types of enterprises they established, such as a mill to make
nixtamal, indicates their growing numbers.[73] Dozens of these smaller
commercial establishments, commonly known as *changarros*, sold low-
priced goods to the laboring classes.[74] Like their Chinese counterparts,
these smaller stores cut into the market share of the larger, more expen-
sive, Sonoran-owned emporiums.

EL AGENTE VIAJERO

By the 1890s Mexican manufacturing had made important strides in textiles, beer, and other consumer goods.[75] Construction of the Mexican Central Railroad to Paso Norte (present-day Ciudad Juárez) and other improvements in communications allowed Mexican industrialists gradually to penetrate markets in the north. The establishment of regular shipping lines in the Pacific also facilitated their access into the region. Companies in central Mexico began employing traveling salesmen or jobbers to represent them in the region and promote sales. Agents for a wide range of European and American companies also peddled their wares in the state.[76] The presence of these intermediaries signaled an end to the monopoly of Sonoran merchants over supplies and retail merchandise. With the influx of *agentes viajeros* (traveling agents) operating in the state, middle-level merchants worried that their power would diminish. Moreover, to establish a presence in the northern markets, agentes viajeros often sold goods at lower prices than those offered by local distributors. Since they only took orders, the agents also avoided costly state taxes.

Several kinds of traveling agents arrived in Sonora. Some offered services to businesses, representing large printing houses in Mexico City, against which local typographers could not compete.[77] Others sold goods to small shopowners, while yet others dealt directly with the public. The latter frequented urban areas and established outlets in local hotels. They advertised their presence in the press, listed their products, and awaited customers. Having little overhead and selling directly to the population, they offered reduced prices in Mexican pesos. Hotels in Hermosillo and Guaymas became their de facto outlets. Establishments such as the Hotel Cohen (presently Hotel Kino) in Hermosillo set aside special rooms for traveling agents, including ample display suites where they could exhibit their wares. Hermosillenses flocked to the exhibits and placed orders, bypassing the local merchants. This tradition continued well into the twentieth century and led to the formation of hotel associations which catered exclusively to traveling agents.

As Sonoran merchants had feared, the agentes viajeros undercut local sales, driving several smaller enterprises to the verge of bankruptcy. Local businesses complained that they could not compete with prices offered by salesmen representing large concerns in Mexico City. The presence of independent distributors even undermined the dominance of

some older commercial elites and allowed many smaller merchants, especially the Chinese and central Mexicans, to open shops and compete for the growing consumer market. The chambers of commerce in Hermosillo and Guaymas lobbied the governor for relief from outside competition. A letter from the Hermosillo chamber of commerce signed by Ernesto Camou and Adolfo Bley summarized the predicament that these older establishments faced. Camou and Bley argued that previously traveling agents had dealt primarily with wholesalers and therefore had not affected traditional commerce. But in recent years "as day in and day out competition intensifies, their operations have come to resemble actual retail sales."[78]

Relying on more expensive American and even European suppliers, which required transactions in dollars, some of the larger Sonoran merchants had become uncompetitive in some fields. As in the rest of Mexico, merchants found that the market for basic items and low-priced consumer goods had expanded most rapidly. Large concerns, such as those operated by the Camou family, reported that most of their sales during the first decade of the 1900 involved low-priced Mexican products.[79] The economic contacts which Sonoran merchants had so carefully nurtured with suppliers in San Francisco, Arizona, and Europe became counterproductive. Facing recurrent economic crisis, they hurried to find cheaper American or Mexican suppliers. In a letter to his longtime supplier Horvilleur in Paris, José Camou disclosed that his purchases of European goods would continue to diminish since they now "received from Mexico and New York goods we used to buy from Europe."[80] To underscore his point Camou indicated that "we have recently purchased one thousand pieces of *mezclilla* [denim] from the Villa Union factory which is better than anything made in Los Angeles."[81] Large-scale merchants, such as Camou, made the transition and adapted.

Fluctuations in the peso also invariably favored Mexican suppliers.[82] The growing presence of Mexican products did not go unnoticed by the United States consuls in Sonora. In 1903, Consul Albert R. Morawetz at Nogales reported that "trade had declined . . . not only with the United States but also with the European countries partly on account of the unstable value of the peso and partly on account of the increased manufacture of merchandise in Mexico."[83] Though fluctuations in the value of the peso tended to make American goods more expensive, another American official indicated that his countrymen bore some blame for the drop in sales. Consul J. F. Darnall, reported that "salesmen still

come here who cannot speak a word of Spanish . . . and very few take
the trouble to acquire that knowledge of the manners of doing business
peculiar to Latin Americans."[84] Cultural differences complicated busi-
ness for Americans. Mexican importers complained that northern sup-
pliers did not provide invoices in Spanish and weighed merchandise in
pounds not kilos. Customs officers forced Mexicans importers to open
each container and pay duty on every item rather than on the entire
shipment, as had been the practice before. To compensate for dropping
sales, American companies resorted to hiring Cubans as traveling sales-
men. The availability of Mexican goods and the unwillingness to adapt
to local customs hurt U.S. companies.[85]

By 1905, lower-priced goods produced in central Mexico competed
for shelf space with more expensive imported items. Next to "American
salmon," "deviled canned ham," "corned beef," and "baking powder"
(all in English) appeared "manteca Colima" (lard), "fósforos la Seguri-
dad" (matches), "jabón Cocula" (soap), "cigarros Dos Naciones," and
"café Veracruz."[86] In restaurants and saloons, spirits from throughout
Mexico such as Tequila from Jalisco, Cerveza Cuauhtémoc, and Pa-
cífico received equal billing with Sonora's High Life and American
beer.[87] By 1904, Guaymas had the state's first-ever corn tortilla factory
imported from central Mexico.[88] Cheaper clothing and fabric from
Mexico also increased in popularity over foreign textiles.

Pressured by the state's merchants, the government restricted "trav-
eling agents from outside of the state" by imposing special regulations
and levying taxes on them.[89] At first the state charged a monthly tax
ranging from between 25 to 200 pesos in addition to the surcharge im-
posed by the federal government.[90] Local officials had the discretion of
applying the tax as they say fit. Since this did little to deter agents, regu-
lations became even more draconian. In addition to a state assessment,
agents had to pay a municipal tax in every town they visited and had to
submit to strict regulations to conduct business in the state. When en-
tering a new town, they first had to register with local officials indicat-
ing the companies they represented, the kind of merchandise they of-
fered, and whom they intended to call upon. Municipal authorities
required hotel owners to report the arrival of salesmen or to face fines.
Agents not in compliance with these regulations also faced stiff fines,
and even imprisonment.[91]

Confronting similar circumstances, other northern states such as Si-
naloa considered adopting the restrictive Sonoran legislation. Mexican
business concerns objected vehemently to these ordinances. By the end

of the year they had obtained the assistance of the federal government. Writing on behalf of President Díaz, the minister of Hacienda condemned Sonora's laws as a surreptitious attempt to reinstate the detestable alcabala system. He feared what might happen if other states adopted similar statutes and labeled Sonora's laws as an "exaggerated defense of local merchants and industry."[92] United States critics echoed similar sentiments. Manuel Hugues, editor of *El Defensor del Pueblo* in Tucson, condemned the "rich monopolizers of commerce" for trying to stifle competition in Sonora. Traveling agents and their supporters claimed restrictions amounted to state support for the monopoly maintained by the large Sonoran merchant houses. Confronting pressures from the federal government, state officials disguised regulations on agents under a variety of municipal ordinances and local taxes.[93]

In addition to the ordinances, Sonora's elites and merchants searched for other avenues to retain their monopoly over local markets. In both cases, business groups made use of existing stereotypes to gain economic advantages. Unable to outlaw traveling agents or foreign competition, merchants tried to sway public opinion to their side. They intentionally played on the social and even cultural antagonism which existed between Sonorans and outsiders. Newspapers, such as the influential *Imparcial* of Guaymas and others, urged Sonorans to buy goods only from established local merchants and to boycott products sold by traveling salesmen and Asians.[94] Chambers of commerce and trade associations stressed the importance of supporting local businesses. As sales declined further, a Guaymas business journal uncharacteristically lashed out at the American-run company stores, tiendas de raya, labeling them as oppressive vestiges of the colonial era.[95] Efforts by merchants to maintain control of their markets contributed to the growing cultural backlash against Mexican emigrés and foreigners. These nativistic appeals had dire consequences for Asians and affected the tone of relations between Mexicans and Sonorans for future decades.

While conflict between Sonorans and other Mexicans occurred sporadically, over time, passions against southerners lessened.[96] The revolution dramatically increased contact among Mexicans from all over the republic. Moreover, the ouster of Díaz served to depoliticize opposition to Mexico City. Still, throughout the twentieth century, regional prejudice against capitalinos has continued to rear its head and serve the political interest of regional elites. The Chinese had the opposite experience, as the revolution further politicized their presence in the state. Relations with Asians continued to deteriorate during the first

two decades of the twentieth century, reaching extreme levels of xeno-phobia.[97] In 1914, for example, a strike ostensibly led by the "Josefa Ortiz de Dominguez" women's association threatened to expel all Chinese from Cananea. The military intervened to diffuse the situation. Similar violent outbreaks occurred in Guaymas and Magdalena.[98] Middle-sized business interests, politicians, and disgruntled Sonorans continued to blame Asians for the economic difficulties that the state confronted.[99] Still, the rise of prejudices against Asians did not occur in a vacuum. Nor did it merely reflect deeply held northern regional biases against outsiders. Rather, these antagonisms were fueled, in part, by opportunistic politicians and business interests whose control of local markets had been weakened by changing economic conditions.

"The Wine Is Bitter"

Economic growth during the Porfiriato temporarily masked the complex contradictions which Sonora faced. Below the surface tensions persisted, and by the turn of the century, fissures appeared in the coalition that supported the Sonoran triumvirate of Torres, Corral, and Izábal. In the early years of the Porfiriato, the government succeeded in muting public criticism by completing the railroad, containing the Apaches, limiting Yaqui rebellions, stabilizing the chaotic political order, encouraging education, and promoting the promise of development. Members of the triumvirate took personal credit for these developments. They seldom missed an opportunity to be present at graduation ceremonies, the inauguration of public works, the initiation of new mining operations, or in the case of Izábal, leading campaigns against Yaquis or Seris.[1] As conditions deteriorated, their personal association with Sonora's course of development eventually produced a political backlash. Electoral campaigns based on past achievements rang hollow to large sectors of the population.[2] As early promises remained unfulfilled, dissatisfaction with the old regime increased. Opposition forces gained momentum and hacendados, rancheros, small-scale merchants, aspiring urban middle classes, and laborers found common ground.

The panic of 1907 alarmed the generation of Sonorans who came of age during the Porfiriato. In the aftermath of the crisis, the basic tenets of the Sonoran economy declined perceptibly. The Cananea Consolidated Copper Company, the state's largest employer, began laying off workers in September 1907, ceasing all operations by year's end.[3] In the words of one observer, "long wagon-trains, burros-trains, and people

on foot are pouring down the 60 miles of highway from Cananea to Imuris . . . penniless . . . not knowing how they are going to feed themselves on their long journeys to distant homes."[4] As news of the mine closures reached Nogales, Manuel Mascareñas reported that officials had been forced to close the Bank of Sonora as panicked depositors demanded their money.[5] To compensate for the drop in sales, the state government reduced sales taxes in an effort to stimulate commerce.[6] The Bishop of Sonora, Ignacio Valdez-Piña y Díaz, journeyed to Cananea and offered special masses seeking divine intervention to end the crisis.[7] As the mines in the United States closed, streams of Mexican immigrants returned to the state, increasing the numbers of unemployed.[8] A rebellion by insurgent Yaquis and continued government deportations worsened conditions throughout the state. Sonorans did not soon forget the effects of the crisis of 1907.[9]

As late as 1909, José Camou, writing to his partner in Paris, explained why he would not place any orders that year. He reported that American money remained in short supply, silver had become worthless, most cattle had contracted disease and could not be exported, and the few mining companies that reopened employed only skeleton crews.[10] The crisis of 1907, like those in years prior, eroded public support for Sonora's Porfirian leaders. Yet economic crisis alone does not explain the rise of discontent in Sonora.

Grievances against the Sonoran government's social and economic policies persisted throughout the Porfiriato. The forces of opposition arose from Yaquis against land speculators, landed interests against government Indian policy, state officials against municipal authorities, middle-class aspirations against a calcified political structure, labor against employers, and at multiple levels, Sonorans against foreigners. American investments created a complex economic, political, and social web, which at times muted direct criticism of foreigners by certain classes. Yet at various levels, antagonism surfaced, and dissent over economic, political, and even cultural issues reflected apprehensions about the growing foreign presence.

Participation by prominent notables and middle-class persons legitimized the movement against the old order. Leadership in opposition causes did not represent a new role for notables. For most of its early history, Sonora had been gripped by intense inter-elite rivalry. Throughout the Porfiriato, opponents mounted several active electoral challenges against the government in Sonora. In order to advance their own interests, notables, such José María Maytorena and others, co-opted de-

mands raised by the indigenous, laborers, and rancheros. Within certain prescribed limits, the recruitment of other social classes, such as labor or Yaquis, to achieve political objectives did not represent a rupture from past conventions. Still, many elite opposition leaders favored a moderate course, nurturing political networks rather than actively fomenting militant resistance. Maytorena advised followers to refrain from personal attacks against Corral and others, "not to support or become involved in guerrilla war, in order to maintain our forces whole and take advantage of the appropriate moment."[11]

Sonora continued to be a relatively tight-knit society, with a high degree of association among middle classes and notables. Close relations, which had for decades benefited these households, retained their importance. Competing political views among families and close social circles coexisted. These pragmatic groups courted favors with government leaders while associating with critics. Political opposition among family members also offered the opportunity for future reconciliation. During the revolution, it served to mute reprisals against leading supporters of the Porfiriato, who subsequently supported the opposition.

POLITICAL DISCONTENT

Recurring electoral manipulations and the use of *fuereños* (outsiders) to fill local posts distanced government officials from large segments of society. Official positions, including state deputies, senators, district prefects, judges, and municipal authorities, became the domain of a closed circle of family members and allies of the Sonoran triumvirate. Elections became a sham, as the official slate of candidates always emerged victorious.[12] In Hermosillo, for example, the presidency of the town council had been dominated for fifteen years by Ramón Corral's father-in-law, Vicente Escalante.[13] Government favoritism limited opportunities for the growing number of educated middle-class youth who came of age during the Porfiriato. Access to government employment, whether as school teacher or low-level administrator, involved patronage from those in power. State and local officials constantly received letters from recent graduates seeking employment.[14] Government employees who openly associated with the opposition faced dismissal. The growth of dissident political clubs, such as the Club Verde of Hermosillo, reflected increased levels of political dissatisfaction. As discontent mounted, the civility that had once characterized relations between state authorities, notables, and middle-class opponents diminished.

To neutralize opposition, Corral, Izábal, and Torres personally inter-
ceded with the notables and middle class. When social pressures failed,
officials employed other measures, including limiting people's access to
credit and stripping them of their land. Authorities closed opposition
newspapers, intercepted mail, used undercover agents, and relied on the
support of United States authorities to stifle opposition efforts.[15] Gov-
ernment reaction against critics proved reminiscent of those employed
by state officials in the 1850s. Tactics included the selective stationing
of military forces during Yaqui rebellions and the rounding up of Yaqui
workers at harvest times. Maytorena reported that the military forces
which had been protecting his hacienda were withdrawn after he per-
sonally complained to Díaz about Yaqui deportations.[16] The banish-
ment of Yaqui laborers undermined production on most major hacien-
das. Their removal from Maytorena's La Misa hacienda not only left
him without laborers, but it also depleted his economic resources.[17]
Government deportations did not compensate for the varying forms of
credit advancements required to recruit Yaqui laborers. José C. Camou
and Manuel Mascareñas also reported labor shortages on their hacien-
das resulting from the Yaqui expulsions.[18]

UNEVEN DEVELOPMENT

The course of Sonoran economic development fueled political resent-
ment. The rise of the Guaymas-Hermosillo-Nogales corridor and the
emergence of mining enclaves in northern districts profoundly altered
economic and political relations, reorienting commercial activity to-
ward the border. Rural areas bypassed by the railroad, especially those
in the foothills of the Sierra Madre and southern Sonora, languished.
Northern mining centers drained resources from older communities,
and thousands of laborers abandoned the countryside. The district of
Arizpe serves as a case in point. While the region in the immediate vi-
cinity of the Cananea mine prospered, older towns declined. Cananea
absorbed the human resources of the district as farm labor abandoned
the fields to seek higher-paying work in the mines.[19] The municipality
of Cananea expanded, incorporating neighboring villages, the county
seat, Arizpe, lost population, and the former state capital withered.
Small merchants and landowners resented Cananea's dominant position
and contemptuously referred to the American company as the *pulpo de
Cananea* (the octopus of Cananea).[20]

Similarly to Arizpe, the city of Magdalena, the traditional economic

center of this northern district, saw its position diminished by the rise of Nogales. With the creation of the Nogales municipality, Magdalena lost political control over the border area. More importantly, it forfeited the economic leverage it once exercised over the region. The merchants of Magdalena could not compete with their Nogales counterparts who used the zona libre to import foreign products.[21] Medium and small retailers in the old cabecera vehemently opposed the free zone and lobbied for its end. Merchants, rancheros, and hacendados in these areas suffered a decline in resources and status.

For southern cities, like Guaymas and Alamos, the promise of the development proved even more illusory. The completion of the Sonoran railroad ended Guaymas' dominance over trade and commerce. With access to reliable transportation, most exports and imports passed through Nogales.[22] Coastal commerce continued to provide some revenue for the port, but it did not compensate for the loss of trade to the north. Further south, Alamos, once the state capital, also lost ground. Alamenses grew frustrated that the border districts attracted the lion's share of foreign investments.[23] Making matters worse, when the Sud-Pacifico railroad began construction from Guaymas to Mazatlán in 1905, engineers bypassed Alamos. New agricultural centers along the main route, especially at Cajeme and Navajoa, eclipsed Alamos and assured its continued demise.[24] Residents petitioned Corral, a native son, to aid his former birthplace.[25] Finally in 1907 a spur line reached the city; too late to take advantage of the earlier years of prosperity, but in time to participate in the political turmoil which engulfed the state. Excluded from the economic and political spoils of the Porfiriato, Alamos displacement nurtured resistance, and like Guaymas, it became a center of opposition.[26]

LABOR

The development of large-scale mining also gave rise to new forms of protest.[27] Labor quickly became an acknowledged force, and spontaneous protests and organized strikes became part of the political arsenal against government policy. Labor resistance took many forms. Strikes, such as those by workers at Cananea and Empalme in 1906, and numerous work stoppages due to mistreatment or inadequate wages occurred frequently.[28] Beside collective action, individual responses ran the gamut and included lawsuits, physical assaults on racist supervisors, and the burning of company property. Conflict between workers and

their employers, and between entire communities and foreign mining firms, occurred throughout Sonora. As state officials mediated problems regarding labor, water, grazing rights, and land usage, they invariably sided with foreigners. By dismissing local demands, authorities sowed the seeds of future conflict. Resistance did not always reflect organized political activity, but rather, it remained in most cases a spontaneous response to changes in traditional ways of life or immediate economic grievances.

EL TIRO

Surrounded by scrub brush and cactus, El Tiro lay in the middle of the inhospitable Altar desert, where access to water remained critical to the town's survival and to the success of gold-mining operations. A small settlement had existed prior to the arrival of the Sonora Quartz-Mine Development Company of San Francisco. Most residents, including Tohono O'odhams, had eked out an existence from seasonal planting and periodic mining. The establishment of the mine, which used potassium cyanide to treat ores, strained the area's limited water supply. To ensure operations, the American company, according to the police commissioner, Priciliano Murrieta, "had fenced the town well and recycled the water back into its reservoir rather than sharing it with the needy people." Murrieta warned that "water for the inhabitants of this settlement is scarce, growing worse day by day, increasing the likelihood of a conflict between the town people and the American mining company who control the local well."[29]

Beside controlling the town's principal well, the company also operated a tienda de raya and funded a school to further entice laborers. Murrieta requested assistance from the state government because he feared "that the local residents would take by force that which they had been denied."[30] With the town surrounded by a barren desert and without water, the company's policy, according to Murrieta, amounted to blackmail. The district prefect of Altar disregarded Murrieta's complaint. He insisted that the people simply wanted the freedom to prospect and had no experience with working in one place for any length of time.[31] This attitude appeared consistent with the views expressed by the government concerning Altar and the Tohono O'odhams who inhabited the area. On several occasions state-sponsored publications blamed the Tohono O'odhams and their "backward practices" for the lack of development in the district.[32] After consulting with the gover-

nor, the prefect ordered the police commissioner to protect the interests of the American company, disregard the claims of the residents, and "repress any actions by the people."[33] Relations at El Tiro remained tense, but with few alternatives, laborers continued in the employ of the company.

MULATOS

In the district of Sahuaripa, a similar dispute erupted between the large El Rey del Oro Mining Company, which also used deadly potassium cyanide to extract gold and silver from ores, and the people of the towns of Mulatos.[34] Here, environmental concerns became the catalyst for conflict. Leached tailings and poisonous chemicals dotted the area around the mine. Operators dumped the mine's by-products in areas immediately adjacent to the town. The American company discharged water tainted with potassium cyanide into a nearby stream which flowed past the town. When cattle died after drinking from the stream, the townspeople panicked.

Pressured by the populace, the presidente municipal of Mulatos, Severino Aguayo, filed a complaint with the superintendent of the mine. The company responded by blaming the "backward people of the town who do not understand the modern methods being employed by the mine."[35] Having received no assurances from the American firm, local authorities ordered company administrators to construct a pipeline to safely discharge the cyanide away from the town or to shut down the plant. In retaliation, El Rey del Oro ceased all operations and filed a formal protest with the governor.[36] The company hoped that the unemployed workers would pressure local authorities and allow the mine to operate without restrictions. The company's tactics did not intimidate town officials, and the council informed mine operators that as "foreigners, they must respect local laws or face the consequences."[37] After a visit from the American mine owners, the governor overturned the actions of the ayuntamiento and ordered the mine to reopen. He censured the presidente municipal for inciting the town against the company. With little alternative, local authorities complied with the governor's instructions. To embarrass Governor Izábal, local officials posted his edict throughout the town.[38]

Town councils throughout the state resented their loss of autonomy. As events at El Tiro and Mulatos underscore, discord with the existing order involved diverse social groups. In El Tiro, Tohono O'odhams and

Mexican laborers struggled over access to water. In Mulatos, local officials, rancheros, and hacendados clashed with American investors over environmental issues. The state government's heavy-handed support of foreign interests undermined its legitimacy in the eyes of the many Sonorans.

DISSENT AND AMERICANS

Attitudes toward Americans remained a complex issue. No one single response to the American presence emerged. In large mining areas, social inequities and a dual wage system between Americans and Mexicans performing the same task ignited political dissent, labor unrest, and even nationalist sentiments. Statements such as "Sonora es de los Yankees" (Sonora belongs to the Yankees) became common among disgruntled labor leaders. Critics in the press referred to foreign enclaves in Cananea, Empalme, and elsewhere as "Yanquilandia," "Dolaria," and "Bolillolandia" (white bread).[39] In the aftermath of the 1906 strike at Cananea, worker propaganda lamented that in Sonora "Yankees, Blacks and Chinese are valued more than Mexicans."[40]

Criticism of American symbols, especially the railroad, increased in frequency and reflected the extent to which foreign undertakings had become tarnished. Newspapers frequently referred to the Sonoran railroad as the *ferro-tortuga* (the rail tortoise) and ridiculed its inability to keep schedules. The railroad had its problems: engines failed, tracks proved unsound, bridges needed repair, and at times, the trains even derailed. Given these conditions, one popular adage reminded passengers that on most days a good team of Sonoran horses could travel faster between Guaymas and Hermosillo than the railroad.[41]

Not surprisingly, condemnation of the railroad originated in the southern regions of the state or from displaced areas in the north. Newspapers in Alamos, Arizpe, and Guaymas denounced American control of the enterprise. In 1901, for example, the *Distrito de Alamos* published an article blasting the proposal to bring 1,500 Americans as apprentices for Mexican railroads.[42] It editorialized that Mexicans, not Americans, should be given preference in employment. In 1902, Lázaro Gutiérrez de Lara and Ignacio Corella, editors of the Arizpe newspaper *El Porvenir,* insisted that Sonora would never be free of American tutelage until it had rail contact with Mexico City. Echoing arguments first raised in the 1870s, they urged construction of a southern rail line in order to safeguard the Mexican north from the United States.[43]

Indignation against the American-owned railroad had many causes. Although the iron horse provided the state with efficient transportation, people in the countryside continued to be unfamiliar with its workings. Cases of persons being killed or dismembered by the train occurred with frightening regularity.[44] In case after case, company officials blamed Mexicans for the accidents. Sonorans countered that American operators, concerned with meeting schedules, refused to stop when encountering a person on the tracks. In part, conflict with the U.S. railroad underscored the clash between the forces of "modernity" and those of "tradition." American control over the enterprise, however, recast this dilemma in a different light. Dissidents construed the actions of the U. S.-controlled railroad as part of a general policy of disdain for Mexicans.

Ranchers also claimed that the railroad indiscriminately killed their cattle which crossed the tracks. In Buena Vista, in the district of Arizpe, they reported losing "more cattle to the Cananea railroad than they had to the Apaches."[45] The governor refused to intercede and suggested that cattlemen deal directly with the company. When confronted by a similar predicament, ranchers south of Guaymas took matters into their own hands. They complained to the American superintendent of the railroad regarding their dead cattle. When the matter persisted, they forced the district prefect to arrest the superintendent.[46] Much to their chagrin, Governor Torres ordered the American official released. In areas where the railroad attempted to enclose their track with barbed wire, residents protested the closure of access to grazing lands. In Cerro Pelón, ranchers destroyed the hated *alambre de pua* (barbed wire) because it prevented their stock from freely grazing on the range.[47]

The railroad also came under attack in urban areas. The manager of the Sonoran Railroad Company, J. A. Naugle, complained about acts of vandalism, especially rock throwing, directed against train cars as they entered and left Guaymas. Naugle became especially incensed at the damage done to his private car when he lent it to Agustín Bustamante, a powerful Guaymas merchant. According to Naugle, a barrage of rocks had smashed the windows on the Pullman. A few days later, as the train pulled out of the Torres station, it once again came under attack.[48] While this was a nuisance, the railroad appeared far more concerned by the placing of debris on the track in order to derail the train. On several occasions, Mexican railroad workers angry over wage disparities set fire to tracks and overturned water tanks.[49] Guillermo Robinson, the railroad's lawyer, insisted that the government conduct a

thorough investigation to ascertain if this activity reflected the work of an organized band.[50] The government concluded that most attacks appeared to be the work of disgruntled workers or groups of youths rather than organized political resistance.

The middle classes adopted a more ambivalent attitude toward the Americans. They openly complained about American cultural influences and the large number of "uneducated" Americans who arrived in Sonora. At Cananea, for example, Simón Montaño, publisher of the *Gaceta de Cananea,* complained that labor problems would be improved if officials dismissed the uneducated and drunken American foremen who spoke no Spanish and who viewed the Mexicans as inferiors.[51] Rather than openly attacking American investments, the middle classes sought to discredit United States influence by exposing the contradictions of American society. To this end, the prolific Sonoran press commonly reported on the thorny issue of race relations in the United States.[52]

Exposing the adverse treatment that Mexicans and blacks received in the United States appeared to be a way of undermining American influence in Sonora. To underscore the hostile situation confronted by Mexicans in the United States, the local press published accounts from the Spanish-language newspapers in California and Arizona. One article in a Magdalena paper advised Sonorans not to go north, "first there is no work, as a people we are not united and second our cousins (the Americans) treat us badly, only those who are totally Americanized or given to adulation have it a little easier."[53] It warned Sonorans that if they ever committed an infraction they would be judged by the infamous "lynch law."[54] Mexican consuls would provide no relief, since most spent their time "living the good life" and making money by staging sham September 16 and May 5 celebrations.[55]

The adverse treatment of American blacks received attention in the Sonoran press. When a crowd of whites in Georgia lynched a black man and then set him afire, newspaper headlines in Sonora read "Negros a la Parilla en Georgia" (Blacks Barbecued in Georgia). Beside condemning the lynching of the unfortunate man, the newspapers added: "what must blacks in Cuba be thinking . . . the concern of the United States' press over Cuban blacks is at best hypocritical."[56] The connection between acts of racial violence in the United States and American foreign policy did not appear to be coincidental. By associating United States race relations and foreign policy in Latin America, the dissident press hoped to expose contradictions inherent in American society. To this

end, American military incursions into Cuba and the Philippines received wide coverage. Descriptions of Cuban efforts to gain independence from Spain, and later from the United States, appeared regularly, attracting many sympathizers in Sonora. On the occasion of the death of Antonio Maceo, the leading black figure of Cuban independence, a Guaymas newspaper published a poem in his honor.[57] In reporting on Christmas pastorelas held at a Guaymas theater in 1896, *El Imparcial* reported that the festivities had been repeatedly interrupted by shouts of "Viva Cuba Libre."[58] Several small stores in the state bore the name "Cuba Libre."[59] According to *El Porvenir* of Arizpe, the reporting of United States actions abroad served to inform Sonorans "of the true sentiments of the Americans."[60] Porfirian officials ridiculed these concerns, insisting that critics would rather see Sonorans "travel by burro instead of railroad, dress in animal skins and feathers rather than accept anything from the Americans."[61] Sonora, they argued, should be more worried about the establishment of competing silver and copper mines in San Luis Potosí than of the Americans.

GROWING BACKLASH

Diverse social sectors feared that the promotion of American interests had taken its toll on Sonoran society.[62] Extolling the export economy drove many critics to conclude that in Sonora only "mines and wheat mattered, everything else is secondary."[63] The problem, according to one Ures resident, arose because "while the American exploited the riches of the sub-soil, the Mexican suffered from *empleomanía* [the quest for government jobs]."[64] Mexicans, he argued, sought the immediate gains offered by a government post while the Americans exploited the real wealth of the state, its minerals. The *Centinela de Alamos* complained that "the riches of our earth are daily exploited by foreigners . . . because of the reluctance of Mexican capitalist to take risks and invest in their own country."[65] A growing chorus of critics insisted that Mexicans bore the blame for allowing Americans to gain the upper hand in Sonora. In the port city of Guaymas, one critic complained that no Mexican entrepreneur had taken the initiative to build a "beach resort [*balneario*] in the city." Guaymenses, he lamented, would simply have to wait until an American built a resort for Sonorans to enjoy their own beaches.[66] Increasingly, the process of self-evaluation centered on the effect that reliance on foreign-inspired development had produced on the Mexican.

The internal process of reflection also addressed changing social conditions. New-found wealth, urbanization, and large-scale immigration confronted northerners with a host of public social problems including prostitution, alcoholism, and gambling.[67] The wave of moralizing which gripped many countries in the latter part of the nineteenth century found fertile ground in Sonora.[68] Commentators complained that Sonoran society had been corrupted by the rapid changes it had experienced. In response, they adopted a moralistic penchant, hoping to rehabilitate and somehow recapture the old ways of life. An informal circle of educated middle-class youth gave voice and form to this movement. A significant number of these individuals served as teachers or low-level administrators employed by the state government, and many participated in the various committees formed to promote education in Guaymas and Hermosillo. These groups had initially benefited from the economic policies of Corral, Torres, and Izábal. With high expectations, these "children of the triumvirate" expected more from their government. The dozens of newspapers which circulated throughout the state provided an outlet for their expressions, reaching like-minded urban sectors.[69]

Not united by any formal ideology, these individuals sought state intervention in social issues. Their critiques seldom directly attacked the existing political order; but as the government rejected their views, they increasingly focused on the corruption which proliferated within the Sonoran triumvirate. The government denied that any problem existed. In a 1910 publication funded by the government, Pedro Ulloa asserted that pauperism, lawlessness, and abuse of alcohol seldom occurred in the state. When such criminal activity transpired, Ulloa attributed it to Mexicans from other states or to foreigners, not to Sonorans.[70] This propensity for creating scapegoats had a long tradition in Sonora. In a speech before the state congress in 1889, Corral insisted that Sonorans had always possessed a strong moral character. Accordingly, social problems in the state were the result of foreign influences and "contact with Americans along the border."[71] By absolving themselves of responsibility, Porfirian officials earned the enmity of influential middle sectors. Manuel Hugues, whose stinging articles on Porfirian officials forced him into exile, wrote "that in their drunken stupor the supporters of the triumvirate could never hope to discern the problems which confronted Sonora."[72] Political corruption and questions of morality coalesced and became increasingly identified with the actions of Corral, Torres, Izábal and the policies of the Porfiriato.

Sonora had never been an especially over-modest society, and critics did not seek to implant a puritanical order. In the past, issues such as prostitution and alcoholism had been regulated by social pressures exerted by a relatively small, closely knit population. The practice of prostitution did not appear to trouble critics; rather, they reacted to the appearance of moral decay created by the proliferation of bordellos and prostitutes on city streets. They also objected to the growing cases of sexually transmitted disease which afflicted families of the middle class and notables.[73]

Problems with alcoholism and the abundance of drinking establishments came under attack. In Hermosillo, the presence of twenty formal cantinas and an untold number of store fronts which illegally dispensed liquor were blamed for the "vice and drunkenness which grows day by day."[74] The countryside proved to be no different. To escape the hardships of mining, laborers increasingly turned to drinking.[75] Preoccupation over public drunkenness surfaced in every major city. Here again critics objected to the public display and the social problems caused by excessive alcohol consumption; drinking by women also became an added area of concern.[76] One incident which caused a public furor in Guaymas involved two drunks who staggered into a wake and proceeded to give the corpse his "last drink."[77] Writing in the *Razón Social,* Rosa Granillo blamed drinking for broken families and the abandoned children which wandered the streets of Guaymas.[78]

Proposals to combat public drunkenness ranged from forming a government commission to study the problem to using a purported "Russian remedy" which called for injecting drunks with a weak solution of strychnine.[79] To exert social pressure, a Guaymas newspaper began printing the names of all persons arrested for public drunkenness.[80] In Hermosillo, the *Antorcha Sonorense* demanded that the government dismiss all state employees who abused alcohol or had been arrested for public drunkenness.[81] Hoping to capitalize on the new morality, W. F. Chenoweth, an American doctor, opened the International Institute for the Treatment of Alcoholism, Tobacco, Opium and Cocaine in Nogales.[82] The prohibition movement which gained impetus in Sonora after the revolution traces its origins to the morality campaigns of the early 1900s.[83]

In an effort to reinforce morality, social critics also exalted the importance of the family. Revitalizing the institution of the family would strengthen Sonoran values, they argued. In Guaymas, *La Razón Social* repeatedly editorialized on issues of family life, the role of women, and

the effects of alcoholism on society. One young writer, Plutarco Elías Calles, frequently wrote articles concerning the merits of family life and matrimony. Having been abandoned by his father at a young age, Calles proclaimed that "the family unit should be the basic foundation of society. . . . To the degree that family life is better organized, society will be better off."[84] Calles chastised men who frequented houses of prostitution and abused liquor. Parenthetically, he argued that a nation's weakness could be directly attributable to the moral decay of the family. By lauding the virtues of family life, fidelity, and responsibility to children, this generation of Sonorans, such as Calles, sought to rectify what they perceived as the ills of society.

Admonitions regarding the family made the issue of women paramount, and commentators devoted countless pages to bettering their conditions. Contemporary views expressed in Europe and the United States concerning women found resonance in Sonora.[85] Most traditional recommendations centered on the need to improve the education of women and their role in society.[86] Bettering the status of women was tied to uplifting the status of the family. Not all commentators limited their views to these conventional areas. Women also wrote about their own conditions and proposed plans for greater equality in education and politics, engendering lively debates.[87] Writing under pen names or their own, women addressed many social issues. The *Razón Social* of Guaymas regularly printed a column by women which dealt with social issues, music, art, philosophy, and education.

Social concerns and issues of morality fused with the growing political discontent. Those dissatisfied with social conditions insisted that "it is not the people who are to blame, but rather the capitalist who pays meager wages and . . . the state which allows houses of prostitution and saloons to proliferate."[88] Popular perceptions of social decay undermined the moral authority of the Sonoran government. Morality commissions formed in most major towns and took an active role in politics, fueling the protest movement which took shape against the Porfiriato. In August 1911, for example, the Comisión Moralistas of Hermosillo sent a delegation to Mexico City to meet with Francisco Madero and seek his support in their campaigns.[89] Workers associations in Cananea identified prostitution, drinking, gambling, and education as key issues for labor to address.[90] These experiences formed the moralistic orientation of Sonoran revolutionary leaders. Under their direction, the state took an active role as a social benefactor, founding or-

phanages, regulating and later outlawing the sale of liquor, and severely restricting public conduct.

The rapid shift from a frontier to an international border fueled much of the unrest which erupted in Sonora in the early 1900s. In a few short years, Sonora had been transformed from an unknown northern province to one of the most prosperous states in Mexico. Thirty years earlier, the principal dilemmas facing the state had been raids by Apaches and the machinations of long-time caudillo Ignacio Pesqueira. These issues now paled by comparison to the new challenges the state confronted. During the first decade of the twentieth century, several protest movements took shape in Sonora. The struggle of Mexican labor against foreign enterprises for better pay and working conditions gradually emerged. Municipal and other lower-level officials resented the growing erosion of their local power and withdrew support from the Porfiriato. Confronting a repeated economic crisis and recurring political inaction, a disaffected, educated middle class distanced itself from the Porfiriato. Influential land owners, displaced by the course of development, added their voices and provided important legitimacy to the growing political movement.

Support for the government eroded among the traditional pillars of the Porfiriato. Personal appeals by members of the triumvirate no longer swayed notables. Former supporters of the Díaz administration, including Mascareñas, Bonilla, and the Camous, distanced themselves from the politics of the Porfiriato. In previous years, they had journeyed to the capital to be seen in the company of Díaz. Now, when a select number received invitations to attend a banquet in honor of Don Porfirio in Mexico City, a great number contrived excuses for not attending.[91] Powerful elites, including staunch supporters of the government, had been adversely affected by the policies of the triumvirate. The wanton deportation of Yaquis had seriously depleted their labor force. In commerce, merchants witnessed the erosion of their markets and looked for scapegoats.

By early 1911, the status of the Sonoran notables appeared in danger. From Mexico City came reports that Díaz and Corral had resigned and gone into exile in Paris. As tensions mounted in Sonora, Torres and the interim governor, Alberto G. Cubillas, commissioned a special train and fled in the middle of the night, barely escaping with their lives.[92] Before leaving, they commissioned Mascareñas, their agent in Nogales, to transfer their assets from the Banco de Sonora to banks in the United

States. Other notables also made plans to send their families to California and Arizona and shifted funds to American banks. Deluged by throngs of anxious passengers, trains departed Hermosillo for Nogales filled to capacity.

The government forces remaining in Hermosillo erected fortifications and dug trenches in preparation for an assault. Within the town, dissent also surfaced. On Sunday, May 28, 1911, crowds gathered and attacked the public symbols of the Porfiriato and the Sonoran triumvirate. Protestors tore down statues and emblems at the Parque Corral, the municipal market, and calle Don Luis and Don Porfirio and renamed the sites in honor of Mexico's new revolutionary leaders: Francisco Madero, Pascual Orózco, and Aquiles Serdan. The excited multitude marched on the homes of Torres, Izábal, Monteverde, and Escalante, threatening to lynch the hated Porfiristas. Unable to find their intended targets, the mob instead sacked the homes of several Chinese merchants.[93] Troops had to be used to quell the crowds.

From Hermosillo, José Camou wrote to his father in Los Angeles that disorder reigned throughout the state.[94] Ranches, mines, and the railroad had been raided, and the state capital lived under the threat of imminent attack by rebels. The insurgents camped in Ures and demanded 20,000 pesos from the chamber of commerce for not attacking the city.[95] Leading merchants and landed elites quickly filled the void left by the fleeing Porfiristas and dealt with the rebels. In Hermosillo, the merchants association elected José C. Camou and Alejandro Lacy, two previous stalwarts of the Porfiriato, to negotiate with the revolutionaries who threatened the state capital. A temporary offering of 5,000 pesos dissuaded the rebels from attacking. Except for the triumvirate and their close associates, most notables, including those previously associated with the Porfiriato, made concessions and weathered the political storms which engulfed the state.

Conclusion

Repeated patterns of conflict marked the early Sonoran experience. Isolated in the far northwest, Sonorans struggled to forge a society against a harsh and unforgiving environment; in the process they became entangled in a destructive caste war against the Yaquis and other indigenous peoples. They fought equally ruinous wars, both among themselves and against central powers, and repelled foreign aggressors, real and imagined. Throughout this period, an air of uncertainty hung over this society, and life for the average person continued to be tenuous. These events conditioned the early world of the Sonoran, influencing class, social, and ethnic relations and economic strategies. Isolation, a dominant feature of the colonial epoch, increased after independence in 1821. Popular culture captured these experiences, ensuring their diffusion and shaping the basis of a regional identity.

War established the United States-Mexico border, but conflict alone did not define the region. The border acquired meaning as a result of growing interaction between Mexicans and Americans. For Sonora this process began when hundreds of Mexicans migrated north during the 1850s to work in the mines of southern Arizona. Racial violence between Americans and Mexicans in southern Arizona and northern Sonora demarcated the region for both groups. The contraband which inundated Sonora in the post-1870 period accelerated the process of definition. During the 1880s, the construction of the railroad spurred the founding of the first border settlement in the region and introduced broad levels of economic and cultural exchanges, giving new meaning to border relations. This period witnessed a phase of unrestricted face-

to-face contact between Mexicans and Americans. This open cycle came to an end with the presence of thousands of United States troops on the border during the Mexican Revolution. The increased militarization of the border imposed new restrictions on contact and recast the nature of social relations between Mexicans and Americans. During the twentieth century, the border has continued to be defined by immigration, violence, cultural exchanges, rapid population growth, industrialization, and ecological degradation.

Border relations with the United States during the second half of the nineteenth century left an indelible imprint on the region. At this level, Sonora shared many features with fin de siècle Latin America. The ascent of new political actors coincided with the restructuring of economic relations, the rise of foreign-dominated mining centers, the growth of labor, and rapid urbanization. Several unanticipated consequences also accompanied this process of development. The region experienced substantial outward migration, the rise of transborder family networks, and broad-based exposure and adaptation to new cultural patterns. On the surface, these changes appeared less conflictive than raids by Apaches, yet for Sonoran society they proved equally disruptive. Conflicts from the past also continued to plague Sonoran society. Wars against the Yaquis, Mayos, and Seris continued to cost lives and drain resources. Political conflict became less sanguine but no less bitter.

The early conflict that characterized exchanges after the Mexican-American war and the period of filibuster invasions gave way to accommodation between elites in both countries. Conflict continued to characterize cross-border relations, but now it was cushioned by an intense socioeconomic relationship. Notables and some middle sectors adopted a new attitude in dealing with foreigners, in particular the North Americans. Foreign investments, especially American, became an indispensable element of the state's development. Whether in commerce, in which merchants established new alliances with California suppliers, or in mining, in which foreign concerns employed thousands of laborers, Americans acquired a new social and economic standing. These developments did not occur without some resistance. A complex and at times contradictory relationship evolved regarding foreigners. At one level, the government and commercial interests eagerly promoted investments by the United States and others. For many Sonorenses, United States standards and commercial products defined the parameters of modernity. Yet at another level, the general population viewed relations with

foreigners with ambiguity and a measure of distrust. Popular culture continued to capture and give expression to the contemporary problems with foreigners, labor issues, questions of morality, and other social conflicts. The widespread perception of a disconnected and unconcerned government eroded the authority of the Sonoran triumvirate. The economic consensus forged among politicians and notables failed to sustain their control of society.

Foreign-dominated enterprises became the driving force of Sonora's economy. They restructured relations of production, bringing together thousands of Sonoran men and women, Yaquis, Mexican immigrants, and foreigners. Inevitably, this daily interaction fostered some level of accommodation. Yet clashes with foreigners as well as with Mexicans from other states continued to occur. Eventually, contradictions among Mexicans and Sonorans abated, giving rise to a new sense of labor solidarity. Labor became an important political force—to be cajoled, co-opted, and repressed by those vying for power.

The legacy of uncontrolled and unregulated mining plagued Sonorans long after the mines had shut down and the foreigners had departed. The mines' need for lumber led to the wholesale deforestation of Sonora's timberland, enlarging the desert environment. Mountains of mining waste dotted the countryside. The toxic chemicals used to leach the minerals scarred the ground above and, below the surface, seeped into aquifers, leaving a damning legacy for future generations. Yet mining investments proved economically advantageous to many local elites.

As mines grew, so did the consumer market for goods. The records of such Sonoran merchants as Camou, Escobosa, Ruiz, and others reflect the extent to which they relied on sales to mines for a substantial portion of their profits. Since their sales were tied to the productivity of the mines, merchants, including the largest in the state, remained vulnerable. If production declined, as it did in the crisis of 1907, their sales plummeted. The sale of inexpensive consumer goods rose sharply, while the market for expensive goods remained unchanged. Expansion of the lower sector opened the door for new competitors, in particular, for Mexican jobbers and Chinese merchants, who undercut local commerce. Merchants turned to cheaper Mexican suppliers and even resorted to nativism in order to undermine competitors and secure the loyalty of their customers.

The association between economic progress and American investments invariably affected how broad segments of the population viewed foreigners. Even those Sonorans who lamented the pervasive North

American influence, and they were many to be sure, seldom challenged the basic economic framework which sustained the state's development. Instead, critics blasted the abusive actions of individual foreigners and the disparity in treatment but rarely attacked the foundation of this economic relationship. Not all foreigners received the same treatment. Chinese, for example, who competed with local merchants, did not conform to the dominant image of progress and faced severe repression.

Beyond these economic aspects, the migration of thousands of Sonorans to the American territories increased the informal social relations between Arizonans and Sonorans. Structural ties now coexisted with the familial and the personal. These new associations produced multiple cultural ramifications. Conflict no longer narrowly framed the nature of contact between people along the border. Interpersonal relations complicated the political and the economic sphere. Cross-border interaction led to the rise of a complex web of relations which included family and business networks. These structures supplanted those which had previously existed between Sonora's notable families and Europeans, and included Mexicans who had migrated to the United States as well as business partnerships with Americans. Yet cultural exchanges reflected the asymmetrical power relations between Mexico and the United States.

The elite and middle classes readily adapted American values and customs, equating them with progress and modernization. Many of the elite learned English and, when possible, sent their children to be educated in the United States. They procured the outward physical signs of "modernity."[1] Vacations for the upper classes invariably included trips to American resorts, such as Santa Monica, California; Niagara Falls; and even Hot Springs, Arkansas.[2] The middle classes settled for an occasional trip to Tucson. In bars and saloons, Sonorans drank beer imported from St. Louis, viewed American movies, and heard music on imported phonographs. Popular American sports, such as boxing and baseball, attracted both rich and poor Sonorans. The association of Americans with progress influenced the selection of names for stores and services. Signs announcing American style hotels, butchers, bakers, and distilleries marked the streets of Hermosillo, Guaymas, and Nogales.[3] Outsiders thought that Sonorans had become to close to their *primos del norte* (northern cousins).[4]

On the surface it is very easy to draw the conclusion that northern Mexicans had become "Americanized." The simplistic notion that con-

tact with another culture implies the wholesale abandonment or rejection of traditional culture does not capture the complex nature of border exchanges.[5] Mexicans were not simply passive recipients of American culture; instead they actively participated in the transformation of their society.[6] Exposure to American norms, even when accompanied by conspicuous consumption, did not necessarily require the people of Sonora to abandon their traditional culture. In fact the opposite may indeed be true.[7] A pattern of asymmetrical exchanges between Americans and Mexicans may have served to reinforce a sense of regional pride.[8]

Rather than being unilinear, border cultural exchanges reflect a web of multidimensional interaction involving negotiation and resistance. These multiple layers coexist throughout society, though under specific circumstances one feature becomes dominant. Border residents therefore did not develop a sense identity only in relation to the other. These were not hermetically sealed communities that could exist in isolation from each other. In the case of Sonoran border towns, they depended on each other for their material well-being. A complex web of familial, social, and economic relations, which at times included conflict and at times accommodation, influenced identity.

Under these conditions, Sonorans adopted American customs that did not violate their traditions. Mexicans of all social classes willingly incorporated many features, such as dress, food, and sports, which initially had a foreign origin. These transactions expanded the basic cultural patterns of northwestern Mexicans. Foreign customs were reconfigured and incorporated as new elements of a regional culture. In the process, they ceased being conceived of as foreign entities. Fashion and sport represent examples of this type of cultural transformation. Imported blue jeans and other denim products became popular among rural and urban sectors. This rugged material suited the needs of the region, and Sonorans utilized these garments for both work and recreation. Sonoran merchants, such as the Camous, circumvented American suppliers and produced the pants locally.[9] This lowered the price and ensured further acceptance. This style of clothing gradually became a part of the dress of northwest Mexico, ceasing to have direct foreign connotations. This particular fashion became an element of popular norteño folklore. Baseball, introduced in the 1870s, underwent a similar transformation and became an integral recreational feature of this society. It quickly ceased being identified as an "American" sport

and became infused with local traditions, acquiring its own distinctive Mexican character. This cultural phenomenon also occurred in Cuba, Venezuela, and elsewhere in the Caribbean.

Yet, other American-inspired activity continued to be identified with foreigners and elites and never acquired a mass following. Bicycle clubs retained a class bias, demarcating the social status of elites, and thus never developed into a popular support. The same occurred with American-inspired holidays such as Thanksgiving, which Americans introduced in the nineteenth century and elites emulated but which never became integrated into the popular culture. Language also played a similar, yet more complex role. Groups which interacted with Americans used English, but it never supplanted Spanish. The use of English denoted a particular social status and, as such, it became a source of ridicule.

Border interactions continued to reflect dominant power relations and issues of class. The idea of a harmonious and inclusive culture shared by people on both sides of the border obscured the conflictive character of these exchanges. Not everyone had access to the benefits of a border society. Nonetheless, knowledge of foreign customs became essential for those groups involved in border trade. The average person, however, whether Mexican or American, continued to view the border as a potential source of conflict. Border relations remained extremely fluid. The same people who wore blue denim pants and played baseball, criticized the excessive use of English, went out on strike against American-owned companies, and under certain conditions, picked up arms and fought against the United States as they did in Nogales in 1918. Border relations required a balancing act between those groups which derived material benefits from increased interaction and those which did not.

Since the turn of the century, rifts had existed between notables and the Sonoran triumvirate of Corral, Torres, and Izábal. The political group that rose to power with Porfirio Díaz suffered the brunt of the revolutionary anger in 1911. In the wake of their departure, groups of notables and their middle-class allies stepped in to fill the power vacuum. Many offspring of notable families joined the ranks of the revolution, assuming positions in the local, state, and military power structure. One of Mascareñas' sons supported Orozco, and another sided with Calles, eventually becoming national president of the Banco de México.[10] One of the younger Camous became mayor of Hermosillo and continued to manage business operations.[11] A descendant of Juan

"John" Robinson became an aide of Obregón, while others continued to be active in the Guaymas city government.

Once again notables had adapted, forged alliances with the middle classes, and incorporated other groups, such as labor and Yaquis. This co-optation took place in the cultural realm as well as in the political. Culturally, this meant appropriating the symbols of northern resistance in much the same way as Corral had attempted previously with the Yaqui leader Cajeme. Reality and myth blended as cultural symbols from the past, such as the filibuster raids at Guaymas and Caborca and Yaqui autonomy became linked to contemporary labor struggles at Cananea and norteño resistance to central authority. Gradually, these symbols became part of a growing norteño folklore. The leadership of notables in the revolution eased the transition from the old regime to the new power structure, limiting the scope of change in their state. The leadership role they provided proved decisive in setting the tone for the revolution in the northwest and eventually throughout Mexico.

Notes

INTRODUCTION

1. Foucault, *Order of Things*, xx.

2. See Katz, *Secret War in Mexico*, 20.

3. See Anderson, *Imagined Communities*, 14–15.

4. See Vasconcelos, *Breve historia de Mexico*, 584. Vasconcelos described Alvaro Obregón as "tall, white, clear eyes and robust, resembling a criollo of Spanish heritage." See also Hernan Solis Garza, *Los mexicanos del norte*, (México: Editorial Nuestro, Tiempo, 1971), 51–72. For contemporary depictions, see Jesús Felix Uribe, "El desfile de los ganaderos," *Unisono* (Hermosillo), May 18, 1988, 2; and Nugent, *Spent Cartridges of the Revolution*, 15.

5. Bernal, "Cultural Roots," 25–33; Iturriaga, *La estructura*, 241.

6. See for example, Solis, *Los mexicanos del norte*.

7. Willens, "Social Change," 259. Willens observed that "the society emerging out of the frontier condition may be relatively egalitarian or seigniorial, it may be composed of small holders or large estates or a mixture of both."

8. See Voss, *On the Periphery*, 9, 29.

9. See Alejandra Moreno Toscano and Enrique Florescano, *El sector externo y la organización espacial y regional de México 1521–1910* (Puebla: Universidad Autónoma de Puebla, 1977), 13–14.

10. For Texas/Chihuahua, see Martínez, *Border Boomtown*, 9.

11. See Thomas D. Hall, *Social Change*, 209.

12. Martínez, *Border Boomtown*, 22.

13. Bustamante, "Frontera México-Estados Unidos," 20.

14. Domingo Sarmiento, *Life in the Argentine Republic in the Days of Tyrants: or, Civilization and Barbarism* (in Spanish) (1845), trans. Mrs. Horace Mann (1868; reprint, New York: Hafner, 1971).

15. See Hart, *Revolutionary Mexico*, 9.

16. See Knight, *U. S.–Mexican Relations.*

17. Simpson, *Many Mexicos.*

18. See Ruiz, *The People of Sonora;* Cerutti, *Burguesía y capitalismo;* Saragoza, *The Monterrey Elite;* and Wasserman, *Capitalist, Caciques, and Revolution.*

19. See Martínez, *Troublesome Border,* 111.

20. This process also took place in southern states. See Wells, *Yucatán's Gilded Age.*

21. Bonfil Batalla, *México profundo,* 75.

22. See Jane Dale Lloyd, *El proceso de modernización,* 13.

23. For example see León-Portilla, "The Norteño Variant," 77–114. See Carr, "Las peculiaridades," 327.

24. Paasi, "Institutionalization of Regions," 120.

25. BCUSCN, Colección Pesqueira, serie 1, tomo 4, October 13, 1830, decree which divided Sonora and Sinaloa.

26. See Voss, *On the Periphery,* 107.

27. Ibid., 33–34.

28. "Letter from Ignacio Zúñiga to Carlos María Bustamante," December 1, 1842, 6. (Yale Latin American Pamphlet Collection).

29. Nicoli, *El estado de Sonora,* 10.

30. ABO, Ramón Corral, "El Estado," *La Constitución,* March 1, 1889, 1.

31. Galindo y Villa, *Geografía de México,* 114.

32. See Bassols Batalla, ed. *Lucha por el espacio social.*

33. Harris, *A Mexican Family Empire,* 153.

34. See Bassols Batalla, ed. *Lucha por el espacio social;* and Bassols Batalla, *El noroeste de México.*

35. See Acuña, *Sonora Strongman;* and Wasserman, *Capitalist, Caciques, and Revolution,* 47.

36. Harris, *A Mexican Family Empire,* 27.

37. See Carr "Las peculiaridades," 327.

38. Cerutti, *Burguesía y capitalismo;* Saragoza, *The Monterrey Elite,* 32.

39. See Cerutti, "Monterrey y su ambito regional," 8–10.

40. See Von Mentz, et al., *Los pioneros del imperialismo,* 127–30.

41. José Velasco, *Noticias estadísticas,* 69.

42. See Wasserman, *Capitalist, Caciques, and Revolution,* 94.

43. Alfonso Luis Velasco, *Geografía y estadística,* 206.

44. See Ruiz, *The People of Sonora.*

45. Alfonso Luis Velasco, *Geografía y estadística,* 205–6.

46. Saragoza, *The Monterrey Elite;* and Cerutti, *Burguesía y capitalismo.*

47. See Wasserman, *Capitalist, Caciques, and Revolution,* 6.

48. Aguilar Camín, *La frontera nómada,* 88–89.

49. See Monroy, *Thrown among Strangers,* 100, 135. Also Pitts, *Decline of the Californios,* 109.

50. See Hu-DeHart, *Yaqui Resistance and Survival,* 8–9.

51. Peñafiel, *Estadísticas de la República Mexicana,* n.p.

52. Voss, *On the Periphery,* 300.

53. See Katz, *Secret War in Mexico,* 7.

54. APD, caja 3, legajo 5, no. 1122, May 11, 1880, Manuel González to José G. Carbó.

55. APD, caja 26, legajo 10, no. 012619, January 12, 1883, Luis Torres to Lic. José Negrete.

56. See Coerver, "Federal-State Relations," 568–69.

57. APD, caja 4, legajo 5, no. 001762, April 16, 1880, José G. Carbó to Porfirio Díaz.

58. APD, caja 26, legajo 10, no. 012654, May 25, 1883, Ramón Corral to José G. Carbó. Espríu, a native of Alamos, was elected an alternative delegate from Guaymas.

59. Coerver, "Federal-State Relations," 571.

60. APD, caja 26, legajo 10, no. 012619, January 12, 1883, Luis Torres, Hermosillo, to Lic. José Negrete, Guaymas.

61. APD, caja 26, legajo 10, no. 12793; January 24, 1885, Ramón Corral to José G. Carbó.

62. See La Constitución, April 12, 1887, 1.

63. Ruibal Corella, Carlos R. Ortiz, 126.

64. APD, caja 26, legajo 10, no. 012587, August 12, 1882, General José G. Carbó, Mazatlán, to Rafael Izábal, Hermosillo.

CHAPTER 1. "DUST AND FOAM"

1. For the application of this idea to other environments see Giddens, "Time, Space and Regionalisation," 274. Also see Habermas, Communication, 106.

2. Braudel, The Mediterranean, 231.

3. See Voss, On the Periphery, 24.

4. Vicente Calvo, Descripción política, 135. Also Voss, On the Periphery, 24–92.

5. Herskovits, Cultural Dynamics, 202.

6. Warren, Dust and Foam, 169. Also Stone, Notes on Sonora, 11.

7. Ober, Travels in Mexico, 654.

8. C. Combier, Voyage au Golfe de California, (Paris: Arthus Bertrand Editeur, 1864), 174.

9. Bird, Land of Nayarit, 18.

10. AHGES, carpeton 433, January 15, 1871, prefect reports, Guaymas and Hermosillo. Also see, Dispatches of United States Consuls, Guaymas, Mexico, December 4, 1861, statement of U. S. Consul Alden, and July 8, 1868, A. Willard, annual report.

11. "Guaymas, Sonora," New York Times, December 10, 1858, 6.

12. Combier, Voyage, 174.

13. Ober, Travels in Mexico, 653.

14. Alfonso Luis Velasco, Geografía y estadística, 168.

15. John Hall, Travel and Adventure in Sonora, 33.

16. Alfonso Luis Velasco, Geografía y estadística, 205.

17. Guillet, "Notas sobre Sonora," 8.

18. John Hall, Travel and Adventure in Sonora, 87.

19. Guillet, "Notas sobre Sonora," 9.

20. Stone, *Notes on Sonora*, 8.

21. Hardy, *Travels*, 96.

22. John Hall, *Travel and Adventure in Sonora*, 88.

23. AHGES, carpeton 422, December 31, 1869, quarterly report of the prefect of Hermosillo to the governor.

24. Charles Poston, cited in Browne, *Adventures in Apache Country*, 245.

25. "Sonora and Guaymas," *New York Times*, December 10, 1858, 6.

26. Bird, *Land of Nayarit*, 14.

27. See Warren, *Dust and Foam*, 165; Vicente Calvo, *Descripción política*, 36. Also Voss, On the Periphery, xiii.

28. Warren, *Dust and Foam*, 168; Bird, *Land of Nayarit*, 14.

29. Warren, *Dust and Foam*, 169. Also Browne, *Adventures in Apache Country*, 133.

30. Combier, *Voyage*, 237.

31. For Guaymas, see Ober, *Travels in Mexico*, 654.

32. John Hall, *Travel and Adventure in Sonora*, 34. Also Pinart, "Voyage en Sonora," 220.

33. Browne, *Adventures in the Apache Country*, 171.

34. Ibid.

35. Vicente Calvo, *Descripción política*, 153.

36. Ibid., 153.

37. AHGES, carpeton 594 [Paris], 1888–1889, and carpeton 832 [Chicago], 1892–93.

38. AHGES, carpeton 433, "Noticias estadísticas," January 15, 1871, report of the prefect of Hermosillo to the governor.

39. Vicente Calvo, *Descripción política*, 157.

40. "Industria Local," *El Eco del Valle* (Ures), August 9, 1894, 2.

41. Also see Lumholtz, *El México desconocido*, 26; and Bartlett, *Personal Narratives*, 268.

42. Vicente Calvo, *Descripción política*, 43; Iberri, *El viejo Guaymas*, 14.

43. Warren, *Dust and Foam*, 166–67.

44. Ibid., 166. For another example, see AHGES, carpeton 354, September 15, 1860, inventory of the house of Manuel Sosa in Guaymas. The inventory included both Sosa's business as well as residence. His property was confiscated in order to cover unpaid taxes.

45. See Urrea de Figueroa, *My Youth in Alamos*, 16.

46. See Acuña, *Ignacio Pesqueira;* and Voss, *On the Periphery*, 74. Also see Ruibal Corella, *Carlos Ortiz*, 34.

47. Vicente Calvo, *Descripción política*, 158.

48. "Late from Sonora," *New York Times*, April 26, 1854, 7. Also "Letter from Guaymas," *New York Times*, March 5, 1865, 6.

49. León-Portilla, "The Norteño Variant," 102.

50. See ACMH, caja 14, 1858–1870, and caja 16, 1874–1890. Church archives contained extensive records of marriages between Sonorans and foreigners. Also Vicente Calvo, *Descripción política*, 159; and Warren, *Dust and Foam*, 179.

51. ACMH, caja 14, Marriage records, 1858–1870.

52. "Statement of Don 'Juan' John A. Robinson," Bancroft Library, m-m 375, reel 97, (hereafter cited as Robinson, "Statement"). Also see in Nogales, private collection of Eduardo Robinson (AER), a direct descendant of "don Juan," no. 105, January 10, 1882, Juan Robinson to his daughter Francisquita Robinson (in Spanish).

53. Dispatches of United States Consuls in Mexico, Guaymas, record group 59, microcopy 284, reel 1, November 12, 1859, Farrelly Alden to the State Department.

54. Guillet, *Notas sobre Sonora*, 22.

55. Ibid., 22.

56. AHGES, carpeton 368, March 7, 1861, Juan Camou to Ayuntamiento de Guaymas. In letters to the town council, Camou refers to himself as a *súbdito Francés* (French subject).

57. Also see Davila, *Sonora histórico y descriptivo*, 113.

58. AHMRUS, Copiadoras Camou, April 7, 1889, José Camou in Hermosillo to Juan P. Camou in Guaymas.

59. Browne, *Adventures in Apache Country*, 171.

60. See "Description of Sonora," *New York Times*, December 10, 1858, 6. The actual number of inhabitants may be exaggerated. Other accounts place the population at between 3,500 and 4,000.

61. "Guaymas, Sonora," *San Francisco Chronicle*, December 4, 1861, 4.

62. ACMH, caja 14, 1858–1870, and caja 16, 1874–1890.

63. Combier, *Voyage*, 207.

64. Ibid., 221.

65. See for example Vicente Calvo, *Descripción política*, 38–39, 111–59.

66. Marie Robinson Wright, *Picturesque Mexico* (Philadelphia: J. B. Lippicott, 1897), 305.

67. Vicente Calvo, *Descripción política*, 155.

68. AHGES, carpeton 832, January 26, 1892, list of materials sent to Chicago exhibit.

69. Warren, *Dust and Foam*, 198.

70. Combier, *Voyage*, 166.

71. Alfonso Luis Velasco, *Geografía y estadística*, 184.

72. Vicente Calvo, *Descripción política*, 158.

73. Officer, *Hispanic Arizona*, 20.

74. Vicente Calvo, *Descripción política*, 122–23.

75. Ibid., 123.

76. See Voss, *On the Periphery*, 80.

77. Officer, "El año negro," 2:89.

78. Poston, Building a State, 74.

79. Officer, *Hispanic Arizona*, 210.

80. AHCES, tomo 25, exp. 766, February 1, 1861, Manuel Monteverde, iniciativa por derechos de mujer.

81. Miguel León-Portilla, *Endangered Cultures* (Dallas: Southern Methodist University, 1990), 206.

82. José Velasco, *Noticias estadísticas*, 65–74.

83. Horacio Sobarzo, *Vocabulario Sonorense* (Hermosillo: Gobierno del Estado, 1984), 21.

84. See Foster, "Speech Forms and Perception." The analysis on interpersonal relations draws primarily from Foster and the research on the collection of letters from the Camou family in the Museo Histórico de la Universidad de Sonora, church records in Hermosillo, criminal proceedings, and newspapers of the period found in the state archives.

85. AHMRUS, Copiadoras Camou, no. 180, January 7, 1888, José Camou to Juan Ochoa.

86. AHGES, carpeton 457, October 7, 1877, Prefect of Alamos to the governor.

87. AHGES, carpetons 812–17, 1892–1899. Also see *La Constitución,* April 15, 1880, 3, report of the Superior Court. Defendants were listed by name and apodo.

88. Foster, "Speech Forms and Perception," 119.

89. For example, see ACMH, caja 7, 1892, marriage of Javiela Alvarez and Juan (John) Ames, and caja 14, 1905, Marriage of Artemisa Rodriguez and Robert Keith. Also AHGES, carpeton 1049, November 6, 1881, Neupomuseno Quijada to the governor.

90. See ABO, "Teatro de aficionados" in Ures performed "Un novio para la niña," *La Voz de Sonora,* January 25, 1856, 3. Also see "Teatro de aficionados en Ures," *La Estrella de Occidente,* February 12, 1875, 4.

91. ABO, *Boletín Oficial,* March 29, 1878. Also see AHGES, carpeton 433, March 31, 1871, quarterly report of the prefect of Guaymas. The prefect reported the opening of a theater operated by José Parra y Alvarez.

92. ABO, "Opera Italiana," *La Estrella de Occidente,* June 13, 1873, 3.

93. AHGES, carpeton 448, January 6, 1873, G. Corrella, prefect of Guaymas.

94. AHGES, carpeton 354, December 4, 1860, prefect of Guaymas to Governor Pesqueira.

95. See Consul Louis Hostetter, *Annual Report of Commercial Relations, North America,* 2:169.

96. Lange and Riley, *The Southwestern Journal,* 223. Bandelier reported on the popular use of the accordion.

97. AHGES, carpeton 433, January 15, 1871, district prefect of Hermosillo to the governor, "Noticias estadísticas."

98. Vicente Calvo, *Descripción política,* 42. Dances among the elite, according to Calvo, included the Spanish *contradanzas, vals, minuet,* and *cuadrillas.* Popular dances among the masses, or *muchedumbre,* as they were called, included the *fandango, guaco, jaranda,* and the *cigueña.*

99. See Reyna, "Notes on Tejano Music," 81–94.

100. Audubon, *Western Journal,* 140.

101. AHGES, carpeton 433, January 15, 1871, district prefect of Hermosillo to the governor, "Noticias estadísticas."

102. Vicente Calvo, *Descripción política,* 177.

103. John Hall, *Travel and Adventure in Sonora,* 79.

104. Ibid., 79.

105. ABO, *Boletín Oficial,* May 11, 1877, 2.

106. See Beene, "Sonora," 10.

107. Vicente Calvo, *Descripción política,* 167. Also see Bishop, *Old Mexico,* 330. Bishop observed similar practices among the predominantly Sonoran population of San Francisco.

108. AHMRUS, Colección Camou, no. 301, March 6, 1889, Juan Camou in Hermosillo to his brother José Camou in Guaymas.

109. Vicente Calvo, *Descripción política,* 168.

110. AHMRUS, Colección Camou, no. 126, December 17, 1888.

111. AHMRUS, December 17, 1888, José Camou to Ernesto y Eugenio Camou.

112. ABO, *La Estrella de Occidente,* December 1865, several issues; and *La Constitución,* October 23, 1879. Also John Hall, *Travel and Adventure in Sonora,* 42–43.

113. Stone, *Notes on Sonora,* 13. Also Zamora, *La Cohetera, mi barrio.*

114. "Correspondencía de Magdalena," *Las Dos Republicas* (Tucson), August 31, 1878, 1.

115. John Hall, *Travel and Adventure in Sonora,* 41.

116. AHGES, carpeton 1039, April 26, 1892, Junta Patriotica de Guaymas.

117. AHGES, carpeton 454, August 9, 1873, Junta Patriotica. Also see *La Constitución,* September 19, 1884.

118. "16 de Septiembre," *Las Dos Republicas,* September 23, 1877, 2.

119. Don Nestor Fierros, interview by author, Hermosillo, Sonora, June 6, 1990. For most of his life, Don Nestor worked as a cowboy; in later years, he became an amateur historian.

120. AHGES, tomo 2471, exp. 3, February 10, 1909, report on the number of Plazas de Toros in Sonora.

121. "Toros el Domingo," *Revista Popular* (Alamos), April 6, 1903, 3. Also *La Razón Social* (Guaymas), November 22, 1897; "Gacetilla, Toros," *El Imparcial* (Guaymas), February 19, 1908; "Toros," *El Doctor Ox,* August 23, 1894.

122. See Vicente Calvo, *Descripción política,* 123. Also Ulluoa, *El Estado de Sonora,* 32.

123. Vicente Calvo, *Descripción política,* 123.

124. ABO, "Fiestas en el pueblo de Caborca," *La Estrella de Occidente,* January 13, 1870. Also AHGES, carpeton 469, August 15, 1876, plan de Propios y Arbitros del Ayuntamiento de Altar. In Altar people also engaged in a game of *pelota* (ball); however, no descriptions exist as to the nature of the game. Also see Pfefferkorn, *Description of Sonora,* 185. Pfefferkorn was a German missionary who lived in Sonora from 1767 to 1778. He describes how he was beaten in a race by a man on foot even though he was on horseback.

125. ABO, "Fiestas en el pueblo de Caborca," *La Estrella de Occidente,* January 13, 1870, 6.

CHAPTER 2. MERCHANTS, MINERS, AND LABOR

1. See Hogan, "The Frontier as Social Control," 35–52.

2. See Voss, *On the Periphery,* 80. Also Ingersoll, *In and under Mexico,* 87.

3. This pattern holds true for other northern states. See for example Iturriaga, *La estructura,* 244. The five northern border states of Sonora, Chihuahua, Coahuila, Nuevo Leon, and Tamaulipas had only 682 Catholic churches. By contrast, the central state of Puebla had 1,899.

4. See Lázaro de la Garza y Ballesteros, *Pastoral de Lázaro de la Garza y Ballesteros, Obispo de Sonora as sus diocesanos* (México: Impreso Juan Ojeda, 1837), 4.

5. See Corbala Acuña, *Sonora y sus constituciones,* 86.

6. Ibid., 128.

7. See John Hall, *Travel and Adventures in Sonora,* 256–57.

8. AHGES, carpeton 365, February 5, 1861, Pedro Tato, prefect of Guaymas. Also carpeton 422, June 6, 1870, Francisco Serna, interim prefect of Hermosillo, to the governor.

9. AHGES, carpeton 365, January 8, 1861 and January 30, 1861, Judges Manuel Cordova and Agustin Muñoz.

10. AHGES, carpeton 397, March 6, 1867, report of prefect and military commander of Hermosillo.

11. AHGES, carpeton 397, April 26, 1867, district of Hermosillo.

12. AHGES, carpeton 448, November 21, 1873, and May 1, 1875.

13. Dispatches from United States Consuls in Mexico, Guaymas, Sonora, record group 59, microcopy 284, reel 1, September 1854, Juan Robinson, annual report.

14. See Mora, "Entrepreneurs in Sonora," 181.

15. See *Estrella de Occidente,* March 29, 1872, 3. General Francisco Serna headed the committee.

16. AHGES, carpeton 397, April, 26, 1867, Junta Cotadizadora del Asunto del Rio. In total, the committee collected over 7,000 pesos for the river project. Wealthy merchants such as Celedonio Ortiz gave 500 pesos; Francisco Noriega and the Camou brothers donated 250 each. To avoid public criticism and maintain their standing, a host of individuals including public officials, small retailers, foreigners, and widows also donated.

17. AHCES, caja 44, June 15, 1875, contract between ayuntamiento of Guaymas and Guillermo Randall, Juan Luken and Iberri and Huerta for the establishment of public lighting in Guaymas.

18. AHGES, carpeton 458, July 10, 1874, contract between ayuntamiento de Hermosillo and Eduardo Rodríguez.

19. AHGES, carpeton 865, June 23, 1887, contrato de iguala between state government and Napoleon Graff.

20. AHGES, carpeton 865, June 8, 1888, contrato de iguala between state government and Vicente A. Almada.

21. The Camou family made it a practice to rent their buildings to the local authorities. In Hermosillo the local jail from 1860 to the 1870s was leased from the Camous.

22. José Velasco, *Noticias estadísticas,* 19.

23. AHMRUS, Periódicos *El Voto de Sonora,* February 1, 1842. The local press reported on the arrival and departures of ships and their cargoes.

24. ABO, *La Estrella de Occidente,* various issues, 1860–1870; also,

AHGES, carpeton 293, December 16, 1856, report of the port captain of Guaymas, Tomas Spence; Stone, *Notes on Sonora,* 8. Also Browne, *Adventures in Apache Country,* 245. Also see Iberri, *El viejo Guaymas,* 11–14.

25. Warren, *Dust and Foam,* 171. Also Audubon, *Western Journal,* 121. While visiting the mining town of Jesús María in Chihuahua, Audubon observed that everything "used here is brought from . . . Sonora which is ten days travel."

26. See Warren, *Dust and Foam,* 176–77.

27. *Annual Report of Commercial Relations* (September 1870), 297. Consul Willard describes one incident in which a German ship, unable to strike a bargain at Guaymas, docked at Mazatlán and then reappeared at Guaymas with its goods already "naturalized."

28. See Warren, *Dust and Foam,* 177.

29. Combier, *Voyage,* 176.

30. Ibid., 179.

31. See Warren, *Dust and Foam,* 177.

32. Vicente Calvo, *Descripción política,* 41.

33. Iberri, *El viejo Guaymas,* 13–14.

34. Ibid., 15. It was never know what the last box contained; on occasion it was filled with luxury items, while at others, simply bricks or cement for ballast.

35. Combier, *Voyage,* 217.

36. Ibid., 218.

37. *Annual Report of Commerical Relations* (1871), 297.

38. Dispatches from United States Consuls in Mexico, Guaymas, record group 59, microcopy 284, September 30, 1872, report, consular office of Guaymas.

39. Ibid.

40. See Combier, *Voyage,* 261. Also see Scheina, "Unexplored Opportunities," 400.

41. Reid, *Reid's Tramp,* 245. Also see Browne, *Adventures in Apache Country,* 245.

42. Stone, *Notes on Sonora,* 8.

43. AHGES, carpeton 365, January 31, 1861, order prohibiting individual travel. Also carpeton 354, December 24, 1860, prefect of Guaymas to the governor. The prefect reports that he had dispatched a platoon of soldiers to patrol the road from Guaymas to La Cieneguita and that the prefect of Hermosillo would organize a platoon to patrol from La Cieneguita to Hermosillo.

44. AHGES, carpeton 365, April 5, 1861, list of merchants that had donated funds to keep the road open.

45. Stone, *Notes on Sonora,* 8.

46. Galaz, *Dejaron huella,* 325. *Annual Report of Commercial Relations* (1868), 646. The bulk of the mint's silver production was either coined or turned into paste.

47. *Annual Report of the Commercial Relations* (1868), 646.

48. Vicente Calvo, *Descripción politica,* 52.

49. AHGES, carpeton 433, 1870–1871, reports of district prefect of Her-

mosillo and Guaymas to the governor of the state. Also carpeton 448, April 30, 1873, prefect of Arizpe to the governor.

50. Warren, *Dust and Foam,* 172.

51. Ibid., 176.

52. See Mora, "Los comerciantes," 215.

53. AHGES, carpeton 865, January 4 and 24, 1888, governor to G. Möller, Guaymas.

54. AHGES, carpeton 466, March 8, 1875, Guaymas Ayuntamiento, Juan Robinson, president.

55. Combier, *Voyage,* 216

56. AHMRUS, Cartas Camou, May 6, 1891, Escobosa and Sons to Miguel Carreaga Bilbao, Spain.

57. AER, Copiadoras Mascareñas (April/July 1886), April 4, 1886, Manuel Mascareñas to Don Antonio Hoyas.

58. AER, Copiadoras Mascareñas (April/July 1886), December 26, 1886, Pascual Camou, Hermosillo, to Manuel Mascareñas. Unable to visit the area, Camou asked Mascareñas to inspect the ranches and determine the actual value of the land.

59. See J. M. Luttrell, "A Trip in Sonora," *Arizona Quarterly Illustrated* (January 1881) 3:23.

60. AHMRUS, Cartas Camou, April 2, 1897, Juan P. M. Camou, Hermosillo, to Juan P. Camou in Guaymas.

61. AHGES, carpeton 467, March 8, 1875, Juan Robinson, Jr., Guaymas Ayuntamiento to the governor.

62. AHGES, carpeton 647, September 5, 1892, Guaymas economic census.

63. Vicente Calvo, *Descripción política,* 64. Also see Pfefferkorn, *Description of Sonora,* 43–44. Pfefferkorn supports Calvo's contention, adding that it was necessary to "procure from Spain practically all necessities" in Sonora.

64. AHGES, carpeton 448, January 6, 1873, report of Guaymas prefect.

65. AHGES, carpeton 11, August 8, 1874, petition from merchants in Guaymas to Governor Pesqueira. Pesqueira denied the petition, arguing that Sonoran lumber products would cost three time more than foreign lumber.

66. AHGES, carpeton 448, January 6, 1873, report prefect of Guaymas. The tile used to decorate the central plaza of Guaymas, for example, had been imported from Italy.

67. Cummings, *Cincinnati & Sonora Mining Association,* 45. Also Hamilton, *Border States,* 24, 25. And Lange and Riley, *The Southwestern Journal* 2:229.

68. Alfonso Luis Velasco, *Geografía y estadística,* 166.

69. BCUSCN, Colección Pesqueira, tomo 2, *El Sonorense,* February 27, 1852, 1. Also see *El Sonorense,* December 7, 1855, 1.

70. See for example BCUSCN, Decreto del Gobernador Manuel María Gándara, *La Voz de de Sonora,* December 7, 1855.

71. See BCUSCN, *El Sonorense,* February 27, 1852, 1.

72. See Gracida Romo, *El Problema de la harina,* 6–10.

73. Pavía, *Los Estados,* 322.

74. See Tutino, *From Insurrection to Revolution*, 7.

75. Combier, *Voyage*, xv, 166.

76. Alfonso Luis Velasco, *Geografía y estadística*, 69.

77. John Hall, *Travel and Adventure in Sonora*, 51.

78. Alfonso Luis Velasco, *Geografía y estadística*, 91–199. And Pérez Hernández, *Geografía de Sonora*, 74–116.

79. John Hall, *Travel and Adventure in Sonora*, 62.

80. Ibid., 65.

81. See AHGES, carpeton 454, July 30, 1858, Charles Stones to the governor. Stone represented a commercial house in Mexico City which had contracted with the federal government to measure the terrenos baldios in the state.

82. Most opposition centered on the efforts of Captain Charles Stone. Regarding elsewhere in Latin America, see Fifer, *United States Perceptions*, 6. The United States was on an extensive mapping enterprise throughout Latin America.

83. John Hall, *Travel and Adventure in Sonora*, 61.

84. See AHGES, carpeton 422, August 3, 1870, prefect of Guaymas to the governor.

85. See Camou Healy, *Cocina Sonorense*, 59.

86. See Bassols Batalla, *El noroeste de Mexico*, 125.

87. González Navarro, "El trabajo forzoso en México," 588.

88. See Knight, "Mexican peonage," 45.

89. See John Hall, *Travel and Adventure in Sonora*, 269.

90. Combier, *Voyage*, 213. Also see John Hall, *Travel and Adventure in Sonora*, 52.

91. John Hall, *Travel and Adventure in Sonora*, 52.

92. Vicente Calvo, *Descripción política*, 69.

93. AER, Coleccción Manuel Mascareñas, no. 245, July 3, 1897, Mascareñas to Luis Torres.

94. González Navarro, "El trabajo forzoso en México," 590–91. As early as 1835, peons in Coahuila escaped to the north.

95. Ibid.

96. BCUSCN, Colección Pesqueira, tomo 4, 1830, "Ley de Sirvientes que establece relación entre amo y sirviente," 218–34.

97. John Hall, *Travel and Adventure in Sonora*, 270.

98. AHMRUS, Cartas Camou, no. 180, January 7, 1888, José Camou to Juan Ochoa.

99. Galaz, *Dejaron huella*, 289. According to notarial records, on February 13, 1849, amos Antonio Uruchurtu and Juan Camou entered into contracts with servants Pedro Silva, Rafael Villa, Luis Ramírez, and others to mine for gold in California. The servants were to be paid a salary of ten pesos for twenty-four days of work a month.

100. González Navarro, "El trabajo forzoso en México," 591. The following year the governor managed to overturn the legislatures decree.

101. AHGES, carpeton 448, July 10, 1873, Mineral de los Llanos, prefect, to secretario de estado.

102. AHMRUS, Cartas de la Familia Camou. The Camous utilized servant labor to maintain their ranches. See, for example, January 7, 1888, José Camou to Juan Ochoa (sirviente).

103. AHGES, carpeton 365, March 25, 1861, M. Escalante, prefect, to Governor Pesqueira.

104. Ibid.

105. See Manuel González Ramírez, "Fuentes para la historia de la Revolución mexicana, patronto de la historia de Sonora, 1900–1950," (Hermosillo, 1950, manuscript), 4:977. List of Yaqui women and children distributed among elites of Hermosillo in 1902.

106. AHGES, carpeton 355, 1860, Ures, Manuela Celedonia to Francisco Salcido.

107. AHGES, carpeton 365, March 25, 1861, M. Escalante, prefect, to Governor Pesqueira.

108. Ibid.

109. González Navarro, "El trabajo forzoso en México," 591–601.

110. See AER, Copiadora, February 1905, no. 162, records of Rancho Santa Barbara, "Noticia de Indios Yaquis que tengo en Buena Vista." Mascareñas, who produced cattle for export to the United States, kept precise records of each peon and what they owed.

CHAPTER 3. "THE REPOSE OF THE DEAD"

1. Lorenzo García, *Apuntes sobre la campaña contra los salvajes en el estado de Sonora,* (Hermosillo: Imprenta de Roberto Bernal, 1883), 6.

2. Hogan, "The Frontier as Social Control," 35–52.

3. González Ramírez, "Fuentes para la historia," 2: 400–409.

4. Warren, *Dust and Foam,* 202. Also William Perkin, *William Perkin's Journal of Life at Sonora, 1848–1852,* ed. James Scobie (Berkeley: University of California Press, 1964), 312.

5. M. Theirs, speech in the French Chamber, cited in John Hall, *Travel and Adventures in Sonora,* 145.

6. Silvio Zavala, "The Frontiers of Hispanic America," in *The Frontier in Perspective,* ed. Walker D. Wyman and Clifton B. Kroeber (Madison: University of Wisconsin Press, 1957), 48.

7. Ernesto de Vigneaux, *Viaje a México* (Guadalajara: Banco Industrial de Jalisco, 1950), 11.

8. León-Portilla, "The Norteño Variant," 103.

9. Aguilar Camín, "The Relevant Tradition," 107.

10. See AHGES, carpeton 293, January 19, 1856, governor of Sonora to president of the Junta de Fomento of Guaymas.

11. de Vigneaux, *Viaje a México,* 11.

12. García, *Apuntes sobre la campaña,* 6.

13. See Hu-DeHart, *Yaqui Resistance and Survival,* 94. The Yaquis were repeatedly accused of seeking to maintain "a nation within the state."

14. José Velasco, *Noticias estadsticas,* 96. Velasco feared that if ever the

Apaches in the north and the Yaqui in the south formed an alliance, Mexican Sonora would be lost.

15. Hu-Dehart, *Yaqui, Resistance and Survival,* xii. Hu-Dehart places the number of Yaquis at approximately 11,501. See also Stone, *Notes on Sonora,* 18. Stone places their numbers at between 10,000 and 12,000.

16. AHGES, carpeton 365, March 25, 1861, prefect of Hermosillo, M. Escalante, to Governor Ignacio Pesqueira.

17. AHGES, tomo 2193, exp. 4, 1907, list of persons in Guaymas who had taken captured Yaqui children as servants.

18. Sergio Ortega Noriega, "La Mision de la Pimeria Alta," in *Historia general de Sonora, de la conquista al estado libre y soberano de Sonora,* ed. Ignacio del Río y Sergio Ortega Noriega (Hermosillo: Gobierno del Estado, 1985), 124. Also Corral, *Obras históricas,* 257.

19. Spicer, *Cycles of Conquest,* 115–16.

20. Corral, *Obras históricas,* 259.

21. BCUSCN, tomo 3, 1850, May 18, 1852, Cayetano Navarro, prefect of Salvación, to acting governor, Fernando Cubillas.

22. Manuel González Ramírez, "Patronato de la historia de Sonora 1900–1950," vol. 2, Cayetano Navarro, April 25, 1850, 556–57.

23. BCUSCN, Colección Pesqueira, tomo 3, May 18, 1852, Cayetano Navarro to acting governor Fernando Cubillas.

24. BCUSCN, Colección Pesqueira, tomo 3, May 25, 1852, Fernando Cubillas to General Miguel Blanco.

25. González Ramírez, "Patronato de la historia de Sonora," 2: 559. Contract between José de Aguilar, acting governor, and Pablo Rubio and Jesús Moreno for Tiburón. The two speculators took possession of the island but eventually lost the contract.

26. Corral, *Obras históricas,* 212.

27. See Lejeune, *La guerra Apache,* 21. Also see AHGES, carpeton 449, June 23, 1873, prefect of Moctezuma, J. Aragón, to secretary of state.

28. BCUSCN, Colección Pesqueira, Serie 3, 1851–1856, *La Voz de Sonora,* tomo I, no. 10, November 30, 1855. The secretaría de gobierno reports the state's population at 124,979 inhabitants. Of that figure, only 33,118 resided in the four northern districts. Statistics by district were as follows: Altar, 5,311; San Ignacío (later known as Magdalena), 6,987 (this figure still included settlements such as Tucson which no longer belonged to México); Arizpe, 8,488; and Moctezuma, 12,332. Velasco argued that the state's population did not exceed 100,000 between 1845 and 1850 (José Velasco, *Noticias estadísticas*). Also see Forbes, *Apache, Navajo, and Spaniard,* 207–8.

29. Stone, *Notes on Sonora,* 21–23.

30. José Velasco, *Noticias estadísticas,* 96.

31. *Annual Report of the Commercial Relations* (1871), 904. Consul Alexander Willard, Guaymas, Sonora. Willard reported that the state's population had decreased from 150,000 during the 1830s to 108,211 in 1869.

32. Ibid. A large percentage of births, especially in rural areas, were never recorded. This may account for the large discrepancy between deaths and

births. Nonetheless the figure serves to underscore the calamitous situation confronted by the state as a result of the wars with Apaches and Yaquis.

33. AHGES, carpeton 344, February 16, 1859, residents of Altar to the governor. The letter argued that Apache raids made it impossible to engage in commercial relations with other parts of the state.

34. AHMRUS, Periódicos, *La Voz del* Pueblo (Ures), December 1, 1852, 2.

35. See Valencia Ortega, "La formación," 6–9.

36. Cummings, *Cincinnati and Sonora Mining Association,* 8.

37. Ibid., 4.

38. González Ramírez, "Patronato de la historia de Sonora," 2: 467; *El Sonorense* (Ures), February 7, 1850, tomo 3, no. 7, governor to inhabitants.

39. See Treutlein, *Missionary in Sonora.*

40. "Nacionales de Cumpas," *Estrella de Occidente,* March 19 1869. Payment for scalps. Also *Estrella de Occidente,* December 31, 1869. During 1869 the government earmarked 12,000 pesos for Apache scalps.

41. AHMRUS, Colección Periódicos, *El Sonorense* (Ures), June 14, 1850, 3.

42. AHGES, carpeton 422, September 28, 1870, prefect of Hermosillo to municipal authorities. Also see *Annual Report of the Commercial Relations* (1871), 299.

43. John Hall, *Sonora,* 148.

44. Lejeune, *La guerra Apache,* 21.

45. Corral, *Obras históricas,* 85. Corral described one battle in 1871 between Tohono O'odhams and Apaches which left over one hundred dead.

46. Zúñiga, *Rapida ojeada,* 113.

47. Corral, *Obras históricas,* 107. Also Wyllys, *The French in Sonora,* 50.

48. García, *Apuntes sobre la campaña,* 10.

49. Mowry, *Arizona and Sonora,* 35.

50. See *Reminiscences of John B. Frisbee, 1823–1909,* Bancroft Library, m-m 351, HG 79–80. Frisbee was a young army officer during the Mexican-American war.

51. Stone, *Notes on Sonora,* 23.

52. González Ramírez, "Patronato de la historia de Sonora," 2: 483.

53. AHGES, carpeton 422, January 26, 1870, report of Wenceslao Martínez to governor. Martínez informed the governor that Apaches had been seen in the vicinity of San José de Guaymas, 5 miles southeast of Guaymas.

54. See Zamora, *La Cohetera, mi barrio,* 47.

55. Warren, *Dust and Foam,* 170

56. AHGES, carpeton 433, March 14, 1871, prefect of Hermosillo to governor.

57. González Ramírez, "Patronato de la historia de Sonora," 3: 644.

58. Ibid., 2: 401, 649–50, December 20, 1842, testimony of Ignacio Peraza and Ignacio Gálvez before the prefect of Hermosillo.

59. See *El Sonorense* (Ures), October 13, 1848, Gándara to Ministro de Guerra y Marina.

60. Eduardo W. Villa, *Historia del Estado de Sonora* (Hermosillo: Gobierno del Estado, 1984), 242.

61. González Ramírez, "Patronato de la historia de Sonora," 2: 403–6.

62. Ibid., 2: 658. Also see Beene, "Sonora," 20.

63. González Ramírez, "Patronato de la historia de Sonora," 1: 38.

64. See, for example, AHGES, carpeton 424, September 6, 1845, ranch of José Terminel. Terminel cast forty-five votes, in the name of all Indian employees.

65. AHGES, carpeton 449, January 20, 1873. See "Petition of the Residents of Sahuaripa concerning Constitutional Reforms number 36, to Governor and State Assembly." (Reform no. 36 dealt with the Yaqui and Mayo right to vote.) Also see ABO, "Reformas Constitucionales," La Estrella de Occidente, November 29, 1872, 3.

66. ABO, "Reformas Constitucionales," La Estrella de Occidente, November 29, 1872, 3.

67. Manuel Corbala Acuña, Sonora y sus constituciónes (Hermosillo: Editorial libros de México, 1972), 114. Copy of the 1861 Constitución and the applicable reforms incorporated in 1872–1873.

68. Corral, Obras históricas, 81.

69. AHGES, carpeton 422, May 28 and May 30, 1870, prefect Guaymas to interim prefect, Francisco Serna. Attack on Guaymas by Fortino Vizcaíno.

70. See "Juan Sin Miedo," Mazatlán, June 20, 1870, in Dispatches from the United States Consuls, Guaymas, September 30, 1870, Alexander Willard.

71. See Hobsbawm, Bandits, 24.

72. Slatta, Bandidos, 3.

73. Corral, Obras históricas, "Biografía de José María Leyva Cajeme."

74. For a similar experience, see Paul Vanderwood, "Nineteenth-Century Mexico's Profiteering Bandits," in Slatta, Bandidos, 11.

75. Combier, Voyage, 219.

76. AHGES, carpeton 449, January 25, 1873, prefect of Hermosillo to governor.

77. AHGES, carpeton 458, June 1, 1874, pena de muerte segun ley de saltadores y plagarios de 1873, P. Ramírez and Santiago Campbell.

78. AHGES, carpeton, July 23, 1860, list of articles stolen from the Mina San Pedro.

79. AHGES, carpeton 433, May 13, 1871, Guaymas District, G. Corella.

80. AHGES, carpeton 433, August 18, 1871, captain of artillery to municipal president of San Marcial.

81. AHGES, carpeton 448, December 4, 1873, District of Altar prefect, F. Redondo, to governor.

82. AHGES, carpeton 433, August 14, 1871, Prefect G. Corella to governor.

83. AHGES, carpeton 324, December 19, 1858, prefect of Arizpe to commander of Fronteras.

84. APD, Sección Carbó, legajo 10, caja 27, no. 13050, May 21, 1885, report from the San Diego newspaper The Sun.

85. AHGES, carpeton 365, April 19, 1861, Ventura Angulo to prefect of Guaymas. Angulo demanded 250 pesos as compensation for his crops.

86. "Lamentable Escandalo," *La Constitución*, November 25, 1880, 3.

87. AHGES, carpeton 422, May 17, 1870, prefect of Hermosillo to governor.

88. AHGES, carpeton 433, March 6, 1871, petition from residents of Magdalena to governor concerning theft of cattle and horses in their border district. The petitioners claimed that the brands of their cattle were being changed and sold in Arizona.

89. AHGES, carpeton 471, July 1, 1879, prefect of district of Altar to governor. A special delegation was commissioned to find a solution to the problem.

90. AHGES, carpeton 596, Municipio de Arizpe to governor regarding the constant theft of cattle.

91. AHGES, tomo 2376, exp. 7, October 31, 1908, Manuel Mascareñas to Governor Luis Torres.

92. AHGES, carpeton 433, March 6, 1871, suplica de los ciudadanos de Magdalena.

93. AHGES, tomo 2376, exp. 7, October 23, 1908, Prefect M. Martínez to secretary of state.

94. AHGES, tomo 2376, exp. 8, May 29, 1908, Dionisio González to governor.

95. AHGES, carpeton 462, February 5, 1875, prefect of Alamos to citizens, regarding registration for the Guardia Nacional. For a view of the Guardia elsewhere in Mexico; see Thomson, "Bulwarks of Patriotic Liberalism," 22:1, 31–68.

96. González Ramírez, "Patronato de la historia de Sonora," 400–401, September 7, 1835, decree number 85, Manuel Escalante y Arvizu y Joaquin V. Elías.

97. AHCES, carpeton 25, exp. 760, Julian Escalante, January 21, 1861, instructions for inscription in Guardia.

98. *Annual Report of Commercial Relations* (1869), September 30 1868. Consul Alexander Willard reported the military change.

99. AHGES, carpeton 424, February 15, 1870, Rosario Campo, jefe of the Guardia Nacional, to conscripts. The draftees also complained about being trained by army officers who expected them to act as professional soldiers.

100. AHGES, carpeton 365, March 1, 1861, and carpeton 366, July 1, 1861, list of exonerated individuals.

101. AHGES, carpeton 457, September 26, 1877, prefect of Hermosillo to governor. Also see carpeton 990, July 11, 1885, report of municipal authorities of Los Bronces.

102. AHGES, carpeton 457, July 13, 1877, pres. municipal de San Marcial to prefect of Guaymas. Ayuntamiento de San Marcial needs arms to quell public disorder and drunks.

103. AHGES, carpeton 324, November 13, 1858, Santiago García, prefect of Arizpe, to military commander of Fronteras. And see AHGES, carpeton 433, January 15, 1871, statistical reports, Hermosillo.

104. AHGES, carpeton 397, January 21, 1867, report of prefect of Guaymas, Remigio Riviera, to governor. Weapons in the state were obtained from both private merchants and government sources. Private merchants imported arms to Sonora at first from Europe and later from the United States. For ex-

ample, the American ship *Continental* arrived at Guaymas January 21, 1867, with a cargo of 500 Enfield rifles, 500 Springfield rifles, 126 Mt. Storm carbines, 21 sables, 50 Colt revolvers, 25 Remington revolvers, and an assortment of munition belts, 60 barrels of powder, and 11,000 bullets for rifles and 7,500 for pistols.

105. BCUSCN, Colección Pesqueira, Segunda Serie, tomo 4, 1852–1892, Capitan Guillet, *Notas sobre Sonora, 1864–1866* (University of Sonora, 1866, manuscript), 15.

106. AHGES, carpeton 324, May 25, 1858, prefect of Arizpe, Santiago García, to governor.

107. AHGES, carpeton 433, August 14, 1871, report of Prefect Guaymas.

108. AHGES, carpeton 457, Hermosillo, January 8, 1877, Francisco Espino, Jefe militar, Proclamation to citizens.

109. AHGES, carpeton 448, December 31, 1872, district prefect of Arizpe to governor.

110. AHGES, carpeton 422, October 31, 1870, prefect of Magdalena to governor. Also see carpeton 433, June 30, 1871, prefect of Magdalena, quarterly report.

111. AHGES, carpeton 457, October 10, 1877, visit of prefect to Altar.

112. AHGES, carpeton 433, February 6, 1871, Prefect P. Ramírez to governor. The towns of San Ignacío, Imuris, and Magdalena requested exemption from the service.

113. AHGES, carpeton 449, November 11, 1873, rancher Jesús Provencio to the local district prefect of Moctezuma.

114. AHGES, carpeton 324, December 19, 1858, prefect of Arizpe to commander of military presidio at Fronteras. The prefect lectured the commander about the problems that the draft and his actions caused to local farmers.

115. AHGES, carpeton 354, October 22, 1860, petition from the town of Baviacora, Arizpe, to Governor Pesqueira. The residents insisted that they were unable to pay the sum the governor had imposed on the town. The petition was signed by over fifty residents.

116. AHGES, carpeton 354, October 14, 1860, petition of the towns people of Baviacora to governor of Sonora.

117. Ibid.

118. See for example AHGES, carpeton 467, February 6, 1875, commercial census of Arizpe. Also carpeton 354, July 1, 1860, "loan" requested of Guaymas merchants by government to fight the Yaqui. Also carpeton 365, February 24, 1861, residents of Guaymas to governor. The Guaymenses opposed the imposition of any new taxes.

119. AHGES, carpeton 324, December 16, 1858, and January 8, 1859, prefect of Arizpe to commander of presidio at Fronteras.

120. AHGES, carpeton 458, March 9, 1874, municipal president of Santa Cruz to prefect of district of Magdalena.

121. Ibid.

122. AHGES, carpeton 324, January 8, 1859, prefect of Arizpe to commander of Fronteras, reported noticing increases in deserters over previous years. Also carpeton 448, April 30, 1873, quarterly report of prefect of Arizpe

to governor. The situation of Arizpe mirrors that occurring in other northern districts.

123. ABO, *La Estrella de Occidente*, December 24, 1869, 3.

124. AHGES, carpeton 398, December 30, 1869, prefect of Magdalena to municipal presidents of the district.

125. AHGES, carpeton 448, July 2, 1873, correspondence received by governor from American consul in Guaymas, Alexander Willard, regarding case of Frank J. Boisville.

126. APD, Sección Carbó, legajo 10, caja 27, no. 12127, June 24, 1885, Pedro Hinojosa to Carbó.

127. AHGES, carpeton 448, July 22, 1873, Prefect Lucas Llain to secretary of state. After the rape, the men brutally beat the woman.

128. AHGES, carpeton 448, July 17, 1873, Lucas Llain to secretary of state.

129. AHGES, carpeton 422, April 30, 1870, prefect of Hermosillo to governor. Francisco Gutiérrez murdered Anastasio Vega after the race. None of the participants attempted to apprehend Gutiérrez because they were disarmed.

130. AHGES, "Problemas con armas," *La Gaceta de Cananea*, August 7, 1910.

131. AHGES, carpeton 471, decree to citizens, law passed March 23, 1872, prohibiting weapons in town. Also AHGES, carpeton 468, July 17, 1875, laws governing the use of arms.

132. AHGES, carpeton 471, May 15, 1876, José María Rangel, Colonel 15 Batallon de Linea y Comandante Militar del Distrito, Guaymas.

133. AHGES, carpeton 812, 813, and 814, Ramo Justicia, 1892–1893– 1894. Contains several cases of "attempted escapes." Also AHGES, carpeton 831, January 23, 1893, January 26, 1893, Ramo Justicia, municipal president of Arizpe, to prefect.

134. León-Portilla, "The Norteño Variant," 105.

135. See, for example, Rafael Izábal staged invasion of Tiburon, "En la isla de Tiburon," *Mundo Ilustrado*, México, February 19, 1905, 21:8.

CHAPTER 4. A LEGACY OF DISTRUST

1. Mañach, *Frontier in the Americas*, 4–8.

2. Navarro García, *Sonora y Sinaloa*, 67.

3. Hugh Murray, "Mexico" in *The Encyclopedia of Geography* (Philadelphia: George W. Gorton, 1841) 5:331. Also see Pattie, *Personal Narrative*, 249. And Hardy, *Travels*, 96.

4. Combier, *Voyage*, 225.

5. McWilliams, *North from Mexico*, 53.

6. Dunbier, *The Sonoran Desert*, 105.

7. See Dakin, *A Scotch Paisano*, 36–37.

8. John Hall, *Travels and Adventures in Sonora*, 50.

9. See Southworth, *El Estado de Sonora*, 19. See also McWilliams, *North from Mexico*, 137–38.

10. See Officer, *Hispanic Arizona,* 270.

11. See Camarillo, *Chicanos in a Changing Society,* 60.

12. Bartlett, *Personal Narrative,* 290.

13. See José Velasco, *Noticias estadísticas,* 243.

14. Also see Beene, "Sonora," 71.

15. AHGES, Exp. 110.1/879, Memoria de Ignacio Pesqueira al Congreso del Estado, 1870, 2–3.

16. José Velasco, *Noticias estadísticas,* 97–108.

17. Two other routes originated at Magdalena. The first turned east toward Cocospera and the old presidio at Santa Cruz. The other proceeded north towards Imuriz and San Ignacio across Los Nogales in the direction of the presidios at Tubac and Tucson.

18. See Brunckow, *Report to Stockholders,* 5.

19. Walker, "Freighting from Guaymas," 293.

20. Poston, *Building a State,* 73. Poston's publication originally appeared in the *Overland Monthly* in 1894.

21. See ibid. Also see Pumpelly, *Across America and Asia,* 7.

22. See Jay J. Wagoneer, *Early Arizona,* 389.

23. Poston, *Building a State,* 71.

24. John Hall, *Travel and Adventure in Sonora,* 133, 150.

25. Poston, *Building a State,* 72–74.

26. Alphonse Pinart Collection, Bancroft Library, Univ. of California, Berkeley, HG 175–77, mm-381, documents relating to Northern Mexico, Series 3, 1842–1861 (hereafter Pinart Collection, BL), June 20, 1857, prefect and military commissioner of the district of Santa Cruz, (later Magdalena) to governor.

27. John Hall, *Travel and Adventure in Sonora,* 38.

28. AHGES, carpeton 347, May 17, 1859, Alphonse Coindreau to governor.

29. AHGES, carpeton 354, June 1, 1860. Governor Pesqueira named Captain Antonio Aguilar to inspect the newly established port of La Libertad. Also see Uribe García, "El desarrollo de las comunicaciones," 156.

30. BCUSCN, Colección Pesqueira, Segunda Serie, tomo 4, 1857–1892, Capitan Guillet, "Notas sobre Sonora," 21.

31. Wagoneer, *Early Arizona,* 409.

32. PAHS, Customs Records, National Archives, record group 56, January 1859, Calabazas inspector, Jack Donalson, to Sam Jones, collector of customs, Las Cruces, New Mexico.

33. North, *Samuel Peter Heintzelman,* 145. Cerro Colorado, December 13, 1858.

34. August 15, 1857, Charles Poston to Mowry, in Mowry, *Memoir of the Proposed Territory,* 22.

35. John Hall, *Travel and Adventure in Sonora,* 140.

36. See *Annual Report of the Commercial Relations* (1870), Mexico, Guaymas, 296, October 1, 1870, Consul Alexander Willard. The consul estimated that less than one-third of the exported silver ever passed through customs. The regular duty on exports was 8 percent.

37. PAHS, Customs Records, National Archives, record group 56, no. 231, July 25, 1859, Calabazas inspector, Jack Donalson, to Sam Jones, collector of customs, Las Cruces, New Mexico.

38. AHGES, carpeton 291, November 10, 1856, report from the district prefect of San Ignacio to the governor of the state.

39. See North, *Samuel Peter Heintzelman*, 145.

40. AHGES, carpeton 291, November 10, 1856, prefect of San Ignacio to governor.

41. See North, *Samuel Peter Hientzelman*, 25.

42. "Carpenter wanted," "Laborers wanted," The *Weekly Arizonian* (Tucson), August 11, 1859, 4.

43. See North, *Samuel Peter Heintzelman*, 112. Cerro Colorado, October 28, 1858.

44. Ibid., 101. Cerro Colorado, October 10, 1858.

45. See John Hall, *Travel and Adventure in Sonora*, 270.

46. Poston, *Building a State*, 73.

47. Parks, "The History of Mexican Labor," vi. See Pumpelly, *Across America and Asia*, 26.

48. John Hall, *Travel and Adventure in Sonora*, 151, 186.

49. "Ran Away," *Weekly Arizonian*, June 16, 1859, 3.

50. John Hall, *Travel and Adventure in Sonora*, 186.

51. "A Great Outrage," *The Arizonian*, May 19, 1859, 2.

52. Ibid.

53. John Hall, *Travel and Adventure in Sonora*, 191.

54. "The Sonoita Valley Massacre," *The Arizonian*, May 19, 1859, 2. Also see Sheridan, *Los Tucsonenses*, 36.

55. "A Great Outrage," *The Arizonian*, May 19, 1859, 2.

56. Ibid.

57. See North, *Samuel Peter Heintzelman*, 110. Cerro Colorada, October 25, 1858.

58. August 15, 1857, Charles D. Poston to Mowry, in Mowry, *Memoir of the Proposed Territory*, 21.

59. Browne, *Adventures in Apache Country*, (New York: Arno Press, 1971), 133–34.

60. See Sonnichsen, *Tucson*, 45.

61. See North, *Samuel Peter Heintzelman*, 66. Tucson, August 28, 1858.

62. For Texas, see De León, *They Called Them Greasers*, 9.

63. Wagoneer, *Early Arizona*, 388.

64. John Hall, *Travel and Adventure in Sonora*, 150–51.

65. See Mowry, *Memoir of the Proposed Territory*, 26.

66. Sheridan, *Los Tucsonenses*, 36.

67. Raphael Pumpelly cited in Parks, "The History of Mexican Labor," 39.

68. Ibid., 95.

69. October 1, 1857, J. A. Douglas to Mowry, in Mowry, *Memoir of the Proposed*, 21.

70. Ibid., 20.

71. See "Territorial Prison in Yuma," *New York Times*, March 1, 1896, 5.

72. See *Exposición de la Hacienda*, 282. The Mexican foreign affairs office compiled a partial list of Mexicans who had been lynched or killed by Americans. Also see John G. Bourke, "A Lynching in Tucson," *New Mexico Historical Review* 19 (4) (July 1944): 233–42.

73. Wagoneer, *Early Arizona*, 394.

74. "Mexican Horse Thief Killed," *Weekly Arizona*, March 3, 1859.

75. John Hall, *Travel and Adventure in Sonora*, 150–51.

76. Mowry, *Memoir of the Proposed Territory*, 19.

77. "Sopori Ranch," *Weekly Arizonan*, March 3, 1859, 2.

78. ABO, *La Estrella de Occidente*, April 19, 1872, 4.

79. ABO, *La Estrella de Occidente*, January 26, 1872, 4.

80. Charles Poston to Sylvester Mowry in Mowry, *Memoir of the Proposed Territory*, 22.

81. Pumpelly, *Across America and Asia*, 6.

82. John Hall, *Travel and Adventure in Sonora*, 198.

83. Thompson, "Time," 91–92.

84. See North, *Samuel Peter Heintzelman*, 92. Tubac, September 28, 1858.

85. BCUSCN, Colección Pesqueira, *La Voz de Sonora*, December 14, 1855. Over one hundred residents of Guaymas signed a petition swearing that never again would they allow Sonora to lose territory (Browne, *Adventures in Apache Country*, 164). Browne visited Sonora on the eve of the French intervention, and reported that Sonorans still looked at Americans with "a lurking suspicion . . . notwithstanding our peaceful profession."

86. Wagoneer, *Early Arizona*, 390.

87. John Hall, *Travel and Adventure in Sonora*, 181.

88. Browne, *Adventures in Apache Country*, 134.

89. AHGES, carpeton 384, gaveta 16-1, May 2, 1862, United States Colonel James Carleton, California Volunteers, to governor of Sonora.

90. ABO. See "Asesinatos y desordenes en Arizona," *La Estrella de Occidente*, March 15, 1872, 1–2.

91. See Roberts, "Francisco Gándara," 227.

92. See Uribe García, "El desarrollo de las comunicaciones," 157–58. Also see BCUSCN, tomo 3, Colección Pesqueira, *La Voz de Sonora*, December 7, 1855, advertisement for stagecoach service between Hermosillo and Guaymas; and ABO, *La Estrella de Occidente*, February 5, 1869, advertisement for service between Hermosillo and Tucson.

93. AHGES, carpeton 365, April 15, 1861, Alfonso Coindreau to Governor.

94. Hamilton, *Border States*, 35.

95. See Browne, *Adventures in Apache Country*, 173.

96. "Letter from United States Consul Farrelly Alden and W. G. Moody," *San Francisco Chronicle*, December 4, 1861.

97. Dispatches of United States Consuls in Mexico, Guaymas, Mexico, record group 59, microcopy 284, reel 1, December 4, 1861, Farrelly Alden to Department of State. Also see *Annual Report of Commercial Relations* (1864), 719, Consul Farrelly Alden Guaymas. Americans miners by 1863 had invested

more than one million dollars in over eighteen mining projects throughout the state.

98. AHGES, carpeton "País de México," *Representación que el vecindario de la capital del Estado de Sonora dirige al supremo gobierno de la nación por conducto del gobierno del estado* (Ures: Imprenta del Gobierno del Estado, 1856), 13.

99. BCUSCN, Colección Pesqueira, tomo 3, 1851–1856, *La Voz de Sonora*, tomo 1, no. 13, December 21, 1855, "Excepción de Sonora y demas estados fronterizos," 2.

100. Mañach, *Frontier in the Americas*, 4–8.

101. John Hall, *Travel and Adventure in Sonora*, 133.

CHAPTER 5. "A NEW BORDER EMPIRE"

1. "Yuma Territorial Prison," *New York Times*, March 1, 1896, 5.

2. As examples, see V. A. Malte-Brun, *La Sonora et ses Mines*. Also Cummings, *Cincinnati and Sonora Mining Association*; Moody, *Mines in Mexico*; Stone, *Notes on Sonora*; Mowry, *Arizona and Sonora*. Also "Letter from Consul Farrelly Alden," *San Francisco Chronicle*, December 4, 1861. Similar articles appeared in the *New York Times*—see "Description of Sonora," January 1, 1865.

3. AHS, Biographical file: Ada E. Jones, ms. 389, 2, folder 9. Jones's father was Robert Ekey. Also see ms. 652. Arthur Peck arrived in southern Arizona in 1872 from Nevada, where he worked as a miner.

4. AHS, Tucson, Biographical file: Rena Matthews, ms. 125, January 21, 1903.

5. See Hamilton, *Border States of Mexico*, 193.

6. ABO, "Necesidad de un Cónsul Mexicano en Tucson," *La Estrella de Occidente*, July 23, 1873, 3.

7. "Unworked Mining Lands," *New York Times*, December 12, 1878. Also "Farms in the Great West," *New York Times*, June 4, 1880.

8. "Mexican consul in Tucson," *Arizona Citizen*, December 18, 1875, 2.

9. See "Inmigración," *El Fronterizo*, Tucson, October 13, 1878, 2.

10. See *Exposición de la Secretaría de Hacienda*, 282. What the Mexican publication did not say was that Mexican elites in Tucson supported the action.

11. AGN, Gobernación, 881(11)7, July 14, 1881, Mexican consul at Tucson to Luis Torres.

12. AGN, Gobernación, 881(11)7, August 4, 1881, report of District of Altar, Luis Torres to Gobernación.

13. AHGES, carpeton 531, July 11, 1884, prefect of Magdalena.

14. AHGES, carpeton 823, September 7, 1878, Manuel Escalante, Tucson, Mexican consul, to Secretaría de Relaciones Exteriores.

15. "De la discusión nace la luz," *Las Dos Republicas*, July 22, 1877, 4. The term *Latino* appeared in the original Spanish.

16. "Citizenship and the Ballot," *Arizona Daily Star*, January 29, 1879, 2.

17. ABO, *La Estrella de Occidente*, November 20, 1874, 4.

18. See *Arizona Daily Star,* February 17, 1879, 1.

19. "Tucson," *San Francisco Chronicle,* July 19, 1891, 4:2.

20. ABO, "Sonora y los americanos," *La Constitución,* March 24, 1881, 2–3.

21. See *El Fronterizo,* Tucson, October 24, 1880, 2.

22. Ibid.

23. *Archivo del General Porfirio Díaz,* , tomo 30 (1961): 140–41, December 18, 1879, Francisco Prieto to Porfirio Díaz.

24. AGN, Gobernación, 881(10)5, June 1, 1881, Luis E. Torres to Gobernación.

25. AGN, Gobernación, 881(10)5, June 1, 1881, Luis E. Torres to Gobernación.

26. The term *Sonorenses americanizados* was coined by *La Estrella de Occidente,* November 20, 1874, 4.

27. AHS, Newspapers, *El Fronterizo* (Tucson), December 28, 1879, 2, prefect of Altar L. M. Redondo to Carlos I. Velasco.

28. "General Serna," *Arizona Daily Citizen,* October 30, 1875, 2.

29. AGN, Gobernación, 2a-879-(5)-(2)-(51), June 4, 1879, acting governor, Francisco Serna, to Secretaría de Estado, despacho de Gobernación.

30. *El Fronterizo,* October 13, 1878, 2.

31. See *Arizona Daily Citizen,* March 18, 1876, 3. Visit to Mariscal by Carrillo. Also *Arizona Daily Citizen,* June 10, 1876, 3. Tucson city council discussed upcoming visit to town by General Mariscal.

32. The founding of the Alianza Hispano-Americana on January 14, 1894, was proudly reported in the Sonoran press. Ads appeared regularly in the local press encouraging Sonorans headed north to join. See, for example, *El Estado de Sonora,* April 13, 1897, 3. For a study of the Mexican community in Tucson, see Sheridan, *Los Tucsonenses.*

33. Combier, *Voyage,* 210.

34. AHGES, carpeton 365, May 29, 1861, prefect of Guaymas, to governor.

35. AHGES, carpeton 354, June 21, 1860, prefect of Guaymas to governor; AHGES, carpeton 397, March 6, 1867, prefect of Guaymas to governor. In 1867 Federico Fiedemann, a merchant, disavowed his German past and requested Mexican citizenship.

36. AHGES, carpeton 422, June 10, 1870, Wenceslao Martínez to governor.

37. *Archivo del General Porfirio Díaz,* tomo 26 (1958): 39, July 29, 1877, C. E. Treviño to Díaz.

38. AHGES, carpeton 605, several requests, April 15 to December 14, 1889, Díaz to governor of Sonora.

39. AHGES, carpeton 12, September 10, 1877, governor of Sonora.

40. See Gibson, *The Kickapoos.*

41. AHGES, carpeton 11, February 10, 1873, report of district prefect of Ures.

42. See Spicer, *Cycles of Conquest,* 138–39.

43. AHGES, carpeton 1047, January 31, 1889, William Struges to Ramón Corral.

44. AHGES, carpeton 1047, April 8, 1887, Ortiz to administrator of Aduana Sasabe. Ortiz had to pay one thousand pesos as bond until the matter was resolved.

45. AHGES, carpeton 344, February 16, 1859, petition of residents of Altar to governor.

46. Ibid.

47. ABO, "Report of the district prefect of Altar," *La Estrella de Occidente,* November 19, 1869, 3.

48. Ibid. Also see AHGES, carpeton 449, June 9, 1873, report of prefect of Magdalena.

49. See *Arizona Daily Citizen,* March 18, 1876, 3. L. M. Jacobs and Company Agents for the Celebrated Terrenate Flour Mills of Joseph Pierson, Manufacturers of flour Imuris, Sonora, Mexico.

50. AHMRUS, Periódicos, "Una ojeada a nuestra Frontera del Norte," *La Reconstrucción* (Hermosillo), June 5, 1877Also see Lange and Riley, *The Southwestern Journal,* 2: 283.

51. Dispatches of United States Consuls in Mexico, Guaymas, record group 59, microcopy 284, roll 2, September 30, 1875, Alexander Willard, annual report.

52. AHGES, carpeton 422, October 31, 1870, quarterly report of the prefect of Magdalena.

53. ABO, *La Estrella de Occidente,* November 19, 1869, 3, prefect of Altar to governor.

54. ABO, *La Estrella de Occidente,* May 21, 1869, 2, prefect of Magdalena, quarterly reports. See AHGES, carpeton 365, March 11, 1861, prefect of Guaymas quarterly report to governor.

55. SCUA, Manuel Mascareñas Papers, ms. 14, *El Municipio, órgano del ayuntamiento de Guaymas,* April 20, 1878, 1–3.

56. Ibid.

57. Ibid.

58. See *Archivo del General Porfirio Díaz,* tomo 30 (1961): 168.

59. See *Archivo del General Porfirio Díaz,* tomo 29 (1960): 118. June 10, 1878, Ignacio M. Escudero, in charge of hacienda, to Porfirio Díaz.

60. AER, Colección Camou, November 22, 1891, Juan P. Camou, Hermosillo, to J. P. M. Camou, Guaymas.

61. AER, Colección Camou, March 31, 1892, Juan P. M. Camou, Hermosillo, to Juan P. Camou, Guaymas.

62. AER, Colección Camou, September 20, 1895, Stockton Milling Company, San Francisco to P. Camou, Guaymas.

63. Dispatches of the United States Consul in Mexico, Guaymas, record group 59, microcopy 284, roll 2, September 30, 1877, Alexander Willard. Willard reports that the voyage up the Colorado took approximately twenty days.

64. AHGES, carpeton 464, August 5, 1875, list of passengers on board the Montana. The Montana returned on September 29, 1875, with twelve more American soldiers.

65. Walker, "Freighting from Guaymas to Tucson," 293.

66. Dispatches of the United States Consul in Mexico, Guaymas, record group 59, microcopy 284, roll 2, September 30, 1877, Alexander Willard.

67. Walker, "Freighting from Guaymas," 294.

68. Ibid., 300.

69. See *Annual Report of the Commercial Relations* (1872), Mexico, Guaymas, 687. September 30, 1872, Consul A. F. Garrison, report. American interests had repeatedly lobbied for this privilege.

70. AHGES, carpeton 422, June 29, 1870, prefect of Guaymas to governor.

71. AHGES, carpeton 448, February 21, 1873, prefect of Guaymas to governor.

72. *Annual Report of Commercial Relations*, Mexico, Guaymas (1879), 1:432, Consul A. Willard.

73. See *Exposición de la Secretaría de Hacienda*, 35.

74. Archivo del General Profirio Díaz, tomo 20 (1955): 222. Guaymas, March 31, 1877, Quirino García to Porfirio Díaz.

75. AGN, Gobernación, 2a-871-(2)4, "Apuntes sobre un viaje al Colorado," December 21, 1870, Alfredo V. Sandoval.

76. Ibid.

77. AGN, Gobernación, 2a-871(2)-(4)-[51], April 15, 1871.

78. Myrick *Railroads of Arizona*, ,1:20.

79. AGN, Gobernación, 880(10)6, April 26, 1877, B. Zelma to Secretaría de Hacienda.

80. AHGES, carpeton 11, August 14, 1874, W. Iberri to Secretaría de Fomento. Iberri complained that despite many promises federal agents had yet to arrive.

81. See *Exposición de la Secretaría de Hacienda*, 34–35.

82. Ibid., 296. In Mazatlán, local officials detained the U.S. ship *Montana* for transporting 349 bundles not listed on its manifest.

83. AGN, Gobernación, 880(10)6, August 6, 1880, Luis Torres to Secretario de Gobernación.

84. See *Exposición de la Secretaría de Hacienda*, 35.

85. Dispatches of United States Consuls in Mexico, Guaymas, record group 59, microcopy 284, roll 2, September 30, 1877. Also see APD, legajo 5, caja 3, no. 1191, July 27, 1880, General Manuel González to Díaz. González reported that contraband in Sonora had become scandalous.

86. *Annual Report of Commercial Relations*, 430. Report year 1879.

87. See, *El Torito* (Guaymas), July 26, 1878, 2.

88. *Archivo del General Porfirio Díaz*, tomo 27 (1958): 207. August 7, 1877, Eugenio Duran to Díaz.

89. Dispatches of United States Consuls in Mexico, Guaymas, record group 59, microcopy 284, roll 2, September 30, 1875 and September 30, 1877, A. Willard.

90. See J. M. Luttrell, "A trip in Sonora," *Arizona Quarterly Illustrated*, January 1881, 24.

91. *Archivo del General Porfirio Díaz*, tomo 26 (1957): 10. May 15, 1877, Patricio Avalos to Díaz.

92. Ibid., 10.

93. *Archivo del General Porfirio Díaz,* tomo 29 (1960): 118–19. June 10, 1878, Ignacio Escudero, customshouse director, Tepic, to Porfirio Díaz.

94. Ibid., 10.

95. *Annual Report of Commercial Relations,* 430. Report year 1879.

96. See *El Torito,* Guaymas, July 26, 1878. The newspaper represented Guaymas interests and attacked Serna, who they claimed engaged in contraband.

97. AHGES, Justicia, carpeton 823, April 15, 1879, Martin Palacios, customs agent, Guaymas, to governor. Also see *La Constitución,* July 17, 1879.

98. Pinart, "Voyage en Sonora," October 26, 1878, *Bulletin de la Société de Géographie,* (September 1880), serie 6, no. 20 July—Dec. 1880, (Paris: Librairie Ch. Delagrave, 1880), 219.

99. "Decreto que establece pena de prision," *La Constitución,* July 17, 1879, 1. Repeat offenders had jail terms doubled and tripled.

100. ABO, *La Constitución,* September 23, 1880, 3–4.

101. *Archivo del General Porfirio Díaz,* tomo 23 (1957): 12. May 15, 1879, Patricio Avalos to Porfirio Díaz.

102. ABO, "Contrabando," *La Constitución,* December 23, 1880, 4.

103. ABO, *La Constitución,* several issues: January 27, 1881; March 24, 1881; March 31, 1881, August 1, 1881.

104. *Annual Report of Commercial Relations Nations* (1879), Mexico, Guaymas, 1: 430.

105. Ibid., 431.

106. ABO, "Contrabando," *La Constitución,* March 13, 1880, 4.

107. ABO, *La Constitución,* August 8, 1881, 4.

108. See *Annual Report of Commercial Relations* (1876), Mexico, Guaymas, 756. October 1, 1876, Consul A. F. Garrison, report.

109. See "Smuggling into Sonora," *Arizona Quarterly Illustrated,* October 1880, 7.

110. See *Annual Report of Commercial Relations* (1885), North America, 664.

111. Dispatches of United States Consuls, Mexico, Guaymas, record group 59, microcopy 284, roll 2, September 30, 1875, Alexander Willard to state department, annual report.

112. Ibid.

113. AHMRUS, *La Reconstrucción* (Hermosillo), June 5, 1877. Also ABO, "El Contrabando," *Boletín Oficial,* May 17, 1878.

114. AHMRUS, Periódicos, *La Era Nueva,* January 13, 1878, and July 23, 1878.

115. Ibid., *La Era Nueva* (Hermosillo), July 23, 1878.

116. Dispatches of United States Consuls in Mexico, Guaymas, record group 59, microcopy 284, roll 2, September 30, 1878, A. Willard.

117. Schwatka, *Cave and Cliff Dwellers,* 92.

118. *Annual Report of Commercial Relations* (1871), 297. Report year 1870.

119. See *Exposición de la Secretaría de Hacienda,* 13.

120. AHGES, carpeton 433, January 21, 1869, report Junta Revisora de Guaymas.

121. AHGES, carpeton 467, December 14, 1874, Censo Económico de Guaymas.

122. AHGES, carpeton 464, August 5, 1875, list of passengers on board the *Montana.* List included Fermin Camou and several other Guaymas merchants.

123. See AER, business records of Rafael Escobosa and Juan P. Camou. 1880 through 1900.

124. AER, Colección Camou, folio 216, December 31, 1898, invoice from Wenceslao Loaiza and Company, San Francisco California to J. P. Camou.

125. W. Iberri, G. A. Iberri, G. A. Iberri, Agentes Comerciales, and Miguel Latz agentes, *El Comercio,* June 18, 1897, 2. Also see AER, Colección Camou, April 6, 1894, Miguel Latz to J. P. Camou. Also *El Imparcial,* October 27, 1906, Antonio F. González, representative of Armour Packing Company, Kansas City, Mo.; and *El Imparcial,* February 19, 1908. Antonio González and A. Albeldi represented the Armour Packing Company and the Swift Meat Company.

126. AHGES, carpeton 422, March 18, 1870, Wenceslao Martínez, Guaymas prefect, to governor.

127. AHGES, carpeton 424, July 11, 1870, petition of Guillermo Andrade and Nicolas Gaxiola submitted to governor by prefect of Guaymas, W. Loaiza.

128. See Caballero, *Almanaque Histórico,* 189–90. Also see *Artes y Letras,* Mexico, October 11, 1908.

129. AER, Colección Camou, several, April 11 and 16, 1891, Puerto de Santa Rosalia, Le Directur General Boleo to J. P. Camou.

130. See AER, Colección Camou, August 25, 1891, M. Borquez, Globe, Arizona, to J. P. Camou, Guaymas. Also November 10, 1891, C. A. Wilson, Wilcox, Arizona, to J. P. Camou. In most cases a younger Camou, usually the son, serviced the American clients.

CHAPTER 6. "TO BE OR NOT TO BE"

1. ABO, "Quien vencera siempre es el progreso," *La Constitución,* June 4, 1881, 4. "To be or no to be" appeared in English.

2. See "México, España y Estados Unidos," *La Reserva* (Hermosillo), February 3, 1892, 1.

3. ABO, "La prensa en Sonora," *La Constitución,* August 15, 1881, 3.

4. See *La Estrella del Occidente,* March 29, 1872, 1.

5. *Exposición de la Secretaría de Hacienda,* 117.

6. AGN, SCOP, Ferrocarril, no. 6/771, 1865. Also AHCES, tomo 25, exp. 760, March 4, 1861, contract between Angel Trías and state government.

7. Pletcher, "American Capital," 59–69.

8. AGN, SCOP, Ferrocarril, no. 6/771 1865, contract for rail line by General Angel Trías. Also see Almada, *Diccionario de historia,* 240.

9. See Suplemento to *Estrella de Occidente,* December 13, 1872, 5.

10. Ibid. Willard continued lobbying on behalf of the Sonoran state government. In 1876 Willard was once again promoting a railroad in California and

on the U.S. East Coast. See *Estrella de Occidente,* August 1, 1876, 3. The publication described Willard as Sonora's most active promoter in the United States.

11. AHGES, Carpeton 10, June 1, 1872, contract for railroad between Guaymas and Arizona, James Eldredge to governor.

12. ABO, Editorial "Sonora demanda el derecho," *La Estrella de Occidente,* May 31, 1872, 3.

13. AGN, SCOP, no. 6/97-1, June 1875, contract with David Boyle Blair.

14. AGN, SCOP, no. 6/99-1, 1876, Guillermo Andrade y Compañía, México, project to build railroad between Guaymas and San Francisco, passing through Yuma, Arizona. Andrade had ties to Wells Fargo.

15. Sebastián Lerdo de Tejada, cited in Pletcher, "Railroads in Sonora," 15.

16. See Alexander Willard, Consul of the United States, in *Annual Report of Commercial Relations* (1880), 434. Report year 1879.

17. See reprint of speech by Blas Balcarcel, *Estrella de Occidente,* February 27, 1875.

18. ABO, *La Estrella de Occidente,* April 12, 1872, 3–4.

19. ABO, "Profecía del diputado Lemus," *La Estrella de Occidente,* December 10, 1869, 4.

20. ABO, *La Estrella de Occidente,* March 29, 1872.

21. ABO, *La Estrella de Occidente,* May 31, 1872, 3; and April 12, 1872, 3–4.

22. AHS, Newspaper collection, "Suplemento," *El Fronterizo,* February 29, 1880.

23. See the *Arizona Daily Citizen,* June 6, 1877, 3. Report on trip by Quiroga and A. Almada.

24. AHS, "La Sonora," *El Fronterizo,* February 8, 1880. The rebuttal was written by F. T. Davila, who later authored *Sonora histórico y descriptivo.*

25. AHS, *El Fronterizo,* February 15, 1880, 1.

26. AHS, *El Fronterizo,* March 14, 1880, 1.

27. Pletcher, "American Capital," 66.

28. Ibid., 64.

29. Pradeau Collection, Arizona State University, series 4, box 3, folder 4.

30. *Exposición de la Secretaría de Hacienda,* 57. Also, AGN, SCOP, no. 6/82-1 [October 12, 1877] and 6/90-1, revised October 21, 1881, contract between Mexican government and David Ferguson, Sebastian Camacho, and Robert R. Symons. These men were principals in the actual construction of the Sonoran railroad, which was completed October 25, 1882, at a cost of $5,032,128 and extended 422 kilometers from Guaymas to Nogales, Arizona.

31. ABO, "Quien vencera siempre es el progreso," *La Constitución,* June 4, 1881, 4.

32. ABO, "El ferrocarril de Sonora y el peligro de anexión," *La Estrella de Occidente,* December 13, 1872, special issue, 5.

33. *Annual Report of Commercial Relations* (1877), 757. Report Year 1876. The consul noted a general decline of population both foreign and native.

34. ABO, "Gacetilla, El Ferrocarril," *La Constitución,* April 29, 1880, 3–4.

35. AGN, SCOP, 6/41-1 March 10, 1882, Sebastian Camacho to SCOP. First annual report of Sonoran Railroad.

36. SAMC, reel 44, "Exitación en Guaymas," October 27 1880, José M. Fernández.

37. Pletcher, "American Capital," 68. Also see, Iberri, *El viejo Guaymas*, 8. One such person, named Chale, worked as guard for the railroad. He eventually married a local Mexican woman. On Sunday he would dress as a charro and parade on horseback down the streets of Guaymas.

38. *Annual Report of Commercial Relations* (1881), 59, A. Willard. Report year July 1880.

39. AGN, SCOP, 6/70–1, February 1, 1883, report of Leopoldo Zamora to SCOP. The number of Americans included the two hundred blacks brought by the railroad

40. Ibid.

41. AGN, SCOP, 6/70–1, February 13, 1883, report of Mexican government engineer Leopoldo Zamora to SCOP. Also AGN, SCOP, 6/60–4 October 23, 1883, Sebastian Camacho to SCOP. "Clasificación local de Fletes, Tarifas, Sonoran Railway Company." All railroad circulars for merchandize and passengers rates appeared in Spanish and English.

42. Ibid.

43. "Far Reaching Designs of Boston Capitalist," *New York Times*, February 27, 1880.

44. Ibid.

45. "Prueba del ferrocarril," *La Constitución*, November 18, 1880, 1.

46. SAMC, reel 44, October 27 1880; "Exitación en Guaymas," José M. Fernández.

47. *El Monitor del Comercio*, cited in the *New York Times*, September 24, 1880, 4.

48. Ibid.

49. *La Constitución*, February 17, 1881, 3.

50. SAMC, reel 44, December 14, 1880, governor to Secretaría de Fomento.

51. *La Constitución*, February 17, 1881, 3.

52. SAMC, reel 44, telegram from D. B. Robinson to Carlos Ortiz, October 1, 1881.

53. SAMC, reel 44, July 13, 1882, letter to Secretaría de Fomento.

54. SAMC, reel 6, May 18, 1881, José Maytorena to secretary of state.

55. See *New York Times*, September 24, 1880, 4. Also Thomas Philip Terry, *Terry's Guide to Mexico* (New York: Houghton Mifflin Company, 1933), 92.

56. *New York Times*, September 24, 1880, 4.

57. SAMC, reel 44, "Exitación en Guaymas," October 27, 1880, José M. Fernández.

58. *Annual Report of Commercial Relations* (1884), 230. Report year ending December 1883.

59. AHS, papers of Rena Matthews, ms. 125, folder 5, description of Empalme, 1920.

60. Also see AHS, papers of Rena Matthews ms. 125, folder 6, 1920.

61. Cy Warman, cited in Pletcher, "American Capital," 68.

62. SAMC, reel 6, December 28, 1880, Luis Torres to Juan Torres and Capitan Liborio Miranda Policia de Campo del Ferrocarril.

63. ABO, *La Constitución,* November 12, 1881, 2.

64. AHGES, carpeton 1049, November 6, 1881, Nepomuseno Quijada to governor.

65. ABO, "Gacetilla, El Ferrocarril," *La Constitución,* April 29, 1880, 3–4.

66. *La Constitución,* September, 30, 1880, 2.

67. *Annual Report of Commercial Relations* (1884), 230. Report year ending December 1883.

68. ABO, "Edicto, Juzgado del Distrito de Sonora," *La Constitución,* September 9, 1880, 4.

69. "Denuncias," *La Constitución,* July 21, 1880, 3. Andres Camou placed land under Victoria, Esperanza, and Carlos Camou. In addition, Francisco, José J., Luis T., and Juan P. M. Camou acquired land.

70. *La Constitución,* January 29, 1881, 4.

71. "Nacori Chico," *La Constitución,* June 1, 1881, 4.

72. SAMC, reel 44, August 13, 1881, Joaquin Monroy, prefect of Magdalena to governor.

73. AGN, SCOP, Ferrocarril, no. 6/73-1, October 25, 1885.

74. *Annual Report of Commercial Relations* (1891), 151. Report year 1890.

75. Díaz Duffo, cited in Pletcher, "American Capital," 54.

76. *Annual Report of Commercial Relations* (1885), 56. Report year 1884.

77. *Annual Report of Commercial Relations* (1886), 663. Report Year 1885. And Dispatches from United States Consuls in Mexico (1887), vol. 23, microcopy 274, July-September 1887. Report year 1886.

78. *Annual Report of Commercial Relations* (1886), 663. Report Year 1885.

79. AGN, SCOP, 6/60-4, January 13, 1882, Sebastian Camacho to Ministro de Fomento.

80. AGN, SCOP, 6/90-1, September 14, 1880, contract between Mexican government and David Ferguson and Robert Symon. Although the contract was subsequently revised, the rate structure remained the same.

81. *Annual Report of Commercial Relations* (1884), 229. Report year ending December 1883.

82. AGN, SCOP, 6/60-4 July 20, 1883, Felizardo Torres and Ramón Corral to Ministro de Fomento.

83. See report of Consul Willard, *Annual Report of Commercial Relations* (1884), 227. Also *Annual Report of Commercial Relations* (1888), 274.

84. AGN, SCOP, 6/42-1, December 31, 1885, annual report of Sonora Railroad.

85. AGN, SCOP, 6/42-1, 1882-1911, annual reports of Sonora Railroad.

86. AGN, SCOP, 6/42-1, February 17, 1883, Leopoldo Zamora, government engineer, to SCOP. In February 1883, for example, from Hermosillo the company sold 219 tickets for Guaymas, 89 for Torres, the junction of the Minas Prietas road, 67 for Pesqueira, 64 for Magdalena, 73 for Nogales, and 69 for the rest of the stations.

87. See Ruiz, *The People of Sonora,* 51–62.

88. See Salazar, *Mexican Railroads,* 22.

89. Dispatches of United States Consuls in Mexico, no. 63, vol. 19, April-

Sept. 1886, report from Consul Willard, Guaymas. Also "Mexican Oranges," *San Francisco Chronicle,* June 6, 1891.

90. AGN, SCOP, 6/42-1, March 11, 1896, J. A. Naugle to SCOP, report.

91. AHMRUS, Cartas Camou, February 22, 1889, José Camou to Juan Camou in Guaymas.

92. AHMRUS, Cartas Camou, May 7, 1889, José Camou to Juan Camou. The entire family planned a weekend at the beaches of Guaymas.

93. AGN, SCOP, 6/70-1, January 27, 1883, Leopoldo Zamora to SCOP.

94. AHMRUS, May 6, 1889, José Camou to Juan Camou in Guaymas. Special train from Guaymas for concert in Hermosillo.

95. "Excursion," *El Monitor,* February 5, 1893.

96. AGN, SCOP, 6/60-4, April 13, 1883, Leopoldo Zamora to SCOP.

97. Greenville Holms, "Sonora," *Chamber's Journal* (September 14, 1901) 198 (4): 658.

98. "Interrupción," *La Constitución,* July 13, 1894, 1. "Los Ferrocarriles del Estado de Sonora," *El Porvenir,* March 23, 1902.

99. *Annual Report of Commercial Relations* (1886), 668. Report year 1885.

100. "A Mexican Night: The Toast and Responses," (New York: Democratic Club, 1892) 49.

101. "Notable Nuptials in Sonora: A Wedding in Mexico," *New York Times,* March 9, 1881, 2.

102. *La Voz del Estado,* June 1904, excursions to San Francisco ($69.50), Los Angeles ($50), St. Louis Exposition ($98.40); *El Heraldo de Cananea,* February 1, 1903, excursions to Santa Monica, Long Beach, and Santa Catalina.

103. See ABO, *La Constitución,* October 7, 1880, 2-4.

CHAPTER 7. BETWEEN CULTURES

1. See Martínez, *Border Boom Town,* 22. As a major hub in United States east-west transportation, El Paso did not rely exclusively on Ciudad Juárez for its development.

2. See Goodenough, *Culture Language and Society,* 99. Also Rosaldo, *Culture and Truth,* 209-10.

3. Emory, *Boundary Survey,* no. 3, 118.

4. "Settlers win in the Nogales, de Elías Grant, *Nogales Sunday Herald,* December 17, 1893, 1. For a detail account of the land grant, see Suarez Barnett, "La reclamación," 1(1), 5.

5. See "Los Dos Nogales," *El Monitor,* February 5, 1893, 1.

6. "Nogales: Its Past, Present, and Future," *The Oasis,* May 13, 1899, 1.

7. ABO, *La Constitución,* September 23, 1880, 3-4.

8. AHS, Biographical file: John T. Brickwood, 1849-1912, 1.

9. PAHS, January 24, 1883, Secretaría de Relaciones Exteriores to governor of Sonora. The letter was a copy of a communiqué sent by the Mexican consul in Tucson on October 12, 1882.

10. Ripley Hitchcock, cited in Cy Warman, *The Story of the Railroad* (New York: D. Appleton, 1913), 248.

11. PAHS, Biographical file: Edward Titicomb, 41. Also see Flores García, *Nogales,* 28.

12. "Los Dos Nogales," *El Monitor,* February 5, 1893; 1.

13. Agnes Morley Cleaveland, *No Life for a Lady* (Lincoln: University of Nebraska Press, 1977), 23–24.

14. ABO, *La Constitución,* July 11, 1884, 3, law which decrees Municipality of Nogales, Sonora. Also see AHGES, carpeton 616, census of the district of Magdalena, of which Nogales was a part.

15. ABO, *La Voz de Sonora,* March 5, 1858, President Benito Juárez to governor of Sonora.

16. See Flores García, *Nogales,* 40.

17. PAHS, "Aviso al Público," November 17, 1884, Aduana Fronteriza, Nogales, Sonora, J. Venegas and J. Duplant, Administradores.

18. See Martínez, *Border Boom Town,* 23.

19. Ibid., 20.

20. See AER, payroll records of Santa Barbara ranch, 1890–1910.

21. *Oasis,* November, 30, 1895, 2.

22. PAHS, Biographical file: dictation of John T. Brickwood, taken by J. M. Long, January 6, 1889. Long was a book agent for the Bancroft History Company.

23. PAHS, Biographical file: dictation of Louis Proto, taken by J. M. Long, January 8, 1889.

24. AHGES, carpeton 596, November 20, 1889, Alfonso Luis Velasco, president Club Romero to Ramón Corral.

25. AHGES, tomo 1625, May 19, 1900, petition from the residents and merchants of Santa Cruz in opposition to the zona libre.

26. AHGES, *La Justicia,* March 29, 1914, 1. During the revolution, the border was periodically closed. The newspaper lamented the effects of the closure on Sonora's border merchants; in particular, on grocery stores who depended on this trade.

27. AHS, *Arizona Graphic,* October 7, 1899, 2.

28. Reed, *Insurgent Mexico,* 245.

29. *Oasis,* May 13, 1899, 2.

30. Rochlin and Rochlin, "Heart of Ambos Nogales," 161–80. In 1893 the simple stone monument was replaced by a permanent steel fixture. For a map of Nogales, see AHGES, *El Monitor,* February 5, 1893, 1. Also see AHGES, Mapoteca #11–13, Plano de Nogales.

31. *Oasis,* July 9, 1909, 4.

32. *El Monitor,* May 13, 1899, 2.

33. "Los Dos Nogales," *El Monitor,* February 5, 1893, 1.

34. Ibid.

35. *Nogales Frontier,* November 7, 1885, 1.

36. *El Monitor,* July 7, 1893, 1.

37. Bird, *Sonora* and *The Land of Nayarit.*

38. Dispatches from United States Consuls in Mexico, Nogales, Sonora, record group 59, microcopy 283, July 18, 1890, Consul Delos Smith.

39. Robert Bracker, conversation with author, Nogales, Arizona, February 4, 1991. Mr. Bracker attended the Colegio Franco Español in Mexico City in the 1940s.

40. Henry J. Lloyd, *Freemasonry in Arizona*, 8.

41. PAHS, Ephemeral collection, "Societies and Fraternal Organization, Masons," records of Nogales, Arizona, Masonic Lodge no. 11, charter August 6, 1892. The early meetings of the Masonic lodge were held in a building called el Charito. Dispensation granted October 15, 1897.

42. SCUA, ms.14, box 5, folder 3, August 21, 1893, Free and Accepted Order of Masons, Nogales, Lodge no. 11 to Manuel Mascareñas.

43. See *El Monitor*, Nogales, July 7, 1893, 1; and Ready, *Nogales*, 8.

44. PAHS, Nogales Women's Clubs, Women's Beneficence Club, 1890, Women's Auxiliary founded 1915, Women's Club of Nogales, 1922.

45. PAHS, Nogales Women's Clubs, general club minutes, 1923–1924. The program on "Negro folk songs" may reflect the earlier presence of large numbers of Buffalo Soldiers in Nogales, Arizona.

46. "El baile de traje," *El Estado de Sonora*, February 28, 1896, 1.

47. PAHS, Biographical file: Ada Jones, manuscript "Early Schools of Nogales," n.d.

48. Cited in Aguilar Camín, *La frontera nomada*, 108.

49. AHGES, tomo 1583, exp. 2, April 11, 1898.

50. *Oasis*, May 15, 1899, 2; *Oasis*, April 18, 1896, 2.

51. *Oasis*, December 6, 1894, 5.

52. *Oasis*, December 6, 1894, 5.

53. "Nogales," *Oasis*, May 13, 1899, 2.

54. See for example, *El Estado de Sonora*, Abril 13, 1897, preparations for celebration of May 5, 1862.

55. *Oasis*, January 19, 1895, 4.

56. *New York Times*, March 24, 1895, 29:6.

57. "Ecos Sociales," *El Estado de Sonora*, February 28, 1896.

58. *New York Times*, March 24, 1895, 29.

59. AHGES, carpeton 825, June 27, 1885, and August 15, 1885.

60. AHGES, *El Eco del Valle* (Magdalena), August, 3, 1893.

61. "Arizona," *San Francisco Chronicle*, January 1, 1891.

62. James Speedy had been born in Valparaiso, Chile, in 1846. His parents came to California in 1849 during the gold rush.

63. AER, Copiadora Manuel Mascareñas, February 1891–July 1892, April 18, 1892, Mascareñas to Corral.

64. AGN, SCOP, Ferrocarril, March 17, 1884, L. Gutiérrez Guaymas to Secretaría de Fomento.

65. "Nogales," *Oasis*, May 13, 1899, 1.

66. AGN, SCOP, Ferrocarril, April 15, 1884, S. Echeverría, Secretaría de Fomento, to L. Gutiérrez Guaymas; also August 19, 1884, Secretaría de Fomento José Peñas to S. Camacho Ferrocarril de Sonora, Guaymas.

67. AGN, SCOP, Ferrocarril, August 19, 1884, Secretaría de Fomento José Peñas to S. Camacho Ferrocarril de Sonora, Guaymas.

68. The name Naco came from the last syllables in Arizona, (Na) and the last two in Mexico (co).

69. See Sandomingo, *Historia de Agua Prieta,* 43. This is also the case with the 1907 founding of Calexico and Mexicali.

70. AHGES, tomo 1633, exp. 1, November 15, 1899, registro de Naco. Comisario L. de la Fuente.

71. AHGES, tomo 1633, exp. 1, November 15, 1899, registro de Naco. Comisario L. de la Fuente.

72. AHGES, tomo 1633, exp. 1, June 19, 1901, 3, petition by Naco residents to governor.

73. AHGES, tomo 1633, exp. 1, July 15, 1901, Ramón Cárdenas, prefect of Arizpe, to governor.

74. AHGES, tomo 1633, exp. 1, November 15, 1899, registro de Naco, Comisario L. de la Fuente.

75. AHGES, tomo 1633, June 19, 1901, petition from Naco residents to governor.

76. AHGES, tomo 1633, exp. 1, July 26, 1901, Comisario of Naco, Jacobo Mendóza, to prefect of Arizpe, Ramón Cárdenas.

77. AHGES, tomo 1633, exp. 1, May 23, 1900, secretary of state to Comisario de Policia.

78. AHGES, tomo 1633, exp. 1, July 28, 1902, petition of residents of Naco to governor. This petition was signed exclusively by Mexicans.

79. Cartas Camou, August 24, 1904, Rafeal Camou to Juan P. Camou, cited in Valencia Ortega, "La formación," 14.

80. AHGES, tomo 1695, exp. 1., March 22, 1901, district prefect of Arizpe, Ramón Cárdenas, to governor of Sonora.

81. AHGES, tomo 2190, May 3, 1907, governor to police commisioner.

82. *El Estado de Sonora,* April 1, 1899, 2.

83. Hizinger, *Treasure Land, A Story,* 143.

84. See *Arizona Graphic* (Phoenix), October 7, 1899, 1.

85. Incidents of American officers involved with Mexican women proved equally conflictive. See Meed, *Bloody Border,* 205–9.

86. APD, legajo 12, caja 5, no. 002440, *The Daily News* (Nogales, Arizona), March 7, 1887, 2.

87. Ibid.

88. APD, legajo 12, caja 5, no. 002439, "A Frontier Fight," *San Francisco Chronicle,* March 4, 1887, 3.

89. APD, legajo 41, caja 5, March 10, 1887, March 12, 1887, March 31, 1887, communication between Porfirio Díaz and Luis Torres.

90. APD, legajo 12, caja 5, no. 002492, *San Francisco Morning Call,* March 8, 1887.

91. APD, legajo 12, caja 7, no. 03338, *El Eco de La Frontera,* March 27, 1887.

92. See *New York Times,* December 6, 1886, 1.

93. APD, legajo 46, caja 3, no. 1214, April 5, 1887, telegram, Torres to Díaz.

94. AHGES, *El Eco del Valle*, August, 3, 1893. In describing an incident involving Sheriff Roberts of Nogales, the paper mentioned that Sonorans still have not forgotten the Arvizu case.

95. APD, legajo 41, caja 3, no. 192, April 5, 1887, Porfirio Díaz to Luis Torres.

96. Ibid.

97. "An Outrage," *The Arizona Weekly Citizen*, March 19, 1887, 2.

98. APD, legajo 12, caja 5, no. 002452, March 25, 1887, Torres to Díaz.

99. APD, legajo 12, caja 5, no. 002450, March 5, 1887, Torres to Díaz.

100. SCUA, Manuel Mascareñas Papers, ms. 14, box 5, folder 6, December 21, 1899, Mascareñas to Ignacio Mariscal, foreign relations, Mexico. Also in AHGES, tomo 1567, March 1, 1900, consul of Nogales to governor of Sonora.

101. Ibid.

102. APD, legajo 12, caja 5, no. 002452, March 25, 1887, Díaz to Torres.

103. "How It Was Done: Settlers Win in the Nogales de Elías Grant," *Nogales Sunday Herald*, December 17, 1893, 1.

104. Ibid.

105. PAHS, Biographical file: Henry O. Flipper.

106. PAHS, Ada Jones, "The Early School of Nogales," statement of Doris K. McGuire, supervisor, Nogales elementary schools, 10.

107. *El Mundo*, México D. F., August 30, 1896, Asalto a la Aduana de Nogales.

108. PAHS, chamber of commerce, minute no. 13, Sept 6, 1906, telegram of protest to the *Los Angeles Examiner*.

109. For an eyewitness account of the events of March 1913, see PAHS, Battle for Nogales, by Ada Jones.

110. Ivey and French, *Army Life* (Douglas: Douglas Printing Company, 1917), 19; and Camp, *Mexican Border Ballads*.

111. Jones, *Prohibition Laws*, 3. Jones was the attorney general of Arizona.

112. See Suárez Barnett, "El 27 de Agosto de 1918," 2.

113. PAHS, "Report on Recent Trouble at Nogales," September 1, 1918, General D. R. Cabell to commanding general, Southern Divisions, 2.

114. PAHS, September 2, 1918, José Garza Zertuche, Mexican consul to Nogales, Arizona, to Secretaría de Relaciones Exteriores.

115. PAHS, "Report on Recent Trouble at Nogales," September 1, 1918, General D. R. Cabell to commanding general, Southern Divisions.

116. See Suárez Barnett, "El 27 de Agosto de 1918," 3.

117. Martínez, *Fragments*, 196.

118. PAHS, August 29, 1918, Carrol M. Counts, district intelligence officer, El Paso Texas, to Department of Intelligence Office, Fort Sam Houston, Texas.

119. PAHS, September 2, 1918, José Garza Zertuche, Mexican consul to Nogales, Arizona, to Secretaría de Relaciones Exteriores.

120. Martínez, *Fragments*, 194–95.

121. PAHS, August 27, 1918 file, November 29, 1918, Lieutenant James Potter, 10th Cavalry, to Adjunct General of the Army.

122. See "Fresh Fields for Rod and Gun, Sonora, Mexico" *Sunset* 8 (3) (January 1902): 106.

123. *Folleto de Recuerdo,* 74.

124. "The Relation between Nogales, Arizona, and the West Coast of Mexico," *Revista Comercial de Sonora y Sinaloa,* December 1924, 1.

125. PAHS, chamber of commerce, minutes, pro-Nogales advertising in 1927–1930; a total of $12,892.25 was spent. The chamber received 5,546 inquiries from throughout the world.

126. PAHS, Nogales, Arizona, chamber of commerce, summary of 1930 and 1933 activities. International Relations Committee included A. A. Castaneda, Louis Escalada, Joel Quiñones, O. A. Smith, and Thomas H. Robinson.

127. *Folleto de Recuerdo,* 19.

128. See AHGES, tomo 2376, exp. 4, March 9, 1908, Mexican consul in Tucson, Arturo Elías, to governor of Sonora.

129. *Folleto de Recuerdo,* 19.

130. G. R. Michaels, "Nogales is the Largest Port of Entry on the Mexican Border," *Arizona Highways* (February 1931), 12.

CHAPTER 8. "THE GREATEST MINING CAMP"

1. See Greenville Holms, "Sonora," *Chambers Journal* (September 4, 1901) 198(4): 658.

2. For Cananea, see Ruiz, *The People of Sonora,* 85. Also Sonnichsen, *Colonel Greene,* 39.

3. "Estado de Sonora," in Southworth, *Las minas de México* (1905), 210–35.

4. *Oasis,* July 2, 1904, 3.

5. Davila, *Sonora histórico y descriptivo,* 199.

6. Southworth, *El Estado de Sonora,* 49.

7. Bird, *Land of Nayarit,* 28.

8. AHMLC, Presidencia, caja 2, 1905–1907, Teniente Colonel C. Romero to Luis Torres, La Colorada. Several reports on attacks by Yaquis.

9. Combier, *Voyage,* 209–13.

10. José Velasco, *Noticias estadísticas,* 186.

11. *Oasis,* April, 4, 1896. Johnson sold El Yaqui and El Tiro mines in Altar to an American firm.

12. *Oasis,* December 28, 1895.

13. "History of Amarillas," *Oasis,* December 30, 1899.

14. Gracida Romo, "Auge y crisis," 397.

15. Ibid., 397.

16. *Oasis,* June 13, 1896, 1, survey of Ignacio Bonillas.

17. Southworth, *El Estado de Sonora,* 49–51. Also see Bird, *The Land of Nayarit,* 31. In the early 1900s, the Ohio group sold their interest in the mine for close to $5 million to a New York company headed by John W. Gates. See "Rothchilds buy Amarillas, Gran Central, Crestón, Minas Prietas, La Colorada," *Oasis,* August 26, 1896; and "Rothchilds to buy mines . . . September 5, 1896 sale for $10,000,000," *Arizona Silver Belt,* April 16, 1896, 1.

18. *Annual Report of Commercial Relations* (1908), 2:170.

19. See, for example, "Pan American Mining Company," *Oasis*, August 31, 1895, Minas Prietas. Also see *Oasis*, November 12, 1898.

20. Clarence King, *The Minas Prietas Report* (New York: Minas Prietas Mining Company, 1881), 1–2; *Oasis*, December 28, 1895.

21. "Minas Prietas Camp, Sonora, Mexico," *Mining and Scientific Press*, April 27, 1895, 260.

22. *Oasis*, July 10, 1897.

23. *Oasis*, September 23, 1899.

24. *Annual Report of Commercial Relations* (1903), 452.

25. Ruiz, *The People of Sonora*, 60. Also see Federico García y Alva, *Album Directorio del Estado de Sonora* (Hermosillo: Imprenta Antonio Monteverde, 1907).

26. *Oasis*, May 23, 1896.

27. *Annual Report of Commercial Relations* (1903), 463.

28. After Torres's ouster, the station was renamed Estación Serdan.

29. García y Alva, *Album crónica*. Seymour gave several speeches on behalf of the foreign community.

30. Alfonso Luis Velasco, *Geografía y estadística*, 174. Minas Prietas had 1,607 inhabitants, Comisaría de Estación Torres 350, La Colorada 200, and Zubiate 150.

31. Southworth, *El Estado de Sonora*, 48. Also see *Annual Report of Commercial Relations* (1903), 496.

32. Bird, *Land of Nayarit*, 28.

33. "Mexico," *Mining and Scientific Press*, February 5, 1898, 164.

34. *Oasis*, August 22, 1895.

35. *Annual Report of Commercial Relations* (1908), 2:170.

36. Southworth, *El Estado de Sonora*, 50.

37. Almada, *Diccionario de historia*, 166.

38. Southworth, *El Estado de Sonora*, 50.

39. Corral, *Memoria de la Administración*, 480. Also see Alfonso Luis Velasco, *Geografía y estadística*, 174. Velasco puts the population at 1,807 during the earlier years.

40. "Aviso," *La Constitución*, November 23, 1894, 3.

41. Gracida Romo, "El Sonora moderno," 4:84.

42. *Arizona Silver Belt*, April 16, 1896, 1.

43. "Minas Prietas," *Mining and Scientific Press*, April 27, 1895, 260.

44. *Resumenes del Censo del Estado de Sonora 1895* (Guaymas: Imprenta Eduardo Gaxiola, 1895), 36.

45. Ruiz, *The People of Sonora*, 59.

46. AHMLC, Presidencia, caja 3, 1907–1908, September 10, 1908, La Colorada, Plaza Luis Torres.

47. *Oasis*, April 13, 1895. Also "Minas Prietas," *Mining and Scientific Press*, April 27, 1895, 260.

48. AHMLC, Tesoreria, caja 1, 1894–1903, March 1, 1897, purchase agreement between agente Fiscal Pedro Oriol and Oscar Raintree, company treasurer.

49. See Gracida Romo, "Auge y crisis," 401.

50. AHMLC, Presidencia, caja 4, 1909–10, October 27, 1909, Crestón Colorada to municipal president.

51. AHMLC, Presidencia, caja 1, October 3, 1899, W. T. Barrett, manager, Prietas store, to Comisario, La Colorada.

52. *Oasis*, February 29, 1896. Ramón Corral, Victor Aguilas, Ignacio Bonillas, and Gustavo Torres visited the camp.

53. *Oasis*, April 20, 1895. Izábal visits La Colorada.

54. See Gracida Romo, "Auge y crisis," 403.

55. *Resumenes del Censo*, 36.

56. See AHMLC, caja 1, 1894–1903, Tesoreria y Justicia.

57. Ulloa, *El Estado de Sonora*, 123.

58. *Resumenes del Censo*, 8–14.

59. Ibid., 20.

60. Ibid.

61. Ibid., 32.

62. See Ingersoll, *In and under Mexico*, 106–7.

63. AHMLC, Presidencia, caja 1, 1898–1904, May 25, 1900, F. Verdugo to municipio; AHMLC, Presidencia, caja 2, 1905–1907, June 20, 1906, school director Minas Prietas to Comisario.

64. Corral, *Memoria de la Administración*, 506–7.

65. *Resumenes del Censo*, 15–19.

66. Ibid., 34.

67. Southworth, *El Estado de Sonora*, 50.

68. Ibid., 53.

69. Corral, *Memoria de la Administración*, 506–7.

70. García y Alva, *Album Directorio*, sn.

71. Ingersoll, *In and under Mexico*, 37.

72. See Thompson, "Time," 91–92.

73. *Oasis*, May 23, 1896.

74. Romero Gil, "Crisis y resistencia," n.p.

75. *Resumenes del Censo*, 22–34.

76. AHMLC, Presidencia, caja 1, 1898–1904, Corte de Caja, Prietas Store and Gran Central Stores, August 1902.

77. AHMLC, Tesoreria sn., caja 1, 1894–1903, "Impuestos de García y Bringas," January 21, 1899, Comisarío, Eduardo Muñoz, La Colorada.

78. See Gracida Romo, "Auge y crisis," 402.

79. AHMLC, Presidencía, caja 1, 1898–1904, October 31, 1901, list of merchandise, saloons, and industry in Minas Prietas and La Colorada.

80. García y Alva, *Album Directorio*, n.p.

81. Ibid., n.p., Rancho el Tecolote. Alejandro, Roberto, Eugenio, y Ricardo Rodríguez propietarios.

82. *Resumenes del Censo*, 46.

83. Ibid.

84. Bird, *Sonora*, 34.

85. Holms, "Sonora," 658. See also Bird, *Sonora*, 34.

86. *Annual Report of Commercial Relations* (1908), 2:170.

87. *Oasis*, June 9, 1900.

88. See "From Benson to Bocoachi," *Sunset,* (March 1899) 11 (5):94.

89. *El Explorador,* April 21, 1901.

90. AHGES, tomo 1645, exp. 5, June 10, 1901, Manuel Uruchurtu to state treasurer. Uruchurtu had dispatched three separate caravans to La Colorada with between twenty and thirty damajuanas of mezcal each.

91. Holms, "Sonora," 658.

92. See Gracida Romo, "El Sonora moderno," 85.

93. "Los Hermanos Quiroz," *Oasis,* June 17, 1900.

94. *Oasis,* December 8, 1900.

95. AHMLC, Presidencia, caja 4, 1909–1910, October 27, 1909, E. F. Rowell, president, La Colorada International Organization of Odd Fellows, no. 25, to municipal president La Colorada.

96. AHMLC, Presidencia, caja 1, 1898–1904 January 39, 1901, R. Salazar, Treasurer.

97. *Resumenes del Censo,* 22–34.

98. AHMLC, Minas Prietas/La Colorada, Presidencia, caja 1, 1898–1904, October 31, 1901, Tomas Rivera, list of assessed taxes.

99. Officials at Cananea later adopted a similar practice. See AHGES, tomo 1807, exp. 1, September 16, 1902, report of Filiberto Vazquez Barroso, presidente municipal, Cananea, 14.

100. AHMLC, Tesoreria, caja 1, 1894–1903, June 27, 1903. Luisa Juárez arrested and expelled from town.

101. AHMLC, Tesoreria, May 31, 1898, Inspector Medico de Sanidad. See also Presidencia, caja 1, 1898–1904, December 30, 1904, "Informe de las meretrices que hoy fueron inspeccionadas."

102. AHMLC, Presidencia, caja 3, 1907–1908, January 8, 1907, Arthur Edwards, U.S. citizen, to presidente municipal regarding Luisa Moreno.

103. See Holmes, "Sonora," 658.

104. AHMLC, Presidencía, caja 3, 1907–1908, May 7, 1908, Chale Wong Sam, citizen of China, to municipal president.

105. AHMLC, Presidencia, caja 1, 1898–1904, informe de prostitutas, December 30, 1904.

106. AHMLC, Presidencia, caja 1, 1898–1904, Reportes Judiciales: March, April, May, June, July, and September 1898.

107. AHALC, Presidencia, caja 4, October 23, 1909, October 27, 1909, report of women arrested for fighting.

108. AHGES, tomo 1623, exp. 4, La Colorada, Minas Prietas, March 5, 1900. Delfino Jiménez killed Antonio Gil Samaniego at the billiard of Juan Miguel Salcido.

109. AHMLC, Presidencia, caja 2, 1905–1907, July 7, 1907, Miguel Encinas, prefect of Sahuaripa, to municipal president of Minas Prietas regarding prisoner Guadalupe Hernández sent by cordillera.

110. For a broader discussion of the Rurales in Mexico, see Vanderwood, *Disorder and Progress,* 63.

111. AHMLC, Presidencia, caja 2, 1905–1907, December 9, 1907. Desertion of Leonardo Ramírez.

112. AHMLC, Presidencia, caja 2, 1905–1907, April 28, 1907, Coronel

Manuel Tumborell, riña entre miembros de la Guardia Nacional. Also August 8, 1907, soldiers fighting, President Municipal to Luis Torres.

113. AHMLC, Presidencia, caja 2, 1905–1907, June 14, 1907, Guardia del Cuerpo Rural Antonio Salazar and Domingo Telles killed Ramón López.

114. AHMLC, Presidencia, caja 2, 1905–1907, May 20, 1907, governor to Colonel Manuel Tumborell.

115. AHMLC, Presidencia, caja 2, 1905–1907, November 3, 1906, Lieutenant Carlos Pinal to Lieutenant Coronel Miguel Hermosa.

116. AHGES, tomo 1807, exp. 1–2, and tomo 1808, exp. 14, report of Filiberto Vásquez Barroso, municipal president of Cananea, September 16, 1902 and September 16, 1903.

117. AHMLC, Presidencía, caja 1, Justicia, 1898–1904, March, 1897. Antonio Madrid arrested for false boletas.

118. "La Gran Central Store," Oasis, November 13, 1897.

119. AHMLC, Tesoreria, caja 1, 1894–1903, report by Antonio Rivera regarding a Yaqui known as El Lapiz arrested for theft in mines. See also "Minas Prietas," Mining and Scientific Press, April 27, 1895, 260.

120. Ruiz, The People of Sonora, 115.

121. For examples of this practice, see AHGES, tomo 2442, exp. 30, May 1, 1909. At Mineral Chiapas workers complained about strip searches by a "despotic" Russian foreman.

122. AHGES, tomo 1695, exp. 1, reports of accidents: March 27, 1901, Mina Gran Crestón, Hermosillo; July 1, 1901, Minas Prietas, Hermosillo; July 17, 1901, El Crestón, Minas Prietas. Tomo 1869, exp. 12, October 26, 1903 and November 5, 1903, El Crestón, Minas Prietas; November 18, 1903, Gran Central, Minas Prietas.

123. Invariably Americans also became victims, but in much smaller numbers. See Oasis, May 14, 1898, death of John L. Miller who died in a premature explosion.

124. Ingersoll, In and under Mexico, 64, 83. Also AHGES, tomo 3016, exp. [no number], April 1913, report of accident cases received in Cananea Hospital.

125. Oasis, October 30, 1897; La Colorada.

126. Oasis, January 15, 1898; La Creston.

127. AHGES, La Colorada, Minas Prietas, tomo 1623, exp. 4, December 1898 to December 1900, Aguilar to prefect. December 26, 1899, Francisco García, died, car fell down tunnel. February 1, 1900, cave-in on tunnels 6 and 7, Juan Flores dead. March 3, 1900, La Gran Central, Juan Rocha, ladder gave way and Rocha fell down tunnel. March 7, 1900, unnamed Indian killed. April 26, 1900, Manuel Gardillas, Lazaro Ballesteros, Francisco Costa crushed by machinery which fell in tunnel 6; presidente municipal to prefect, July 4, 1900, Gran Central, José Peralta fell 50 feet serious injuries. July 4, 1900, El Crestón, Teodoro Estrada, Honesimo de La Mora, Gerardo Cerda, killed in cave at number 8 tunnel. September 15, 1900 Accident Gran Central, Pres Municipal Minas Prietas, several pieces of machinery fell down shaft killing unnamed two Mexican workers. The Oasis, April 2, 1898, two Mexicans killed in explosion.

128. See Ingersoll, In and under Mexico, 86.

129. Gracida Romo, "Auge y crisis," 404.

130. Cosío Villegas, *Historia Politica*, 2:708.

131. *Oasis,* June 12, 1897, strike by Yaquis at Pan American Mining Company.

132. *Oasis,* August 28, 1897; and *Oasis* September 18, 1897.

133. AHMLC, Presidenc*a, caja 1, 1898–1904, May 1897, arrest of Francisco Valenzuela at Las Amarillas.*

134. AHMLC, Tesorería, caja 1, 1894–1903, January 31, 1899, report of Comisario Miguel Hérmosa. Also see Presidencia, caja 1, 1897–1904, March 1897.

135. "Guarida de fumadores de Opio La Colorada," *El Correo de Sonora,* November 19, 1901 1.

136. AHMLC, Presidencía, caja 1, 1898–1904, March 1897, summary of crimes, Manuel Encinas store.

137. AHMLC, Presidencia, caja 2, 1905–1907, June 10, 1907, Presidente Alberto Cubillas, interim governor, to Municipal de Minas Prietas, regarding a visit by an attache to the Chinese embassy to investigate the death of Tan Kan Lan of Minas Prietas.

138. See Beene, "Sonora," 178. At La Trinidad in Sahuaripa, Mexican miners in one incident pelted the American manager with rocks and taunted him with shouts of "gringo cabrones."

139. AHGES, La Colorada, Minas Prietas, tomo 1623, exp. 4, September 24, 1900, Feliciano Monteverde to Governor Izábal. Visiting the Hughes were Sr. Manuel Romero and Srta. Josefa Quiñones.

140. Almada, *Diccionario de historia,* 166.

141. AHMLC, Presidencia, caja 1, 1898–1904, J. Cruz, Club Politico Bernardo Reyes.

142. AHMLC, Presidencia, caja 1, Junta Patriotica, August 12, 1901, Feliciano Monteverde presidente, Coronel Miguel Flores vocal.

143. AHMLC, Presidencia, caja 1, Comisario de Policia. Junta patriotica, September 1, 1901, Gilberto López president and Manuel M. Dieguez vocal.

144. AHMLC, Presidencia, caja 2, 1905–1907, September 11, 1906, Luis Torres to military commander La Colorada.

145. Enrique Orduños, interview by author, La Colorada, August 15, 1990. Orduños witnessed the collapse.

146. *Annual Report of Commercial Relations* (1909), 170.

147. *Annual Report of Commercial Relations* (1908), 2:170

148. Bird, *Land of Nayarit,* 32. Also *Oasis,* June 13, 1896, 1.

149. For an example of water issues see AHGES, tomo 1693, exp. 2, prefect of Sahuaripa to governor, May 29, 1901. Conflict over water rights between residents of Mulatos and *El Rey del Oro Mining Company.*

150. Gracida Romo, "Auge y crisis," 405.

151. AHMLC, Presidencia, caja 2, 1905–1907, May 23, 1907, C. Romero, Colonel La Colorada.

152. AHMLC, Presidencia, caja 4, 1909–1910, August 31, 1909, report of closure of several stores.

153. AHMLC, Presidencia, caja 4, 1909–1910, March 25, 1909, Sorteo para el ejercito.

154. AHMLC, Presidencia, caja 4, 1909–1910, October 5, 1909, complaint to municipal authorities signed by Miguel Valencia, Filomeno Ibarra, Navarro Arvizu, and a host of others. Also see November 27, 1909, J. Loustanau, new police Comisario.

155. Taylor, "Massacre at San Pedro," 138.

156. Enrique Orduños, interview by author, La Colorada, August 15, 1990.

157. Gracida Romo, "Auge y crisis," 405.

CHAPTER 9. "THE YANKEES OF MEXICO"

1. See García y Alva, *Album crónica*, n.p.

2. Uruchurtu, *Comentarios de la actualidad*, 1.

3. *Annual Report of Commercial Relations,* Mexico (1903), 436–39. American investments in Chihuahua amounted to $31.9 million of which $21.3 million was in mining. Oaxaca was ranked next with $13.6 million in "doubtful tropical agricultural companies." The United States embassy believed that if accurate figures could be made, Oaxaca's figure would be reduced and place Nuevo León fourth behind Chihuahua, with $11.4 million.

4. ABO, *La Constitución,* August 3, 1883, 4, notice regarding opening of Guatemalan consulate. AHGES, carpeton 13, Don León Gutiérrez named Spanish consul in Guaymas, April 14, 1879. W. H. Koebel, ed. *Anglo South American Handbook* (New York: MacMillan and Co, 1921), 443. Lloyds of London also maintained an agent in Guaymas.

5. Frederick Simpich, "A Mexican Land of Canaan," *National Geographic* 36 (4) (October 1919):309.

6. ABO, *La Estrella de Occidente,* January 15, 1869, 4. The paper carried an ad for a "new" English school run by Carlos F. Gompertz in the home of Florencio Monteverde. In Alamos, to the south, another English school opened later that same year.

7. BCUSCP, tomo 3, 1851–1856, November 18, 1852.

8. Ibid.

9. SCUA, Manuel Mascareñas Papers, ms. 14, no. 39, September 18, 1888.

10. AHGES, *El Noticioso* (Guaymas), July 27, 1910, 1.

11. See Goodenough, *Culture, Language, and Society,* 31.

12. SCUA, Manuel Mascareñas Papers, September 18, 1888, ms. 14, no. 39. Also, AHMRUS, Copiadoras Camou, August 16, 1898, Copper Queen Consolidated Mining Company, Bisbee Arizona, to Eduardo Camou.

13. *Annual Report of Commercial Relations* (1899), report October 1, 1899.

14. *Annual Report of Commercial Relations* (1903), 150.

15. AHMRUS, Copiadoras Camou, January 4, 1889, no. 174, José Camou refers to "pipe"; March 1, 1889, no. 286, "taxes"; April 30, 1908, no. 73, refers to "depleted stock" in writing to suppliers in France.

16. AHMRUS, Copiadoras Camou, no. 17–19, November 7, 1888, José Camou in Hermosillo to Juan Camou in Guaymas.

17. INAH, Cartas Camou, February 15, 1908, José Camou to Harris and Frank Inc., Los Angeles.

18. ABO, *La Constitución*, November 11, 1880, 3. And *La Constitución*, February 11, 1887, 4. The paper included an advertisement for the Santa Catalina Girls School in San Bernardino, California.

19. SCUA, Manuel Mascareñas Papers, ms. 14, no. 14, August 7, 1888, Manuel Mascareñas to Rafael Ruiz. In preparation for the trip, Mascareñas asked Ruiz to secure American dollars for use during his trip.

20. SCUA, Manuel Mascareñas papers, Manuel Mascareñas, ms. 14, no. 472, December 14, 1890, Mascareñas to Don Mariano Roman.

21. AHMRUS, Copiadoras Camou, nos. 44–46, November 16, 1888, José Camou to his children Eugenio and Ernesto in Mexico City. AHGES, Colección Periódicos *La Libertad* (Guaymas), July 2, 1902, 105. Alejandro Ainslie was the editor of the state's official newspaper, *La Constitución*. He accompanied his children to Mexico City and enrolled them in the Colegio de Ingles de Tacubaya.

22. SCUA, Manuel Mascareñas Papers, ms. 14, no. 39, September 18, 1888. Hoping to impress their parents, the Camou and Mascareñas children would write them in English. Also AHMRUS, Copiadoras Camou, April 4, 1906. Cristina Camous' letter to her father was written in English. Letters from her father reflected the growing influence of English. They were addressed "Dear Chamaca."

23. AHMRUS, Copiadoras Camou, November 16, 1888, José Camou to Eugenio and Ernesto in Mexico City.

24. ABO, *La Constitución*, January 25, 1884, 1. The actual decree was promulgated on December 14, 1883.

25. See for example AHGES, carpeton 454, July 30, 1856, Charles P. Stone to Governor Pesqueira, translated and certified by Tomas Robinson.

26. "In Fair Hermosillo," *San Francisco Chronicle*, January 8, 1893, 5.

27. See *El Fronterizo*, January 25, 1880, 1.

28. Goodenough, *Culture, Language, and Society,* 61.

29. Ibid., 63.

30. See *El Distrito de Alamos*, October 16, 1904, 3, soft-drink factory.

31. AHGES, *El Heraldo de Cananea*, February 1, 1903, 2; and *El Heraldo de Cananea* October 28, 1905, 2. Also see Ingersoll, *In and under Mexico*, 53. Ingersoll describes his surprise to find that the word *quequi* meant cake.

32. AHGES, Periódicos, *La Libertad*, Guaymas, April 26, 1902, advertisement Hotel California "Estilo Moderno Americano" (modern American style). Also see Escobosa Gamez, *Cronicas*, 33.

33. AHMRUS, Periódicos, *El Hogar Catolico*, January 1, 1903, 1.

34. AHMRUS, Copiadoras Camou, no. 107, December 12, 1888, José Camou in Hermosillo to Francisco Seldner in Guaymas.

35. *El Correo de Sonora*, November 19, 1901, 4

36. AHGES, *El Imparcial* (Guaymas), December 23, 1896, 3.

37. "Gritura," *El Imparcial,* July 29, 1893, 3.

38. AHGES, Periódicos, *El Eco del Valle* (Ures), May 31, 1894.

39. ABO, *La Constitución*, April 17, 1885, 4, advertisement for Hotel

Palacio in Hermosillo. Also see AHGES, Periódicos, *El Monitor Democrático* (Hermosillo), February 8, 1912, 4, advertisement for Hotel Central. The hotel also claimed to serve fresh oysters and Mumms Champagne.

40. AHGES, Periódicos, *La Libertad* (Guaymas), January 5, 1902, advertisement Hotel Gambuston.

41. AHGES, Periódicos, *El Estado de Sonora*, October 12, 1895. Also *El Monitor*, August 21, 1896.

42. See *La Razón Social* (Guaymas), November 15, 1897, "La Central," "Sadwiches finos" and *El Gladiador*, Cananea, February 6, 1912, 1, opening of a *Loncheria*.

43. AHGES, "La Luz Electrica," *El Correo de Sonora*, March 22, 1899, 4.

44. "Gacetilla de Hermosillo," *El Imparcial*, September 2, 1900.

45. AHGES, "Gacetilla," *El Imparcial* (Guaymas), September 2, 1900, 2.

46. *El Estado de Sonora*, October 12, 1895; *El Correo de Sonora*, October 10, 1899.

47. AHMRUS, *Sonora Moderno*, March 11, 1905, 3; and AHGES, *El Porvenir* (Caborca), November 4, 1909, advertisement for a bar named "La Chilena."

48. *Sonora Moderno*, August 25, 1908. Destileria Sonorenses Whiskey de Kentucky.

49. AHGES, "Struggle for Life," *El Eco del Valle*, July 12, 1894. Ad appeared in English.

50. *El Noticioso* (Guaymas), October 20, 1909, 1. Jesse Moore Whiskey.

51. AHGES, Periódicos, *El Monitor* (Nogales), June 16, 1893, 2–3. Also *El Eco del Valle*, August 15, 1891.

52. AHGES, Periódicos, *El Trafico* (Nogales), June 1, 1892, 4.

53. AHGES, *Sonora Moderno*, March 11, 1905, 1, advertisement for a "thrift store" in Magdalena, used "Staples and Fancey Groceries, Descounts."

54. See *Exposición de la Secretaría de Hacienda*, 267.

55. See *Cananea Herald*, December 28, 1902.

56. "Asociación Cristiana," *La Asociación del Pueblo* (Guaymas), July 15, 1870, 7.

57. "La salvaguardia de la Patria," *El Hogar Catolico*, May 16, 1903.

58. ACMH, caja 29, 1886–1910, November 17, 1900, Circular Arch-Diocesano.

59. See Ulloa, *El Estado de Sonora*, 36. Ulloa cites less than 2,000 Protestants, 821 Buddhists, and 358 Mormons in the state in 1910.

60. See PAHS, Religion, *The Home Missionary*, Protestant efforts in Nogales, March 1897, 532–33.

61. AHGES, *El Correo de Sonora*, November 19, 1901, 3.

62. See *Arizona Daily Citizen*, November 27, 1875, 2.

63. AHGES, *El Correo de Sonora*, November 19, 1901, 3.

64. *El Nacional* (Guaymas), November 12, 1912, Thanksgiving Day announcement.

65. AHGES, *El Heraldo de Cananea/The Cananea Herald*, November 25, 1907. Advertisement for the Cananea Copper Company store. The paper was published in English and Spanish.

66. AHGES, *Cananea Herald-Heraldo,* November 25, 1907.

67. See *Oasis,* December 6, 1894, 5.

68. *El Imparcial* (Guaymas), December 27, 1909, 3.

69. *El Grillo* (Cananea), November 30, 1909, Botica Benito Juárez.

70. PAHS, December 9, 1907, petition from merchants of Nogales to town council.

71. See Durazo, *El beisbol en Sonora,* 10, 22.

72. See *El Correo de Sonora,* Mayo 21, 1900, Guaymas against Club La Colorada; and *El Imparcial* February, 19, 1908, 4., special excursion train for baseball championship between team Hermosillo and team Empalme.

73. See *El 13 de Julio Guaymas,* June 2, 1894, concurso de Pelota, Jorge Boido, E. Martínez, Fernándo Castellanos, Carlos Cañez, Ignacio Iberri.

74. Simpich, "A Mexican Land of Canaan," 4.

75. AHGES, *El Imparcial,* Guaymas, October 22, 1892, 1.

76. Sobarzo, *Vocabulario sonorense,* 192. Also see Angel Encinas Blanco, "En su origen pochis y pocho," *El Imparcial,* February 9, 1991, 2d.

77. AHGES, *La Constitución,* December 12, 1910, 3. The ad read: "For Rent, A very beautiful home on the outskirts of town, seven rooms and kitchen, fine garden, roses, apply to Luis E. Torres."

78. See, AHGES, *EL Cuarto Poder,* August 5, 1911.

79. Ibid.

80. AHGES, *El Eco del Valle* (Ures), March 14, 1895, 1.

81. Ibid.

82. Goodenough, *Culture, Language, and Society,* 62–63.

83. INAH, Cartas Camou, November 28, 1906, José Camou to Leon Horvelieru requesting subscriptions of "La couturiere Parisienne" for Amelia Monteverde de Torres.

84. INAH, Cartas Camou, February 15, 1907, José Camou. Request for Rafael Izábal.

85. See Garcia y Alva, *Album cronica,* n.p.

86. ABO, *La Constitución,* December 7, 1888, 2.

87. See León-Portilla, "The Norteño Variant." Also see González, *La ronda de las generaciones.*

88. Bernal, "Cultural Roots," 25–32.

89. See Braudel, *The Mediterranean,* 1:242–43. Braudel points out that harsh climates frequently impose a certain frugality on life, in which the practical is emphasized.

90. AHCES, box 57, Ramón Corral, November 29, 1880.

91. See Corral, *Memoria de la administración,* tomo 2, 4. Also see AHGES, carpeton 950, Education 1898. The director of the state girls school resigned because of the low pay. She reportedly received 75 pesos a month.

92. SCUA, Manuel Mascareñas papers, ms.14, no. 223, August 1, 1889, Nogales, Sonora. Mascareñas became so frustrated with the absence of children that he ordered the teachers to visit the parents home to seek an explanation.

93. For example, see SCUA, Manuel Mascareñas Papers, ms. 14, no. 14, August 7, 1888, Manuel Mascareñas to Rafael Ruiz.

94. AHCES, box 57, November 29, 1880, speech by Ramón Corral.

95. Ibid.

96. Ibid.

97. ABO, *La Constitución*, July 18, 1884, 3. Speech delivered to graduating school children by General Crispin de S. Palomares.

98. AHCES, box 57, November 29, 1880, speech by Ramón Corral.

99. Alfonso Luis Velasco, *Geografía y estadística,* 235–36.

100. AHMRUS, Copiadoras Camou, no. 312, March 11, 1889, José Camou to Juan Camou.

101. SCUA, Manuel Mascareñas Papers, ms. 14, 1888, vol. 14, no. 61.

102. AER, Mascareñas Copiadora, 1896–1899, vol. 7, p. 257, July 21, 1897, Manuel Mascareñas to María Solan.

103. Uruchurtu, *Apuntes biográficos,* 55. Uruchurtu was a personal friend of Corral. The work originally appeared 1910. See also Ruibal Corella, *Carlos R. Ortiz,* 81.

104. Ruibal Corella, *Carlos R. Ortiz,* 81.

105. Uruchurtu, *Apuntes biográficos,* 555.

106. Much of the material for the schools was purchased in the United States. See AHGES, carpeton 865, 1888, "Informe de Ramón Corral," 11th legislature. The assembly allocated close to $8,000 to acquire furniture and materials in the United States. Also see Corral, *Memoria de la administración,* 2:2–5.

107. ABO, *La Constitución,* August 28, 1891, speech by Ramón Corral concerning education.

108. Ibid. The Colegio de Sonora opened its doors January 1, 1889, with 46 pupils.

109. AHGES, carpeton 876, July 5, 1890, list of students attending night school.

110. AHGES, tomo 2594, exp.9, year-end report 1900, state responses to federal questionnaire concerning education. Also see ABO, *La Constitución,* September 21, 1894, 1, speech by Rafael Izábal to state legislature. By comparison, in 1894 the state had allocated a budget of $143,736 for education. The government payroll included 258 instructors.

111. AHGES, tomo 1584, exp. 2, September 7, 1900, William Melczer to Rafael Izábal; and September 24, 1900, contract between Melczer and state of Sonora.

112. ABO, *La Constitución,* August 28, 1891, 2.

113. See AHGES, tomo 2338, exp. 5, January 22, 1908.

114. "La educación de la mujer," *La Razón Social* (Guaymas), December 8, 1897. Colaboradores, P. E. Calles.

115. Dworak and Elías Calles, *La Revista Escolar,* September 3, 1901.

116. AHGES, carpeton 924, September 4, 1896, list of instructors in the Guaymas School District.

117. AHGES, carpeton 924, June 15, 1896, Ramón Corral, Law of Public Instruction.

118. Ramón Corral, *Obras históricas, biografía de José María Leyva Cajeme* (Hermosillo: Biblioteca Sonorense de Geografía e Historia, 1959), 150–92.

119. In this, the experience of Sonora is not unique. Under the Porfiriato, conscious attempts were undertaken to incorporate the Indian into the national mainstream by romanticizing past heroes. See APD, legajo 12, caja 21, no. 10132, October 2, 1887, letter from Vicente Rivas Palacios to Porfirio Díaz. In the letter, Rivas Palacios congratulated Díaz on the idea of building a monument to exalt Cuauhtémoc. Also see "En honor a Cuauhtémoc," in *El Mundo Ilustrado* (Mexico), August 24, 1902, año 9, tomo 2, n.p.

120. See AHGES, tomo 1903, Miguel Lopez, *Apuntamientos para la Historia de Sonora*, Tesis de examen profesional, Hermosillo, Colegio de Sonora, 1903.

121. Simpich, "A Mexican Land of Canaan," 311.

122. See Wells and Joseph, "Moderninzing Visions."

123. "El adelanto de los pueblos, mejoras materiales," *La Razón Social* (Guaymas), November 15, 1897, 1.

124. AHGES, tomo 1584, exp. 4, September 22, 1896, Junta de Mejoras, Alamos, to Governor Ramón Corral.

125. "Necedidades Urgentes de Guaymas," *El Doctor Ox*, February 5, 1893, 5.

126. See "Contrato Ayuntamiento de Hermosillo y Sr. L. W. Mix para la pavimentación y banquetas de la capital," *La Constitución*, May 27, 1898, 1. Also see Uribe Garcia, *Breve Historia*, 22.

127. See "Contrato de Ayuntamiento de Hermosillo y Sr. L. W. Mix para construir unos edificios," *La Constitución*, June 7, 1898, 1. A few weeks later he also received a contract to build the Nogales, Sonora, water works. *La Constitución*, June 24, 1898, 1.

128. "In Fair Hermosillo," *San Francisco Chronicle*, January 1, 1893, 5.

129. "Nogales–Its Future," *Oasis*, May 13, 1899, 2.

130. "Mejoras," *Moctezuma Ideal*, June 1, 1907, 1.

131. "In Fair Hermosillo," *San Francisco Chronicle*, January 1, 1893, 5.

132. *Moctezuma Ideal*, June 1, 1907, 1

133. *El Hogar Catolico*, May 16, 1903.

134. *El Guaymas Comico*, May 11, 1899, 3.

135. "Juegos de Harina," *El Trafico*, February 18, 1894, 3.

136. "Necesidad de un mercado Público," *El Doctor Ox*, February 5, 1893, 1.

137. AHGES, "El vicío y la embriaguez." *El Correo de Sonora*, November 15, 1898, 2.

138. Ibid.

139. Vicente Calvo, *Descripción política*, 164.

140. AHMRUS, *El Correo de Sonora* (Guaymas), March 22, 1899, 2. News from Hermosillo, March 21, 1899.

141. "Moralidad Pública," *El Doctor Ox*, August 9, 1894, 1.

142. Ibid.

143. "Carrera de caballo es ahora sport," *El Correo de Sonora*, Marzo 5, 1903.

144. See "Concurso de Belleza," *El Domingo*, April 3, 1898; and "Concurso de Belleza," *El Nacional*, November 21, 1912.

145. "Partida de Pesca," *El Imparcial*, December 23, 1896.

146. "Partida de Pesca," *El Correo de Sonora* (Guaymas), May 20, 1901, Vapores Jalisco y Lucile, Jalisco.

147. See Beezley, *Judas at Jockey Club,* 44.

148. "Cuestion Palpitante," *El Imparcial,* November 21, 1894, 2.

149. "Agencia de bicicletas, plantel de la corrupción," *El Correo de Sonora* (Guaymas), May 30, 1899.

150. "Cuestion Palpitante," *El Imparcial,* November 21, 1894, 2. The argument appeared in English.

151. Ibid.

152. Ibid.

153. AHGES, *El Eco del Valle* (Ures), December 20, 1894. Excursiones al rancho de la Noria de Borques.

154. "En bicicleta, bella Guapa elegante y gentil," *La Linea Recta,* November 13, 1894.

155. AHGES, *El Eco del Valle,* June 14, 1891. Traveling phonographs in Ures. Also *El Eco del Valle* (Ures), May 31, 1894. Record player exhibited at the hotel Killen.

156. *Annual Report of Commercial Relations* (1909), 169. Report year 1908.

157. "Cine de los Hermanos Stahl," *El Imparcial,* February 19, 1908, 2.

158. AHGES, tomo 2541, exp.1, May 17, 1910, Commissioner Santa Ana to governor.

CHAPTER 10. THE POLITICS OF SCAPEGOATING

1. Regarding the Chinese, see Cumberland, "The Sonoran Chinese." Also Dambourges Jacques, "The Anti-Chinese Campaigns"; Hu-DeHart, "Immigrants to a Developing Society," 51; Hu-DeHart, "Racism"; Hu-DeHart, "La comunidad China"; Trueba Lara, "Los chinos en Sonora"; and Gómez Izquierdo, *El movimiento antichino.*

2. *Annual Report of Commercial Relations* (1909), 168.

3. INAH, Cartas Camou, José Camou to L. Horvilleur, September 14, 1907.

4. Iberri, *El Viejo Guaymas,* 66.

5. Charles Cumberland, "The Sonoran." Cumberland argued that Sonoran anti-Chinese sentiment was linked to the social turmoil unleashed by the Mexican Revolution. Sonoran prejudice against outsiders, and toward Asians in particular, existed long before the explosive events of 1910.

6. AHGES, carpeton 1048, July 15, 1881, Gobernación to governor of Sonora.

7. See AHGES, tomo 2543, exp. 5, October 22, 1910, Mexican consul Calexico to governor. Petition by Thomas P. Daly to employ 300 to 400 Chinese to pick cotton on land acquired near Mexicali.

8. AHGES, carpeton 1048, July 15, 1881, Gobernación to governor of Sonora.

9. Ibid.

10. *Arizona Daily Citizen,* July 9, 1879, 3.

11. AHGES, carpeton 1048, October 9, 1881, prefect of Arizpe to governor.

12. AHGES, carpeton 1048, October 1, 1881, prefect of Guaymas to governor.

13. *Resúmenes del Censo,* 16.

14. Izábal, *Memoria de la Administración,* 148.

15. AHGES, tomo 1900, exp. 34, June 10, 1904. Also June 22, 1904, Corral to governor of Sonora.

16. AHGES, tomo 1900, exp. 34, November 18, 1903, official commission in charge of Asian immigration to governor of state.

17. Izábal, *Memoria de la Administración,* 149. Japanese numbered less than twelve, mostly in Cananea. Also see Departamento de Estadística Nacional, *Sonora, Sinaloa y Nayarit,* 71. Asians in 1927 numbered 5,135 men and 114 women dispersed over three states: Sonora, Sinaloa, and Nayarit.

18. "Mercado de Cananea," *El Cuarto Poder,* August 5, 1911, 3. The following names appeared on the roster: Marcelino Villegas, Quong Yuen, Yang Kee, Song Fo, Sang Fo, Quong Lung Shing, Sang Sing, Wong Young, Sam Kee, Frank Helui, Ley Qui, Yuen Tay, Sing Chon Co, Tac Ley, Miguel Casanova, Sum Lee, Ko Mono, Juan Lee Chung, Hop Siong, and Hip Tay Lung. Names have been copied as they appeared in Spanish original.

19. Hu-Dehart, "Immigrants to a Developing Society," 50.

20. Mora, "Sonora," 64.

21. "Necesidad de oponernos a la inmigración China," *Cananea Herald/ Heraldo de Cananea,* March 22, 1903.

22. *Annual Report of Commercial Relations,* North America Mexico (1908), vol. 2, 168, report of Consul Louis Hostetter, Hermosillo.

23. Ibid.

24. AHGES, carpeton 1048, July 15, 1881, prefect of Altar to governor of Sonora.

25. AHGES, tomo 1645, exp. 5, list of leading merchants, May 26, 1901.

26. See Federico García y Alva, *México y sus progressos,* n. p.

27. Federico García y Alva, *Album crónica.*

28. Comité de recepción, *Periodico publicado,* 5–7.

29. See "Dos Carros del Carnaval en Guaymas," *Artes y Letras* (Mexico), March 10, 1912, vol. 7, no. 259, n. p.

30. "Chinos celebraron," *El Monitor Democratico,* January 15, 1912, 1.

31. "Union Fraternal China," *La Montaña* (Cananea), December 21, 1916, 3.

32. See Gracida Romo, "Auge y crisis," 402.

33. "Chinese Lodge in City of Cananea," *Cananea Herald,* August 25, 1906.

34. "Defensa de los Chinos," *El Nacional,* December 12, 1912.

35. INAH, Cartas Camou, October 31, 1906, José P. Camou, Hermosillo, to L. Horvilleur, Paris.

36. AHGES, tomo 1900, exp. 34, November 18, 1903, official commission on Asian immigration to the governor of the state.

37. AHGES, tomo 2558, exp. 18, March 16, 1910, governor of Sonora to Vice President Corral.

38. "Chinos, Mas Chinos," *El Eco de Sonora*, March 15, 1897, 1.

39. "Mas Chinos y mas Chinos," *El Noticioso*, May 13, 1901, 1.

40. See for example, *El Criterio Publico*, June 26, 1903, 2. While condemning Chinese immigration, the newspaper ran ads for Tung Chung Ling and Siu Fo Ching y Cia.

41. "Mas Chinos y mas Chinos," *El Noticioso* May 13, 1901, 1.

42. "La infección amarilla," *El Estado de Sonora* (Nogales), Simón Montano, 1.

43. *Cananea Herald/Heraldo de Cananea*, March 22, 1903, Marcus D. Smith, editor.

44. "Chinks Attack British Ships" and "Wily Japs Escape," *Cananea Herald*, November 4, 1907.

45. "Un Chino asesinado en Magdalena," *El Correo de Sonora*, November 9, 1898, 1.

46. AHGES, tomo 1623, exp. 4, La Colorada/Minas Prietas, December 19, 1900, presidente municipal to prefect. Chen Chan stabbed by Manuel Gómez.

47. "Mormon Colonies in Mexico," *San Francisco Chronicle*, In Chihuahua, Mormons formed three colonies: Juárez, Dublan, and Díaz.

48. O'Dea, "The Mormons," 162.

49. AHGES, tomo 1825 exp., n. p., Janaury 31, 1903, Orson Brown, comisario, to governor, general census of the inhabitants of Colonia Morelos.

50. See *Annual Report of Commercial Relations*, North America (1902), 436.

51. Nicoli, *El Estado de Sonora*, 10.

52. See APD, legajo 40, caja 2, doc. (000090), no.2, 1888, Peñafiel, *Estadísticas de la República Mexicana*.

53. AHGES, carpeton 467, state census 1892; and carpeton 647, state census 1906. Census statistics were collected by district.

54. *Resúmenes del Censo*, 14.

55. See Voss, *On the Periphery*, 107.

56. Perkins, *Three Years in California*, 312.

57. BCUSCP, Colección Pesqueira, tomo 2, 1852, report of the commission, February 12, 1852, 1.

58. Ibid., 2.

59. AHGES, tomo 1869, exp. 8, February 9, 1903, Corral to Torres.

60. Ibid.

61. AHMRUS, Copiadoras Camou, Torin, August 18, 1894, J. P. Camou to J. Camou. The younger Camou had been condemned to service in the Yaqui valley.

62. See for examples AHGES, carpeton 823, 830, and 831, Ramo Justicia, 1893. More than 125 men deserted in one month.

63. See Sobarzo, *Vocabulario sonorense*, 117.

64. Other Northern Mexicans commonly use the terms *chilango, chúntaro,* and *mejiquillo* to describe Southerners. By contrast, *guacho* is used primarily in Sonora.

65. See Sobarzo, *Vocabulario sonorense*, 117. The term is not used exclusively in Sonora. Throughout South America it is commonly used to describe outsiders or transients.

66. For a modern depiction of the term, see Teheran, *Riata, La octava Plaga! El Cazador de guachos*, 13.

67. AHGES, *El Correo de Sonora*, May 20, 1901, 2.

68. Ibid.

69. APD, legajo 5, caja 41, no. 001762, August 16, 1880, Carbó to Díaz.

70. AHGES, tomo 2525, January 1909, governor to prefect of Magdalena.

71. See for example Victor M. Venegas, "En favor de Sonora," in Comité de recepción, *Periódico publicado*, 11.

72. AHGES, carpeton 467, state census 1892, Guaymas District; and carpeton 647, state census 1906, Guaymas District.

73. "Molino de Nixtamal," Francisco Zepeda, *El Cuarto Poder,* January 31, 1912.

74. AHGES, tomo 2245, exp. o, Censo Comercial de Hermosillo, November 9, 1906. The census listed 334 mercantile establishments in Hermosillo.

75. Regarding increased Mexican industrial and manufacturing output, see Haber, *Industry and Development*, 30.

76. *Annual Report of Commercial Relations*, (1901), 482–83, report year 1900.

77. AHGES, "Agentes viajeros," *El Imparcial*, February 19, 1908, 3.

78. AHGES, tomo 1901, June 24, 1904, Hermosillo chamber of commerce, Adolfo Bley, and Ernesto Camou to governor.

79. INAH, Cartas Camou, February 4, 1909, José Camou to L. Horvilleur.

80. INAH, Cartas Camou, June 26, 1907, José Camou to L. Horvilleur, Paris.

81. INAH, Cartas Camou, June 26, 1907, José Camou to L. Horvilleur, Paris.

82. For changes in the currency, see Martínez, *Border Boom Town*, 171.

83. *Annual Report of Commercial Relations* (1903), 150. Consul Albert R. Morawetz Nogales, Sonora.

84. *Annual Report of Commercial Relations* (1900), 577. Nogales, Sonora Consul J. F. Darnall.

85. *Annual Report of Commercial Relations* (1901), 482–83.

86. AHMRUS, Periódicos *El Comercio* (Hermosillo), January 13, 1905, 3, advertisement for Casa Luis Encinas.

87. AHGES, *La Razón Social* (Guaymas), November 15, 1987, 4.

88. AHGES, Periódicos *El Criterio Publico* (Guaymas), December 27, 1904, announcement for opening of corn tortilla factory in Guaymas.

89. AHGES, tomo 1901, July 1, 1904, proclamación del Gobernador.

90. AHGES, tomo 1645, exp. 5., February 22, 1901, law concerning establishment of taxes on shipments of ordered goods.

91. AHGES, tomo 1901, July 1, 1904, Francisco Muñoz, vice governor of the state, regulations governing traveling agents.

92. AHGES, tomo 1901, October 11, 1904, Hacienda to governor of Sonora.

93. See "Agentes Viajeros," *El Defensor,* March 4, 1905, 1.
94. AHGES, *El Imparcial,* February 19, 1908, 3.
95. "Las Tiendas de Raya," *El Puerto de Guaymas,* June 9, 1902, 1.
96. See Teheran, *El Cazador de guachos.*
97. Cumberland, "The Sonoran Chinese."
98. "Huelga Femenina," *La Justicia,* February 25, 1914. And "Comite Pro-Raza," *El Nacionalista,* April 16, 1924.
99. See University of Arizona, Special Collections, José María Arana Papers, 1904–1921, ms. 9; and Espinoza, *El Ejemplo de Sonora.* Both Arana and Espinoza actively participated in the anti-Chinese campaigns of the 1920s.

CHAPTER 11. "THE WINE IS BITTER"

1. Aguilar Camín, *La frontera nómada,* 63.
2. *El Elector,* May 2, 1907.
3. "No se deben alarmar," *Heraldo de Cananea,* September 30, 1907. The mine remained closed until the summer of the following year.
4. "Special Correspondent," *Mining and Scientific Press,* November 16, 1907, 607.
5. AER, Copiadora, Julio 1906/Enero 1911, September 15, 1907, no. 109, Manuel Mascareñas to Max Mueller.
6. "Reduce Payments," *Cananea Herald,* November 4, 1907; and "Reduced Taxes" *Cananea Herald,* November 25, 1907.
7. "Prepare for Bishop's Coming," *Cananea Herald,* November 18, 1907.
8. AGN, Gobernación, 1a 907–8(1)(1), November 1, 1907, Mexican vice consul at Clifton, Arizona, to Gobernación. The vice consul reported a deluge of unemployed Mexican laborers seeking to return to Mexico. Similar reports appeared from Mexican consuls throughout the southwest.
9. See Ruiz, *The People of Sonora,* 229–30.
10. INAH, Cartas Camou, February 15, 1909, José Camou to L. Horvilleur, Paris.
11. JMMC, June 10, 1909, José M. Maytorena to Rodolfo Reyes.
12. ABO, *La Consitutción,* June 19, 1891, election results by district.
13. Almada, *La Revolución,* 29.
14. AHGES, carpeton 951, February 19, 1898, Marcelino Castillo seeks job as teacher.
15. Almada, *La Revolución,* 30.
16. JMMC, May 19, 1910, José M. Maytorena to Madero.
17. JMMC, May 23, 1910, José M. Maytorena to Rodolfo Reyes.
18. INAH, Cartas Camou, July 10, 1908, José C. Camou to L. Horvilleur, Paris. And AER, Copiadora, July 1906/January 1911, no. 9, June 21, 1906, Mascareñas to José María Miranda.
19. *El Porvenir,* June 25, 1905; Izábal, *Memoria de la Administración,* 148–49.
20. *El Porvenir* (Arizpe), June 25, 1905, 1.
21. AHGES, tomo 1625, April 25, 1899. Petition from businesses of Magdalena who had been displaced by the free zone. Also see, May 19, 1900, peti-

tion from nearby Santa Cruz, district of Magdalena in opposition to the zona libre.

22. See Dispatches of the United States Consuls in Mexico (1892), vol. 39, 122, December 31, 1891, report of Consul Alexander Willard.

23. See comments published in *El Distrito de Alamos,* October 16, 1904.

24. Aguilar Camín, *La frontera nómada,* 39-40.

25. See *El Distrito de Alamos,* April 15, 1906.

26. See *El hijo del Fantasma,* Benjamin Hill, January 2, 1909. Also Aguilar Camín, *La frontera nómada,* 19-46.

27. See Tilly, "Social Movements," 297-317.

28. AHGES, June 1, 1906, prefect of Guaymas to governor. Request police assistance to control strikers at Empalme. See Ruiz, *The People of Sonora,* 97. Also see Romero Gil, "Crisis y resistencia."

29. AHGES, tomo 1695, exp. 1, July 3, 1901, police commissioner of El Tiro, Priciliano Murrieta, to district prefect and governor.

30. Ibid.

31. Ibid., July 3, 1901, prefect of Altar, E. Ferreira, to police commissioner at El Tiro.

32. See Federico García y Alva, *México y sus progresos, Album directorio del Estado de Sonora.*

33. AHGES, tomo 1695, exp. 1, July 5, 1901, secretary of state to district prefect of Altar, E. Ferreira, and to Priciliano Murrieta.

34. AHGES, tomo 1693, exp. 2, May 29, 1901, prefect of Sahuaripa to governor.

35. AHGES, tomo 1693, exp. 1, May 26, 1901, E. A. Brandon, superintendent El Rey del Oro Mining Company, to municipal authorities and district prefect, Sahuaripa.

36. AHGES, tomo 1693, exp. 1, June 27 1901, "Extraordinary session" Mulatos ayuntamiento.

37. AHGES, tomo 1693, exp. 1, June 24, 1901, presidente municipal, Mulatos, to superintendent of El Rey Mining Company.

38. AHGES, tomo 1693, exp. 1, July 17, 1901, ayuntamiento de Mulatos to district prefect of Sahuaripa.

39. See "Yanquilandia," *La Voz del Obrero,* February 21, 1913. Also see "Sonora para los Yankees, el sueño dorado," *El Noticioso* (Guaymas), November 10, 1901, 1; Almada, *La Revolución,* 27.

40. AHGES, tomo 1738, legajo 3, "Obreros Mexicanos." Leaflet distributed in Cananea, June 1906.

41. *El Doctor Ox* (Guaymas), August 9, 1894, Alejandro Wallace. Wallace was the son of a Canadian. Also see "El ferrotortuga de Sonora," *Huracan,* October 6, 1895.

42. "Porque americanos y no mexicanos," *Distrito de Alamos,* December 22, 1901, 1.

43. "Los ferrocarriles en el Estado de Sonora," *El Porvenir* (Arizpe), March 23, 1902.

44. For several examples, see AHGES, tomo 1695, exp. 1, April 8, 1901, San Ignacio, victim unknown; June 25, 1901, prefect of Magdalena to gover-

nor, death of Juan Alvarez by railroad; tomo 2645, exp. 2, June 13, 1910, Magdalena, death of José Robles; tomo 2525, exp. 7, August 12, 1909, death of Alberto Moraga.

45. AHGES, tomo 2478, exp. 2, February 4, 1909, ayuntamiento of Buena Vista to governor.

46. AHGES, tomo 2478, exp. 2, February 22, 1909, comisario de Agiabampo to governor.

47. AHGES, tomo 2478, exp. 2, January 22, 1909, prefect, Ures, to governor.

48. AHGES, tomo 1623, exp. 4, June 31, 1900. J. A. Naugle to governor. Also see tomo 1623, exp. 4, July 5, 1900, and July 6, 1900, J. A. Naugle to governor.

49. AHGES, tomo 2525, exp. 5, November 16, 1909 and November 18, 1909, comisario of Empalme to governor of Sonora.

50. AHGES, tomo 1623, exp. 4, November 3, 1900 and November 5, 1900, Guillermo Robinson to governor. Robinson was a descendant of Juan A. Robinson. Also see tomo 2525, exp. 5, August 28, 1909.

51. "Obreros y Capataces," *Gaceta de Cananea,* February 4, 1908, 1.

52. *El Doctor Ox,* February 5, 1893.

53. "La repatriación de mexicanos," *La Voz del Estado* (Magdalena), June 7, 1896, 1. Included reprints from the *Cronica Mexicana,* Bakersfield, California.

54. See McWilliams, *North From Mexico,* 127. Word of these atrocities quickly spread throughout the southwest United States and northern Mexico.

55. *El Heraldo de Cananea,* February 1, 1903, 2. Los Consules Mexicanos. Originally published in El *Estado de Sonora* (Guaymas).

56. "Negros a la Parilla en Georgia," *El Trafico* (Guaymas), May 1, 1899.

57. "A Cuba en la muerte de Maceo," *El Imparcial,* December 23, 1896, 3.

58. "Gacetilla," *El Imparcial* (Guaymas), December 23, 1896, 3.

59. "Announcements," *El Correo de Sonora* (Guaymas), November 15, 1898.

60. "Crueldad de americanos," *El Porvenir* (Arizpe), April 27, 1902, 3.

61. "Mexico, España y Estado Unidos," *La Reserva* (Hermosillo), February 3, 1892. The writers of the newspaper included top government officials.

62. *El Distrito de Alamos,* December 22, 1901. See Cosío Villegas, *Historia Moderna de México,* 708.

63. "Proxima crisis," *El Eco del Valle* (Ures), March 19, 1891.

64. *EL Eco del Valle* (Ures), June 15, 1891, 2.

65. "Lecturas populares," *El Centinela de Alamos,* February 26, 1899, 2.

66. "Balneario en Guaymas," *El Criterio Publico,* May 26, 1908, 3.

67. Articles relating to issues of morality filled the pages of local newspapers. See, for example, "Dos plagas sociales, embriaguez y vagancia," *El Criterio Publico,* June 26, 1903. Also "Comision de Embriaguez," *La Antorcha de Hermosillo,* June 30, 1900; and "Las Casas de prostitución," *El Imparcial,* November 21, 1894.

68. See Koven and Michel, "Womanly Duties," 1080.

69. See Deeds, "José María Maytorena," 31. Deeds reports that 34 percent of the population could read and write by 1910.

70. See Ulloa, *El Estado de Sonora,* 34–35.
71. Corral, *Informe leido,* 9.
72. See Manuel Hugues, *El Defensor del Pueblo,* May 4, 1905, 2.
73. "Las Casas de Tolerancia," *El Estado de Sonora,* June 9, 1897, 1.
74. "El vicío y la embriaguez," *El Correo de Sonora,* November 15, 1898, 2.
75. See Ruiz, *The People of Sonora,* 193.
76. See "Moralidad y Lenguaje," *Gaceta de Cananea,* August 2, 1908; and *El Trafico,* September 19, 1899, 1.
77. "Escandalo," *El Noticioso* (Guaymas), October 20, 1909.
78. See articles by Laura and Rosa Granillo, *La Razón Social,* December 1, 1897, 1.
79. *La Antorcha Sonorense* (Hermosillo), June 30, 1900, 3. Also "La embriaguez," *La Constitución,* August 31, 1894, 1–2.
80. *El Trafico,* September 19, 1899, 2.
81. "Contra la Embriaguez," *Antorcha Sonorense,* June 30, 1900, 3.
82. "Instituto Internacional," *El Monitor* (Nogales, Az.), July 7, 1893.
83. See AHGES, tomo 3201, exp. [no number], Cesario G. Soriano, interim governor of Sonora, January 1918. Decree regarding liquor consumption. Also see tomo 3201, exp. [no number], October 10, 1918, Mexican embassy in United States to Plutarco Elías Calles. The prohibition movement in the United States requested information about prohibition in Mexico, in particular, in Sonora.
84. "A los padres de familia," *La Razón Social* (Guaymas), December 1, 1897. Other articles in *La Razón Social* dealt with drunkenness, the role of the women, and education.
85. "La mujer en el siglo actual," *La Razón Social,* November 22, 1897, 3.
86. "Necesidad de instruir la mujer," *La Razón Social,* December 8, 1897, 1.
87. See articles by Laura and Rosa Granillo, *La Razón Social,* December 1, 1897, 1.
88. *El Porvenir* (Arizpe), April 27, 1902, 2.
89. "Comision Moralista de Hermosillo," *El Monitor Democrático,* Agosto 25, 1911.
90. "Cuadro Negro," *La Voz del Obrero* (Cananea), Sociedad de Obreros "Aquiles Serdan," August 26, 1912, 1.
91. AHGES, tomo 2552, exp. 1, June 18, 1910, telegram, Corral to acting governor Alberto Cubillas.
92. INAH, Cartas Camou, May 11, 1911, May 12, 1911, and May 17, 1911, José Camou to J. C. Camou, Los Angeles, 461–62.
93. Ibid., May 29, 1911.
94. Ibid., May 29, 1911.
95. Ibid., May 29, 1911, José C. Camou to J. Camou, Los Angeles.

CONCLUSION

1. "Las bicicletas," *El Imparcial* (Guaymas), November 21, 1894, 2. Also see Beezely, *Judas at the Jockey Club,* 41.
2. INAH, Cartas Camou, September 21, 1908, José C. Camou, Hot

Springs, Arkansas, to Dionisio D. Aguilar, Hermosillo. Also Federico García y Alva, *México y sus progresos*. Advertisement for "Ferrocarril Southern Pacific, Sunset Route" offering trips to Southern California at reduced rates.

3. *El Imparcial* (Guaymas), February 19, 1908.

4. "A Mexican Land of Canaan," *The National Geographic Magazine* (October 1919) 36 (4): 311.

5. Rosaldo, *Culture and Truth*.

6. Rowe and Schelling, *Memory and Modernity*, 2.

7. Leopoldo Zea, Arturo Warman, Carlos Monsivais, *Características de la cultura nacional* (México: Universidad Autónoma de México, 1969), 13. Also see Kroeber, *Anthropology, Race, Language, and Culture*, 429–37.

8. Castellano Guerrero, "La influencia norteamericana."

9. See advertisement in *Artes y Letras* (México), October 11, 1908.

10. AER, Copiadoaras Mascareñas, July 22, 1931, Guillermo Mascareñas to Alberto Mascarenas, director general del Banco de México. Also see Deeds, "José María Maytorena," 38. Manuel Jr. was leader of the Ozorquistas in Sonora.

11. INAH, Cartas Camou, June 4, 1912, José C. Camou to Eduardo Ruiz. Camou complained about the difficulty of being mayor and running his business.

Bibliography

PRIMARY SOURCES

MEXICO, ARCHIVES

Archivo de la Catedral Metropolitana de Hermosillo (ACMH).
Archivo del Boletín Oficial del Estado de Sonora (ABO).
Archivo del H. Municipio de la Colorada (AHMLC).
Archivo Eduardo Robinson, Colección Mascareñas and Colección Camou, Nogales (AER).
Archivo General de la Nación, México Gobernación (AGN).
Archivo General de la Nación, México, Secretaría de Communicación y Obras Públicas (AGN, SCOP).
Archivo Histórico del Congreso del Estado de Sonora (AHCES).
Archivo Histórico del Gobierno del Estado de Sonora (AHGES).
Archivo Histórico del Museo de Historia Regional de Universidad de Sonora (AHMRUS).
Archivo Porfirio Díaz, México, Universidad Ibero-Americana (APD).
Biblioteca Central de la Universidad de Sonora, Colección del Noroeste (BCUSCN).
Biblioteca Central de la Universidad de Sonora, Colección Pesqueria (BCUSCP).
González Navarro, Manuel, Patronato de la Historia de Sonora, 1900–1950. 5 vols. (manuscript).
Instituto Nacional de Antropología e Historia. Hermosillo, Sonora, Biblioteca, Cartas Camou (INAH).

UNITED STATES, ARCHIVES

Arizona Historical Society, Tucson, Arizona (AHS).
José María Maytorena Collection, Honnold Library, Claremont Colleges (JMMC).

Manuel Mascareñas Papers, Special Collection, University of Arizona (SCUA).
Pimeria Alta Historical Society, Nogales, Arizona (PAHS).
Pradeau Collection, Chicano Research Collection, Department of Archives and
 Manuscripts, University Libraries, Arizona State University.
Sonoran Archive, Microfilm Collection, Arizona Collection, Department of Ar-
 chives and Manuscript, University Libraries, Arizona State University
 (SAMC).
United States Department of State, Dispatches from United States Consuls in
 Mexico, Guaymas, Sonora. 1832–1896.
United States Department of State, Dispatches from United States Consuls in
 Mexico, Nogales, Sonora. 1889–1906.
United States Department of State, Dispatches from United States Consuls in
 Mexico, Hermosillo, Sonora. 1905–1906.

PRIMARY PRINTED SOURCES

*Annual Report of the Commercial Relations Between the United States and For-
 eign Nations.* Washington D. C.: Government Printing Office, 1869–1912.
Archivo del General Porfirio Díaz, Memoria y Documentos. Vols. 1–30.
 México: Editorial Elede, 1947–1961.
Audubon, John W. *Audubon's Western Journal 1849–1850.* Cleveland: Arthur
 Clark Company, 1906.
Balbas, Manuel. *Crónicas de la guerra del Yaqui 1899–1901.* Hermosillo:
 Gobierno del Estado, 1985.
Bancroft, Hubert Howe. *History of the North Mexican States.* Vols. 15 and 16.
 San Francisco: Bancroft and Company, 1884.
———. *Resources and Development of Mexico.* San Francisco: The Bancroft
 Company, 1893.
Bartlett, John Russell. *Personal Narratives of the Exploration and Incidents in
 Texas, New Mexico, California, Sonora and Chihuahua.* 1854. Reprint, Chi-
 cago: Rio Grande Press, 1965.
Bianconi, F. *Le Mexique a la portée des Industriels, des Capitalistes, des Négo-
 ciants, Importateurs, et des Travailleurs.* Paris: Imprimerie Chaiz, 1889.
Bird, Allen T. *Sonora, Mexico.* Nogales: Sonora Railway, 1900.
———. *The Land of Nayarit.* Nogales, Ariz.: Arizona and Sonora Chamber
 of Mines, 1904.
Bishop, William Henry. *Old Mexico and Her Lost Provinces.* New York: Har-
 per & Brothers, 1883.
Boston and Sonora Consolidated Mining Company. Directors' Report. Iowa:
 Boston and Sonora Consolidated Mining Company, 1882.
Browne, John Ross. *Adventures in Apache Country: A Tour Through Arizona
 and Sonora.* New York: Arno Press, 1971.
Brunckow, Frederick. *A Report of Frederick Brunckow to a Committee of the
 Stockholders of the Sonoran Exploring and Mining Company.* Cincinnati:
 Railroad Record Print, 1859.
Caballero, Manuel. *Almanaque histórico y monumental de la República Mexi-
 cana, 1883–1884.* México: Editor el Noticioso, 1883.

Calvo, Vicente. *Descripción política, física, moral y comercial del Departamento de Sonora, en la República Mexicana.* Museo Regional de la Universidad de Sonora, 1843. Manuscript.

Camp, F. B. *Mexican Border Ballads.* Douglas: Author, 1916.

Comité de recepción, *Periodico publicado como recuerdo de la visita de que el ilustre sonorense Don Ramón Corral hizo a este puerto Noviembre 1904.* Guaymas: Imprenta de Eduardo Gaxiola, 1904.

Cooke, Philip St. George. *Exploring Southwestern Trails 1846–1854.* Glendale: California, Arthur H. Clark Company, 1938.

Coppey, Illypolite. *Monsieur Raousset en Sonore.* México: Imprimerie de J. II. Lara, 1855.

Corral, Ramón. *Informe leido por el C. Ramón Corral vice gobernador constitucional de Sonora ante la legislatura del mismo estado.* Hermosillo: Gobierno del Estado, 1889.

———. *Memoria de la administración del Estado de Sonora.* Vols. 1 and 2. Hermosillo: Imprenta de Gaxiola, 1891.

———. *Reseña histórica del Estado de Sonora.* Hermosillo: Imprenta del Estado, 1900.

Cummings, Cherry. *Cincinnati and Sonora Mining Association.* Cincinnati: Wrightson & Company, 1866.

Davila, F. T. *Sonora histórico y descriptivo.* Nogales: Oasis Printing House, 1894.

Dworak, Fernando, and Elías Calles, Plutarco. *La Revista Escolar: mensual pedagógico.* Guaymas: Imprenta de A. Ramírez, 1901.

Emory, William H. *Report of the United States and Mexican Boundary Survey.* Austin: Texas State Historical Association, 1987.

Espinoza, José Angel. *El ejemplo de Sonora.* Mexico: Autor, 1932.

Exposición de la Secretaría de Hacienda de los Estados Unidos Mexicanos sobre la condición actual de México y el aumento del comercio con los Estados Unidos. México: Imprenta del Gobierno en Palacio, 1879.

Fleury, E. "Noticias geológicas, geográficas y estadísticas sobre Sonora y Baja California." BCUSCN, Hermosillo, 1864. Manuscript.

Folleto de recuerdo, Tren especial de la excursión comercial de la ciudad Llave, Key City. Nogales: Chamber of Commerce, 1919.

Galindo y Villa, Jesús. *Geografía de México.* Barcelona: Editorial Labor, 1930.

García, Lorenzo. *Apuntes sobre la campaña contra los salvajes en el estado de Sonora.* Hermosillo: Imprenta de Roberto Bernal, 1883.

García y Alva, Federico. *Album crónica fiestas efectuadas en Sonora en honor del señor vice-presidente de la República Don Ramón Corral y de la Señora Amparo V.E. de Corral.* Hermosillo: Imprenta de Belisario Valencia, 1905.

———. *México y sus progresos, álbum directorio del estado de Sonora.* Hermosillo: Imprenta de Antonio B. Monteverde, 1905.

Guillet, C. "Notas sobre Sonora. 1864–1866." Colección Pesqueira, Serie 2. Vol. 4. No. 8. BCUSCN. Manuscript.

Hall, John. *Travel and Adventures in Sonora.* Chicago: J. W. Jones Stationary and Printing Company, 1881.

Hamilton, Leonidas. *Border States of Mexico, Sonora, Sinaloa, Chihuahua and Durango.* Chicago: Leonidas Hamilton, 1881.

Hardy, Robert William H. *Travels in the Interior of Mexico 1825–1828.* London: Henry Colburn & Richard Bentley, 1829.

Hizinger, George J. *Treasure Land: A Story.* Tucson: Arizona Advancement Company, 1897.

Iberri, Alfonso. *El viejo Guaymas.* México: Editorial Jus, 1962.

Ingersoll, Ralph McA. *In and under Mexico.* New York: The Century Company, 1924.

Izábal, Rafael. *Memoria de la administración pública del Estado de Sonora 1903–1907.* Hermosillo: Imprenta de Antonio Monteverde, 1907.

Jones, Wiley E. *Prohibition Laws, Federal and State in Force in the State of Arizona,* Phoenix: Office of the Attorney General, 1917.

Lange, Charles L., and Carroll L. Riley, eds. *The Southwestern Journal of Adolph Bandelier 1883–1884.* Albuquerque: University of New Mexico Press, 1970.

Lejeune, Louis. *La guerra Apache en Sonora, 1885–1886.* Hermosillo: Gobierno del Estado, 1984.

Lloyd, Henry J. *A History of Freemasonry in the State of Arizona.* Los Angeles: Los Angeles Freemason, 1912.

Logan, Walter S. *A Mexican Night: The Toast and Responses to Señor Matías Romero.* New York: Democratic Club, 1892.

Lumholtz, Carl. *El México desconocido.* México: Publicaciones Herrerias, 1945.

Malte-Brun, M. V. A. *La Sonora et Ses Mines.* Paris: Arthus Bertrand, 1864.

Marryat, Frederick. *Travels and Adventures of Monsieur Violet in California, Sonora and Western Texas.* New York: Routledge and Sons, 1845.

Moody, W. G. *A Comparison of the Northern Mines and Southern Mines in Mexico, with a Description of Two of the Mining Districts in North-Eastern Sonora.* San Francisco: Towne & Bacon Book and Card Printers, 1863.

Mowry, Sylvester. *Memoir of the Proposed Territory of Arizona.* Washington: Polkinhorn Press, 1857.

———. *Arizona and Sonora: The Geography, History and Resources of the Silver Region of North America.* 1864. Reprint, New York: Arno Press, 1973.

Nentvig, Juan. *Descripción geográfica de Sonora.* México: Secretaría de Gobernación, 1971.

Nettleton, E. S. *Report on the Yaqui Irrigation Project.* New York: Sonora and Sinaloa Irrigation Company, 1893.

Nicoli, José Patricio. *El Estado de Sonora, Yaquis y Mayos, estudio histórico.* México: Imprenta de Francisco Díaz de León, 1885.

North, Diane M. T. *Samuel Heintzelman and the Sonora Exploring and Mining Company.* Tucson: University of Arizona Press, 1980.

Nye, William F. *La Sonora, etendue, population, climat, produits du sol, mines, tribus indiennes.* Paris: La Revue Britannique, 1864.

Ober, Frederick A. *Travels in Mexico, and Life among the Mexicans.* Boston: Estes and Lauriat, 1883.

Obregón, Alvaro. *Ocho mil kilómetros de campaña*. México: Fondo de Cultura Económica, 1959.

Oswald, Felix L. *Summerland Sketches, Ramble in the Backwoods of Mexico and Central America*. Philadelphia: J. .Lippincott, 1880.

Pattie, James O. *The Personal Narrative of James O. Pattie*. Lincoln: University of Nebraska Press, 1984.

Pavía, Lazaro. *Los estados y sus gobernantes ligeros apuntes históricos, biográficos y estadísticos*. México: Tipografía de las Escalerillas, 1890.

Peñafiel, Antonio. *Estadística de la República Mexicana*. México: Tipografía de Fomento, 1889.

Pérez Hernández, José María. *Geografía del Estado de Sonora*. México: Tipografía del Comercio, 1872.

Perkins, William. *Three Years in California: William Perkins' Journal of Life at Sonora, 1849–1852*. Edited by William Scobie and Dale L. Morgan. Berkeley: University of California Press, 1964.

Pfefferkorn, Ignacio. *Descripción de la provincia de Sonora*. 1756–1767. Hermosillo: Gobierno del Estado, 1979.

Pinart, Alphonse. "Voyage en Sonora." *Bulletin de la Sociéte de Géographie*, series 6, no. 20: 193–244 (July–December 1880).

Poston, Charles. *Building a State in Apache Land*. Tempe: Aztec Press, 1963.

Pumpelly, Raphael. *Across America and Asia: Notes of a Five Year Journey around the World and of Residence in Arizona, Japan, and China*. New York: Leypoldt & Holt, 1870.

Reed, John. *Insurgent Mexico*. New York: International Publishers, 1969.

Reid, John C. *Reid's Tramp, or A Journal of the Incidents of Ten Months of Travel through Texas, New Mexico, Arizona, Sonora, and California*. Austin: The Steck Company, 1935.

Remington, Frederic. "An Outpost of Civilization," *Harper's Magazine* 88 (523): 71–80 (December 1893).

Resúmenes del censo del Estado de Sonora 1895. Guaymas: Imprenta de Eduardo Gaxiola, 1895.

Riesgo, Juan M. and Antonio Valades. *Memoria estadística del Estado de Occidente*. Guadalajara: Imprenta de C. E. Alatorre, 1828.

Robinson, Thomas Warren. *Dust and Foam: or, Three Oceans and Two Continents*. New York: Charles Scribner Press, 1858.

Romero, Matías. *Mexico and the United States*. New York: The Knickerbocker Press, 1898.

Salazar, Luis. *Mexican Railroads and the Mining Industry*. México: Tip El Minero, 1901.

Schuyler, Howard. *The Sonora Railway, Resource and Revenue*. San Francisco: Rice, 1878.

Schwatka, Frederick. *In the Land of Cave and Cliff Dwellers. 1893*. Glorieta, N. M.: Rio Grande Press, 1971.

Sierra, Justo. *The Political Evolution of the Mexican People*. Austin: University of Texas Press, 1975.

Sonora, Sinaloa y Nayarit: estudio estadístico y económico social, departamento de estadística nacional.1927. México: Imprenta Mundial, 1928.

Southworth, J. R. *El Estado de Sonora, México, sus industrias, comerciales, mineras, y manufactureras.* Hermosillo: Gobierno del Estado, 1897.

———. *Las minas de México.* México: Southworth, 1905.

———. *Las minas de México.* 2nd ed. México: Southworth, 1910.

Stone, Charles P. *The State of Sonora.* Washington: Henry Polkinhorn Printer, 1861.

Treutlein, Theodore E. ed. *Missionary in Sonora, The Travel Reports of Joseph Och 1755–1767.* San Francisco: California Historical Society, 1965.

Ulloa, Pedro. *Folleto conmemorativo de la memorable jornada del 13 de julio de 1854.* Hermosillo: Imprenta Moderna de R. Bernal, 1907.

———. *El Estado de Sonora y su situación económica al aproximarse el primer centenario de la independencia nacional.* Hermosillo: Gobierno del Estado, 1910.

Uruchurtu, Manuel R. *Apuntes biográficos de Don Ramón Corral. 1854–1900.* 1910. Reprint, Hermosillo: Gobierno del Estado, 1984.

———. *Comentarios de actualidad.* México: Eusebio Gómez de la Puente, 1904.

Velasco, Alfonso Luis. *Geografía y estadística del Estado de Sonora.* México: Tipografía T. González, 1895.

Velasco, José Francisco. *Noticias estadísticas del Estado de Sonora.* 1850. Hermosillo: Gobierno del Estado, 1985.

Vigneaux, Ernesto. *Viaje a México.* Guadalajara: Banco Industrial de Jalisco, 1950.

Viveros, Germán. *Informe Sobre Sinaloa y Sonora de José Rodríguez Gallardo, 1750.* México: Archivo General de la Nación, 1975.

Wilson, Robert A. *Mexico: Its Peasants and Its Priest.* New York: Harper and Row, 1856.

Zamora, Agustín A. *La Cohetera, mi barrio.* Hermosillo: Gobierno del Estado, 1982.

Zavala, Palemón. *Perfiles de Sonora.* Hermosillo: Gobierno del Estado, 1984.

Zúñiga, Ignacio. *Rápida ojeada al Estado de Sonora, 1835.* Hermosillo: Gobierno del Estado, 1985.

NINETEENTH- AND EARLY-TWENTIETH-CENTURY
SONORAN NEWSPAPERS AND MAGAZINES

Boletín Oficial (Ures), 1876–1879.
La Constitución (Hermosillo), 1880–1910.
La Estrella de Occidente (Ures), 1855–1876.
El Iris de Paz (Ures), 1845.
El Sonorense (Ures), 1855.
El Voto de Sonora (Ures), 1850.
La Voz de Sonora (Ures), 1856.

Alamos, Sonora

Revista Popular

Altar, Sonora
La Opinión (Altar)
El Porvenir (Caborca)
El Progreso (Altar)

Arizpe, Sonora
El Eco de Arizpe
El Porvenir

Cananea, Sonora
Casos y Cosas
El Correo de Cananea
La Democracia
El Elector
La Gaceta de Cananea
El Gato
El Gladiador
El Grillo
El Heraldo de Cananea / The Cananea Herald
Justicia
Libertad
El Minero de Sonora
La Montaña
El Nacionalista
El Tiempo
La Voz de Cananea
La Voz del Obrero

Guaymas, Sonora
El 13 de Julio
El Bien Público
El Brochazo
El Comercio
El Correo de Sonora
El Criterio Público
El Doctor Ox
El Eco de Sonora
La Gaceta
Guaymas Cómico
El Huracán
El Imparcial
La Libertad
La Linea Recta
El Monitor Democrático
El Municipio
El Nacional
El Noticioso

El Puerto de Guaymas
La Razón Social
El Torito
El Trafico

Hermosillo, Sonora

Antorcha Sonorense
El Comercio, Diario de Hermosillo
El Comisionista
El Eco de Sonora
El Hogar Católico
El Imparcial
La Reserva
Treinta/Treinta
Unisono

Magdalena, Sonora

La Propaganda
Sonora Moderno
La Voz del Estado

Nogales, Sonora

El Estado de Sonora

Ures, Sonora

El Eco del Valle

México, Distrito Federal

Artes y Letras
El Combate
Mexican Herald
El Mundo Ilustrado

United States Magazines and Newspapers

Arizona Highways
Chamber's Journal
Harper's Magazine
Las Dos Repúblicas (Los Angeles)
Mining and Scientific Press
National Geographic
New York Times
San Francisco Chronicle
Sunset

Nogales, Arizona

El Independiente
El Monitor

Nogales Frontier
Nogales Sunday Herald
Oasis
Revista Comercial de Sonora y Sinaloa
El Triunfo

Tucson, Arizona

Arizona Citizen
Arizona Daily Star
Arizona Quarterly Illustrated
Arizona Silver Belt
El Fronterizo
La Sonora
Weekly Arizonian

SECONDARY SOURCES

Acuña, Rodolfo F. *Sonora Strongman: Ignacio Pesqueira and His Time*. Tucson: University of Arizona Press, 1974.
Aguilar, Fernando. "Apuntes para la historia de Sonora y Sinaloa." Hermosillo, Sonora, 1925. Manuscript.
Aguilar Camín, Hector. *La frontera nómada, Sonora y la Revolución Mexicana*. México: Siglo XXI, 1977.
———. "The Relevant Tradition: Sonoran Leaders in the Revolution," in *Caudillo and Peasant in the Mexican Revolution*. D. A. Brading, ed. Cambridge: Cambridge University Press, 1980.
———. *Saldos de la Revolución*. México, Ediciones Océano, 1984.
Almada, Francisco R. *La Revolución en el Estado de Sonora*. México: Instituto Nacional de Estudios Históricos de la Revolución Mexicana, 1971.
———. *Diccionario de historia, geografía y biografía sonorense*. Hermosillo: Gobierno del Estado, 1983.
Anderson, Benedict. *Imagined Communities*. London: Verso Press, 1983.
Armstrong, John A. *Nations before Nationalism*. Chapel Hill: University of North Carolina Press, 1982.
Bassols Batalla, Angel. *El noroeste de México, un estudio geográfico económico*. México: Universidad Nacional Autónoma de México, 1972.
———. *México: Formación de regiones económicas*. Mexico: Universidad Nacional Autónoma de México, 1979.
———, ed. *Lucha por el espacio social, regiones del norte y noreste de México*. México: Universidad Nacional Autónoma de México, 1986.
Beene, Delman Leon. "Sonora in the Age of Ramón Corral, 1875–1900." Ph.D diss., University of Arizona, 1972.
Beezley, William H. *Judas at the Jockey Club and Other Episodes of Porfirian Mexico*. Lincoln: University of Nebraska Press, 1987.
Bernal, Ignacio. "The Cultural Roots of the Border: An Archaeologist's View." In *Views across the Border: The United States and Mexico*, edited by Stanley Ross. Albuquerque: University of New Mexico Press, 1978.

Bonfil Batalla, Guillermo. *México profundo: Una civilización negada*, México: Secretaría de Educación Pública, 1987.

Boyd, Consuelo. "Twenty Years to Nogales: The Building of the Guaymas-Nogales Railroad." *The Journal of Arizona History* 22 (3): 295–324 (Autumn 1981).

Braudel, Fernand. *The Mediterranean and the Mediterranean World in the Age of Philip II.* New York: Harper and Row Publisher, 1972.

Brophy, Blake. *Foundlings on the Frontier, Racial, and Religious Conflict in Arizona Territory. 1904–1905.* Tucson: University of Arizona Press, 1972.

Bustamante, Jorge. "Frontera México-Estados Unidos: reflexiones para un marco teórico." *Frontera Norte* 1 (1): 20 (Enero-Junio 1989).

Calvo, Laureano Berber. *Nociones de la historia de Sonora.* México: Editorial Porrúa, 1958.

Camarillo, Albert. *Chicanos in a Changing Society: From Mexican Pueblos to American Barrios.* Cambridge: Harvard University Press, 1979.

Camou Healy, Ernesto. *Cocina Sonorense.* Hermosillo: Instituto Sonorense de Cultura, 1990.

Carr, Barry. "Las peculiaridades del norte mexicano, 1880–1927: ensayo de interpretación." *Historia Mexicana* 22 (3): 320–46 (Enero-Marzo 1973).

Castellano Guerrero, Alicia. "La influencia norteamericana en la cultura de la frontera norte de México." In *La frontera del norte,* edited by Roque González Salazar. México: El Colegio de México, 1981.

Cerutti, Mario. *Burguesía y capitalismo en Monterrey, 1850–1910.* México: Claves Latinoamericanas, 1983.

———. "Monterrey y sus ambito regional, referencia histórica y sugerencias metodológicas, (1850–1910)." Universidad Autónoma de Nuevo León México, 1988.

Coerver, Don M. "Federal-State Relations during the Porfiriato: The Case of Sonora, 1879–1884." *The Americas* 33 (4): 567–84 (April 1977).

Corbala Acuña, Manuel. *Sonora y sus constituciones.* Hermosillo: Editorial Libros de México, 1972.

Cosío Villegas, Daniel, ed. *Historia moderna de México, el Porfiriato, la vida política interior.* Vols. 1 and 2. México: Editorial Hermes, 1972.

———, ed. *Historia moderna de México, el Porfiriato, la vida social.* México: Editorial Hermes, 1972.

Cumberland, Charles. "The Sonoran Chinese and the Mexican Revolution." *Hispanic American Historical Review* 40 (2): 191–211 (May 1960).

———. "The United States-Mexican Border." *Rural Sociology* 25 (5): 1–236 (June 1960).

Dabdoub, Claudio. *Breve historia del Valle del Yaqui.* México: Editorial Tradición, n.d.

Dakin, Susanna Bryant, ed. *A Scotch Paisano in Old Los Angeles.* Berkeley: University of California Press, 1978.

Dambourges Jacques, Leo Michael. "The Anti-Chinese Campaigns in Sonora, Mexico, 1900–1931." Ph.D. diss., University of Arizona, 1974.

Deeds, Susan. "José María Maytorena and the Mexican Revolution in Sonora." *Arizona and the West* (Spring 1976): 21–40; (Summer 1976): 125–48.

De León, Arnoldo. *They Call Them Greasers: Anglo Attitudes toward Mexicans in Texas, 1821–1900.* Austin: University of Texas Press, 1983.

Dunbier, Roger. *The Sonoran Desert.* Tucson: University of Arizona Press, 1968.

Duncan Baretta, Silvio R., and John Markoff. "Civilization and Barbarism: Cattle Frontiers in Latin America." *Comparative Studies in Society and History* 20 (4): 587–620 (October 1978).

Durazo, Miguel S. *El béisbol en Sonora.* Hermosillo: Durazo, 1956.

Escobosa Gamez, Gilberto. *Crónica, cuentos y leyendas sonorenses.* Hermosillo: Gobierno del Estado, 1984.

Fifer, J. Valerie. *United States Perceptions of Latin America, 1850–1930.* Manchester, England: Manchester University Press, 1991.

Flores García, Silvia Raquel. *Nogales un siglo en la historia.* Hermosillo: INAH-SEP, 1987.

Forbes, Jack D. *Apache, Navajo, and Spaniard.* Norman: University of Oklahoma Press, 1979.

Foster, George M. "Speech Forms and Perception of Social Distance in a Spanish-Speaking Mexican Village." *Southwestern Journal of Anthropology* 20 (2):107–23 (Summer 1964).

Foster, Harry L. *A Gringo in Mañana-land.* New York: Dodd, Mead and Company, 1924.

Foucault, Michel. *The Order of Things: The Archeology of Human Science.* New York: Vintage Books, 1973.

Galaz, Fernando A. *Dejaron huella en el Hermosillo de ayer y hoy.* Hermosillo: Imprenta a cargo del Autor, 1971.

Geertz, Clifford. "Ideology as a Cultural System." In *Ideology and Discontent,* edited by David Apter. New York: The Free Press, 1964.

———. *The Interpretation of Culture.* New York: Basic Books, 1973.

Gellner, Ernest. *Nations and Nationalism.* Ithaca: Cornell University Press, 1983.

Gibson, Arrell Morgan. *The Kickapoos: Lords of the Middle Border.* Norman: University of Oklahoma Press, 1963.

Giddens, Anthony. "Time, Space, and Regionalisation." In *Social Relations and Spatial Relations,* edited by Derek Gregory and John Urry. London: McMillan, 1985.

Giese, Anna Mae. "The Sonoran Triumvirate: Preview in Sonora 1910–1920." Ph.D. diss., University of Florida, 1975.

Gómez Izquierdo, José Jorge. *El movimiento antichino en México, 1871–1934.* México: Instituto Nacional de Antropología e Historia, 1992.

González, Luis. *La ronda de las generaciones.* México: Secretaría de Educación Pública 1984.

González Navarro, Moisés. "El Trabajo Forzoso en México. 1821–1917." *Historia Mexicana* 27 (4): 588–615 (Abril-Junio 1978).

Goodenough, Ward H. *Culture, Language, and Society.* Menlo Park: Benjamin Cummings Publishing, 1981.

Gracida Romo, Juan José. "El Sonora moderno, 1892–1910." In *Historia General de Sonora.* Tomo 4, Sonora Moderno. Hermosillo: Gobierno del Estado de Sonora, 1985.

———. "El Problema de la harina y las relaciones comerciales entre Sonora y Sinaloa en 1881." *Boletín de la sociedad sonorense de historia* no. 28 (September-October 1986).

———. "Auge y crisis del mineral La Colorada." In *Memoria XI Simposio de Historia y Antropología de Sonora.* Hermosillo: Universidad de Sonora, 1987.

Haber, Stephen H. *Industry and Development: The Industrialization of Mexico.* Stanford: Stanford University Press, 1989.

Habermas, Jürgen. *Communication and the Evolution of Society.* Boston: Beacon Press, 1976.

Hall, Thomas D. *Social Change in the Southwest 1350–1880.* Lawrence: University of Kansas Press, 1990.

Harris, Charles. *A Mexican Family Empire: The Latifundio of the Sánchez Navarro 1765–1867.* Austin: University of Texas Press, 1975.

Hart, John Mason. *Revolutionary Mexico: The Coming and Process of the Mexican Revolution.* Berkeley: University of California Press, 1987.

Hennessy, Alistar. *The Frontier in Latin American History.* London: Edward Arnold Press, 1978.

Herskovits, Melville. *Cultural Dynamics.* New York: Alfred A. Knopf 1966.

Hobsbawn, E. J. *Bandits.* New York: Pantheon Books, 1969.

Hogan, Richard. "The Frontier as Social Control." *Theory and Society* 14 (1): 35–51 (January 1985).

Hopkins, Durazo. "Datos sobre el proceso de mestizaje en Sonora, un caso diferente." Hermosillo, Sonora, 1984. Manuscript.

Hu-Dehart, Evelyn. "Immigrants to a Developing Society: The Chinese in Northern Mexico, 1875–1932." In *The Chinese Experience in Arizona and Northern Mexico.* Tucson: Arizona Historical Society, 1980.

———. "Racism and Anti-Chinese Persecution in Sonora, Mexico 1876–1932." *Amerasia Journal* 9 (2): 1–28 (1982).

———. *Yaqui Resistance and Survival: The Struggle for Land and Autonomy, 1821–1910.* Madison: University of Wisconsin Press, 1984.

———. "La comunidad China en el desarrollo de Sonora." In *Historia General de Sonora.* Tomo 4, Sonora Moderno. Hermosillo: Gobierno del Estado de Sonora, 1985.

Iturriaga, José E. *La estructura social y cultural de México.* México: Fondo de Cultura Económica, 1951.

Katz, Friedrich. *The Secret War in Mexico.* Chicago: University of Chicago Press, 1981.

Knight, Alan. "Mexican Peonage: What Was It and Why Was It?" *Journal of Latin American Studies,* no. 18 (1986): 41–74.

———. *U.S.-Mexican Relations, 1910–1940: An Interpretation.* La Jolla: Center for Mexican American Studies, 1987.

Koven, Seth, and Sonya Michel. "Womanly Duties: Maternalist Politics and the Origins of the Welfare State in France, Germany, Great Britain, and the United States, 1880–1920." *American Historical Review* 95:4: 1076–1108 (October 1990).

Kroeber, A. L. *Anthropology, Race, Language, and Culture.* New York: Harcourt and Brace, 1948.

León-Portilla, Miguel. "The Norteño Variety of Mexican Culture: An Ethnohistorical Approach." In *Plural Society in the Southwest,* edited by Edward Spicer and Raymond Thompson. New York: Weatherhead Foundation, 1972.

Lloyd, Jane Dale. *El proceso de modernización capitalista en el noroeste de Chihuahua (1880–1910).* México: Universidad Iberoamericana, 1987.

López Encinas, Francisco. *Sonora, frontera codiciada.* Hermosillo: Sygma Gráfica, 1985.

Luna, Jesús. *La carrera pública de don Ramón Corral.* México: Secretaría de Educación, 1975.

Mañach, Jorge. *Frontiers in the Americas: A Global Perspective.* New York: Teachers College Press, 1969.

Martínez, Oscar J. *Border Boom Town: Ciudad Juárez since 1848.* Austin: University of Texas Press, 1978.

———. *Troublesome Border.* Tucson: University of Arizona Press, 1988.

———. *Fragments of the Mexican Revolution.* Albuquerque: University of New Mexico Press, 1990.

McWilliams, Carey. *North from Mexico: The Spanish-Speaking People of the United States.* New York: Greenwood Press, 1968.

Meed, Douglas V. *Bloody Border: Riots, Battles, and Adventures along the Turbulent U.S.–Mexican Borderlands.* Tucson: Westernlore Press, 1992.

Mendizabal, Miguel Othón. *La evolución del noroeste de México.* México: Departamento de Estadísticas, 1930.

Molina, Flavio Molina. *Historia de Hermosillo antiguo.* Hermosillo: Fuentes Impresores, 1983.

Monroy, Douglas. *Thrown among Strangers: The Making of Mexican Culture in Frontier California.* Berkeley: University of California Press, 1990.

Monsivais, Carlos. "The Culture of the Frontier, The Mexican Side." In *Views across the Border,* edited by Stanley R. Ross Albuquerque: University of New Mexico Press, 1978.

Mora, Gregorio. "Los comerciantes de Guaymas y el desarrollo económico de Sonora, 1825–1910." In *IX Simposio de Historia de Sonora.* Hermosillo: Instituto de Investigaciones Históricas, 1984.

———. "Entrepreneurs in Nineteenth Century Sonora, Mexico." Ph.D. diss., University of California, 1987.

———. "Sonora, al filo de la tormenta, Desilusión con el porfiriato, 1900–1911." In *The Revolutionary Process in Mexico,* edited by Jaime Rodríguez. Los Angeles: UCLA Latin American Center, 1990.

Moreno Toscano, Alejandra, and Enrique Florescano. *El sector externo y la organización espacial y regional de México 1521–1910.* Puebla: Universidad Autónoma de Puebla, 1977.

Myrick, David F. *Railroads of Arizona.* Vol. 1. Berkeley: Howel North, 1975.

Navarro García, Luis. *Sonora y Sinaloa en el Siglo XVII.* Sevilla: Escuela de Estudios Hispano Americanos, 1967.

North, Diane M. *Samuel Peter Heintzelman and the Sonora Exploring and Mining Company.* Tucson: University of Arizona Press, 1980.

Nugent, Daniel. *Spent Cartridges of the Revolution.* Chicago: University of Chicago Press, 1993.

O'Dea, Thomas F. "The Mormons: Church and People." In *Plural Society in the Southwest,* edited by Edward Spicer and Raymond Thompson. Albuquerque: University of New Mexico Press, 1972.

Officer, James. *Hispanic Arizona, 1536–1856.* Tucson: University of Arizona Press, 1987.

———. "El año negro de Antonio Comanduran." In *Memoria, XII Simposio de Historia y Antropología.* Hermosillo: Instituto de Investigaciones Históricas, 1988.

Officer, James, Henry Dobyns, Manuel González, and Thomas Sheridan. *Frontier Tucson, Hispanic Contributions.* Tucson: Arizona Historical Society, 1987.

Ortega Noriega, Sergio. "Crecimiento y Crisis del Sistema Misional 1686–1767." In *Historia general de Sonora, de la conquista al estado libre y soberano de Sonora,* edited by Ignacio del Río and Sergio Ortega Noriega. Vol. 2. Hermosillo: Gobierno del Estado, 1985.

Paasi, Anssi. "The Institutionalization of Regions: A Theoretical Framework for Understanding the Emergence of Regions and the Constitution of Regional Identities." *Fennia* 164 (1986): 120.

Parks, Joseph. "The History of Mexican Labor in Arizona during the Territorial Period." Master's thesis, University of Arizona, 1961.

Paz, Teodoro O. *Guaymas de ayer.* Guaymas: Patronato 1974.

Picón-Salas, Mariano. *Gusto de México.* México: Porrúa y Obregón, 1952.

Pitts, Leonard. *The Decline of the Californios: A Social History of Spanish-Speaking Californians.* Berkeley: University of California Press, 1966.

Pletcher, David M. "American Capital and Technology in Northwest Mexico, 1876–1911." Ph.D. diss., University of Chicago, 1946.

———. "The Developments of Railroads in Sonora." *Inter-American Economic Affairs* 1 (4): 3–45 (March 1948).

Pradeau, Alberto F. "Pozole, Atole, and Tamales: Corn and Its Uses in the Sonora-Arizona Region." *Journal of Arizona History* 15 (1): 1–7 (Spring 1974).

Ready, Alma, ed. *Nogales, Arizona, 1880–1980, Centennial Anniversary.* Nogales: Nogales Centennial Committee, 1980.

Reyna José R. "Notes on Tejano Music." *Aztlan* vol. 13 (Spring-Fall 1987).

Rivera, Antonio G. *La revolución en Sonora.* Hermosillo: Gobierno del Estado, 1981.

Roberts, Virgina Culin. "Francisco Gandara and the War on the Gila." *Journal of Arizona History* 24 (3): 221–36 (Autumn 1983).

Rochlin, Fred, and Harriet Rochlin. "The Heart of Ambos Nogales: Boundary Monument 122." *The Journal of Arizona History* 17 (2): 161–80 (Summer 1976).

Romero Gil, Juan Manuel. "Crisis y resistencia social en las minas de Sonora." Paper presented at the XVII Simposio de Historia y Antropología de Sonora, Hermosillo, February 1992.

Rosaldo, Renato. *Culture and Truth*. Boston: Beacon Press, 1989.

Rosenzweig, Fernando. *Estadísticas económicas del Porfiriato, fuerza de trabajo y actividad económica por sectores*. México: Colegio de México, 1965.

Ross, Stanley, ed. *Views across the Border*. Albuquerque: University of New Mexico Press, 1978.

Rowe, William, and Vivian Schelling. *Memory and Modernity*. London: Verso, 1991.

Ruibal Corella, Juan Antonio. *Perfiles de un patriota*. México: Editorial Porrúa, 1979.

———. *Carlos R. Ortiz, el federalista*. México: Editorial Porrúa, 1984.

Ruiz, Ramón Eduardo. *The Great Rebellion*. New York: W. W. Norton, 1980.

———. *The People of Sonora and Yankee Capitalists*. Tucson: University of Arizona Press, 1988.

Sandomingo, Manuel. *Historia de Agua Prieta*. Agua Prieta: Imprenta Sandomingo. 1951.

Saragoza, Alex. *The Monterrey Elite and the Mexican State, 1880-1940*. Austin: University of Texas Press, 1988.

Scheina, Robert. "Unexplored Opportunities in Latin American Maritime History." *The Americas* 48 (3): 397-406 (January 1992).

Sepulveda, Cesar. *La frontera norte de México: historia, conflictos 1762-1975*. México: Editorial Porrúa, 1976.

Sheridan, Thomas E. *Los Tucsonenses: The Mexican Community in Tucson, 1854-1941*. Tucson: University of Arizona Press, 1986.

Simpson, Leslie Byrd. *Many Mexicos*. Berkeley: University of California Press, 1946.

Slatta, Richard, ed. *Bandidos: The Varieties of Latin American Banditry*. New York: Greenwood Press, 1987.

Smith Jr., Cornelius C. *Emilio Kosterlitzky: Eagle of Sonora and the Southwest Border*. Glendale: The Arthur H. Clark Company 1970.

Sobarzo, Horacio. *Episodios históricos sonorenses*. México: Editorial Porrúa, 1981.

———. *Vocabulario sonorense*. Hermosillo: Gobierno del Estado, 1984.

Solis, Hernan Garza. *Los mexicanos del norte*. México: Editorial Nuestro Tiempo, 1971.

Sonnichsen, C. L. *Colonel Greene and the Copper Skyrocket*. Tucson: University of Arizona Press, 1974.

———. *Tucson: The Life and Times of an American City*. Norman: University of Oklahoma Press, 1982.

Spicer, Edward H. *Cycles of Conquest: The Impact of Spain, Mexico, and the United States on the Indians of the Southwest, 1533-1960*. Tucson: University of Arizona Press, 1962.

———. *The Yaquis: A Cultural History*. Tucson: University of Arizona Press, 1980.

Stagg, Albert. *The Almadas and Alamos, 1783-1867*. Tucson: University of Arizona Press, 1978.

Stout, Joseph Allen. "The Last Years of Manifest Destiny, Filibustering in Northwest Mexico 1848-1862." Ph.D. diss., Oklahoma State, 1971.

Suárez Barnett, Alberto. "El 27 de Agosto de 1918." Nogales, Sonora. Manuscript.

——. "La Reclamación del Rancho Nogales de Elías." *Boletín de la sociedad sonorenses de historia en Nogales* 1 (1): 5–9 (January-February 1983).

Taylor, Thomas H. "Massacre at San Pedro de la Cueva, The Significance of Pancho Villa's Disastrous Sonora Campaign." *Western Historical Quarterly* 7 (2): 125–50 (April 1977).

Teheran, José. *Riata, La octava Plaga! El cazador de guachos.* Hermosillo: Taller Literatura Libre, 1984.

Thompson, E. P. "Time, Work-Discipline, and Industrial Capitalism." *Past and Present* no. 38 (December 1967): 56–97.

Thomson, Guy P. C. "Bulwarks of Patriotic Liberalism: The National Guard, Philharmonic Corps and Patriotic Juntas in Mexico, 1847–1889." *Journal of Latin American Studies* 22 (1): 31–68 (February 1990).

Tilly, Charles. "Social Movements and National Politics." In *Statemaking and Social Movements: Essays in History and Theory,* edited by Charles Bright and Susan Harding. Ann Arbor: University of Michigan, 1984.

Trueba Lara, José Luis. "Los chinos en Sonora: una historia olvidada." *El Tejabán* no. 2 (Febrero 1990): 7–96.

Turner, Frederick C. *Dynamic of Mexican Nationalism.* Chapel Hill: University of North Carolina Press, 1968.

Tutino, John. *From Insurrection to Revolution in Mexico: Social Basis of Agrarian Violence, 1750–1940.* Princeton: Princeton University Press, 1986.

Uribe García, Jesús Félix. "El desarrollo de las comunicaciones en Sonora y la influencia norteamericana." In *Memoria IX simposio de historia de Sonora.* Hermosillo: Instituto de Investigaciones Históricas, 1984.

——. *Breve historia urbana de Hermosillo.* Hermosillo: Sociedad Sonorense de Historia, 1987.

——. *El Hermosillo de las huertas a las acequias.* Hermosillo: Sociedad Sonorense de Historia, 1987.

Urrea de Figueroa, Otilia. *My Youth in Alamos, La Ciudad de los Portales.* Glendale: Dolisa Publications 1983.

Valencia Ortega, Ismael. *Cananea.* Hermosillo: INAH-SEP, 1984.

——. "El caso de la familia Camou." In *Memoria XII simposio de historia de Sonora.* Hermosillo: Instituto de Investigaciones Históricas, 1988.

——. "La Formación del la propiedad territorial, en la frontera: El caso de la familia Camou." Paper presented at the First Arizona/Sonora Colloquium, Nogales, Arizona/Nogales, Sonora, September 1991.

Valenzuela, Clodoveo. *Sonora contra Carranza.* México: Sisniega y Hno. Editores, 1921.

Vanderwood, Paul. *Disorder and Progress, Bandits, Police and Mexican Development.* Wilmington: Scholarly Resources, 1992.

Vasconcelos, José. *Breve historia de México.* México: Ediciones Botas, 1935.

Villa, Eduardo W. *Compendio de historia del estado de Sonora.* México: Ed. Patria Nueva, 1937.

von Mentz, Brígida. Verena Radkau, Beatriz Scharrer, and Guillermo Turner.

Los pioneros del imperialismo Aleman en México. México: Ediciones de la Casa Chata, 1982.

Voss, Stuart F. *On the Periphery of Nineteenth Century Mexico, Sonora, and Sinaloa. 1810–1877.* Tucson: University of Arizona Press, 1982.

Voss, Stuart F., Diana Malmori, and Miles Wortman. *Notable Family Networks in Latin America.* Chicago: University of Chicago Press, 1984.

Wagoner, Jay J. *Arizona Territory 1863–1912: A Political History.* Tucson: University of Arizona Press, 1980.

———. *Early Arizona: Prehistory to Civil War.* Tucson: University of Arizona Press, 1985.

Walker, Henry Pickering. "Freighting from Guaymas to Tucson." *Western Historical Quarterly* 1 (3): 291–304 (July 1970).

Wasserman, Mark. *Capitalist, Caciques, and Revolution: The Native Elite and Foreign Enterprise in Chihuahua, Mexico.* Chapel Hill: University of North Carolina Press, 1984.

Weber, David J. *The Mexican Frontier 1821–1846: The American Southwest under Mexico.* Albuquerque: University of New Mexico Press, 1982.

Wells, Allen. *Yucatán's Gilded Age.* Albuquerque: University of New Mexico Press, 1985.

Wells, Allen, and Gilbert M. Joseph. "Modernizing Visions. Chilango Blueprints and Provincial Growing Pains: Mérida at the Turn of the Century." *Mexican Studies/Estudios Mexicanos.* 8 (2): 167–216 (Summer 1992).

Willens, Emilio. "Social Change on the Latin American Frontier." In *The Frontier: Comparative Studies,* edited by David H. Miller and Jerome O. Steffen. Norman: University of Oklahoma Press, 1977.

Wyllys, Rufus K. *The French in Sonora.* Berkeley: University of California Press, 1932.

Zavala, Silvio. "Los esclavos indios en el norte de México siglo XVI." In *El norte de México y el sur de Estados Unidos.* Tercera reunión de mesa redonda sobre problemas antropológicos de México y Centro America. México: Sociedad Mexicana de Antropología, 1943.

———. "The Frontiers of Hispanic America." In *The Frontier in Perspective,* edited by Walker D. Wyman and Clifton B. Kroeber. Madison: University of Wisconsin Press, 1957.

Zea, Leopoldo. "La cultura nacional en el siglo XIX." In *Trayectoria de la cultura en México.* México: Editorial Jus, 1974.

Zorilla, Luis. *Historia de la relación entre México y los Estados Unidos de América, 1800–1958.* México: Editorial Porrúa, 1979.

———. *Monumentación de la frontera norte en el Siglo XIX.* México: Secretaría de Relaciones Exteriores, 1981.

Index

Text:	10/13 Sabon
Display:	Sabon
Index:	Donna Kaiser
Maps:	Bill Nelson
Composition:	J. Jarrett Engineering, Inc.
Printing and binding:	Thomson-Shore

DATE DUE

MAY 9 1997	

UPI 261-2505 G PRINTED IN U.S.A.